Visualizing War

CW00952573

Wars have always been connected to images. From the representation of war on maps, panoramas, and paintings to the modern visual media of photography, film, and digital screens, images have played a central role in representing combat, military strategy, soldiers, and victims. Such images evoke a whole range of often unexpected emotions from ironic distance to boredom and disappointment. Why is that? This book examines the emotional language of war images, how they entwine with various visual technologies, and how they can build emotional communities. The book engages in a cross-disciplinary dialogue between visual studies, literary studies, and media studies by discussing the links between images, emotions, technology, and community. From these different perspectives, the book provides a comprehensive overview of the nature and workings of war images from 1800 until today, and it offers a frame for thinking about the meaning of the images in contemporary wars.

Anders Engberg-Pedersen is Associate Professor of Comparative Literature at the University of Southern Denmark. He holds a PhD from Harvard University in Comparative Literature and from Humboldt Universität in German Literature. He is the author of *Empire of Chance: The Napoleonic Wars and the Disorder of Things* and editor of *Literature and Cartography: Theories, Histories, Genres*.

Kathrin Maurer is Associate Professor of German Literature at the University of Southern Denmark. She holds a PhD from Columbia University in German Literature and has also worked as an Assistant Professor at the University of Arizona. She is the author of *Visualizing the Past: The Power of the Image in German Historicism*.

Routledge Advances in Art and Visual Studies

Visualizing War

Emotions, Technologies, Communities

Edited by Anders Engberg-Pedersen and
Kathrin Maurer

Routledge
Taylor & Francis Group

LONDON AND NEW YORK

First published 2018
by Routledge

2 Park Square, Milton Park, Abingdon, Oxfordshire OX14 4RN
52 Vanderbilt Avenue, New York, NY 10017

Routledge is an imprint of the Taylor & Francis Group, an informa business

First issued in paperback 2019

Library of Congress Cataloging in Publication Data
A catalog record for this book has been requested

ISBN: 978-1-138-69343-2 (hbk)
ISBN: 978-0-367-32273-1 (pbk)

Typeset in Sabon
by Swales & Willis Ltd, Exeter, Devon, UK

Contents

Figures

Preface

Spectacle, Surveillance, and Just War Today

W.J.T. Mitchell

Why and how do we visualize war? The question immediately divides the issue between seeing and showing, watching and representing: strategies of surveillance, espionage, mapping, and stagings of scenarios, on the one hand, and the "spectacle war," on the other—the images of heroism, mass violence, atrocity and glory, the propaganda images that degrade the enemy and stir the passions of "our side." It should be emphasized that "visualization" here is a synechdoche for the entire sensorium and the media that extend our senses over the globe. Hearing and reading about war (or anything else) prompts us to engage in processes of virtual visualizing or "seeing as." Listening in is as important as watching over. Verbal images and metaphors (e.g. the metaphor of a "War on Terror") may be even more potent than photographs.[1]

By the time anyone reads these words, it is safe to predict that a war—a violent conflict involving mass murder of human beings—will be going on somewhere in the world. This war will produce spectacular images of destruction and suffering. Massive explosions, collapsing buildings, scores of maimed, dismembered bodies, and columns of refugees will appear in the news media. And a parade of politicians flanked by ribboned generals will hold press conferences denouncing the criminal behavior of the perpetrators and promising swift vengeance and the restoration of justice. On the day I wrote these words (April 6, 2017), the Assad regime in Syria provided the world with images of women, children, and infants transformed into hideous corpses by an attack of poison gas, a war crime denounced by most of the world, and dismissed as a false accusation by the Syrian regime and its Russian allies. And the immediate response of world leaders was, as usual, the spectacle of indignation and steadfast resolve not to let these crimes go unpunished, details to be supplied, also as usual, much later. By the evening of April 7, the President of the United States had responded with a missile attack on the Syrian airbase that was alleged to be the source of the gas attack. As a military action, it was meaningless (a "pinprick" was the label generally applied), and certainly a violation of international law and the US Constitution. Nevertheless, it was greeted with widespread acclaim in the United States and abroad. Attacks like this, along with the spectacular images of atrocity that provoke and justify them, have become the new normal.

This collection of essays is dedicated to two critical assessments of war and visualization that are in tension with one another. The first is that this is nothing new. The spectacle of war as conveyed in media images, verbal, visual, or musical, has been a staple of human culture from the ancient world to today. But the second is an attempt to reckon with the history of this awful syndrome, and to investigate the differences in the way that war has been represented, mediated, and condensed into images that

stick in memory, incite passion, and monumentalize victory, not to mention those images that provoke boredom and indifference as a result of their abundant normalization. This is a deeply nuanced and particularized history. War may always be with us, but not always in the same form. It changes with the invention of new technologies, and in fact produces numerous technical innovations in its own right. War is the mother of invention, as Friedrich Kittler has shown, linking cinema to the machine gun, the situation room, and the "theater" of war, stereophonic sound reproduction to aerial guidance systems and sonar, and the typewriter to cryptology and the decoding of secret messages.[2] All of the modern technical innovations of "entertainment media"—verbal, acoustic, and visual—are grounded in military research. The Internet was pioneered by the US Defense Department; in the form of social media it has now become a new "theater of war" in its own right, the battleground of disinformation and propaganda that characterizes our post-truth era of alternative facts, mass delusion, and radical skepticism.

So war is not simply something that changes with the history of technology and political systems. It is a principal driver of that history, and arguably, the driver that could bring that history to an end. Since the end of the Cold War, we have seen numerous predictions of the end of history and the final triumph of capitalism. The Cold War itself was envisioned as an insane endgame to the history of civilization aptly labelled "MAD" (Mutually Assured Destruction), with the prospect of a global nuclear war reducing the world to a Hobbesian state of nature, a "war of all against all." Perhaps now that we are seeing what the final victory of capitalism looks like—the degradation of democracy by oligarchy and predatory neoliberal capitalism—we will be able to foresee a different pathway to the end of history accelerated by climate change, immiseration of growing populations, and the predictable emergence of new international terrorist movements. Fred Jameson's mordant remark that it is now easier to envision the extinction of the human species than the end of capitalism seems more than ever to describe accurately a vision of the future of ubiquitous war.

Given this gloomy prospect, we might ask ourselves what is the point of investigating the history of visualizing war. The ritual answer is that we study history in order to avoid repeating it. But the predictable response to this answer is quick to follow: the only thing we learn from history is that we do not learn from history. As Richard Rorty observed (echoing Henry Ford): "History is just one damn thing after another."[3] The best we can hope for from the study of history is the preservation of a record, an archive, and a set of narrative patterns and critical reflections that might be of help to some future counselor to a sovereign who is faced with fatal decisions about peace or war. This seems like a very remote prospect, especially at the present moment in the United States, where the most powerful individual on the planet comes to these decisions armed with militant ignorance and the emotional maturity of a spoiled 12-year-old boy. The current President of the United States is not interested in the wise counsel of experts in history, diplomatic or military, much less in the larger political and cultural histories that surround these more specialized histories. One suspects that Donald Trump's visualizations of war are based in reality TV and war movies. He has already forced a decisive shift in the strategic posture of the United States, from Obama's vision of peace through negotiations and political settlements, to a posture of readiness for all-out war. The drastic cutting of the State Department's budget and the huge expansion of the military budget are the real-world evidence of this strategic shift.

It is easy to make another prediction. By the time you read these words, the United States will have entered into a new "shooting war," as the jargon has it. The US will be involved in a large, spectacular military action—invasion, occupation, but above all, aerial and drone combat with repeatedly staged spectacles of "victory." The "shock and awe" spectacles of American military prowess staged by George W. Bush in the destruction of Baghdad in 2003, ideally followed by a quick "Mission Accomplished" photo op, will provide Trump with a perfect scenario. Trump's fundamental promises to the world were that he would make the US a winner again. That means, in his terms, that we will "look like winners," at least for a few news cycles. The long-term effects (e.g., the endless debacle of Iraq, the hollowness of the "Mission Accomplished" staging), will be suppressed or erased by other crises. And so it is in Trump's direct political interest to provoke a spectacle war somewhere. The immediate public reaction to his missile attack on Syria certainly taught him that much. The televised images of Tomahawk missiles launched into the night sky accompanied by rousing martial music seemed like the perfect moral response to the Syrian gas attack, a "proportional" response that was purely symbolic, the proverbial "shot across the bow."

If there is any history lesson that Trump applied in this action, it is that George W. Bush went from record low public approval in August 2001 to record high approval after September 11. Becoming a "war president" gave Bush the extraordinary powers justified by a state of emergency. So the perfect provocation for a new US "spectacle war" was not an intervention or escalation of an already existing conflict (therefore, not Afghanistan or Iraq). It required a spectacular image to provide a pretext, a "casus belli" offering a moral justification for an attack. And so, as I was writing these words, Trump, beleaguered by falling poll numbers, and under criminal investigation by the FBI, has more than enough motivation to seize the most obvious fresh target, namely Syria. In the space of one week, (April 3–7, 2017) Trump's official line about military adventures in the Middle East was reversed. At the beginning of this week, he was ridiculing the long tradition of American moral and humanitarian concerns as a reasonable basis for going to war. His isolationist "America First" doctrine meant that we would leave Syria alone, and let our new friend and ally, Vladimir Putin, continue to maintain the murderous Assad regime. But the release of lurid videos of dead and dying children murdered in Assad's gas attacks gave him the rare opportunity to seize the moral high ground. He declared that Assad had now crossed many lines (even though that line had been crossed many times before, and he had repeatedly opposed his predecessors' attempts to punish the Assad regime for much worse atrocities). Trump was thus able to ignore the niceties of legality and strategic planning, and launch an instant retaliation justified by impulsive moral outrage. The fact that a war against Syria would put the US on a collision course with Russia might be a complicating factor, but the upside for Trump is that it would for a moment de-odorize the smell of his collusion with the Russians in smearing Hillary Clinton and helping his rise to the presidency. If Syria should prove too complex a target, there is always North Korea waiting in the wings, with its own lures as a site of irredeemable evil, and its accompanying problems as a client of China.

Was Trump's notoriously thick skin about harms to other people (the poor, refugees, the "losers" of the world) suddenly penetrated by these awful images? It seems not to have been penetrated by the fact that his policies have consistently prevented these suffering innocents from seeking asylum in the United States. Images of dying refugees are "sad," but to admit the actual subjects of those images to the US is out

of the question. Trump has notably *thin* skin when it comes to perceived injuries or insults to himself, as evidenced by his vitriolic reactions to comedy shows that satirize him. Had he suddenly discovered compassion for others? Or was this a calculated reaction, very useful for supporting his transition to the status of "War President," a status that proved to be so helpful to the Bush presidency? He is in desparate need of a legislative victory at this moment, and an open-ended congressional authorization for military action in Syria will undoubtedly provide an easy win. Or he cannot bother with that, and remain a reliably "loose cannon," improvising continued military strikes justified by little more than some convenient television images. Nothing like a spectacular "just war" to unite the American people behind you, especially that part of the American electorate that fell for this con man in the first place.

The whole theory of "just war" is itself undergoing a visible transformation in our time. Traditionally this concept governed two notions of justice: 1) the "justified" war that is a defensive response to invasion, or that is provoked by some outrageous action that provides a moral casus belli; 2) the just *conduct* of war, observance of so-called "laws of war" that prohibit attacks on civilians, mandates the honorable behavior of soldiers risking their lives in combat, and forbids the use weapons of mass destruction that murder large numbers of civilians. Clearly these two notions of just war are becoming increasingly quaint. Even the "nuclear option," unthinkable before the Trump election, is now "on the table," as this administration ponders the nuclear re-arming of Japan. And the just conduct doctrine has been eviscerated by the emergence of drone warfare, in which the more powerful side boasts combatants who only see the war on a screen in an air-conditioned control room thousands of miles from the action. Drone operators degrade the moral status of "visualizing war" to a new historic low. They also make this armchair combat risk-free and hygienic for the predatory operators. Occasionally their work of destructive surveillance rises to level of spectacle, as in the recent film, *Eye in the Sky*, which sentimentalizes the drone operator as a deeply moral agent who resists following orders that might lead to the death of a little girl near the target. The US military has adopted this Hollywood fantasy by inventing a new form of post-traumatic stress disorder, what we might call "perpetrator trauma" caused by the stress of seeing on screen the death and destruction one has caused.[4] In this case, and in the larger strategic framework, the whole notion of just war has been hollowed out. The expression "just war" should now be redefined in terms of American colloquial usage: it is "just war," in the sense that it is "only war," "war as usual," or "just another war"; war no longer understood as state of exception or emergency that interrupts peace, but war as itself the new normal.

The study of visual culture and iconology, which traces the migrations of images across the boundaries of media and perception itself, engages both sides of the "visualizing war" problematic. That is, the structuring of vision itself by practices of spectacle and surveillance, seeing and being seen—on the one hand, propaganda, spectacle, arousal of war fever; on the other, the endless technical innovations in the arts of surveillance, mapping, spying, and penetration of the enemies' defenses. Interestingly, in today's war, in the age of what Jan Mieszkowski calls "anti-social media," a whole new terrain of information war has unfolded. It is conducted by a new combination of spectacle and surveillance techniques, instantiated by the Russian hacking of the American presidential election. No one questions that there was a concerted attack by Russian cyber-warriors on Hillary Clinton, and that they supplied US right-wing media with a massive amount of abusive misinformation

and outright slander of Clinton. This was accompanied by a noticeable public tilt of the Alt-Right toward Russia (a bastion of authoritarian macho leadership, White Christianity, and cunning aggression). Just a coincidence, of course, that so many of Trump's inner circle had extensive business and other dealings with Russia.

In other words, this was both a highly visible war of images and words, and an insidious, invisible campaign that "deconstructed" (in Trump adviser Steven Bannon's terms) the credibility of main stream professional media. Trump's peculiar combination of huckster jingoism, media "celebrity," and conspicuous display of wealth turned out to be the perfect combination. Populations (e.g., the notorious castrated white male working class) were shepherded into media niches where their fears and fantasies of renewed potency could be nurtured. And the white women of America stood by their men. Amazingly, the popularity of Putin and Russia not just with the Alt-Right, but with the Republican voters, has increased measurably with the onset of the Trump "epoch."

And it is an epoch rather similar in magnitude to 9-11, which launched the fantasy of an endless and unwinnable "war on terror" as the prevailing metaphor made literal for US military policy in the twenty-first century.[5] Those who visualize war in terms of images need to remember that *verbal* images like the war on terror can wind up structuring an entire strategic posture. Obama's eight years provided a reversal of the pendulum ("war on terror" was replaced by the bureaucratic euphemism, "overseas contingency operations") but only temporarily, as the seeds of American fascism were nurtured by the relentless obstructionism of the Republican Party during his presidency. With Trump we have come to the perfect synthesis of oligarchic crony capitalism, militarism, and populist charisma. Right now it is a race between two narratives: one leads toward the exposure of Trump's corruption, his collaboration with Russia, and subsequent impeachment; the other leads to a war that, given this so-called president's disposition, is sure to be spectacular. And it will be just war.

Notes

1 See my book, *Cloning Terror: The War of Images, 9-11 to the Present* (Chicago: The University of Chicago Press, 2011), for a discussion of the role of verbal images and metaphors in the framing of war.

2 Friedrich Kittler, *Gramophone, Film, Typewriter* (Stanford: Stanford University Press, 1999), xli.

3 The actual source of this famous quotation is in doubt. It is often attributed to Arnold Toynbee, but Henry Ford is sometimes given credit, and it punctuates Rorty's ironic, anti-progressivist view of history.

4 See Grégoire Chamayou. *A Theory of the Drone*. Trans. Janet Lloyd (New York: The New Press, 2014).

5 See *Cloning Terror*, xviii–xviii, 28–29, for a discussion of the literalizing of this master metaphor or "metapicture" of the war on terror.

Introduction

Anders Engberg-Pedersen and Kathrin Maurer

This book investigates images of war—the emotions they evoke, the technologies that produce them, and the communities they build. Wars have always been connected to images. From the representation of the Trojan War on ancient vases and Medieval battles on finely woven carpets to the modern visual media of photography, film, and digital screens, images have played a central role in representing combat, military strategy, soldiers, and victims. Images can witness, aestheticize, and reflect war. They can also incite war. A frequent way of thinking about images of war is to understand them as icons such as the photos of the hooded prisoner in Abu Ghraib or, from the Vietnam War, of Phan Thị Kim Phúc, known as the Napalm girl. Derived from the Greek *eikon* (likeness, image), the meaning of the term goes back to images of holy figures in Byzantine church paintings. The primary function of these religious icons was to create a connection between the viewer and God. Not unlike the religious icons, there are some images of war that reach out to the viewer, emanate an emotional energy, and become powerful fixtures of our collective memory. Scholars of art history, visual studies, and media studies have discussed Aby Warburg's notion of the pathos formula as a key term to describe iconic images of war and understand their emotional intensity.[1]

This book, however, turns to the images of war that do not adhere to an iconic emotional language and its cultic universal gestures of human suffering, mourning, or (anti-) heroism. Rather, we investigate how images of war may elicit unexpected and complex emotions. The chapters reveal a number of surprising emotional responses, such as boredom, coolness, disappointment, or ironic distance. These more equivocal emotional registers are often defined by the 'aesthetics of the poor image,' which consciously breaks with conventional norms of beauty and the sublime. These images can point to the situation they were made in, to the subject that took the picture, and to the processes of image production. They often have an ineffaceable bond to the real and expose the event of taking the picture as Ariella Azoulay has noted in her work on photography.[2] Robert Capa's shaky D-Day pictures taken in the midst of the battle serve as examples for this kind of aesthetics, or the images taken by prisoners inside Auschwitz—"images in spite of all," in Georges Didi-Huberman's phrase.[3] These images are blurred and cross-faded, their gaps and white spots activate the power of the imagination to project something that escapes realist representation. Katarzyna Ruchel-Stockman's essay investigates this aesthetics of the poor image (Chapter 7). Analyzing films about the political conflicts during the Arab Spring, movies that are mostly based on amateur mobile camera recordings and footage, she explores the iconographic, emotional, and community-building aspects of such 'imperfect' images of war.

Non-iconic images of war, however, do not always have to engage with the aesthetics of the poor image. They can also be grotesque, surreal, paradoxical, trivial, comical, and even campy. Alexander Kluge's filmic episodes of World War I, for example, are representative of these types of images. By means of comical and ironic distortion his images suggest ambiguity, complexity, and openness, and thus point to the interpretative challenges of visualizing war. Hovering between documentary realism and aesthetic incommensurability non-iconic images of war activate the power of the imagination and challenge the viewer's hermeneutic apparatus. Their in-betweenness enables the viewer to observe critically the emotional and community-building discourses in which these images of war are embedded. Stephan Jaeger demonstrates that these problems of representation are not only present in artistic film, experimental literature, and photography of war. Also historical museums, traditionally institutions bound to authenticity and documentarism, grapple with the hermeneutic "obstinacy" (*Eigensinn*) of these images. His analysis of a selection of World War II museums (Chapter 10) shows how their use of images constructs poietic experimental and simulated spaces of remembering. These spaces do not simply depict, document, or even reconstruct the past, rather, in a non-mimetic way, they allow for self-reflexive and multi-perspectival experiences of war.

The book engages a varied visual material tracing the images of war across distinct media, objects, and genres such as war cartography, panoramas, photography, sculpture, film, and computer simulations. Literary images of war in, for example, Ernst Jünger's prose, will also be investigated since poetic texts not only create mental images, but also raise questions of the interaction between text and image. As W.T.J. Mitchell has noted there are indeed no purely visual media. From Aristotle's observations of performative art, to Barthes theories on image/music/text, to mass media, theories about mental images, and even painting, all images are hybrid media and, as Mitchell suggests, need forms of language. Either in the image itself or in their perception, images are dependent on linguistic discourses and words.[4] Informed by this concept of mixed media, *Visualizing War* analyzes a whole range of image types (static, dynamic, moving, mental, poetic) from the Napoleonic era until today. The analysis of their entwinement with textual discourses, be it in literature, public media, or political statements, is crucial for our understanding of the ways in which war has been visualized during the past two centuries. The volume, however, does not provide a linear historical narrative about the evolution of these images of war. Rather, it offers a discussion of individual cases that in their singularity serve as so many prisms that exemplify the modes and conditions for how images represent and refract war. Specifically, it shows how images of war generate emotions, how they are interlinked with different technologies, and how they can shape emotional communities.

Equivocal Emotions

Just as this book seeks to draw attention to the wide range of non-iconic images of war, it also seeks to expand the standard repertoire of emotions that war elicits. Achilleus' anger, Colonel Kurtz's horror are cultural examples of the way war has produced a limited range of strong emotions that recur regularly in the cultural history of war. Among them, the dysphoric emotions loom large, but the euphoric ones such as enthusiasm and the thrill of battle equally belong to the stock of emotional responses in cultural representations. Their fairly limited number is balanced by their intensity—an

intensity that would seem to reduce complexity and singularize and reinforce a given emotion once it has taken hold. Given the prevalence of these cultural representations of the emotional responses to war, it is little surprise that they have attracted the most critical attention. The same may be said of the philosophical and political engagement with the emotions. For, historically, the emotions that have played a role in the main theories of stratecraft are unambiguous strong emotions. For Aristotle and for Hobbes, the basis of political communities and political action lies in fear and anger. They belong to what Philip Fisher has called "the vehement passions."[5] In similar fashion neuroscience and psychology have long established what Ruth Leys has labeled the "basic emotions paradigm"—the existence of between six and nine emotions such as fear, anger, disgust, joy, sadness, and surprise that, in this view, are natural, universal, and hard-wired into the brain. Bypassing conscious interference and interpretation, these basic emotions are seen as reflex-like bodily responses to external stimuli.[6]

The present book, however, seeks to widen the lens and bring to light the expansive landscape of war emotions that have been overshadowed by the focus on the basic emotions. In the interstices between the solid emotional pillars of anger, fear, joy, disgust, etc., we find a range of complex, composite, and equivocal emotions that cannot be reduced to the uniformity or reflex-like simplicity of the basic emotions. Moreover, these ambivalent emotions are in a different modal state than the traditional ones. They do not display the all-encompassing intensity that grips the viewers and immediately seizes every fiber of their being. Less intense, they are situated at the lower end of the scale, and, more diluted, their temporal frame is longer. These are not powerful feelings in spontaneous overflow, but complicated mixed emotions, sometimes trivial, sometimes of minimal intensity, that nevertheless constitute widespread emotional responses to war.

Sianne Ngai's recent attempt to transform and expand the repertoire of aesthetic categories is an invitation to rethink the aesthetics of warfare.[7] Alongside the traditional emotions, which more complex ones do we find? How do forms of revulsion, of fear, of anger or of empathy and pity intersect one another? How do more mundane affects inflect them? And with which representational strategies are they linked? Do non-iconic images elicit what we might call *non-iconic emotions*? Over and above the recurring basic emotions, the book presents a number of examples of unexpected, equivocal, and mixed emotional responses to warfare that fall outside of the traditional aesthetic analysis of war.

Emotions and Affects

This approach complicates a distinction that has emerged in the critical vocabulary. Passions, emotions, affects, and feelings are the main terms that make up the semantic matrix in which the theoretical discussion has moved.[8] Often used interchangeably, they have nevertheless given rise to efforts at conceptual definitions that seek to distinguish between their subjective or objective nature, the first and the third person, the individual and the social, the structured and the unstructured.[9] In particular, emotions and affects have been separated. The split originated in psychoanalysis to distinguish the psychologist's perspective, which observes objective affects in the analysand, from the perspective of the analysand who *has* emotions and feels them, but, as Ngai notes, the distinction has since deepened.[10] For Brian Massumi, emotions are not merely personal, they also entail a narrative sequence

or structure that endows them with content and meaning. Affects, on the other hand, are nonconscious in kind, they lack organized structures, and evade clear-cut qualifications. Rather, in a Deleuzian vocabulary, they are dispersed and modulated by intensities.[11] In this view, emotions and affects should be held clearly apart since they "follow different logics and pertain to different orders."[12]

For the study of war images, the distinction is often useful. It is doubtless correct, as Massumi argues, that images have effects at the visceral, nonconscious level and that their political power relies on an affective force that operates below the surface of explicitly formulated ideology. Yet, a cultural inquiry into the emotional and affective valences and workings of war images also needs to attend to the ideologies and strategies that surround the production and reception of war images and that are folded into the very structure of the images themselves. The chapters in this volume examine how individual and collective emotions emerge from the poetics of the war image and at the same time they show how in the poietic production of emotions various strategies are used to complicate, modulate, or change the basic emotions.[13] The sharp distinction between affect and emotion therefore cannot be rigidly upheld, and the contributors follow a more flexible taxonomy. While the equivocal emotions analyzed in the first section of the volume would appear to tend toward the affective given their increased complexity, this complexity is often the result of deliberate representational strategies that consciously seek to thwart an immediate emotional response to the images of war. When Christine Kanz (Chapter 3) notes the deep-rooted longing for intense sensory and emotional experiences leading up to World War I, she at the same time shows how a writer like Ernst Jünger creates an emotional detachment in his war writings as a protective shield to prevent the mind from being overpowered by the intensity and shock of the war images his texts also conjure forth. Jünger's blasé coolness, so to speak, is the result of a set of literary choices with the specific purpose of presenting an autonomous subject who remains sovereign amidst the whirl of violent impressions. Likewise, female bystanders in World War II such as the army nurses Ingeborg Ochsenknecht and Erika Summ would develop and strategically deploy an emotional distance in their memoirs in order to shield themselves from the horrors they experienced at the front (Chapter 1). Suppressing the extreme emotions of trauma and horror, they cultivated a register of more subdued emotions that allowed them to continue their work. But, as Elisabeth Krimmer notes, it is just this shift of emotional registers that also marks their silent complicity with the Nazi atrocities they witnessed firsthand. And Alexander Kluge's films (Chapter 2), mentioned above, consistently infuse the images of war with absurdity, fantasy, and even comedy thereby arresting and reformatting conventional emotional responses. Such engagements with war images point to the need for careful examinations of the deliberate emotional strategies deployed as well as the expansion of the basic emotions paradigm to include the equivocal, mixed emotions produced by war imagery.

Emotional Technologies

The deliberate management of the emotions is intimately tied up with technological inventions. The history of war technologies is usually framed in terms of the gradual, or at times sudden, increase in the human capacity to act in the world. Extending the reach and power of the human senses, technologies from maps to drones serve as tools that enable soldiers and officers to perform military operations of greater magnitude,

xviii Anders Engberg-Pedersen and Kathrin Maurer

with greater precision, and with greater efficiency. But these technologies perform operations in both directions. They operate not just on the world but equally on the military subject who uses them. Technology has not simply made man into "a kind of prosthetic God," as Freud suggested, but as Walter Benjamin countered, "technology has subjected the human sensorium to a complex kind of training."[14] Serving as tools to manage worldly events, military technologies have also served as tools to generate, control, and manage emotions. The second section of the book samples an array of *emotional technologies* from 1800 to the present that evoke and format emotional states in the user(s) from boredom and exhaustion via frustration to fear and excitement. The modern wargame was invented to simulate and rationalize military operations, but as Anders Engberg-Pedersen shows (Chapter 4) its efficiency as a training device is inseparable from its entertainment value and the conjuring of emotional effects in the players. The maps on which the game is played, the rules that organize its ludic form, and the dice that shape its operational order are themselves agents that interpellate the full spectrum of the players' bodies and minds. In their more recent digital versions, immersive training scenarios have further been designed both to preempt and to treat war trauma through an elaborate processing of the soldiers' emotional apparatus.

Immersion and the suspension of disbelief have been key desiderata in various inventions that seek to engage the subject at the emotional level. Long before virtual reality enabled a 360-degree simulation of a fictional or actual part of the world, the optical technology of the panorama served political purposes by means of total immersion. In its military version, the panorama appealed to the citizens and sought to shape a national community that might more easily be persuaded to go to war. Yet, as Kathrin Maurer points out, (Chapter 5) it was difficult to maintain public interest in the panorama in part because of its obvious propagandistic purpose and in part because newer technologies emerged that offered the viewer a chance to escape the panoptic fantasy of complete representation.

In order to perceive the role of emotions in technological inventions, in order to see them as *emotional technologies*, these few examples demonstrate that it is necessary to zoom out from the devices and contraptions themselves and situate them in the larger political, military, or social context out of which the emerged in the first place. As Jonathan Crary has argued, such technical devices are

> points of intersection where philosophical, scientific, and aesthetic discourses overlap with mechanical techniques, institutional requirements, and socioeconomic forces. Each of them is understandable not simply as the material object in question, or as part of a history of technology, but for the way in which it is embedded in a much larger assemblage of events and power.[15]

To make an emotional technology visible and draw out its consequences the aesthetic field in particular is a useful resource. Thus the unintended psychic effects of waging war on screen, i.e. drone technology, are, for example, brought out by Omer Fast's semi-documentary "5,000 Feet Is Best." Troubling standard assumptions about the links between physical and emotional distance, Svea Braeunert in her analysis of Fast's film suggests that contemporary war images create new forms of intimacy that have potentially dire consequences in the form of PTSD (Chapter 6). As tools to build emotional resilience and to treat traumatic experiences, liquid crystal screens with

their fusion of proximity and distance also have the power to induce trauma once they have become integrated into the military apparatus. Analyzing the technologies and situating them in their political, military, and aesthetic context, the section thus complements the view on the genealogy of military technology as one of increasing rationalization with its equally important emotional component.

Emotional Communities

These emotional technologies and their forms of visualization also have the power to build communities. A community is a dynamic and variable entity constructed by common attitudes, values, opinions, and emotions. It therefore refers to what Ferdinand Tönnies has summarized in his concept of *Gemeinschaft*, i.e. a collective based on mutual relationships, property, roles, beliefs, and language.[16] This concept of community constitutes the counterpart to *Gesellschaft* (society), which is driven by instrumental goals, self-interest, and individual profit. When analyzing the community-shaping aspects of war images, Tönnies' notion of *Gemeinschaft* is productive since it encompasses emotion as one of its constitutive components.

A primary medium to experience emotions collectively is art. In this respect Hermann Kappelhoff's essay is key for our understanding of the relationship between images, emotions, and communities (Chapter 8). By investigating the genre of war films, Kappelhoff spells out its emotional poetics and its community-building effects. In doing so, his theoretical framing comes close to Rancière's assumption that political communities can be shaped through aesthetic experience. In Rancière's well-known theory the connection between art and politics is grounded in the idea of the "distribution of the sensible." As he puts it, "A distribution of the sensible therefore establishes at one and the same time something common that is shared and exclusive parts."[17] The distribution of the sensible represents accordingly the condition of possibility of perception, the *a priori* laws of what is possible to hear, see, think, utter, and apprehend by the senses. Art is therefore a privileged realm in which to experience and to observe the organization of the sensible world. Due to its autonomy, freedom of purpose (*Zweckfreiheit*), and non-instrumentality, modern art represents a medium by which—in theory—one can experiment with the uttering of different opinions, judgments, and tastes without being constrained by religious, political, or economic codes. This experience of aesthetic "dissensus," as Rancière calls it, has in essence a political dimension. The political, however, is not understood in the sense of political representation, party politics, state politics, or law enforcement. Rather clearly related to Schiller's idealist romantic notion of the aesthetic state as well as to the poetic theory of Early German Romanticism, the political is conceived at the level of language, images, music, and poetry. Through the experience of art, one can practice dissent, dismantle hierarchies, and exercise freedom and autonomy, which in turn represents for Rancière a political activity. In our aesthetic experience, we can share common tastes and distastes, likes and dislikes, and different perceptions of beauty. In exercising these aesthetic judgments, we can shape forms of community. Rancière notes:

> The important thing is that the question of the relationship between aesthetics and politics be raised at this level, the level of the sensible delimitation of what is common to the community, the forms of its visibility, and of its organization.[18]

Accordingly, by means of the emotional experience of the aesthetic, we are able to share a sense of community. This sense of community can then, for example, take the form of a collective of critical readers, a group of mourners over the losses of war, or, simply, a community of aesthetic consumers.

Against this theoretical background, Kappelhoff shows how the (politically highly divergent) films by Leni Riefenstahl and Frank Capra can mobilize temporary political communities on the basis of individual emotions. But war images generate a whole array of emotional communities such as the community of war spectators in the nineteenth-century panorama, the community of drone pilots suffering from PTSD, and the memory communities in World War II museums. Thomas Ærvold Bjerre explores Tim Hetherington's photography of American soldiers in Afghanistan (Chapter 9). His essay shows how Hetherington's anti-iconic images undermine the stereotypical ways of male soldier bonding. The portrayal of sleeping or gender-ambivalent soldiers exposes them in their vulnerability, which in turn suggests other forms of male war communities.

Although all the emotional communities discussed in this book have different agendas and settings, it is important to note that they have been formed through the emotional power of war images. But, we might ask, is this power to form and shape communities also true for digital war images on social media? Recent media theorists, such as Fred Ritchin, have posed the question if nowadays digital media culture with its ever-accelerating instantaneousness has eroded the power of images because audiences are constantly fed a stream of war images that leads to ignorance and oblivion.[19] Similarly we might ask whether images of war in the digital age still have the power to build communities? Jan Mieszkowski's essay "War in the Age of Anti-Social Media" (Chapter 11) engages with the problem. He argues that the spectacularization of war, which had its beginnings with the Napoleonic wars in the nineteenth century, culminates in the flood of war images on platforms of social and digital media. War as big data entertainment not only challenges once more the differentiation between 'authentic' and 'staged' representations of war, it also fundamentally erodes the communal element. Although social media can be used to mobilize protest, Mieszkowski demonstrates that the spectacularization of war evokes apathy, ignorance, and disconnectedness—emotional responses that run counter to the nominal sociality of contemporary media.

Bringing together visual studies, literary studies, and media studies in a cross-disciplinary dialogue that spans the past 200 years, the anthology presents a visual archaeology of war in which unconventional war images and their links to emotions, technologies, and communities are brought to the surface. *Visualizing War*, thus, hopes to be a useful tool—or archive—for scholars to extend the material range of war images and, more importantly, to grapple with new forms of visual aesthetics and their emotional power. These non-iconic images of war evade the conventional depictions of horror, victory, suffering, and depredation—they thwart easy categorization and do not allow the viewer an immediate hermeneutic judgment. Rather, as the chapters show, they highlight the conflicting elements that stir the power of the imagination or the poetic imagination. As a visual archaeology, however, the book does not exhaust itself in its descriptive and material purpose. Uncovering the intricate ways in which these visualizations of war operate should, we hope, broaden our understanding of the powerful effects that different visual representations of war have on us as viewers and as members of smaller or larger social and political communities. In this

way, *Visualizing War* might serve as a primer to help us improve our visual literacy and make us more attentive to the way images of war work—to their poetics, to the technologies and media that produce and manage them, to their hidden ideologies and exclusions, and to how they make us see and feel.

Notes

1 For a discussion on icons, see Stephen Eisenman, *The Abu Ghraib Effect* (London: Reaktion, 2007); Gernot Böhme, *Theorie des Bildes* (München: Fink, 1999); Horst Bredekamp, *Theorie des Bildakts: Frankfurter Adorno-Vorlesungen 2007* (Frankfurt am Main: Suhrkamp, 2010); Aby Warburg, *Der Bilderatlas Mnemosyne*, eds Martin Warnke and Claudia Brink (Berlin: Akademie Verlag, 2008); Martin Warnke; "Politische Ikonographie," in *Ikonographie: Neue Wege der Forschung* (Darmstadt: Wissenschaftliche Buchgesellschaft: 2010, 72–85); Georges Didi-Huberman, *Das Nachleben der Bilder: Kunstgeschichte und Phantomzeit nach Aby Warburg*, trans. Michael Bischoff (Frankfurt: Suhrkamp, 2010).
2 Ariella Azoulay, *Civil Imagination: Political Ontology of Photography* (London: Verso, 2012).
3 Georges Didi-Huberman, *Bilder trotz allem* (München: Fink, 2007).
4 W.J.T. Mitchell, "There Are No Visual Media," in *The Visual Culture Reader*, ed. Nicholas Mirzoeff (New York: Routledge, 2013), 7–14.
5 Philip Fisher, *The Vehement Passions* (Princeton, NJ: Princeton University Press, 2002).
6 Ruth Leys, "The Turn to Affect: A Critique," *Critical Inquiry* 37 (Spring 2011): 438–439.
7 See Sianne Ngai, *Our Aesthetic Categories. Zany, Cute, Interesting* (Cambridge, MA: Harvard University Press, 2012).
8 See e.g. Eric Shouse's attempt to distinguish the terms in his brief essay, "Feeling, Emotion, Affect," in *M/C Journal* 8, no. 6 (2005), accessed December 12, 2016, http://journal.media-culture.org.au/0512/03-shouse.php.
9 Sara Ahmed, for example, takes a more fluid approach and uses the terms interchangeably. For a critique of the attempts within neuroscience and cultural studies to separate them into distinct logical and ontological realms, see Ruth Leys "The Turn to Affect," 434–472.
10 Sianne Ngai, *Ugly Feelings* (Cambridge, MA: Harvard University Press, 2005), 26.
11 See in particular chapter 1 "The Autonomy of Affect," in Brian Massumi's *Parables for the Virtual: Movement, Affect, Sensation* (Durham & London, Duke University Press, 2002), 23–45.
12 Massumi, *Parables*, 27.
13 This approach recalls Sara Ahmed's claim that emotions are performative and involve speech acts. See Sarah Ahmed, *The Cultural Politics of Emotion* (Edinburgh: Edinburgh University Press), 2004, 13.
14 Sigmund Freud, *Civilization and its Discontents*, trans. James Strachey (New York: W.W. Norton, 1961), 44; Walter Benjamin quoted in Jonathan Crary, *Techniques of the Observer. On Vision and Modernity in the Nineteenth Century* (Cambridge, MA: MIT Press, 1992), 112.
15 Crary, *Techniques of the Observer*, 8.
16 See Ferdinand Tönnies, *Gemeinschaft und Gesellschaft: Grundbegriffe der reinen Soziologie* (Darmstadt: Wissenschaftliche Buchgesellschaft, 2010).
17 Jacques Rancière, *The Politics of Aesthetics: The Distribution of the Sensible*, trans. Gabriel Rockhill (London: Continuum, 2004), 12.
18 Rancière, *The Politics of Aesthetics*, 18.
19 Fred Richtin, *After Photography* (London: Norton, 2009).

Bibliography

Ahmed, Sara. *The Cultural Politics of Emotion*. Edinburgh: Edinburgh University Press, 2004.
Azoulay, Ariella. *Civil Imagination: Political Ontology of Photography*. London: Verso, 2012.
Böhme, Gernot. *Theorie des Bildes*. München: Fink, 1999.

xxii *Anders Engberg-Pedersen and Kathrin Maurer*

Bredekamp, Horst. *Theorie des Bildakts: Frankfurter Adorno-Vorlesungen 2007.* Frankfurt am Main: Suhrkamp, 2010.

Crary, Johnathan. *Techniques of the Observer: On Vision and Modernity in the Nineteenth Century.* Cambridge, MA: MIT Press, 1992.

Didi-Huberman, Georges. *Bilder trotz allem.* München: Fink, 2007.

———. *Das Nachleben der Bilder: Kunstgeschichte und Phantomzeit nach Aby Warburg.* Frankfurt am Main: Suhrkamp, 2010.

Eisenman, Stephen. *The Abu Ghraib Effect.* London: Reaktion, 2007.

Fisher, Philip. *The Vehement Passions.* Princeton, NJ: Princeton University Press, 2002.

Freud, Sigmund. *Civilization and its Discontents.* Translated by James Strachey. New York: W.W. Norton, 1961.

Leys, Ruth. "The Turn to Affect: A Critique." *Critical Inquiry* 37 (Spring 2011): 434–472.

Massumi, Brian. *Parables for the Virtual: Movement, Affect, Sensation.* Durham & London: Duke University Press, 2002.

Mitchell, W.J.T. "There Are No Visual Media." In *The Visual Culture Reader*, edited by Nicholas Mirzoeff, 7–14. New York: Routledge, 2013.

Ngai, Sianne. *Our Aesthetic Categories. Zany, Cute, Interesting,* Cambridge, MA: Harvard University Press, 2012.

Rancière, Jacques. *The Politics of Aesthetics: The Distribution of the Sensible.* Translated by Gabriel Rockhill. London: Continuum, 2004.

Richtin, Fred. *After Photography.* London: Norton, 2009.

Shouse, Eric. "Feeling, Emotion, Affect." *M/C Journal* 8, no. 6 (2005). http://journal.media-culture.org.au/0512/03-shouse.php (accessed December 12, 2016).

Tönnies, Ferdinand. *Gemeinschaft und Gesellschaft: Grundbegriffe der reinen Soziologie.* Darmstadt: Wissenschaftliche Buchgesellschaft, 2010.

Warburg, Aby. *Der Bilderatlas Mnemosyne.* Edited by Martin Warnke and Claudia Brink. Berlin: Akademie Verlag, 2008.

Warnke, Martin. "Politische Ikonographie." In *Ikonographie: Neue Wege der Forschung*, edited by Sabine Poeschel, 72–85. Darmstadt: Wissenschaftliche Buchgesellschaft, 2010.

Part I
Equivocal Emotions

1 Cropped Vision
Photography and Complicity in Women's World War II Memoirs

Elisabeth Krimmer

Introduction

Many scholars have explored the valence of photography in the context of the Holocaust in order to elucidate the experiences of the victims, witnesses, and survivors of the National Socialist genocide. There are also a number of scholars who dealt with the perspective of perpetrator photography.[1] However, there is as of yet not much that deals explicitly with the photographic legacy of the large number of women who worked for the German army in various functions and who can be categorized as complicit bystanders. In the following, I argue that this group, albeit not directly involved in frontline fighting or the execution of the Holocaust, was crucially important to the functioning of the regime. They made significant contributions to the war effort by providing logistical, administrative, communicative and medical support, and, in doing so, witnessed aspects of the Nazi genocide, such as public hangings, executions of so-called partisans, and rounding up for deportations, particularly if they were deployed to the Eastern front. Thus, like so many others, they were in a position to comprehend the full extent of the regime's cruelty, but chose to look the other way. It is this cropped vision evident in both narrative strategy and visual record that lies at the heart of their complicity with a murderous regime.

In order to elucidate how these female bystanders conceptualized their own role in the Third Reich, this article investigates the affective deployment of photography in two memoirs by army nurses: Ingeborg Ochsenknecht's *As if the Snow Covered Everything: A Nurse Remembers Her Deployment on the Eastern Front*, and Erika Summ's *Shepherd's Daughter: The Story of the Frontline Nurse Erika Summ*.[2] As I will show, the emotional register evident in these texts is more subdued than one might expect. It would seem that both Summ and Ochsenknecht shielded themselves from the full force of the crimes they witnessed and the trauma they experienced by cultivating an emotional distance. While this 'coolness' helped them deal with the terrifying experience of the war and the Holocaust, it also implied a psychic splitting that facilitated their complicity in Nazi atrocities. But before I turn to an analysis of Summ's and Ochsenknecht's memoirs, I would like to discuss the nature of these particular photographs, that is, photos taken by and/or included in memoirs of army auxiliaries and nurses, as well as the theoretical and ethical challenges posed by them.

The Civil Gaze

Anybody who peruses memoirs by women who served the German army in various functions will quickly notice that the photographs included in these texts follow a

predictable iconography. Frequently, the memoirists begin with a number of images that depict their childhood and/or lives before the war. Taken as a whole, these images signify normalcy and innocence and are clearly designed to evoke sympathy with the author. Furthermore, in the context of the Holocaust, they serve an additional function that exceeds the traditional captatio benevolentiae. If we agree with Susan Sontag's assumption that "sentiment is more likely to crystallize around a photograph than around a verbal slogan,"[3] then these pictures have a significant power to widen the gap between what we see in the images, namely the quotidian nature of the author's pre-war existence, and what we know about National Socialist politics of extermination. In other words, these photos of childhood innocence effectively create an emotional distance between the memoirists and the Holocaust.

In addition to images that depict the author's pre-war life in often idyllic terms, memoirs of army nurses, as well as those of auxiliaries, also typically feature photographs from the various frontlines of the war. These wartime images tend to center on three groups of motifs: First, women who were deployed to the Western front, in particular to France and Italy, such as Ilse Schmidt, author of *The Bystander: Memories of a Member of the German Army*,[4] include traditional tourist snapshots of scenery and landmarks.[5] One of the perks of becoming an army auxiliary or a nurse consisted in the opportunity to escape the narrow confines of traditional domesticity and parental authority, and the photos provide ample evidence that these women were eager to travel and see the world.

Second, these memoirs tend to feature a significant number of group shots taken during various outings and vacations, including joyful gatherings on beaches and in cafes and restaurants. Frequently, the figures in these images smile at the camera in ways that are difficult to reconcile with both the memoirist's textual emphasis on the harsh conditions of life on the Eastern front and the contemporary viewer's historical knowledge of this era in general and of the persecution of Jews in particular. It would seem that the effect of these smiles is best captured by Roland Barthes's notion of the punctum, a seemingly irrelevant photographic detail that pierces and attracts the viewer and that "paradoxically, while remaining a 'detail,' . . . fills the whole picture." Barthes also credits the punctum with a certain liminal status when he claims that "it is what I add to the photograph and what is nonetheless there."[6] The notion that something is added that is already there perfectly captures this peculiar dynamic: it is not the smile or the photograph in and of itself that is troubling but their incongruity with our knowledge of mass murder on the Eastern front. In their liminality, the smiles of these auxiliaries and nurses and the quotidian nature of their photographs of everyday life evoke a different version of that which "remained unremembered yet cannot be forgotten"[7]: not the crushing guilt of the perpetrator, not the traumatic suffering of the Holocaust survivor, but the complicity of the bystander who was present but failed to act.

In trying to define the nature of the complicity implied in these images, I found myself reminded of John Berger's analysis of the iconic photo of Che Guevara's dead body, which Berger endows with a moral dimension: "His foreseen death 'will be the perfectly natural result' of all that he has lived through in his attempt to change the world, because the foreseeing of anything less would have meant that he found the 'intolerable' tolerable."[8] To be sure, Berger raises the moral bar so high that it will not only remain out of reach for most of us but would entail annihilation if heeded. And yet, his call for a total commitment to the fight against injustice sheds light on a

sense of opprobrium that adheres to these images: in their focus on the mundane and the ordinary, these photos implicitly suggest that the memoirists found the intolerable nature of the Nazi regime quite tolerable. As Berger reminds us, all "photographs bear witness to a human choice being exercised in a given situation . . . *I have decided that seeing this is worth recording.*"[9] Thus, we cannot but wonder about the choice to highlight outings, social gatherings and vacations amidst a general environment of slaughter and genocide.

While the memoirs of nurses and army auxiliaries include images of the authors' social and professional lives, they contain no visual record of the Holocaust. This should not surprise us. After all, the Nazi regime had issued an order that forbade taking pictures of public executions and violence against civilians (albeit an order that was violated by many).[10] The Nazi policy of censorship, however, does not explain the textual elision of mass murder in memoirs that were frequently written decades after the war. Moreover, it bears mention that, although the Holocaust is excluded from the visual record, German suffering is not. Tellingly, the third group of photos in these memoirs, and the only one that directly acknowledges the context of the war, tends to highlight German victimization. The authors' empathy for their male comrades in arms is evident in the numerous images of wounded German soldiers, soldier's graves, and soldier's funerals, thus creating a clear dichotomy between those whose life is grievable and those who are excluded from the community of mourning.

In *Regarding the Pain of Others*, Susan Sontag argues that

> there is shame as well as shock in looking at the close-up of a real horror. Perhaps the only people with the right to look at images of suffering of this extreme order are those who could do something to alleviate it ... or those who could learn from it. The rest of us are voyeurs.[11]

Sontag's claim that images of manmade atrocities position the viewer as either activist or voyeur is convincing but it does not address the emotional responses set in motion by the pictures of complicit bystanders. Clearly, there is a wide range of possible reactions to these images. In some viewers, the oblivious enjoyment of these seeming wartime idylls may incite a sense of resigned melancholy (what's past is past); in others, it might call forth feelings of disgust and disbelief. Although these two responses appear on the surface to be diametrically opposed, they are surprisingly similar. The danger here lies in the fact that both relegate moral responsibility to a distant past and, in doing so place "the viewer in an emotionally and morally privileged position." As Bernd Hüppauf points out, a possible paradoxical effect of a moral gaze that is driven by empathy for the victims of the Holocaust is "the separation of our own world from that shown in the images."[12] Thus, in focusing on a genocide that is safely relegated to the distant past, viewers can avert their eyes from the pressing issues of their own time. If, as Zelizer has argued, "Holocaust photos have helped us to remember the Holocaust so as to forget contemporary atrocity,"[13] the photos of these smiling bystanders may serve to obscure our own complicity in the humanitarian crises and war crimes of our time.

In his excellent essay on perpetrator photography, Hüppauf is concerned with the limitations of a moral gaze that is motivated by empathy for the victims. But while he is right to warn about the potential dangers implied in this approach, I believe he overstates the incompatibility of the moral gaze with attentiveness to the motivations of the

perpetrators and witnesses. In contrast, I argue that the challenge consists in the effort to combine an understanding of the rationale of contemporary witnesses, bystanders, and even perpetrators with a clear, moral perspective and with an alertness to our own cropped visions in the present. In other words, I propose a theoretical model that allows for empathy for the victims and a moral gaze on the past but combines them with a radical self-reflectivity that remains mindful of the role of the viewer in the present and of points of contact with past bystanders and perpetrators.

In proposing this extended model, I draw on Ariella Azoulay's book *Civil Imagination: A Political Ontology of Photography*, which ponders the possibility of a "civil discourse under conditions of regime-made disaster." Parsing the structural qualities of regime-made disaster, Azoulay claims that "under such conditions, citizenship is restricted to a series of privileges," the most important of which is "the right to view disaster—to be its spectator."[14] If we transfer Azoulay's observations to the context of the Second World War, it becomes evident that even women such as Summ and Ochsenknecht, who worked in close proximity to the frontlines, were granted the right to remain at a relative distance from the multiple sites of mass murder and unlawful executions. But while Azoulay positions the citizen as a spectator of disaster, the most distinctive feature of Summ's and Ochsenknecht's citizenship consists in their refusal to look at atrocities and in the corresponding right to focus on the mundane activities of their immediate circle of friends and colleagues. In order to avoid the call to action that attends to all acts of witnessing, women like Summ and Ochsenknecht cropped their vision and excluded the genocidal atrocities committed by the regime that they served. Thus, the challenge in viewing these photos is to reverse the scopic regime of the National Socialist gaze. Instead of limiting ourselves to setting up "a tribunal in which the photos serve to illustrate guilt,"[15] we need to open both "the space where the image is created" and "the space from which it is viewed" into a plural one. In Azoulay's words, we need to reconstruct a civil gaze that "does not descend upon the photographed person in isolation but is oriented to all participants in the act of photography."[16] Thus, looking at these pictures with a civil gaze involves not only bringing back what was excised from the photos, but also adding the role of the contemporary viewer to the original triangle of complicity. In other words, we need to widen our interpretation beyond the prefigured roles of victim, perpetrator, and bystander to consider our own positionality as viewers in this process.

Finally, in theorizing the significance of these images, we need to be mindful of the fact that concepts of complicity are intricately intertwined with notions of gender. In her study of women and war, Hagemann suggests that "women's participation in the Wehrmacht was one of the best-repressed subjects in postwar Germany" and wonders whether this omission has to do with the fact that women's involvement "illustrates most clearly the everyday participation of the many."[17] Images of female perpetrators and bystanders run counter to the dominant paradigm that relies on the "infantilization and feminization of victims and the concomitant hypermasculinization and thus depersonalization of perpetrators."[18] Because memoirists such as Summ and Ochsenknecht are rarely conceptualized as political agents, gender, as both Hagemann and Hirsch point out, "can serve as a means of forgetting."[19]

In the following, I argue that any model that conceives of World War II nurses and army auxiliaries as apolitical will be laden with significant blind spots. Under the Nazis, the employment of medical professionals was guided by the "Civil Service Restoration Act" (*Berufsbeamtengesetz*), which stipulated that nurses had to fit a certain racial and

political profile. In order to work in her chosen profession, a nurse candidate had to be in good health, prove Aryan descent and either be a party member or proffer a police certificate of good conduct.[20] Nurses who were directly subordinate to the NSDAP, the so-called "brown sisters" (Braune Schwestern), made up only 9.2 percent of all nurses in spite of a massive propaganda effort.[21] The differentiation between this and other groups of nurses, however, is of limited value since the Red Cross had quickly fallen in line with the regime and proudly served under its new official patron, Adolf Hitler. Consequently, Red Cross nurses not only served an institution that was thoroughly militarized and had long abandoned the guiding principle of neutrality, they were also required to swear an oath to the Führer as of January 1, 1938.[22]

As of July 1933, all Red Cross nurses were members of the "Reichsfachschaft Deutscher Schwestern und Pflegerinnen," a professional organization that was beholden to the Reich Ministry of the Interior.[23] Their education was funneled through NS organizations such as BDM and Arbeitsdienst and included massive indoctrination in Nazi politics, human genetics, and, most particularly, the inferiority of the Slavic and Jewish races.[24] Once these nurses were deployed on the various fronts, the organization of the armed services was designed to remind them of their "racially superior" status. For example, nurses were relieved of common household chores, which were typically handled by a newly created underclass of female members of the occupied nations. Consequently, when Summ and Ochsenknecht represent themselves as apolitical innocents who were caught in the fray, we should read their assertions with caution. Since most of the women in Hitler's army did not write memoirs or speak about their experience in public arenas, it is difficult to know how many of them were motivated by their enthusiasm for Nazi ideology—even more so since those few who did write about the war were, as Lower suggests, likely to "exaggerate, mislead, self-glorify, or mollify."[25] Typically, these female memoirists downplay political motivations while their personal lives occupy front and center.

In her study of women in Hitler's killing fields, Wendy Lower concludes that the few women who wrote memoirs or spoke about the war at length

> did not admit to themselves or to us, either then or many years later, in courtrooms or their own memoirs, what their participation in the Nazi regime had actually entailed … They failed to see—or perhaps preferred not to see—how the social became political, and how their seemingly small contribution to everyday operations in the government, military, and Nazi Party organizations added up to a genocidal system.[26]

Clearly there is much that is missing in these memoirs, but there is also much that we can learn by reading these blind spots. I believe it is precisely because these women were seemingly uninvolved and because they downplayed the contributions that they did make that their memoirs can teach us much about the potential for violence in civil society and about the nature of justice. Their truncated narratives of collaboration and compromise and their cropped visions are at the heart of what made the Nazi terror possible.

Erika Summ

The memoir *Shepherd's Daughter* by the army nurse Erika Summ was written many years after the war when Summ's husband died and it was eventually published in

2006. The decision to tell her story was motivated by the prompting of friends and relatives who all showed an interest in her wartime experiences, and Summ reports that the process of writing helped her recover much that she had forgotten. Summ had not originally intended to publish her manuscript but when her son told her about Birgit Panke-Kochinke's book project *Frontlines Nurses and Angels of Peace*,[27] she contacted Panke-Kochinke and, after some hesitation, made her manuscript available. Summ supplemented the text with images to make it "more lively"[28] and also with some notes and poems that she had received from soldiers.

In her foreword, Panke-Kochinke praises Summ's story as an example of how "one can remain humane and alive in the face of death and destruction."[29] To Panke-Kochinke, Summ is an innocent victim who sacrificed her youth to a criminal regime while her story, whose can-do spirit leaves no room for the kind of self-pity that informs so many memoirs of this kind, represents a "counterweight to violence and destruction."[30] Throughout, Summ comes across as a kind and competent professional. And yet, although she is not a Nazi, there would seem to be affinities to National Socialist ideology. These points of contact between the young Summ and National Socialist politics, however, are less disturbing than the complete absence of a retrospective discussion of the murderous crimes inflicted by the Nazis on the Jews and the occupied nations. Although Summ's memoir was written many years after the war, it shows little awareness of the horrendous nature of the Nazi war of extermination.

Erika Summ was born on August 8, 1921 in Stachenhausen in Baden-Württemberg into a hardworking but poor family. However, in spite of material hardship and lack of modern amenities, Summ has fond memories of her childhood. Her parents are kind, and the children enjoy a lot of freedom.[31] Summ emphasizes that her family lived in harmony with nature and with God. She characterizes her father as pious and loyal and points out that prayer is important in her family. In spite of these positive notes, however, there is a dark undertone: both Summ's family and her local community are steeped in violence and death.[32] As Summ draws a vivid picture of her community, readers begin to understand which aspects of National Socialism might have appealed to Summ's family and their neighbors. For example, even young children frequently had to run errands and walk home alone at night, and Summ remembers being afraid of the homeless and unemployed during such outings. In such a milieu, the National Socialist crackdown on supposedly "asocial" individuals promised relief. Later on, when Summ works in labor and delivery, she is tormented by the sight of newborn babies with physical malformations.[33] Here too, one cannot help but wonder how the author responded to the Nazi euthanasia program. Faced with hardship, decease, and death, the National Socialist pseudo-solutions of contemporary problems may have been welcome.

In entitling her memoir *Shepherd's Daughter*, Summ turns her father's profession into a leitmotif. She further emphasizes the motif of the good shepherd by choosing a photo of her father for the cover of her book. In it, her father is a lone figure who walks calmly and upright next to a large flock of sheep along a country road whose embankment is framed by a line of trees. Some sheep graze next to the road, most follow her father. The horizon is framed by a faint trace of wooded mountains. This picture of a mountain idyll with sheep sets the tone for the story. Indeed, of the 38 pictures of Summ's prewar life, no fewer than eight centrally feature activities related to shepherding. They evoke innocence, but also hark back to the Christian concept of a sacrificial lamb, slaughtered to atone for the sins of the world. The motif is clearly

chosen because it creates a safe distance between the narrator and the political arena, echoing Summ's efforts to portray her family as cut off from village life and removed from the political fray of the time.[34] And yet, the theme of shepherding also unwittingly reintroduces the political realm. With its emphasis on leaders and followers, on a "leader who the other sheep follow unconditionally,"[35] it mirrors the political reality of the time. Summ sees herself as a sheep that is corralled into formation: she feels pressured to join the *League of German Girls* (*Bund deutscher Mädel*) amidst a general atmosphere of support for the regime, evident in the palpable increase in SA presence in the village and also in her parents' decision to sport the "yes sticker" that attested to support for the NSDAP.

In the beginning, Summ's family experiences National Socialism primarily as socialism: their farm is divided into seven smaller farms and administered by a Nazi-appointed official. They now live for rent in their own home and are paid a small hourly wage for their labor. In 1934, Summ joins the *Landdienst* (service in agriculture). In 1937, she starts working as a maid and cook for a priest, whose responsibilities include Nazi mandated investigations into the Aryan descent of members of his congregation. The idea to become a nurse arises when Summ meets two Red Cross nurses at a country dance. She is unhappy with her status as a common maid and becoming a nurse offers a way out.[36]

Summ received her training at the Katharinenhospital in Stuttgart in October 1940, followed by an apprenticeship in a labor and delivery station. A big part of her work consists in cleaning so that she feels like a "municipal cleaning woman"[37] for the meager remuneration of 5 Reichsmark per month. Her work is frequently disrupted by air raids, and Summ remembers vividly how the nurses frantically carried baskets with newborns down several flights of stairs to a shelter. When she passed her exam in March of 1942, she was transferred to a hospital in Marbach. Her service for the army starts abruptly when her hospital is taken over by the military and repurposed for wounded soldiers from the Eastern front.

In October 1942 at age 21 Summ is sent to the Eastern front, an experience that she describes as "depressing" and "frightening."[38] She travels solo on a train of soldiers first to Warsaw, then via Brest to Shitomir in the Ukraine. Since nurses with professional training (*Vollschwestern*) enjoy officer rank, Summ is invited to join the compartment of the officers. During the trip, she is exposed, for the first time, to the sight of destroyed villages and partisan activity, including attempts to sabotage the train tracks. In such surroundings, fear of partisans becomes her constant companion.[39]

A siege mentality and constant fear also characterize the atmosphere at the field hospital where she is stationed. And yet, none of this is evident in the photos included in her memoir. Summ's narrative mentions moments of normality, such as snowball fights, card games, the planting of a vegetable and flower garden, and even sightseeing,[40] but she is clear that, for the most part, her days consisted of grueling labor. Summ works for hours on end in rooms that reek of blood and puss amidst the screaming of the wounded,[41] and is exposed to horrifying burns and disfigurations. Tellingly, frontlines nurses often referred to the room for surgery as a "battle field,"[42] thus poignantly expressing the similarity between the experiences of nurses and those of soldiers. In contrast, the photographic record from her time on the Eastern front does not venture inside the hospital. The only image that features wounded soldiers, captioned "Transport of the Wounded," shows a seemingly able-bodied group smiling happily at the viewer from atop a horse-drawn cart.

While several of her pre-war images feature sheep, three of the eight photos from the Eastern front show Summ as a gardener, planting vegetables and harvesting grapes. There is no sense of location—the gardens could be anywhere—and not a trace of the war. The first of the two garden scenes is a long shot showing Summ and a doctor planting barren soil in spring while the second zooms in on Summ and two soldiers amidst lush vegetation in summer. Thus, while the narrative paints a clear picture of decline and escalating violence, the photos suggest progression and growth. Summ never comments on the glaring discrepancy between the content of her narrative and the motifs that dominate her photos.

As the front moves closer, the number of casualties increases drastically, Summ's hospital is bombed, and the chaos of the retreat begins. Army regulations differentiate between the main hospital (*Hauptlazarett*), which is closest to the front, the field hospital (*Feldlazarett*), which is further removed, and the war hospital (*Kriegslazarett*), where nurses such as Erika Summ work. Under normal conditions, there is constant coming and going in these hospitals since all patients whose injuries are not life threatening are immediately moved. However, once the Germans started losing and embarked on a frantic retreat, the neat differentiation into different types of hospitals became meaningless as all hospitals were flooded with newly injured soldiers. Summ's unit is moved to Poland, then Hungary and Czechia. Toward the end of the war, Summ and her fellow nurses care not only for soldiers but also for refugees, including many children.[43] When Summ finally joins the trek herself, she is sick with measles, her train is attacked, and she and her fellow nurses continue on foot until they are taken prisoner by the Americans.[44]

Like many German World War II memoirists, Summ is acutely aware of German suffering, including the plight of the refugees, and this focus is plainly evident in the photographic record. While two of the eight photos from the Eastern front showcase German fatalities, none are devoted to non-German victims. Whereas many photo albums of male soldiers are characterized by a certain fixation with Russian civilians,[45] Summ's attention is directed toward her countrymen. The first of the two photos of German victimization shows a military funeral, the second depicts the makeshift grave of a fellow nurse. The photo of the funeral centers on several coffins already lowered into the ground and a group of soldiers who stand at attention in a barren wasteland that contains no hint of human habitation or vegetation. Although both coffins and soldiers are organized in a line, the effort to create order is foiled by a coffin that sits askew on top of the others and an officer who turns his back to the grave. While nature itself seems to repel the human actors, the viewer's eyes are anchored by a large flag that is draped over one of the coffins and that prominently displays the swastika. Clearly, the swastika functions as the only source of orientation in a starkly inhospitable environment.

Unlike the military funeral, which gives the impression of a formal and semi-dignified affair, the photo of the grave of the nurse Martha Weller shows but few signs of planning. It appears to be situated at the side of a road and is dwarfed by a large, non-descript truck in the background. Perhaps unwittingly, this image speaks to the situation of women near the frontlines. While the soldiers are embedded in a group and their actions governed by ritual, the nurse's grave is framed as a solitary and marginal site. And yet, it too is linked to the National Socialist army through the iconography of the Iron Cross, which is plainly visible on the improvised crucifix that marks the site of the grave. The Iron Cross, which was typically decorated with the

swastika at the center of the cross, offers the only familiar frame of reference and lends stability and meaning in an otherwise disorienting environment.

While Summ highlights German victimization, she does not acknowledge crimes committed by Germans. Consequently, her narrative is truncated and even incoherent. She reports being afraid of the Czechs but provides no context that could explain why the Czechs might want to hurt the Germans. Similarly, she claims that many American soldiers took revenge because they were the children of emigrated Jews,[46] but this desire to take revenge also remains unmotivated since the Holocaust does not feature in her narrative, except for passing references to the deportation of Jews near Pecs and to a nearby ghetto, which she mentions in order to explain why the nurses' toothbrushes were stolen.[47] In comparison, readers learn much about a strip search for SS tattoos to which Americans soldiers submitted German nurses and soldiers alike and that Summ experienced as particularly humiliating. Summ also shares that she felt much sympathy for people who had to vacate their houses for American troops and for fellow nurses who lost their employment because of their NSDAP membership, but does not even mention the millions who died at German hands.

Although Summ's memoir was written many years after the war had ended, it contains next to no criticism of the Nazis. Summ comments on the horror of the war and remembers particularly gruesome sights, such as a dead man hanging from a balcony or public executions in Shitomir.[48] Although the experience was clearly traumatizing, she provides no context and no information about the victims. She wonders where people live in this landscape of ruins and remarks on the absence of children, but there is no thought about who caused the war and to what end. Furthermore, the description of life in an occupied territory is similarly devoid of context. She does not criticize or even acknowledge the imperialist agenda that informs the Nazi pursuit of "Lebensraum." Instead, she shows appreciation for German colonization of the East, particularly for the Volksdeutsche who had "helped to transform the villages into pretty places."[49] When she does take note of the existentially precarious situation of the Ukrainian women, she attributes their poverty to the Bolsheviks who deported their husbands. In general, Summ likes to think of the relationship to the occupied population as a form of commerce between equals,[50] although she admits that theft is a problem. The encounters that stand out in her memory are characterized by kindness and care.[51] In spite of such occasional friendliness, however, the nurses' relationship to the local population is marked by suspicion and mistrust. Summ approaches Ukrainian women with caution since there is always the possibility that they might work with partisan groups and spy on the Germans. Thus, she remembers Ukrainians who were arrested for partisan activities and a Polish partisan who shot at a male nurse and was shot in turn. To Summ, all these events are part of the general moral murkiness of war: "In this war there were so many uncertainties on both sides."[52] There is no acknowledgement of cause and effect and no narrative of guilt and responsibility. Rather, war is portrayed as an all-encompassing devastation that inflicts damage on all parties.[53]

To be sure, many of Summ's experiences during the war can only be described as horrifying. Summ, who turned 24 in 1945, appears to have emerged if not unscathed then at least reasonably intact from a series of experiences that would have devastated a less resilient person: the physical exhaustion that results from prolonged periods of overwork and sleep deprivation, the constant exposure to air raids and to the sight of the most traumatic injuries, along with Summ's own illnesses, including measles, appendicitis, and a bad case of influenza. And yet, when Summ claims "I was able

to save my cheerful temperament over the course of the war,"[54] one cannot help but wonder if her resilience is linked to her refusal to engage with the moral dimension of the Nazi war of extermination.

Inge Ochsenknecht

Inge Ochsenknecht's memoir *As if the Snow Covered Everything: A Nurse Remembers Her Deployment on the Eastern Front* was recorded by Fabienne Pakleppa and published in 2004 by Ullstein with a foreword by Dr. Martha Schad. Like Summ, Ochsenknecht, the mother of the German actor Uwe Ochsenknecht, claims to have been motivated to tell her story by the promptings of friends and relatives, in particular her grandchildren. In addition, she reports that the renewed interest in the war and the Third Reich in the German media, particularly television, brought back memories.[55] Her prologue, however, offers another story of origin that frames Ochsenknecht's experience as deeply traumatizing. Ochsenknecht reports that in 1965 she considered contributing to the meager family income by resuming her earlier work as a nurse. But on the morning of her job interview, she felt sick and during the trolley ride she experienced flashbacks that transported her back in time to the war and the many train rides to the front. In the hospital elevator she is haunted by visions of the soldiers she treated. Simply by stepping into a hospital, Ochsenknecht had opened the floodgates to the memories she had worked so hard to forget. The experience is so terrifying that she decides to find another form of employment. As she explains, she has seen enough injuries and deaths to last her a lifetime. But while she cannot go back to being a nurse, Ochsenknecht realizes that the past will not be shut out and that she will have to tell her story.

Although both women were German nurses on the Eastern front, Ochsenknecht's memoir is different from Summ's both stylistically and politically. While Summ prefers matter-of-fact statement, Ochsenknecht offers descriptive details and enlivens her narrative with dialogue. Such heightened realism is likely due to the fact that, unlike Summ, Ochsenknecht consulted the diary that she kept during the war and even places excerpts from it at the beginning of each chapter. Through this technique, she is able to jump back and forth in time, thus creating a dialogue between her present and past selves. For example, her diary entry on her first visit to Krakow reads: "It is a beautiful city, but unfortunately it suffered much under Polish rule."[56] In contrast, the older Ochsenknecht notices the ideological provenance of this statement and comments:

> When I read these sentences, I realize how Nazi propaganda had blinded me. This is exactly what we were told all the time—that the Poles have only themselves to blame for their misery. But it was the Germans who had started the war and had starved the population.[57]

As these passages show, the juxtaposition of past and present holds the potential for a radical reevaluation of Ochsenknecht's experience during the war.[58] And yet, although the memoir makes an effort to work through the past, it does not fully realize this ambition. Throughout, important insights stand side by side with regurgitated Nazi platitudes, and it is not always clear if Ochsenknecht seeks to convey her former state of mind or if the author is still beholden to her former worldview. Moreover, especially toward the end of the book when we most expect a summary rejection of National

Socialist politics, the narrative fizzles out into a series of anecdotes as rare moments of reflection are dwarfed by long passages that recount pranks and "fun" adventures.

Ochsenknecht's life before the war resembles that of Summ to some extent. Like Summ's family, Ochsenknecht's mother and father are in dire financial straits in the 1920s and 1930s. They have to sell their house and young Inge is not allowed to go to the *Lyzeum*, the most prestigious of the three types of German secondary schools, because the family cannot afford it. Like Summ, Ochsenknecht joins the *League of German Girls*. She applies for the *Labor Service* (Arbeitsdienst), but is rejected for health reasons and starts a year of domestic service (hauswirtschaftliches Volljahr) in her hometown Arnstadt instead. When the war begins, she is excited.[59] Like many others, she is convinced that the war will be over in a couple of weeks, and she welcomes the opportunity to serve her country: "The feeling of 'being needed' gave my life meaning."[60] Even later when she is exposed to numerous hardships on the Eastern front, she reports feeling happy because she is part of something bigger than herself— an opportunity that was only rarely afforded to women in her time.[61]

The excitement of the early years of the war is clearly visible in the photographs included in the memoir. The first image that readers behold, and the only one of the 34 photos in the book that occupies an entire page, features a young, smiling Ochsenknecht in nurse's uniform, a blinding vision in white, standing in front of a large gate. The caption informs us that this is the gate of the hospital in Arnheim, but nothing in the picture indicates a specific location or institutional affiliation. Like many of the pictures that follow, this photo foregrounds a human figure while occluding the viewer's sense of location. Ochsenknecht's photos tend to be closely cropped around the figures they depict and frequently offer only the most general sense of the surroundings. There are no pictures of recognizable tourist attractions or characteristic features of a city or landscape. Rather, the viewer's vision is limited to the small cadre of characters who form Ochsenknecht's social circle.

This focus on herself, colleagues and friends is mirrored in Ochsenknecht's narrative. Ochsenknecht draws a picture of herself as a young girl who shows great interest in boys but none whatsoever in politics. For example, she remembers the first time she attended an event by the NSDAP, but claims that she cannot recall any of the speeches. Rather, what stuck in her mind is the company of her blond cousin whom she adored. The same perspective characterizes her time on the Eastern front, where German women are a rare sight and are consequently showered with attention.[62] To Ochsenknecht, the war is an adventure that allows her to explore romantic relationships, escape the strictures of the family home, and experience a previously unknown freedom.

Ochsenknecht started caring for wounded soldiers in April 1940 when her former school was turned into a reserve hospital (*Reservelazarett*). She finds her work fulfilling and volunteers to be moved closer to the frontlines.[63] In preparation for the attack on Russia, her unit is stationed in Tschenstochau near the Russian border. Here, Ochsenknecht learns quickly that the experience of the nurse, much like that of the soldier, is marked by extremes. Several weeks of bored inaction end abruptly when the first transports of wounded soldiers arrive, and Ochsenknecht gets a first taste of the severity of the wounds incurred in a battle. From now on, weeks of backbreaking labor with 19-hour shifts alternate with periods of relaxation and fun.[64] Although the injuries she saw were far worse than expected, Ochsenknecht, like many a male soldier, became addicted to the adrenaline rush of war and had difficulties adjusting to civilian life.[65]

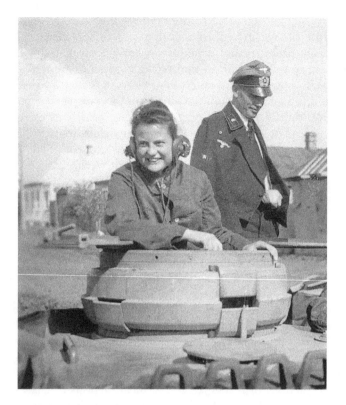

Figure 1.1 With Heinz at the command center.

Source: Ingeborg Ochsenknecht, *Als ob der Schnee alles zudeckte: Eine Krankenschwester erinnert sich an ihren Kriegseinsatz an der Ostfront*. Recorded by Fabienne Pakleppa. Berlin: Ullstein, 2004 (no page number).

Although the photos that correspond to this period of Ochsenknecht's life do not fully convey the horror of this time, they are more open to the reality of the war than the images in Summ's memoir. Unlike Summ, Ochsenknecht includes several images of wounded soldiers, one of whom appears to be in critical condition, and two photos that situate their subjects geographically. Similarly, while there are no photos of Russian towns or civilians, there is one long shot of Russian refugees with the rather vague caption "Summer 1942: Russian Refugees." But there are also numerous pictures that show Ochsenknecht and her fellow nurses, out for walks, frolicking in the snow (one chapter is entitled "Downtime in the Snow Paradise"),[66] and smiling into the camera while riding astride on the turret of a tank or sticking their heads out of the hatch after soldiers took them for a ride (Figure 1.1).

Interestingly, among these images of fun in snow and sun are two whose cropped view of reality opens up as we read Ochsenknecht's narrative. Both photos show Ochsenknecht and her fellow nurses in bikinis during a trip to the sea. In one picture (Figure 1.2), Ochsenknecht and a female friend face the camera as they let the surf wash over their feet.

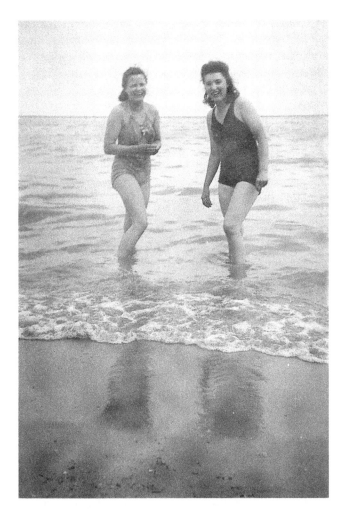

Figure 1.2 Ochsenknecht and a fellow nurse. Trip to the Sea of Azov, May 1942.

Source: Ingeborg Ochsenknecht, *Als ob der Schnee alles zudeckte: Eine Krankenschwester erinnert sich an ihren Kriegseinsatz an der Ostfront*. Recorded by Fabienne Pakleppa. Berlin: Ullstein, 2004 (no page number).

In the other, Ochsenknecht and two men sit on beach towels, getting a tan. Since both images are medium close-ups of the figures, they do not convey a sense of the surroundings. Looked at in isolation, they, like many of the other images, suggest carefree fun and adventure. Yet, when they are re-embedded in the narrative, it becomes clear that such fun required a great deal of repression and blindness. In the verbal description of this mini vacation, Ochsenknecht informs us that she was warned not to swim too far since there were bodies floating in the water.[67] As it turns out, this beach had recently seen military action and had been cleared of corpses, but not of the debris of war or of the dead horses killed in the battle. (Later on, Ochsenknecht swims in the

Don but stops abruptly when she realizes that the pile of Russian uniforms on the bank of the river is the remnant of a mass execution). Clearly, "fun" activities on the Eastern front require a psychic splitting that allows Ochsenknecht to remain blind to much of what was going on around her, and the photos replicate this repression. Ochsenknecht lived in a cropped reality, and her postwar breakdown suggests that a great effort was involved in keeping the edges of this frame from fraying.

As the war progressed, Ochsenknecht's situation and state of mind became increasingly schizophrenic. As nurses Ochsenknecht and her colleagues were in an excellent position to see through the regime's propaganda. After all, they had first-hand experiences of the severity and number of injuries and casualties, which so clearly disproved the lies propagated on the radio. Ochsenknecht did not criticize the Nazi regime, but rather chose to continue to believe in the "Endsieg" and to identify with the soldiers she cared for.[68] Conversely, while Ochsenknecht admired the heroism of her fellow Germans, those who were oppressed and murdered by the Nazis disappear from view in spite of Ochsenknecht's explicit acknowledgment that the relation between the German occupiers and the occupied nation was inherently problematic. Ochsenknecht is aware that the Poles do not like the Germans and that her own relationship with the Russian prisoner who is assigned to be her assistant cannot develop into a friendship because it unfolds within the context of conquest.[69] She also witnessed how German soldiers "requisitioned" food at gunpoint even though the Russians were starving. At the same time, however, the myth of the Germans as liberators continues to frame her experience of the Eastern front.[70]

Even more so than her relationship with the Russians, Ochsenknecht's attitude toward the Jews is characterized by a blindness that is baffling. Thus, she recounts that to her the Star of David was simply another kind of "uniform." Similarly, she claims that the local ghetto was created to prevent the spread of typhus. The most disturbing event, however, is her visit to the Krakow ghetto, which is not featured in any of her photographs. Most likely, the lack of photos in this context is due to official regulations: although the Nazis eagerly documented the atrocities they committed, they were savvy enough to forbid anybody else from taking photos that might serve as evidence of genocide. Even so, however, Nazi policies do not account for the cropped vision of Ochsenknecht's narrative. Ochsenknecht reports that, upon arrival at the ghetto, she and her friend began to flirt with the guards who refused to let them enter. Oblivious to the suffering behind the gates, nurses and guards discuss an exchange of kisses as entrance fee to the ghetto. When the nurses finally gain admission, their eyes are open but they cannot see. Ochsenknecht feels "terribly ill at ease" but cannot verbalize what is wrong here: "Nobody seemed sick or particularly thin, but the faces were somber and sad."[71] Ochsenknecht's visit to the ghetto, more than any other aspect of the memoir, exemplifies drastically how average Germans knew but did not want to know.[72] Even though Ochsenknecht witnessed *Reichskristallnacht*—the Night of Broken Glass, so named because Nazi hoodlums destroyed shops owned by Jews as well as synagogues—visited the Krakow ghetto, and served on the Eastern front for extended periods of time, she claims to have been completely unaware of the fate of the Jews.[73]

Conclusion

The impression one is left with after reading Summ's and Ochsenknecht's memoirs and considering their photos from the war is that of two young women—Summ was

18 and Ochsenknecht 19 when the war started—who dealt with the regime-made disaster of their time by maintaining an emotional distance to much that was bound to upset their equilibrium. This distance is evident in both texts and in the cropped vision that characterizes their snapshots from the war.

While Ochsenknecht openly admits her enthusiasm for Hitler, Summ is more guarded, but her memoir suggests that she was more complicit with National Socialist ideology and more supportive of Nazi policy than she lets on. Indeed, both writers may have been in greater agreement with Nazi racial ideology than they care to acknowledge. However, while uncovering what was left unsaid and unseen is an important part of any attempt to conceive of women as political agents and to analyze the many ways in which they contributed to the war and the Holocaust, it is even more important to consider the conceptual implications for our understanding of complicity. In both Summ's and Ochsenknecht's case, the willingness to support the Nazi regime was not motivated by fanaticism, aggression, or greed. Rather, it was rooted in their cropped vision, in the willingness to turn away and excise from their narratives and images all and any events that they might be compelled to disapprove of on moral grounds.

In *The Sunflower: On the Possibilities and Limits of Forgiveness*, Simon Wiesenthal ponders not only the possibility of forgiveness for perpetrators, but also the lethal implications of complicity. After all, as he points out, the Nazi "minority reigned because of the cowardice and laziness of the majority."[74] I believe that cowardice, laziness, indifference, psychic splitting and emotional distance offer points of contact to the past that are far more salient than sadism or psychopathology—although the latter tend to garner more attention. In our minds, warfare and genocide are extreme experiences that evoke outsized emotions, such as horror, terror, and panic. And yet, Summ's and Ochsenknecht's memoirs are marked not by extreme emotion but by the strenuous effort to keep Nazi atrocities outside of one's field of vision. It is the suppression of trauma and the ability to carry on in spite of the terror that surrounds them that make their complicity possible. Thus, crimes against humanity and everyday normality exist side by side and even condition each other. Consequently, the true challenge presented by these memoirs does not consist in erecting a tribunal for past actions, but in a call to consider the cropped visions of the present, that is, in developing a civil gaze that remains mindful of the blind spots of our own as well as of past centuries.

Notes

1 Scholars who have dealt with photography in the context of the Holocaust include Ulrich Baer, *Spectral Evidence: The Photography of Trauma* (Cambridge: MIT Press, 2002); Georges Didi-Huberman, *Images in Spite of All: Four Photographs from Auschwitz*, trans. Shane B. Lillis (Chicago: The University of Chicago Press, 2003); Marianne Hirsch, *Family Frames: Photography, Narrative and Postmemory* (Cambridge: Harvard University Press, 1997); Bernd Hüppauf, "Emptying the Gaze: Framing Violence through the Viewfinder," in *War of Extermination: The German Military in World War II, 1941–1944*, ed. Hannes Heer and Klaus Naumann (New York: Berghahn Books, 2000), 345–377; Helmut Lethen, *Der Schatten des Fotografen: Bilder und ihre Wirklichkeit* (Berlin: Rowohl, 2014); Andrea Liss, *Trespassing through Shadows: Memory, Photography & the Holocaust* (Minneapolis: University of Minnesota Press, 1998); Paul Lowe, "Picturing the Perpetrator," in *Picturing Atrocity: Photography in Crisis*, ed. Geoffrey Batchen et al. (London: Reaktion Books, 2012), 189–198; Dieter Reifarth and Viktoria Schmidt-Linsenhoff, "Die Kamera der Henker: Fotografische Selbstzeugnisse des Naziterrors in Osteuropa im Zweiten Weltkrieg," *Fotogeschichte* 7 (1983): 57–71; Barbie Zelizer, *Remembering to Forget: Holocaust Memory through the Camera's Eye* (Chicago: The University of Chicago Press, 1998).

2 Ingeborg Ochsenknecht, *Als ob der Schnee alles zudeckte: Eine Krankenschwester erinnert sich an ihren Kriegseinsatz an der Ostfront*, recorded by Fabienne Pakleppa (Berlin: Ullstein, 2004); Erika Summ, *Schäfer's Tochter: Die Geschichte der Frontschwester Erika Summ*, ed. Jürgen Kleindienst (Berlin: Zeitgut, 2006).

3 Susan Sontag, *Regarding the Pain of Others* (New York: Picador, 2003), 85.

4 Ilse Schmidt, *Die Mitläuferin: Erinnerungen einer Wehrmachtsangehörigen* (Berlin: Aufbau, 1999).

5 On the photo enthusiasm of German soldiers during the campaigns in Poland and France see Petra Bopp, *Fremde im Visier: Fotoalben aus dem Zweiten Weltkrieg* (Bielefeld: Kerber Verlag, 2012), 40–43.

6 Roland Barthes, *Camera Lucida: Reflections on Photography*, trans. Richard Howard, foreword Geoff Dyer (New York: Hill & Wang, 1980), 45 and 55.

7 Baer, *Spectral Evidence*, 7.

8 John Berger, *Understanding a Photograph*, ed. and introduced by Geoff Dyer (London: Penguin Books, 2014), 13.

9 Berger, *Understanding a Photograph*, 18.

10 For a record of these images of executions and hangings, see Hamburg Institute for Social Research, ed. *The German Army and Genocide: Crimes against War Prisoners, Jews, and Other Civilians, 1939–1944*, foreword by Omer Bartov, trans. Scott Abbott (New York: The New Press, 1999). For a list of orders related to taking pictures of executions, ghettos and concentration camps, see Reifarth and Schmidt-Linsenhoff, "Kamera der Henker," 62.

11 Sontag, *Regarding the Pain of Others*, 42.

12 Hüppauf, "Emptying the Gaze," 348.

13 Zelizer, *Remembering to Forget*, 13.

14 Ariella Azoulay, *Civil Imagination: A Political Ontology of Photography*, trans. Louise Bethlehem (London: Verso, 2012), 1.

15 "Inszenierung als Tribunal, auf dem die Fotos als Illustration der Schuld fungierten," Lethen, *Schatten des Fotographen*, 161.

16 Azoulay, *Civil Imagination*, 54 and 122.

17 Karen Hagemann, "Home/Front: The Military, Violence and Gender Relations in the Age of the World Wars," in *Home/Front: The Military, War and Gender in Twentieth-Century Germany*, ed. Karen Hagemann and Stefanie Schüler-Springorum (New York: Oxford, 2002), 24.

18 Marianne Hirsch, *The Generation of Postmemory: Writing and Visual Culture after the Holocaust* (New York: Columbia University Press, 2012), 133.

19 Hirsch, *The Generation of Postmemory*, 148.

20 See Horst Seithe, and Frauke Hagemann, *Das Deutsche Rote Kreuz im Dritten Reich (1933–1939). Mit einem Abriß seiner Geschichte in der Weimarer Republik* (Frankfurt am Main: Mabuse, 2001), 191. Jewish nurses were restricted to caring for Jewish patients or in Jewish hospitals, see Ulrike Gaida, *Zwischen Pflegen und Töten: Krankenschwestern im Nationalsozialismus. Einführung und Quellen für Unterricht und Selbststudium* (Frankfurt am Main: Mabuse, 2011), 116.

21 Birgit Panke-Kochinke and Monika Schaidhammer-Placke, *Frontschwestern und Friedensengel: Kriegskrankenpflege im Ersten und Zweiten Weltkrieg. Ein Quellen- und Fotoband* (Frankfurt am Main: Mabuse, 2002), 18.

22 Seithe/Hagemann offer the following characterization of the German Red Cross: "Das DRK nahm einseitig Partei für das nationalsozialistische System, es identifizierte sich zunehmend mit ihm. Ins Blickfeld des DRK traten nicht die Opfer des Regimes, sondern die 'deutschen Helden,' die zukünftig verwundeten Soldaten, denen geholfen werden mußte" ["The DRK unilaterally favored the National Socialist system, it increasingly identified with it. The DRK took note not of the victims of the regime, but of 'German heroes,' the future wounded soldiers to whom one owed assistance"] (Seithe/Hagemann, *Rote Kreuz*, 90). On September 1, 1934 Hitler became "Schirmherr" of the DRK (see Seithe/Hagemann, *Rote Kreuz*, 97). Gertrud Scholtz-Klink in her role as "Reichsfrauenführerin," that is, leader of the NS women's organization, was put in charge of the DRK Reichsfrauenbund, see Lieselotte Katscher, *Krankenpflege und Drittes Reich: Der Weg der Schwesternschaft des Evangelischen Diakonievereins 1933–1939* (Stuttgart: Verlagswerk der Diakonie, 1990), 125.

23 Panke-Kochinke/Schaidhammer-Placke provide detailed information about the number of nurses: "In den Feldformationen und Heimatlazaretten von Wehrmacht und SS befanden sich im August 1941 6745 DRK-Schwestern, 12,497 Schwesternhelferinnen, 4,619 DRK-Hilfsschwestern, 35,472 DRK-Helferinnen, 4,784 Katholische Mutterhausschwestern, 2,482 Diakonissen, 1,054 freie NS-Reichsbundschwestern und 827 sonstige (Johanniterinnen) Schwestern" ["In August of 1941 there were 6,745 DRK nurses, 12,497 assistant nurses, 4,619 DRK auxiliary nurses, 35,472 DRK assistants, 4,784 Catholic nurses, 2,482 Protestant nurses, 1,054 NS-nurses, and 827 others (including members of the order of St. John) in field units and homefront hospitals of Wehrmacht and SS)"] (Panke-Kochinke/Schaidhammer-Placke 155). For June 25, 1944, they list "5,230 Schwestern, 5,543 Hilfsschwestern und Schwesternhelferinnen an der Front; in den Heimatlazaretten: 5,374 DRK-Schwestern, 8,728 katholische Schwestern, 2,751 Diakonie-Schwestern, 3,409 NS-Schwestern, 1,339 sonstige Schwestern, 43,260 Hilfsschwestern" (Panke-Kochinke and Schaidhammer-Placke, *Frontschwestern und Friedensengel*, 155).

24 See Gaida, *Pflegen und Töten*, 30 and Seithe and Hagemann, *Rote Kreuz*, 128–129.

25 Wendy Lower, *Hitler's Furies: German Women in the Nazi Killing Fields* (Boston: Houghton Mifflin Harcourt, 2013), 152.

26 Lower, *Hitler's Furies*, 10–11.

27 *Frontschwestern und Friedensengel*.

28 Summ, *Schäfers Tochter*, 9.

29 "man auch im Angesicht von Tod und Zerstörung menschlich und lebendig bleiben kann," Panke-Kochinke, "Vorwort" 8.

30 " Gegengewicht zu Gewalt und Zerstörung" ("Vorwort" 8). To Panke-Kochinke, the blame for the war lies with those in power who would rather destroy than negotiate.

31 "Für uns Kinder war es einfach schön, dort aufzuwachsen" (Summ, *Schäfers Tochter*, 24).

32 Her father is one of seven brothers, six of whom fought in the First World War, two died. Summ's mother also lost a brother in the war. Others fell victim to disease and accidents, including Summ's two brothers. Summ's teacher is a former officer, who beats the children on a regular basis, and the husband of the local pharmacist suffered a head injury in WWI that caused fits of uncontrolled anger.

33 "Bedrückend waren für mich Missgeburten . . . Für mich waren es schreckliche Erlebnisse, wenn die Mütter zum ersten Mal das behinderte Kind im Arm hielten und bitter weinten" (Summ, *Schäfers Tochter*, 99).

34 "wir lebten ziemlich abseits" (Summ, *Schäfers Tochter*, 67).

35 "Leittier, dem die anderen Schafe bedingungslos folgen" (Summ, *Schäfers Tochter*, 13).

36 In the Second World War, the life of an army nurse offered many perks: it allowed many women to free themselves from the strictures of family and the narrowly defined gender code of a petty-bourgeois environment. The Nazis cleverly mobilized many women's desire to work for a cause larger than themselves. But even women who were not motivated by the desire to serve the fatherland appreciated the increase in power that was afforded by their profession. Particularly during the first years of the war, they also enjoyed a vibrant social life with parties, dances, and outings. On or near the frontlines, a small cadre of women confronted a surplus of men who lavished attention on them. While some women basked in admiration, others report instances of sexual harassment and even rape.

37 Summ, *Schäfers Tochter*, 97.

38 Ibid., 115.

39 "Wenn es dunkel wurde, kam wieder die Angst, mischte sich mit dem unaufhörlichen Rollen der Räder. Dunkelheit bedeutete, dass man ausgeliefert war—den Partisanen, die uns überall und jederzeit verfolgen konnten" ["When it got dark, the fear returned again, merged with the incessant turning of wheels. Darkness meant that one was exposed—to partisans who could follow us everywhere and at all times"] (Summ, *Schäfers Tochter*, 119).

40 Summ goes sightseeing in Hungary and reports that in general "verbrachten wir in Dombovar einen sehr schönen Sommer" ["we spent a very beautiful summer in Dombovar"] (Summ, *Schäfers Tochter*, 154).

41 "Die Belastung ging manchmal bis an die Grenzen dessen, was man ertragen konnte" ["at times the workload reached the outer limits of what one could tolerate"] (Summ, *Schäfers Tochter*, 126).

42 Summ, *Schäfers Tochter*, 109.

43 "Diese Einzelschicksale lasteten sehr auf mir" ["these individual destinies weighed heavy on me" (Summ, *Schäfers Tochter*, 165).

44 Before she is herself taken to a camp in Pilsen, Summ helps hide two German army doctors from the Americans.

45 See Bopp, *Fremde im Visier*, 71.

46 "Viele der Amerikaner sprachen deutsch. Oft waren ihre Eltern ausgewanderte Juden und nun rächte sich mancher" ["Many Americans spoke German. Often their parents were emigrated Jews and now some took revenge"] (Summ, *Schäfers Tochter*, 176).

47 Summ and her fellow nurses were stationed in the houses that had belonged to the deported Jews, a situation that she finds "belastend" (Summ, *Schäfers Tochter*, 153).

48 "Wenn wir durch Shitomir liefen, sahen wir oft Entsetzliches" ["When we walked through Shitomir, we often saw horrible things"] (Summ, *Schäfers Tochter*, 132).

49 "mitgeholfen, die Dörfer in hübsche Ortschaften zu verwandeln" (Summ, *Schäfers Tochter*, 154).

50 "richtiger Tauschhandel" (Summ, *Schäfers Tochter*, 131).

51 She remembers that she gave some Ukrainian workers medicine when they contracted dysentery even though such help was illegal. She also reports that her unit returned a cow to its rightful (Ukrainian) owner: "Das war ein nettes Erlebnis in dieser sonst schrecklichen Zeit" (Summ, *Schäfers Tochter*, 129).

52 "In diesem Krieg gab es so viele Unklarheiten auf beiden Seiten" (Summ, *Schäfers Tochter*, 152).

53 "Was auf allen Seiten und in allen Ländern zerstört wurde, wie viele Menschen getötet wurden, war unfassbar" ["What was destroyed by all parties and in all countries, how many people were killed was incomprehensible"] (Summ, *Schäfers Tochter*, 152).

54 Dennoch konnte ich mir mein fröhliches Wesen durch den Krieg hindurch retten" (Summ, *Schäfers Tochter*, 126).

55 Interestingly, like Summ, Ochsenknecht did not begin the process of recording her story until after her husband's death though neither author offers an explanation for this.

56 "Es ist eine schöne Stadt, doch leider hat sie unter den polnischen Zuständen sehr gelitten" (Ochsenknecht, *Als ob der Schnee*, 57).

57 Wenn ich diese Sätze nachlese, wird mir klar, wie verblendet ich von der Nazi-Propaganda war. Genau das redete man uns damals permanent ein—dass die Polen selbst schuld an ihrer ganzen Misere waren! Dabei waren es die Deutschen, die den Krieg begonnen hatten und die Bevölkerung aushungern ließen.

(Ochsenknecht, *Als ob der Schnee*, 57)

58 For example, Ochsenknecht reports honestly that she was a Hitler devotee even though her father, a World War I veteran, was highly critical of Hitler and the war from the very beginning. When her father tells her that Germany is going to lose the war, she counters: "Der Führer weiß, was er tut" ["the Führer knows what he is doing"] (Ochsenknecht, *Als ob der Schnee*, 49).

59 She remembers being at the train station, feeling safe ("geborgen," Ochsenknecht, *Als ob der Schnee*, 21) in the enormous crowd.

60 "Das Gefühl 'gebraucht zu werden' verlieh meinem Leben einen Sinn" (24). Later, she writes, "Ich fühlte mich nützlich, und das beglückte mich" ["The feeling of 'being needed' gave my life meaning"] (Ochsenknecht, *Als ob der Schnee*, 45).

61 "In diesem Augenblick verspürte ich nur Glück und Stolz. Ich durfte dabei sein" ["In this moment I felt only happiness and pride. I was allowed to be a part of this"] (Ochsenknecht, *Als ob der Schnee*, 127).

62 "so lernten wir ständig neue Männer kennen und wußten, wie man sie dazu brachte, unsere Wünsche zu erfüllen" ["thus we constantly made the acquaintance of new men and knew how to get them to fulfill our wishes"] (Ochsenknecht, *Als ob der Schnee*, 83; see also 96 and 130).

63 When her unit, which comprises 20 nurses (6 "Vollschwestern" and 14 helpers), boards a train to Krakow in June of 1941, she is giddy with excitement.

64 "Ich schuftete in jenen Tagen wie eine Maschine" ["In those days I worked like a machine"] (Ochsenknecht, *Als ob der Schnee*, 87).

65 "als sei ich nach neuen Herausforderungen süchtig geworden" (Ochsenknecht, *Als ob der Schnee*, 184). After a brief vacation at home, she can't wait to get back to the front and toward the end of the war she declares: "Genauso stark wie ich mir wünsche, dass der Krieg aufhört, wünsche ich mich zurück an die Front" ["As much as I wished for the war to be over I wished to return to the front"] (Ochsenknecht, *Als ob der Schnee*, 218). About the injuries, she says: "Dass es so schlimm sein würde, hatte ich nicht erwartet" ["I had not expected that it would be so bad"] (Ochsenknecht, *Als ob der Schnee*, 68).

66 Here, Ochsenknecht remembers feeling like a princess during sleigh rides in a fairy tale forest (Ochsenknecht, *Als ob der Schnee*, 109).

67 See Ochsenknecht, *Als ob der Schnee*, 161.

68 Ibid., 163. Even when Ochsenknecht began to doubt the wisdom of the Führer, she fulfilled her responsibility to uphold the morale of the soldiers: "unsere Aufgabe war es auch, sie auf andere Gedanken zu bringen. Wir durften nicht nach ihren grauenvollen Erlebnissen fragen. Wenn sie davon zu berichten begannen, sollten wir ihnen sagen, dass es jetzt vorbei sei" ["it was our job to turn their minds to other thoughts. We were not allowed to ask about their horrible experiences. When they started talking about them, we were supposed to say that it is all over now" (Ochsenknecht, *Als ob der Schnee*, 98–99).

69 See Ochsenknecht, *Als ob der Schnee*, 138.

70 "Wie viele Ukrainer wünschten sich nichts mehr als die Befreiung ihres Landes von der russischen Herrschaft" ["How many Ukrainians wanted more than anything the liberation of their country from Russian rule"] (Ochsenknecht, *Als ob der Schnee*, 165).

71 "Niemand schien krank oder besonders mager zu sein, doch die Gesichter waren duster und traurig ... ich fühlte mich schrecklich fehl am Platz" (Ochsenknecht, *Als ob der Schnee*, 84–85).

72 This blindness extends not only to the suffering of the Jews and the occupied nations, but to all arenas of Ochsenknecht's life. Tellingly, Ochsenknecht's motto is "Denke nicht, lebe" ["don't think, live"] (Ochsenknecht, *Als ob der Schnee*, 144). Note that Ochsenknecht remembers a pile of amputated limbs behind the front hospitals to which she was assigned, but remarks that at the time the horrible stench and ghastly sight did not bother her at all. After the war, however, she has nightmares about it. Similarly, toward the end of the war, Ochsenknecht had an affair with a married doctor who was addicted to morphine. Even though as a nurse she should be familiar with the signs, she remains blithely unaware of his addiction for the entire duration of the affair. At the same time, her memoir contains critical remarks about the widespread use of drugs and uppers in the army and about the oversupply of alcohol to keep soldiers and nurses from thinking too much— "haben sie ihre Gefühle mit Alkohol zugeschüttet" ["drowned their feelings in alcohol"] (Ochsenknecht, *Als ob der Schnee*, 104).

73 Ob wir damals blind waren, ob wir nicht verstanden, welche Verbrechen die Deutschen an der Ostfront vor unseren Augen begingen? Das werde ich manchmal gefragt, und beim Schreiben dieses Buches stelle ich mir selbst diese Fragen. Von den Todeslagern habe ich erst nach dem Krieg erfahren. Ich habe weder Vergasungswagen noch Massengräber, noch Menschen am Galgen baumeln gesehen. Aber ich wusste von den Hinrichtungen, die als Vergeltung für die Anschläge der Partisanen stattfanden ... Damals dachte ich, das sei in jedem Kriege so. [whether we were blind then, whether we did not understand which crimes the Germans committed on the Eastern front in front of our eyes? Sometimes people ask me this and when I wrote this book I asked myself these questions. I learned of the death camps only after the war. I saw neither gas vans nor mass graves nor people dangling from the gallows. But I knew about the executions that took place in retribution for partisan attacks ... At the time I thought that happens in every war.]

(Ochsenknecht, *Als ob der Schnee*, 171)

74 Simon Wiesenthal, *The Sunflower: On the Possibilities and Limits of Forgiveness* (New York: Schocken Books, 1997), 19.

Bibliography

Azoulay, Ariella. *Civil Imagination: A Political Ontology of Photography*. Translated by Louise Bethlehem. London: Verso, 2012.

Baer, Ulrich. *Spectral Evidence: The Photography of Trauma*. Cambridge: MIT Press, 2002.

Barthes, Roland. *Camera Lucida: Reflections on Photography*. Translated by Richard Howard. Foreword by Geoff Dyer. New York: Hill & Wang, 1980.

Berger, John. *Understanding a Photograph*. Edited and introduced by Geoff Dyer. London: Penguin Books, 2014.

Bopp, Petra. *Fremde im Visier: Fotoalben aus dem Zweiten Weltkrieg*. Bielefeld: Kerber Verlag, 2012.

Didi-Huberman, Georges. *Images in Spite of All: Four Photographs from Auschwitz*. Translated by Shane B. Lillis. Chicago: The University of Chicago Press, 2003.

Flusser, Vilem. *Towards a Philosophy of Photography*. London: Reaktion Books, 1983.

Gaida, Ulrike. *Zwischen Pflegen und Töten: Krankenschwestern im Nationalsozialismus. Einführung und Quellen für Unterricht und Selbststudium*. Frankfurt am Main: Mabuse, 2011.

Hagemann, Karen. "Home/Front: The Military, Violence and Gender Relations in the Age of the World Wars." In *Home/Front: The Military, War and Gender in Twentieth-Century Germany*, edited by Karen Hagemann and Stefanie Schüler-Springorum, 1–41. New York: Oxford, 2002.

Hamburg Institute for Social Research, ed. *The German Army and Genocide: Crimes against War Prisoners, Jews, and Other Civilians, 1939–1944*. Translated by Scott Abbott. Foreword by Omer Bartov. New York: The New Press, 1999.

Hirsch, Marianne. *Family Frames: Photography, Narrative and Postmemory*. Cambridge: Harvard University Press, 1997.

——. *The Generation of Postmemory: Writing and Visual Culture after the Holocaust*. New York: Columbia University Press, 2012.

Hüppauf, Bernd. "Emptying the Gaze: Framing Violence through the Viewfinder." In *War of Extermination: The German Military in World War II, 1941–1944*, edited by Hannes Heer and Klaus Naumann, 345–377. New York: Berghahn Books, 2000.

Koch, Gertrud. *Die Einstellung ist die Einstellung: Visuelle Konstruktionen des Judentums*. Frankfurt am Main: Suhrkamp, 1992.

Katscher, Liselotte. *Krankenpflege und Drittes Reich: Der Weg der Schwesternschaft des Evangelischen Diakonievereins 1933–1939*. Stuttgart: Verlagswerk der Diakonie, 1990.

Lethen, Helmut. *Der Schatten des Fotographen: Bilder und ihre Wirklichkeit*. Berlin: Rowohl, 2014.

Liss, Andrea. *Trespassing through Shadows: Memory, Photography & the Holocaust*. Minneapolis: University of Minnesota Press, 1998.

Lowe, Paul. "Picturing the Perpetrator." In *Picturing Atrocity: Photography in Crisis*, edited by Geoffrey Batchen, Mick Gidley, Nancy K. Miller, and Jay Prosser, 189–198. London: Reaktion Books, 2012.

Lower, Wendy. *Hitler's Furies: German Women in the Nazi Killing Fields*. Boston: Houghton Mifflin Harcourt, 2013.

Ochsenknecht, Ingeborg. *Als ob der Schnee alles zudeckte: Eine Krankenschwester erinnert sich an ihren Kriegseinsatz an der Ostfront*. Recorded by Fabienne Pakleppa. Berlin: Ullstein, 2004.

Panke-Kochinke, Birgit and Monika Schaidhammer-Placke. *Frontschwestern und Friedensengel: Kriegskrankenpflege im Ersten und Zweiten Weltkrieg. Ein Quellen- und Fotoband*. Frankfurt am Main: Mabuse, 2002.

Reifarth, Dieter and Viktoria Schmidt-Linsenhoff. "Die Kamera der Henker: Fotografische Selbstzeugnisse des Naziterrors in Osteuropa im Zweiten Weltkrieg." *Fotogeschichte* 7 (1983): 57–71.

Schmidt, Ilse. *Die Mitläuferin: Erinnerungen einer Wehrmachtsangehörigen.* Berlin: Aufbau, 1999.

Seithe, Horst and Frauke Hagemann. *Das Deutsche Rote Kreuz im Dritten Reich (1933–1939). Mit einem Abriß seiner Geschichte in der Weimarer Republik.* Frankfurt am Main: Mabuse, 2001.

Sontag, Susan. *On Photography.* New York: Anchor Books Doubleday, 1989.

——. *Regarding the Pain of Others.* New York: Picador, 2003.

Summ, Erika. *Schäfers Tochter: Die Geschichte der Frontschwester Erika Summ 1921–1945.* Edited by Jürgen Kleindienst. Berlin: Zeitgut, 2006.

Wiesenthal, Simon. *The Sunflower: On the Possibilities and Limits of Forgiveness.* New York: Schocken Books, 1997.

Zelizer, Barbie. *Remembering to Forget: Holocaust Memory through the Camera's Eye.* Chicago: The University of Chicago Press, 1998.

2 Horsemeat with Cucumber Salad

Laughing at the Images of War in Alexander Kluge's Films

Andrea Schütte

Alexander Kluge's Images of War

Alexander Kluge's oeuvre consistently provides us with a thorough consideration of war, beginning with *Schlachtbeschreibung* (1964) and—for the time being—ending with the recently produced films *Bilderwelten vom Großen Krieg 1914–1918* (2014). Kluge published a whole range of media on the First World War concentrating on the inter-relation between war, image, and art. Aside from the artistic work mentioned above, there are further films, e.g. *The First World War: Art and War/The Absence of the Art of War* (*Der Erste Weltkrieg—Kunst und Krieg/Die Abwesenheit von Kriegskunst* (2010)), *News from the Great War (1914–1918)* (*Nachrichten vom Großen Krieg (1914–1918)* (2014)), as well as numerous films that can be watched on the homepage of the Development Company for Television Program (dctp). As usual, the filmic compositions include photomontages, authentic and faked interviews, short presentations, film clips, scrolling banners etc., which are often subject to technical revision, rearrangement, and reassembly. The type of their presentation changes between documentation, report, staging, commitment etc. Therefore, these products fit perfectly into the aesthetic texture of Kluge's work as it has been described by current scholarship.[1]

Representing, or to be more precise, visualizing war is a constant feature of Kluge's works. Critics often refer to the air raid on Halberstadt, which Kluge experienced as a child, as one of the motives for his literary and filmic representations. Ever since the movie *Die Patriotin* premiered in 1979, processing the experiences of war and expressing them in moving pictures has been the difficulty challenging both Kluge and the viewers. The collected presentations of all the diverse images of World War I that Kluge juxtaposes therefore also constitute a 'bombardment' of images,[2] even if Kluge aims at the very opposite—to thin out the images as he explained with respect to movies:

> People have always envisioned their own images […]. It is the producer's mission to make room for them. Therefore, I thin out the images. The camera always records far too much. That is the disadvantage compared to the stage. Creating a montage of the images, I try to make interspaces that do not become images, but offer a framework for the creation of a third image, an epiphany. For instance, I take the sequence of people in close-up shots and then I develop a long shot that is opposed to it. The viewers can just manage to integrate the resulting contrast that permits the creation of a virtual time and a virtual space between these pictures, generating a third image that has not been seen before. This kind of montage has nothing to do with addition or multiplication, both pictures destroy each other at the interface instead.[3]

This is indeed true for every single scene with their characteristic long takes. Yet the intended effect threatens to get lost in the enormous mass of material, the seemingly endless accumulation of images and stories referring to the First World War. Nevertheless, the viewer can find a common feature throughout all the films: the fake interviews with actors who pose as historical or fictional historical characters. All these interviews have a special effect on the viewer that I will analyze in this essay. First, I will examine the aesthetics of these particular filmic episodes in order to concentrate, in the second part, on their effect on the viewers' emotions: they make them laugh. At a different level, the viewer may discover something that occurs time and again—astonishingly enough—in all of Kluge's films on the First World War: horses. In the third part of this essay I will therefore analyze why Kluge uses the horses as a vehicle to represent the Great War. This essays argues that all of Kluge's comical, indeed grotesque, elements are precisely the ones that in the end turn out to strike a nerve in the viewers' innermost being.

The Aesthetics of the Fake Interviews

Peter Berling, Helge Schneider, and Hannelore Hoger, two actors and one film producer, act as mostly fictive characters who could have lived during the Great War. Their roles are often amusing. Berling represents a headhunter who evaluates the key staff of the German Reich, Schneider plays the role of a taxi dancer at the end of WWI, Hoger acts as Mother Superior at a military hospital in Jerusalem. All these fake interviews follow Kluge's usual dramatic composition: viz. none at all. Hoger, Berling, and Schneider only get to know their roles immediately before the interviews. They are briefly introduced to the historic scene and then they get their costumes. There is no script, so the interviewees must extemporize their roles.[4] The characters are shown in shoulder close-up while they are looking at Kluge, their interviewer, who is not visible on screen. They stay sober and monotonous, Hoger often gives monosyllabic answers, Berling appears clumsy and cumbersome. In most cases, they affirm whatever Kluge suggests. These improvised interviews irritate the audience, because the interviewees seem to know less than their interviewer. They are intentionally tied to an asymmetric state of information. The setup leads to situations characterized by obvious communication difficulties, such as problems of comprehension, slip-ups, or deficient language skills that remain purposely uncut. The question is whether the directed and at the same time improvised images correspond to the requirements of a substantial, meaningful representation of the historic situation? This in turn raises more fundamental questions about the criteria of authenticity, truth-value, and adequacy of images.

 Kluge undermines the criterion of authenticity only at first sight. There are some features that produce an absolute hypertrophy of fiction: the construction of a historic character that is only fictive; the casting of actors well-known to the German audience; the costumes that sometimes tend toward slapstick (Schneider as a demolition expert with a burning cigar); the awkwardness and bulkiness of the dramaturgy. The seeming unproductiveness of the speech acts confer a character of unprofessionalism on this kind of overtly enhanced fiction. Yet, this is the point that leads directly to the criterion of authenticity: the represented historic situation is evidently fake, but nonetheless it appears markedly authentic. With their superficial knowledge of the topic the actors only express what they really know and what they personally associate with this situation. That means that authenticity is not measured according

to the identity of signifier and signified, of what is shown in the image and what it refers to. It is rather based on the correspondence of the individual her-/himself with the current speech act. To heighten this effect, the actors are costumed. The costumes do not really fit well to them, and the inadequacy directs the view to the authentic part of the image:

> Staged action in itself is also autonomous. If you mark that clearly you get an excellent possibility for a cut, since the manipulation of the authentic by the cut or the staged action is substantial. The staged action directs special attention to the authentic.[5]

The performed frame of the situation is filled with the authenticity of communication. The speech act is indirectly forced to fall out of the role design and to reveal the experiences the actor made with the historic situation. The costume discloses a form of open *simulatio* (it has nothing of *dissimulatio*), but the speech act is genuine, i.e. it is in accordance with the actors' historic knowledge, their role-play, and their creativity and associations.

Kluge's fake interviews function as a distortion of the interview with contemporary witnesses who play a crucial role in historic representations. He undermines the integrity and individuality of witnesses and the principle of eye witnessing. He claims that historic experiences "cannot be assigned to a personal identity—an ego whose fictive wholeness would be sealed against an associative exchange."[6] To demonstrate this, the personal "wholeness" appearing in the image is indeed the result of fiction. An open, complex, and dialogic field of experiences can emerge across time and space. Kluge thereby points to an ability to communicate with the historic event. This communication with the historic event is neither approved nor canonized by the official historiography, but refers to a "space of history" where one's own experience can fit in. If the space of history shall come into its own it is perfectly adequate to show a restrained, taciturn French chansonette (alias Hoger) searching for the right French words, or a Count Wronski (alias Schneider) who does not only pretend that he does not know what to say, but who is actually speechless. Kluge chooses a non-representative image of war. His images tend toward a more semiotic conception. Such images should address the rather unorganized experiences of the viewers before they are charged with a fixed meaning of historic representations or, in particular, of images of war:

> The experiences that set [people] in motion don't have to pass through the head but instead through the body, the nerves, the senses, the emotions; they must be able to work on the relationship to history as a comprehensible object.[7]

To facilitate such sensuous experiences with the war even *after* the historic event, it is necessary to provide interfaces for future generations. This is ensured by Kluge's concept of communication with history that addresses the viewer directly through the senses. In his images of war, Kluge tests "associative connections, coalitions with those lively impulses that couldn't develop in the historic line, that have remained only beginnings and have ventured into the dead product of history. Kluge relies on a communication across the times."[8]

Figure 2.1 Hannelore Hoger as Mother Superior Gräfin Gerda v. Ziegenhahn.
Source: Alexander Kluge, *Jerusalem 1917*, www.dctp.tv/filme/weltkrieg-jerusalem-1917/, 00:02:06, accessed August 30, 2015.

These crossings through time and space venture into Kluge's images, they even constitute them—partly in a very direct way: The heads of the actors are often mounted into historic photos that illustrate the represented situation. The montage is evidently amateurish, as shown in Figure 2.1.

The proportions of the mounted heads and the original persons on the photos do not fit at all, so that one may speak of an "interruption of the reality principle."[9] 'Reality' must be considered a fiction. It is always a product of montage, even the 'objective reality' that has canonized certain prioritized views of history. Kluge's images of war try to deconstruct such one-sided interpretations of history: "It must be possible to represent reality as the fiction that it really is."[10] This irrefutably legitimates the bizarre montages of images whose odd effect fades out if you are aware of the constitutional background, the epistemological scepticism.

The rupture within the images as a principle of traversing time and space corresponds to a special technique that Kluge describes as *cross-mapping*:

> Adorno introduces his famous essay on Balzac with the sentence: If a farmer comes to the city everything seems closed to him. [...] And now—as Thomas Mann's Felix Krull—he glances at the windows. And he interprets whatever he doesn't understand in the windows. [...] And he will transfer everything he knows from the village. This is cross-mapping: superimposing the wrong map onto the actual territory or onto a different map and thus producing gaps everywhere. That is exactly what experience does, what a child does automatically when it sees something.[11]

Other sources provide a topographically more accurate statement by Kluge:

> Cross-mapping corresponds to the work order: "Hike through the Harz mountains with a city guide of Greater London." Two maps that do not match each other are overlapped, and the irritation can generate new insights.[12]

By this programmatic irritation Kluge activates—like in a short circuit—an immense amount of energy that vastly surpasses the normal level. Every picture source—a map or an original photo from World War I on the one hand, a completely different map or photo of an actor on the other hand—has a limited potential to capture the viewer's attention. But if they are cross-mapped and blended into on another they generate an enormous inner tension by virtue of the contextual irritation. With respect to the genre 'film,' Kluge explains his principle of using cross-mapping to give meaning to the images:

> You see more than just this image. As the image is not realistic and cannot be placed properly within this context, it becomes an image that follows the spectator. It is an afterimage. This afterimage is the major aspect of the film. At first, something became empty, and afterwards there is an image that does not belong to where it is.[13]

This observation evokes the media-theoretical principle stating that disturbances are productive. What is particular to Kluge is that he has made disturbance into an essential artistic principle that he constantly puts into practice. *All* 'Bilderwelten' (image worlds) of the Great War are intended to irritate in order to avoid a "complete understanding": "If I have understood everything then something has been emptied."[14]

A complete understanding of the war is impossible. Kluge's way to circle around the war with disrupted and disordered images therefore appears highly plausible. Kluge assumes an encompassing incomprehensibility with respect to the Great War: its unclear reasons, the diametrical oppositions of the front of attack in the West and the genuine place of conflict in the East, the precision of war planning (the Schlieffen Plan) and the incapacity of the German Reich's leadership ("Abwesenheit von Kriegskunst"/ the absence of the art of war"),[15] and the unintentionally Dadaistic telegram with which the German Reich declares war on France.

Kluge transfers this excessive incomprehensibility to the internal logic of the image. With all their internal gaps, seeming inconsistencies, and their potential to irritate, the fake interviews are an apt representation of a war that is in itself hardly totally comprehensible. The images do not aim at an unambiguous message that the viewers easily take in. By addressing the viewers' senses the images force an autonomous confrontation with the war. In the following I will analyze one specific irritating feature of Kluge's ambiguous images of war: the comical effect they have on the viewer.

Laughing at the Image of War

All fake interviews on the Great War have a comic effect. Although the situation refers to extremely serious events of the past, it makes the spectator laugh. Kluge elicits several kinds of humor, be it the grotesque, the slapstick, or the capriccio type. The actors

Figure 2.2 Peter Berling as Austrian Veterinarian Officer ("K. u. K. Oberstaatstierarzt")
 Dr. Jauernig.

Source: Alexander Kluge, *Rettet das Pferd!* (2013), www.dctp.tv/filme/10vor11-12082013/, 00:10:54,
accessed August 30, 2015.

perform funny roles on the stage of tragedy or appalling gravity, on the battlefield of
war. But what is the actual function of the comical element in Kluge's aesthetics and
in his aesthetics of war images in particular?

Christian Schulte and Rainer Stollmann have examined the role of the comical char-
acter of Kluge's work very thoroughly.[16] Schulte determines several elements that all
produce comical effects. Let me mention three central ones. First, Kluge's basic strategy
consists of undermining the expectations of the audience. The spectator expects—
especially with respect to a serious topic like the Great War—something significant be
it precise judgements, concise and conclusive evaluations, new objective backgrounds,
a high quality of information. Yet Kluge frustrates these expectations and confronts the
spectator with a different economy of time. He often appears to chat with his interview
partner and seems to get bogged down by insignificant details. Because of the digres-
sions the interviews are sometimes protracted and test the limit of the viewer's patience
for apparently there is no valuable information to be gained. The interaction of expec-
tation and disillusion increases and decreases the tension, and the stress is eventually
discharged in form of laughter, as the relevant theories of the comic know well.[17]

A second comic element consists in the disruption of representation, as Schulte
states. The dialogues with Berling have a comic effect, because they simulate proxim-
ity to the historic event by way of testimony and active participation. But at the same
time, Berling reduces this assumption to absurdity when he sits passively and ponder-
ously in front of the camera displaying all signs of boredom (Figure 2.2).[18]

Here again it is the discrepancy of importance and triviality that the image puts on
display. I will return to this below to examine why the discrepancy makes the viewer
laugh and not cry.

Schulte's third aspect once more refers to cross-mapping. Kluge himself notes its comic effect:

> Rushing through an area with the wrong map or confusing two maps ends up creating funny situations, because you go in the wrong direction in unexpected places. [...] The persistent pursuit of a mistake produces comic effects. If I take mistakes as seriously as correct insights, if emotions—in a way inevitably—produce 50 percent mistakes, and if I describe them with the same care, I will automatically end up with a comic effect. This effect ranges from gloating to a feeling of pleasure, which is simply based on the very fact that this is possible, that the fact that mistakes themselves are not immediately harmful generates freedom.[19]

Here again we deal with the disruption of representation or, more precisely, with the leveling of an obvious disruption within the representation. An incorrect reference is ignored and instead taken as a mark of orientation. If you observe this setting from a distance, the situation changes into slapstick, but only if the person involved does not realize the falseness of the situation. Yet, you certainly become aware that these 'incorrect' references do not necessarily make a person fail. Instead, they open new ways. Nobody will laugh as long as the person involved deliberately produces 'incorrect' passages and considers them a gain of freedom through phantasy. In fact, one is amazed at the newly paced space.

Schulte's arguments are precise. They recognize different levels of the comical, and they are generally persuasive: "In Kluge's work comic effects arise whenever the alleged coherence of a situation reveals its ambiguity."[20] This is entirely in line with the classical theories of the comical. These theories also suggest arguments concerning incongruence, disproportion, and recontextualization in which Schulte's arguments fit perfectly. But all these arguments only describe how a specific context (here: the aesthetics of Kluge's images) *can* be opened for comedy. The mere explanation of the aesthetics of the comical is not fully sufficient because it ignores the crucial role the laughing person has in constituting the comical. Kluge's work calls for an additional analysis of those who feel the comical. At first, this is the laughing viewer. It must be emphasized, though, that the laughter is not necessarily an impatient one. It is often slightly restrained and refracted in itself. This is not only due to the serious matters that are discussed, but also because the viewers concentrate on how the actor meets the expectations the viewers have to the roles the actors play. If we deal with laughter in the following, it shall be understood in this wide range of meaning, from explosive to restrained laughter.

Who laughs about 'Cigar-Willy,' the demolition expert at Vauquois? First the viewer laughs. This is clearly evident, but, oddly enough, the classical comic theories do not really focus on the audience. It is, nevertheless, essential to look at the spectator when you analyze TV. Moreover the interviewer laughs even if you do not see him laughing. Kluge laughs when he looks at the image of the fake demolition expert. The actor laughs by looking at the image of the person he represents, the image of himself in a sense. You can see that actor and interviewer are laughing (even if they do not do it overtly) from a clip where Schneider plays an inventor of blinkers for the artillery. In this scene both the interviewer and the interviewee are laughing, fascinated by the weirdness of the situation. They are laughing about the images they construct. That means that the comical effect is linked to images and

their effects on different levels. Apparently, it is exactly the pictorial quality, the imagery of a situation, which promotes the comic.

Helmuth Plessner's studies on laughter still play a seminal role in this context.[21] Plessner states that the comic situation is characterized by two different ambivalences: an ambivalence of the "structure of the thing itself" on the one hand, and an ambivalence grounded in the human being on the other hand.[22] This anthropological ambivalence is existential insofar as the human being has an "eccentric position": on the one hand, s/he is within him/herself, s/he is a (his/her) body, acts as a body ("being a body"). On the other hand, s/he keeps a distance from him/herself and his/her body at the same time. This distance allows him/her to perceive him/herself and "to say 'I' to himself"[23] to engage his/her body as an instrument ("having a body"). Plessner assumes that the human being has no clear-cut relation to him/herself, but always this ambiguous one.[24]

If someone encounters a comical situation that is characterized by absurdity or ambivalence (as the classical theories of the comical note), they are challenged to find an unambiguous relation to it. They must find a position to and within it because there are certain claims that human beings make: claims to "individuality and thus to being unique, unrepeatable, and irreplaceable, to dignity, self-possession, resilience, balance, harmony between body, soul, and mind."[25] The disruption of the comical situation does not allow the individual—who also has a "rupture" in him/herself because of his/her eccentric position—an unambiguous relation. If this complexity of ambivalence cannot be reduced the intermediation stagnates. The body becomes autonomous, and the human being responds in an expressive way: s/he laughs. S/he "loses the relation to his physical existence, but he does not capitulate as a person."[26]

Plessner reveals the adequacy of the comical images of war: if the situation is unanswerable and non-threatening (these are Plessner's criteria for the relevant bodily expressions), so that only the body reacts, the expression of laughter is not pretentious. Rather, it is a surrogate, a disclosure of an anthropological disability to cope with the situation. It is therefore adequate to respond to a comical situation with comedy:

> The only possible relation to the comic is to not take it seriously. But the necessity of this attitude can be understood only with reference to its unprocessability [Nichtfertig-Werden] by any other means, in accordance with the contrariety inherent in the structure of the comic situations.[27]

There is an "unprocessability" on several levels. The original images of the Great War, especially the brutal ones, evoke a kind of "unprocessability" of the represented subjects. Kluge exposes this "unprocessability " precisely by his technical processing, his techniques of montage, rupture, etc. Finally, the spectator turns the screw once more by virtue of his inability to tackle the ambiguous situation. Evidently, a certain congruence arises between different medial levels, a congruence that, interestingly enough, is based on the principle of incongruence. The laughter about the comical images of war is an expression that lacks an alternative:

> Even in the catastrophe which overtakes his relation to his own body, a relation which he otherwise controls, the human being triumphs and confirms himself as a human being. By slipping as if by accident into a physical process—a process opaque in itself which runs its course compulsively—and giving way to it, by

the disorganization of his inner balance, the human being at once forfeits the relation to his body *and* reestablishes it. The effective impossibility of finding a suitable expression and an appropriate answer *is* at the same time the only suitable expression, the only appropriate answer.[28]

Ultimately, this comprehensive "unprocessability" reveals an "unprocessability" of oneself, just as Kluge does not reach an end with his processing of war images. Kluge wants to touch the innermost feelings of the spectators. That means more than "recreation" and more than a superficial "titillation"[29] that only leads to laughter. We are dealing with a profound convulsion that goes from the level of image production (historical situation) via the quality of image processing (Kluge's clips) up to the image reception and the self-image of the spectator.

Plessner discusses the expressions of laughter and crying simultaneously in order to clarify their common anthropological structure. Just because laughing and crying have similar matrices, we have not been able to explain why Berling's rupture within the representation in case of Berling makes one laugh and not cry. Plessner's theory offers an outline of an answer:

The mode of expression is determined by its release. Releases of laughter include: joy, titillation, comedy, jokes, embarrassment, and games. It is the game, now, that seems to bring us ahead with regard to the fake interviews. If you refer the following thoughts by Plessner to the game Berling plays with his role, you can see why you have to laugh:

> It [the ambivalence] can determine the character of a situation that we regard as uncertain because it depends on our creative readiness and power and at the same time links these in capricious autonomy. We are at once free and not free, we bind and are bound. Between us and the object (the thing or the friend) there is an ambivalent relation which we both master and yet do not master because we are just as much its prisoner as it is under our control. In play, such a relation is established with and against our will.[30]

Berling seems to enjoy his role on the one hand. He plays his part more convincingly than do the other two performers. Berling is able to handle the prescribed situation with idiosyncratic independence. He even disciplines Kluge in one interview asking him whether he was allowed to continue or whether Kluge wanted to take over. At the same time, he is largely bound to the situation, as Kluge directs the speech acts and determines the costumes. All actors, though, respond to the role, join the "doing-as-if." They commit themselves to their 'role image': be it the image of an Austrian veterinarian officer, a demolition expert in Vauqouis, or a Mother Superior of a military hospital in Jerusalem. This sounds trivial as an acting performance, but it adopts the essential elements of the structure of games. According to Plessner, this structure is determined by imagery and responsiveness.[31] We take the situation/the object/the playmate as an image for something, we do not refer to its function within 'reality' (a), and the counterpart reacts correspondingly (b). This results in a situation "of a double in-between—between reality and appearance, binding and being bound."[32]

The imagery should be emphasized. In the images of the Great War that Kluge presents in the fake interviews, the actors develop their role *as* an image. They decide

whether their image shall involve a monocle or a cigar, whether they fly from Jerusalem via Aleppo or take another route, whether they eat horsemeat or not. As long as they can develop their image within Kluge's framework, they seem to enjoy the game:

> [T]he special pleasure in the state of suspense which prevails in play, in the instability of an equilibrium that is really no equilibrium, in the submergence in a world which derives from us and yet does not, which is capricious and yet subject to direction by our will—this pleasure is not to be overlooked.[33]

Mostly the actors don't really laugh, but a large number of the interviewees indicate at least their "pleasure in the state of suspense." This "pleasure" is transferred to the spectator who laughs about the actors. In view of the claims for individuality, uniqueness, and non-substitutability that a human being raises, the boycott of these claims by imitation, role-playing, and costuming can only appear comical. The spectator develops a "pleasure in something ambiguous that does not fit in with the simple either-or of reality."[34] In other words, it is just the game that provides the quality of pleasure, joy, and, finally, of laughter.

That is true for cross-mapping, too. The technique makes the viewer laugh, because it functions as a game. The viewer laughs because the reference points become mobile. This demonstrates that two different systems are elastic enough for their structures to be mapped onto each other. That applies both to the player and to the spectator of the play, who also engages him/herself in the ambivalence of being game leader and playing ball at the same time. Within the game, the spectator adopts the imagery of the situation. S/he joins the "doing-as-if."

The viewer cannot escape the imagery of the situation either, for the non-authenticity is evident. The arrangement of the interviews shapes the non-authenticity of the scene. In the picture, the spectator sees (1) how the actor, outfitted according to Kluge's image (2), develops his image (3) of the role. But it is significant that this proliferation of images does not end up in an artificial unreality that has no foundation in the spectator's reality. It does not become meaningless or irrelevant. Instead, it creates new meanings exactly by way of the interaction of the fake with historic fact. The space of possibilities is extended and opened for polyvalence, absurdity, and fantasy. Only they who do not engage with the conditions of the game and thus of the images, they who consider the ambivalence not as comical but as threatening and inadequate, only they miss the double gain: the gain of pleasure and insight that results from opening the possibilities. By opening the images of war to the comical, Kluge adheres to what he formulated in *Geschichte und Eigensinn (History and Obstinacy)*: to reach people by enabling them to have experiences that initiate motion, that address the body, the senses, and the emotions. The comical images of war offer them a sensomotoric handling of the war. The laughter of the recipient transports the past features of history right into his/her body. And that is where they are and remain bound. By laughing the human being is bound to what s/he laughs about.[35] Ultimately, that means that it is precisely the proliferation of fake war images that bind the spectator to this war.

The Horse in the Image of War

If Kluge touches the innermost nature of the viewer by detour, i.e. by comical representation of such a serious subject as war, we can't ignore the curious imagery that occurs time

and again in the filmic episodes: the horses. They occur both in tragic episodes and in comical ones. In the comical episodes Kluge's filmic style of course appears at the height of its perfection because viewers are confronted with multiple disruptions at the same time. Kluge's representation of war—that is this part's thesis—culminates in the grotesque image of the war horse. But why the horses? In the following I will argue that the horse functions as a dispositive of discourse that ties together tragedy and comedy, the viewers' empathy and distance, and, finally, that it serves as a vehicle of communication—especially in the period around the First World War but also up to now.

"Can a horse laugh?"[36] This is the opening question of Robert Musil's eponymous essay. The narrator answers: yes, it can laugh when it is titillated. And it is twice as ticklish as human beings because it has four armpits. But there are two constraints. On the one hand, the horse cannot laugh at jokes. On the other hand, it could be that nowadays horses are not ticklish anymore. *Before* the Great War they were ticklish, though. The narrator saw a laughing horse at that time: "Well, it was before the war; it could be that since then horses no longer laugh."[37]

Alexander Kluge and Rainer Stollmann approach Musil's question in an interview, but they leave it very quickly because they are more interested in the tickle than in the horse.[38] And yet, Musil's idea that the war could have changed the nature of horses is interesting enough. Reinhart Koselleck immediately comes to mind, since he not only examined equestrian statues, but also supposed to divide history into three periods: a pre-horse, a horse, and a post-horse age.[39] The "historic hippology according to Koselleck"[40] considers the turning point between horse and post-horse age as a "long-time process that covers two centuries, from approx. 1800 up to now."[41] But this process had two significant caesurae: the two World Wars. Both in World War I and II, "the horses kept on playing an irreplaceable, but no longer a decisive role."[42] The loss of the horses' military significance begins with the Great War. In Koselleck's words:

> But even WWII—which was doubtlessly decided by bombers, warplanes, and tanks on land—was mostly waged with mounted troops, at least on the German side. While in WWI, the Germans used 1.8 million horses, there was nearly one million more in WWII, namely 2.7 million. 1.8 million of them died. As a percentage, this death toll is much higher than the one the soldiers had to pay. In this regard, we can take these figures as an indication of the murderous end of the horse era.[43]

In his film *Save the Horse!* Kluge illustrates this murderous end of the horse era.[44] In addition to original photos of the proud Habsburg cavalry and their horse stables, he shows historical photos with dead cavalry horses and horse cadavers on the battlefield (Figure 2.3).

The images also include presentations of horses infected with glanders—that is indeed the topic of the film. Some photos show how veterinarians are sawing off the muzzle and the nostrils of the horses for diagnostic reasons. These horses had to be killed by emergency slaughter. The cruel historic images are complemented by two filmic scenes showing a real emergency slaughter of an infected horse. The horse tries to rear up, but twitches on the ground as it bleeds to death.

The end of the horse era is represented in the image: Bearing Koselleck's historic hippology in mind, you think that the whole horse era has ended with the death of this horse.

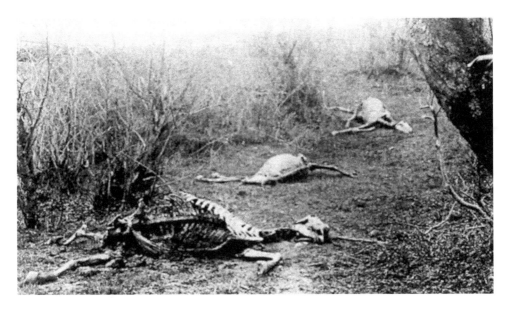

Figure 2.3 Horse cadavers on the battlefield.

Source: Alexander Kluge, *Rettet das Pferd!* (2013), www.dctp.tv/filme/10vor11-12082013/, 00:01:03, accessed August 30, 2015.

At least the images of the death of the horse triggers visions of the end of the Great War and its heavy losses before your inner eye. But this extensive 'katabasis' (death of a single horse, military defeat of the First World War, end of the horse era) is entangled with an 'anabasis' indicated by the joyful marching music. The melodies from the barrel organ run through all presentations including the cruel images. The ascent associated with the descent takes place at the "horse front," as the filmic comment explains:

> In 1918, the Austro-Hungarian Empire lost World War I. The military veterinarians responsible for the horses, however, had won the war before. Astonishingly enough, they had defeated a serious horse disease with their mallein eye test. The war had nearly been lost on the horse front in 1916. But the Austro-Hungarian horses had never been more intact than they were at the moment of capitulation.[45]

The history of the horse is put on the same level as the—anthropocentric, of course— history of the world, even with regard to the terminology: there is a 'horse front' where veterinarians 'wage war' against a severe horse disease, and they 'win the war.' You smile at the absurd image, and at the same time you know about the downfall of the cavalry horses, of the horse era in general. This is what makes this 'victory' rather sad, maybe even desperate.

Why does Kluge make the horses actors of the war? Why does he transform his story into hippology? It is exactly this last question that the historian Ulrich Raulff asks in view of Koselleck's historical hippology, and he finds an answer in Koselleck's oeuvre itself. Koselleck once admired Art Spiegelman's representation of the history of Nazism as an animal fable:

Who has picked up the volumes will quickly notice that it is exactly the indirect statement—that is contained in the animal fable—that has a stronger effect than every direct description, which is nothing more than an objective description of misery. We recognize that aesthetic solutions are possible when they discuss the unanswerability itself, when they take detours that put the reader, the spectator, or the reflecting person in a state where he is forced to reflect without knowing how to integrate all that happened into his memories.[46]

Raulff complements Koselleck with Koselleck: "What constitutes historical reality is decided not only at the level of the sources and their methodical control, but already when the attempt is made to articulate it in the first place."[47]

That corresponds to Kluge's narrative and filmic poetology as it has been formulated and practiced since the *Ulm Dramaturgies* (*Ulmer Dramaturgien*). A subject that has mostly been outside the main focus, enters center stage and thereby develops an irritation that forces you to reflect on it. And it is telling that in case of both Koselleck and Kluge, it is the horse that is used for the detour. Aside from Koselleck's picture collection of equestrian statues there is also a collection in his estate named "horse pure."[48] It includes a photo of Mario Marini's monument The Grand Miracle (*Il Grande Miracolo*) (1953) in Rotterdam, in which horse and equestrian appear to fall. The horse has taken the vertical dimension reserved for the homo erectus, while the equestrian is aligned horizontally. For Koselleck, "the dying of soldiers and the dying of horses" are "seen together and crossfaded."[49]

Koselleck's interplay of horse and human being is intensified by another image in his collection. On a photo of Wilhelm Lehmbruck's 'statue' *The Fallen Soldier* (*Der Gestürzte*) (1915/1916), you see a fallen soldier crawling on all fours. He is forced into the horizontal dimension of the animal:

> That is the point where Koselleck's equestrian history ends and where his horse history begins—the point at which anthropology and zoology switch places and where a human and tragic history becomes possible: a history in indirect speech, a history that shows more than it says.[50]

Is this also Kluge's intention when he combines the horse front with the war front? Does he narrate a horse history in order to narrate a tragic history of man? Is the horse image a detour of the war image because the horse image reveals more? Due to the representation of the emergency slaughter, the film *Save the Horse!* is just as dramatic and intense as Koselleck's photographs of Marini's and Lehmbruck's monuments. But as usual, Kluge irritates this impression through curiosities and absurdities. The smile of the spectator turns into a laughter that sticks in the craw and ends up as a grotesque. Peter Berling, playing the role of the Austrian veterinarian officer Dr. Jauernig, reads out an article from a textbook, word for word. The article is about the preparation of a mallein culture required for the diagnosis of glanders. The complicated formulation sounds like a cooking recipe:

> One kilogram of cut horsemeat was cooked with three liters of water on open fire for two hours. The liquid was then poured into boiling flasks. One percent peptone and 1 percent sodium chloride were added, and all was boiled in a pressure cooker for another two hours.[51]

This impression is substantiated when you consult the book from which Berling quotes. It mentions the "bouillon"[52] and how it is prepared, in particular what you can do to clear the bouillon given the lack of egg whites during the war. Actually, the gastronomic association is realized shortly afterwards:

K: These horses are often referred to as comrades. There is an officer who dies of a headshot and lies next to his horse. The horse stays with him. When he is buried, the horse is inseparable from him and refuses to eat. Are horses faithful or is it an instinctive behavior or is it acquired?

B: This is acquired. [...] In former times, the horse would have been killed and buried next to the officer. [...] Nowadays you wouldn't do that because you can still use the horse and make it get accustomed to a new comrade.

K: When the horse is ill or has a broken leg, when it is not fit for service anymore, it comes to the horse slaughterer. We eat the comrade.

B: Many people like eating horsemeat. It tastes very good, it is a very good ...

K: What does it taste like?

B: A little bit sweetish, a very, very fine and mostly low-fat meat.

K: You must flavor it with a lot of pepper in order to—yes?

B: It depends on your attitude, I mean in general ...

K: Some people say it tastes as sweet as human flesh.

B: I'm not informed about your experiences with human flesh; however, I know horsemeat, and from time to time I like to eat it.

K: What do you serve it with? Can you eat it with cucumber salad? Which side dish would you propose?[53]

Figure 2.4 Butcher sharpening his knife in *Rettet das Pferd!*

Source: Alexander Kluge, *Rettet das Pferd!* (2013), www.dctp.tv/filme/10vor11-12082013/, 00:10:49, accessed August 30, 2015.

Horsemeat with cucumber salad. The conversation is grotesque, because the Lucullan orientation covers the tragic dimension and shifts cultural distinctions to a disproportionate degree. This image is enhanced by the image of a butcher who sharpens his knife in the same room in which the horse is slaughtered (Figure 2.4).

Dr. Jauernig alias Berling knows "horse breeders who are infatuated with their animals, they affectionately care for them, and at the same time they are horse butchers as a secondary profession."[54] The horse friend as a horse eater. Kluge comments provokingly: "I internalize the thing that I love the most."[55]

As a spectator you would like to dissociate from this sort of appropriation. Is the detour via hippophagy not weird enough to prevent you from reflecting further on the sense of this irritation? What is it that keeps the spectator clinging to the scene? Kluge's rhetorical question about what you could eat with horsemeat could indirectly lead to an answer, for the combination of horse and cucumber salad is a historic one. In 1864, Philipp (Greek: horse friend) Reis introduced the telephone apparatus he had invented. According to a myth, a friend spoke the sentence "The horse doesn't eat cucumber salad" into the speaker in order to demonstrate how the apparatus worked. Due to technical failures Reis had not been able to understand this sentence. Allegedly, he understood the first part of the sentence, but failed to comprehend the message in its entirety as it was intentionally devoid of any clear-cut meaning.[56]

This was not the only reason for the telephone to initially remain nothing but a "civil invention."[57] At the beginning it was not considered a useful method of communication in war. Telegraphy was regarded as a superior means of communication since it corresponded much better to the military figuration of power. Due to its literality and "one-way-communication," telegraphy seemed to lend itself to greater control than did the telephone that was based on orality and "two-way-communication."[58] But history showed that telegraphy was unreliable, too. This was, for example, evidenced by the mangled text of the German declaration of war to France. Kluge writes: "It sounds like a Dada-text."[59] Consulting etymology, which suggests the term 'Dada' to be a French children's word for a hobbyhorse, one gets the impression that a horse had galloped through the telegraphed declaration of war.

Taking it slightly more associatively and freely (virtually without a saddle) it would mean: Whenever the horse enters communication, meaning is put into question. You can only fail to understand and to communicate (like Philipp Reis), or you will obtain a surplus of sense from the (white) noise.

Kluge seems to favor the last possibility. He is absolutely proficient in media theory, so it seems obvious what his allusion to the horse-and-cucumber-salad legend aims at: Kluge suggests that we break up conventional connections in order to re-build the image of history, so as to motivate new ways of thinking and facilitate new experiences. He implies that the entropy of information can be highly productive. Surprised by the sudden possibility to discover a new connection, the viewer remains bound to the images of horses. This is the meaning of the grotesque combination of the cruel images of horse cadavers on the battlefield with the comical images of a ponderous, hippophagous veterinarian officer. Admittedly that is strong meat, but you have to fork up the images of war.

Notes

1 See Christian Schulte, ed., *Die Schrift an der Wand—Alexander Kluge: Rohstoffe und Materialien* (Göttingen: V&R unipress, 2012); Heinz L. Arnold *Text+Kritik* 85/86, ed. Alexander Kluge (München: Edition Text+Kritik, 1985) (new edition 2011). (Both publications provide selected research literature that gives a good overview of the state of current scientific discussion.)

2 See Robert Mattheis: "The Carrousel of Topics Practiced by Kluge Wildly Ejects Metaphors and Images" ["Das von ihm [Alexander Kluge] betriebene Themen-Karussell schleudert [...] wild Metaphern und Bilder heraus"], Robert Mattheis, "Mit der Straßenkarte von Groß-London durch den Harz: Eine Würdigung Alexander Kluges aus Anlass seines 80. Geburtstages," 2012, accessed August 30, 2015, www.satt.org/literatur/12_03_kluge.html.

3 Florian Rötzer, "Kino und Grabkammer: Gespräch mit Alexander Kluge," in Schulte, *Die Schrift an der Wand*, 40.

4 See Christian Schulte, "Cross-Mapping: Aspekte des Komischen," in Christian Schulte and Rainer Stollmann, eds., *Der Maulwurf kennt kein System: Beiträge zur gemeinsamen Philosophie von Oskar Negt und Alexander Kluge* (Bielefeld: transcript, 2005), 221.

5 See Kluge in Rötzer, "Kino und Grabkammer," 46.

6 Christian Schulte, "Konstruktionen des Zusammenhangs: Motiv, Zeugenschaft und Wiedererkennung bei Alexander Kluge," in Schulte, *Die Schrift an der Wand*, 73–74.

7 "Die Erfahrungen, die in Bewegung setzen, müssen nicht nur durch den Kopf hindurch, sondern durch Körper, die Nerven, die Sinne, die Gefühle; sie müssen am Geschichtsverhältnis als einem faßlichen Gegenstand arbeiten können." Oskar Negt and Alexander Kluge, *Geschichte und Eigensinn* (Frankfurt am Main: Zweitausendeins, 1981), 777.

8 Schulte, "Konstruktionen des Zusammenhangs," 64.

9 Alexander Kluge and Rainer Stollmann: "Die Macht des Zwerchfells," in Schulte, *Die Schrift an der Wand*, 270.

10 See also the well-known introductory sentence of Alexander Kluge, "Die schlimmste Ideologie: daß die Realität sich auf ihren realistischen Charakter beruft," in Alexander Kluge, *Gelegenheitsarbeit einer Sklavin. Zur realistischen Methode* (Frankfurt am Main: Suhrkamp, 1975), 215.

11 Alexander Kluge, *Facts & Fakes 1*, ed. Christian Schulte and Rainer Gußmann (Berlin: Vorwerk 8, 2000), 24, cited by Andrea Gnam, "Das Interview bei Alexander Kluge. Präzision und Unbestimmtheit," in *Weimarer Beiträge* 54, no. 1 (2008): 140.

12 Alexander Kluge, "'Wie erkennt man einen Dämon? Er schwatzt und übertreibt,'" interview by Thomas Combrink (2004), accessed August 30, 2015, www.kluge-alexander.de/zur-person/interviews-mit/details/artikel/wie-erkennt-man-einen-daemon-er-schwatzt-und-uebertreibt.html.

13 Alexander Kluge, "Cinéma pur, cinéma impur," in *Filmfaust* 26 (1982): 64, cited by Schulte, "Konstruktionen," 72.

14 Alexander Kluge, *Die Patriotin. Texte/Bilder 1–6* (Frankfurt am Main: Zweitausendeins, 1979), 301.

15 This is the title of one of Kluge's films: Alexander Kluge, *Der Erste Weltkrieg: Die Abwesenheit von Kriegskunst* (Zürich: NZZFormat, kairosfilm and dctp, 2010).

16 Rainer Stollmann, "Grotesker Realismus: Alexander Kluges Fernseharbeit in der Tradition von Komik und Lachkultur," in Christian Schulte and Winfried Siebers, eds., *Kluges Fernsehen. Alexander Kluges Kulturmagazine* (Frankfurt am Main: Suhrkamp, 2002), 233–259; Christian Schulte, "Mündig ist der Mensch, wenn er Ausgang hat": Versuch über das Komische bei Alexander Kluge," in *Maske und Kothurn* 51, no. 4 (2005): 517–528; Schulte, "Cross-Mapping."

17 See Klaus Schwind: "Komisch," in *Ästhetische Grundbegriffe. Historisches Wörterbuch in sieben Bänden*, ed. Karlheinz Barck et. al., vol. 3 (Stuttgart, Weimar: Metzler, 2001), 332–384.

18 See Schulte, "Cross-Mapping," 223.

19 Alexander Kluge, "Verdeckte Ermittlung. Ein Gespräch mit Christian Schulte und Rainer Stollmann," (Berlin: Merve, 2001), 84, cited by Schulte, "Cross-Mapping," 227.

20 Schulte, "Cross-Mapping," 231.
21 Helmuth Plessner, *Laughing and Crying: A Study of the Limits of Human Behavior*, transl. James Spencer Churchill and Marjorie Grene (Evanston: Northwestern University Press, 1970).
22 Plessner, *Laughing and Crying*, 91.
23 Ibid., 246.
24 "Thus bodily existence for man is a *relation*, in itself not unequivocal, but ambiguous, a relation of himself to himself (or, to put it precisely, of him to himself)." Plessner, *Laughing and Crying*, 35.
25 Plessner, *Laughing and Crying*, 87.
26 Ibid., 67.
27 Ibid., 90, translation modified.
28 Ibid., 66, translation modified.
29 Rainer Stollmann and Alexander Kluge speak of 'Kitzel': Alexander Kluge and Rainer Stollmann, "Die Macht des Zwerchfells," in Schulte, *Die Schrift an der Wand*, 256. Plessner, though, considers the titillation—because of its superficiality—as a stimulus that is only the trigger of laughing. See the chapter "Expressive Movements of Joy and Titillation," in Plessner, *Laughing and Crying*, 70–75.
30 Plessner, *Laughing and Crying*, 76, translation modified.
31 Ibid., 287.
32 Ibid., 79.
33 Ibid.
34 Ibid.
35 Ibid., 288.
36 Robert Musil, "Can a Horse Laugh?" in Robert Musil, *Posthumous Papers of a Living Author*, trans. Peter Wortsman (New York: Archipelago, 2006), 14–16.
37 Musil, "Can a Horse Laugh?" 14.
38 Kluge and Stollmann, "Die Macht des Zwerchfells," 256.
39 Reinhart Koselleck, "Der Aufbruch in die Moderne oder das Ende des Pferdezeitalters" in Berthold Tillmann, ed., *Historikerpreis der Stadt Münster: Die Preisträger und Laudatoren von 1981 bis 2003* (Münster: LIT Verlag, 2005), 161.
40 See Ulrich Raulff, "Das letzte Jahrhundert der Pferde: Historische Hippologie nach Koselleck," in Hubert Locher and Adriana Markantonatos, eds., *Reinhart Koselleck und die Politische Ikonologie* (Berlin/München: Deutscher Kunstverlag, 2013), 96.
41 Koselleck, "Aufbruch in die Moderne," 168.
42 Ibid., 171. In his novel *Gläserne Bienen* (1957), Ernst Jünger already notes the disappearance of the horses.
43 Koselleck, "Aufbruch in die Moderne," 171–172.
44 Alexander Kluge, *Rettet das Pferd!*, accessed August 30, 2015, www.dctp.tv/?t=0m0s#/ filme/10vor11-12082013/.
45 Alexander Kluge, *Rettet das Pferd!*
46 Reinhart Koselleck, "Formen und Traditionen des negativen Gedächtnisses," in Reinhart Koselleck, *Vom Sinn und Unsinn der Geschichte: Aufsätze und Vorträge aus vier Jahrzehnten*, ed. Carsten Dutt (Berlin: Suhrkamp, 2010), 252 (cited by Raulff, "Das letzte Jahrhundert der Pferde," 102).
47 Koselleck's statement refers to his comment on Alexander Kluge's concept of history, see Reinhart Koselleck, "Fiktion und geschichtliche Wirklichkeit," in Koselleck, *Vom Sinn und Unsinn der Geschichte*, 93 (cited by Raulff, "Das letzte Jahrhundert der Pferde," 103).
48 Raulff, "Das letzte Jahrhundert der Pferde," 96.
49 Reinhart Koselleck, "Der unbekannte Soldat als Nationalsymbol im Blick auf Reiterdenkmale," in *Vorträge aus dem Warburg-Haus*, ed. Wolfgang Kemp et al., vol. 7 (Berlin: Oldenbourg Akademieverlag, 2003), 150 (cited by Raulff, "Das letzte Jahrhundert der Pferde," 105).
50 Raulff, "Das letzte Jahrhundert der Pferde," 106.
51 Kluge, *Rettet das Pferd!* 11:34. Berling quotes from Alexander Hönel and Katrin Tischler, *Das österreichische Militärveterinärwesen 1850–1918: Tierärztliche Tätigkeit zwischen Empirie und Wissenschaft* (Graz: Ares, 2006), 228.
52 Hönel and Tischler, *Das österreichische Militärveterinärwesen 1850–1918*, 226.
53 Kluge, *Rettet das Pferd!* 15:00.

54 Ibid..
55 Ibid.
56 See Stefan Kaufmann, *Kommunikationstechnik und Kriegsführung 1815–1945: Stufen telemedialer Rüstung* (München: Wilhelm Fink, 1996), 187; Frank Haase, *Medien—Codes—Menschmaschinen: Medientheoretische Studien zum 19. und 20. Jahrhundert* (Opladen/Wiesbaden: VS Verlag für Sozialwissenschaften, 1999), 80.
57 Kaufmann, *Kommunikationstechnik*, 187.
58 Ibid., 192.
59 See Alexander Kluge in the booklet of his DVD-edition: Alexander Kluge, *Seen sind für Fische Inseln: Fernseharbeiten 1987–2008* (Frankfurt am Main: Zweitausendeins and dctp, 2009), 113.

Bibliography

Arnold, Heinz L. *Text+Kritik* 85/86, edited by Alexander Kluge. München: Edition Text+Kritik, 1985 (new edition 2011).

Gnam, Andrea. "Das Interview bei Alexander Kluge. Präzision und Unbestimmtheit," *Weimarer Beiträge* 54/1 (2008): 140.

Haase, Frank. *Medien—Codes—Menschmaschinen: Medientheoretische Studien zum 19. und 20. Jahrhundert*. Opladen/Wiesbaden: VS Verlag für Sozialwissenschaften, 1999.

Hönel, Alexander and Katrin Tischler. *Das österreichische Militärveterinärwesen 1850–1918: Tierärztliche Tätigkeit zwischen Empire und Wissenschaft*. Graz: Ares, 2006.

Kaufmann, Stefan. *Kommunikationstechnik und Kriegsführung 1815–1945: Stufen telemedialer Rüstung*. München: Wilhelm Fink, 1996.

Kluge, Alexander. *Gelegenheitsarbeit einer Sklavin. Zur realistischen Methode*. Frankfurt am Main: Suhrkamp, 1975.

——. *Die Patriotin. Texte/Bilder 1–6*. Frankfurt am Main: Zweitausendeins, 1979.

——. "Cinéma pur, cinéma impur." *Filmfaust* 26 (1982).

——. *Facts & Fakes 1*, edited by Christian Schulte and Rainer Gußmann. Berlin: Vorwerk 8, 2000.

——. "Verdeckte Ermittlung. Ein Gespräch mit Christian Schulte und Rainer Stollmann." Berlin: Merve, 2001.

——. "Wie erkennt man einen Dämon? Er schwatzt und übertreibt." Interview by Thomas Combrink, 2004, www.kluge-alexander.de/zur-person/interviews-mit/details/artikel/wie-erkennt-man-einen-daemon-er-schwatzt-und-uebertreibt.html (accessed June 15, 2017).

——. *Seen sind für Fische Inseln: Fernseharbeiten 1987–2008*. Frankfurt am Main: Zweitausendeins and dctp, 2009.

——. *Der Erste Weltkrieg: Die Abwesenheit von Kriegskunst*. Zürich: NZZFormat, kairosfilm and dctp, 2010.

——. *Rettet das Pferd!*, 2013. www.dctp.tv/?t=0m0s#/filme/10vor11-12082013/ (accessed August 30, 2015).

—— and Rainer Stollmann. "Die Macht des Zwerchfells." In *Die Schrift an der Wand— Alexander Kluge: Rohstoffe und Materialien*, edited by Christian Schulte, 255–274. Göttingen: V&R unipress, 2012.

Koselleck, Reinhart. "Der unbekannte Soldat als Nationalsymbol im Blick auf Reiterdenkmale." In *Vorträge aus dem Warburg-Haus*, edited by Wolfgang Kemp et al., vol. 7, 137–166. Berlin: Oldenbourg Akademieverlag, 2003.

——. "Der Aufbruch in die Moderne oder das Ende des Pferdezeitalters." In *Historikerpreis der Stadt Münster: Die Preisträger und Laudatoren von 1981 bis 2003*, edited by Berthold Tillmann, 159–174. Münster: LIT Verlag, 2005.

——. "Fiktion und geschichtliche Wirklichkeit." In Reinhart Koselleck, *Vom Sinn und Unsinn der Geschichte: Aufsätze und Vorträge aus vier Jahrzehnten*, edited by Carsten Dutt, 80–95. Berlin: Suhrkamp, 2010.

——. "Formen und Traditionen des negativen Gedächtnisses." In Reinhart Koselleck, *Vom Sinn und Unsinn der Geschichte: Aufsätze und Vorträge aus vier Jahrzehnten*, edited by Carsten Dutt, 241–253. Berlin: Suhrkamp, 2010.

Mattheis, Robert. "Mit der Straßenkarte von Groß-London durch den Harz: Eine Würdigung Alexander Kluges aus Anlass seines 80. Geburtstages," 2012. www.satt.org/literatur/12_03_kluge.html (accessed August 30, 2015).

Musil, Robert. "Can a Horse Laugh?" In Robert Musil, *Posthumous Papers of a Living Author*. Translated by Peter Wortsman, 14–16. New York: Archipelago, 2006.

Negt, Oskar and Alexander Kluge. *Geschichte und Eigensinn*. Frankfurt am Main: Zweitausendeins, 1981.

Plessner, Helmuth. *Laughing and Crying: A Study of the Limits of Human Behavior*. Translated by James Spencer Churchill and Marjorie Grene. Evanston: Northwestern University Press, 1970.

Raulff, Ulrich. "Das letzte Jahrhundert der Pferde: Historische Hippologie nach Koselleck." In *Reinhart Koselleck und die Politische Ikonologie*, edited by Hubert Locher and Adriana Markantonatos, 96–109. Berlin/München: Deutscher Kunstverlag, 2013.

Rötzer, Florian. "Kino und Grabkammer: Gespräch mit Alexander Kluge." In *Die Schrift an der Wand—Alexander Kluge: Rohstoffe und Materialien*, edited by Christian Schulte, 35–51. Göttingen: V&R unipress, 2012.

Schulte, Christian, ed."Cross-Mapping: Aspekte des Komischen." In *Der Maulwurf kennt kein System: Beiträge zur gemeinsamen Philosophie von Oskar Negt und Alexander Kluge*, edited by Christian Schulte and Rainer Stollmann, 219–232. Bielefeld: transcript, 2005.

——. "Mündig ist der Mensch, wenn er Ausgang hat: Versuch über das Komische bei Alexander Kluge." In *Maske und Kothurn* 51, no. 4 (2005): 517–528.

——. *Die Schrift an der Wand—Alexander Kluge: Rohstoffe und Materialien*. Göttingen: V&R unipress, 2012.

——. "Konstruktionen des Zusammenhangs: Motiv, Zeugenschaft und Wiedererkennung bei Alexander Kluge." In *Die Schrift an der Wand—Alexander Kluge: Rohstoffe und Materialien*, edited by Christian Schulte, 53–76. Göttingen: V&R unipress, 2012.

Schwind, Klaus. "Komisch." In *Ästhetische Grundbegriffe. Historisches Wörterbuch in sieben Bänden*, edited by Karlheinz Barck et al., vol. 3, 332–384. Stuttgart/Weimar: Metzler, 2001.

Stollmann, Rainer. "Grotesker Realismus: Alexander Kluges Fernseharbeit in der Tradition von Komik und Lachkultur." In *Kluges Fernsehen. Alexander Kluges Kulturmagazine*, edited by Christian Schulte and Winfried Siebers, 233–259. Frankfurt am Main: Suhrkamp, 2002.

3 Max Beckmann's Revenants and Ernst Jünger's Drones

Vision and Coolness in the Interwar Period

Christine Kanz

Introduction

This chapter focuses on the question of how emotional detachment—'coolness'—is represented and mediated by war images in texts, art objects, and sculptures in the years between World War I and World War II. In my analysis I will concentrate on works by the artist, art professor, voluntary military medic, and writer Max Beckmann, and by the entomologist, soldier, and writer Ernst Jünger. In their work, both men represented specific vivid memories of war, or visualized battlefield emotions—Beckmann confronting the unforgettable painful sight of dismembered dead bodies, and Jünger reflecting upon painless photo shooting in the midst of war. Beckmann and Jünger reflected on war from different vantage points and via different media—literature and visual art. And they deal with their battlefield emotions in completely different ways. While Beckmann's images and sculptures try to overcome mourning but are still threaded with strains of melancholia, Jünger's texts succeed in performing painlessness and coolness from the very beginning.

The works explored in this chapter are literary and theoretical texts and art objects created in the context and aftermath of World War I, such as Jünger's 1934 essay "On Pain," and Beckmann's 1915 war letters, and one of his sculptures from the 1930s. My main question is if and how the visual perspective—the artist's eye or the camera's eye as well as the drone-like perspective—serves to create emotional distance, and if and how creating art and literature provides an effective means through which writers and artists can deal with emotions, such as mourning caused by their own witnessing of war. These questions invite two further reflections. First, can we actually speak of emotional detachment—coolness—in this context? And, second, is it at all useful to describe visuality as a mode of 'cool' behavior?

Before engaging in a discussion of the connections between literature, art, and battlefield emotions in Jünger and Beckmann, it is important to note that both of these two quite different men shared an urgent, active interest in living, organic matter. More precisely, in Jünger's case, an interest in insects, especially flying insects such as bees; and in Beckmann's, an interest in the possibility of giving birth as a response to his dealing with his memories of dead bodies. The idealization of motherhood and maternity, the obsession with organic matter, with giving birth and with emotional intensity was widespread during the interwar period.[1] During, and especially after, wartime, there was broad cultural and popular interest in everything organic, and in the question of how to deal with emotions regarding the

taking, and especially the giving, of life, i.e., giving birth. Jacob Epstein's sculpture *The Rock Drill* (1913–1915) depicting an embryo in the figure's belly and Erwin Blumenfeld's *Self-Portrait* (around 1936) displaying a male body giving birth to an image of a female face provide just two of the numerous artistic examples of male birth fantasies presented in the arts, in literature, and also in cultural theory (as in psychoanalysis or anthropology) during the first three decades of the twentieth century. Behind these interests in organic matter and in giving birth looms the question how to detach oneself emotionally from haunting war images—and how these examples make a case for giving, instead of taking, life.

War Trauma and Giving Birth: Max Beckmann

After 1914, the art of Max Beckmann is always rooted in the terror of war, even when terror is not immediately discernible in any given image or sculpture (for example, see Figure 3.1). His 1936 sculpture *Adam and Eve*, one of five sculptures he made in the 1930s, portrays Adam as the male mother of Eve (see Figure 3.2).

Figure 3.1 Max Beckmann's *Soldier with Head Bandage* from 1915 is one example of a representation of vivid war memories.

Source: *Atelier Schützengraben. Max Beckmann, Hans Alexander Müller und Alfred Frank zeichnen den I. Weltkrieg*, Catalogue, Museum der bildenden Künste Leipzig, Tübingen, 2014, p. 49 © VG-Bild Kunst, Bonn 2016.

Figure 3.2 Max Beckmann, *Adam and Eve*, front, 1936.

Source: Max Beckmann. Exhibition Catalogue *Max Beckmann: 19. April bis 24. Juni 1984*, Köln: Josef-Haubrich-Art Gallery, 1984, p. 99 and 308. © VG-Bild Kunst, Bonn 2016.

Beckmann created the work three years after his dismissal from a professorship at the Frankfurter Kunstschule. Several months later, he and his wife would flee the Nazis to the Netherlands, taking along many of his art objects that were officially defamed as "degenerate art" (*entartete Kunst*) by the National Socialist regime.[2] Beckman's well-known *Adam and Eve* became part of the Hamburger Kunsthalle's permanent collection in 2014. A close look at Adam's face reveals its startling similarity to Beckmann's 1936 *Self-Portrait* (*Selbstbildnis*).

A little Eve can be seen in the palm of Adam's open right hand, which is positioned directly where, according to the Bible, one of Adam's ribs was taken by God in order to create Eve. Thus, this sculpture reads as a literal reflection of the biblical account of creation. To be more precise, it reflects the post-eleventh-century artistic re-formulation imagining Adam as the creator of Eve—a re-formulation, which also entails a male birth fantasy.[3] The fantasy embodies the fulfillment of the male wish to give birth to a child. This visual assertion states that male birth-giving is possible. The sculpture also asserts the man's double capacity: being a male mother and simultaneously an artist. This complexity of creating a sculpture can be regarded as a process of reflection, which is emotionally detached or even 'cool.' Laurence Rickels investigates in his study *Aberrations of Mourning* the aspect of the so-called unmourned ("die Unbetrauerten"), which embody revenants or vampires haunting the "aberrant" mourner who actually failed to mourn in an appropriate manner.[4] Thus, an artwork representing birth or life giving can also be interpreted as a result of successful mourning (in the sense of overcoming mourning).

Beckmann's huge Adam, holding a small Eve on his right hand just above his belly, was created between the two World Wars. The trauma of World War I still resonates; the terror of World War II is already looming on the horizon. This sculpture visualizes the traumatic war experience, and, at the same time, might be seen as forecasting the outbreak of the next war. Adam's expression is pained, his forehead stricken

with sorrow, and his mouth is open ready to scream. In fact, Beckmann viewed his dismissal from the Frankfurter Kunstschule as the "end of the world,"[5] and it was in this depressing context and atmosphere that he created this dark-colored sculpture.

That World War I was a disastrous rupture for Beckmann is reflected not only in his artwork, but also in biographical material, in particular his *Briefe aus dem Kriege* (*Letters from the War*) that are filled with descriptions of dead bodies and their smells, smashed faces, agonized people and crying voices. His letters suggest a deep personal connection to the war, it was Beckmann's personal belief that he himself had foreseen the war. As he confided to his diary,[6] he had been "pregnant" with this war before its actual outbreak. There was already an internal or mental war going on before the external, actual war began. At first, the war seemed to interrupt boredom, and to feed Beckmann's deep longing for more intensity in life.[7] The gruesome battlefield experience and the suffering it brought came somewhat later. Consequently, it struck Beckmann even harder—and for longer, probably even forever. The physical and nervous breakdown of the voluntary military medic occurred in 1915.[8] From an artistic point of view, after World War I, Beckmann found a new original artistic radicalism. This change in artistic formal style, from a more impressionist attitude to a more expressionist force, must be seen as an immediate consequence of his battlefield experience—a perspective confirmed by his son's afterword to the publication of the letters in 1916.[9]

The son asserts that his father had already dealt with loss, ruin, death, destruction, and even redemption and resurrection before the outbreak of World War I. Having been confronted with such extreme fantasies, he seemed more prepared than others to endure the coming events. However, once confronted with the real battlefield inferno, the scale of destruction seemed inconceivable, exhausting Beckmann's already strained emotional resources almost completely. The entirety of his later view on the world is characterized by this experience of extremes, and is driven by an "expressionist force."[10] The number of dying people was too high to be mentally grasped. The dead were so numerous that they could not be mourned at all, or could only be partially mourned. Still, all of the unmourned had real human faces. If we put ourselves in Beckmann's position, we might be able to imagine the impossibility of forgetting their agonizing eyes as they died on the streets. Thus, they come back, again and again in nightmares or as flashbacks in one's daily life. The revenants are still populating the soul.

It is therefore only logical that many artists and writers in this situation and at that time considered psychoanalysis an ideal method to deal with their traumatic memories. To many intellectuals, psychoanalysis seemed to open the only path to the undead that finally had to be mourned in order to reduce melancholia, sadness, or flashbacks. It seemed the only way to overcome the disturbed or troubled contact and to minimize the psychic disturbances caused by the close and prolonged contact with death and the dying. Of course, the traumatized war witness can never really let the dead bodies go. In this sense, they have become the un-dead or the revenants that populate Beckmann's imagination throughout his life. By means of his imagination Beckmann can re-visualize them consciously and try to (re)establish contact with them. Perhaps, with the help of psychoanalysis or/and the creation of art, it might then become easier to deal with all the gruesome images of war.

War psychiatrist Ernst Simmel investigated the effects of traumatic war experience on the psyche. He directed a special war hospital for people suffering from shell shock,

and would later become a specialist in treating shell shock symptoms relying mainly on hypnosis. The doctor considered traumatic war images too extreme for the human soul to bear and believed that the experience of shock is incorporated into the psyche without conscious knowing. But what is too much for the human soul to grasp can never really disappear, he declared in his 1918 study *War Neurosis and Psychological Trauma (Kriegs-Neurosen und Psychisches Trauma)*.[11] Instead it will remain in the unconscious layer of the human psyche for as long as you live. It will stay there, like a bomb, always waiting to explode.[12] The shell-shocked war veteran's or war witness' soul, mentality, and body are populated by numerous of those unforgettable, unmourned faces. The veteran or witness has incorporated the dead without his or her knowing. Thus, the dead must actually come back again and again, like revenants. As Rickels points out, the shell-shocked individual, similar to the melancholic individual, is not able to accept the loss, and will never cease to suffer from the gruesome images. He will never cease to mourn as he has incorporated the dying bodies into his soul, and in most of the cases without even knowing who they are.[13]

As early as 1915, Beckmann wrote in his letters from the hospital about being haunted by his war experience and battlefield emotions. He wished nothing more than to get rid of them. His letters tell us about his deep-rooted drive to live and to express himself as an artist. In this wish, he compares himself to a loving mother caring for herself, and he uses birth-like images to describe his deep-rooted longing to live and to paint images. Producing images and sculptures that express the intensity of life and life giving, he not only emphasizes his stark inner force to create art but also his extremely strong urge to realize his concept of the ideal form, which, he believed, would finally rid him of his inner torment and mental suffering.[14]

In order to free himself from the *in*-corporated ordeal he has to *ex*-corporate it, so to speak. An entire passage in a letter from April 1915 reads like a description of the act of giving birth to new life and new artistic form at the same time.[15] Drawing on Rickel's theory of the unmourned we can reflect on the consequences of *successful* mourning, which would imply the overcoming of grief and the establishment of a new coolness. What would have happened to Beckmann's artistic capacities if he had succeeded in mourning and dealing with his dreadful battlefield experience? Would he have produced different art objects, freed from the historical context? Would he have been able to create anything at all?

In a famous letter written from the Belgian front in 1915, Beckmann wrote: "My art is feeding on the war."[16] Beckmann himself felt that his work, which visualized the experience of war, was inspired by and therefore to some extent profited from warfare. At least, Beckmann himself imagined this possibility as we can read in another letter of the same year. In this letter, he muses about dealing with battlefield emotions in a way that empowers the mind to detach itself from such haunting emotions. All the images of war, the dark faces of the dead, are still there, and they will probably be greeting him forever. Because of a newly gained capacity for emotional detachment or 'coolness,' however, he would be able to at least paint those unmourned undead. In this perspective, he consciously gets in contact with the dead human faces he has been carrying around inside his mind since his wartime experience and thus painting becomes a way to arrest the haunting revenants.[17]

It seems only logical that all the in-corporated revenants—populating the inward visual space or soul[18]—have to be ex-corporated in order for the artist/mourner to be finally able to say goodbye to them, and at the same time free up space for others,

for new life and a newly gained detachment or coolness. Beckmann's imaginings and ideals of form thus had to be realized and visualized as human-like sculptures consisting of unorganic-organic matter.[19]

Beckmann's Revenants

Imagine walking through a museum. Suddenly, sculptures stand in your way. In a museum, you will see numerous human-like sculptures, competing with you for space, blocking your path. If you ignore them, you are doomed to stumble over them. Unlike the visual images hanging on the museum walls, sculptures are hard to ignore or forget. A sculpture just takes its own space in a room. You have to notice it unless you want to cause an accident. Thus, sculptures are in your way in a double sense. Sculpture's human-like attributes make it a very suitable medium to force you to meet and greet the unmourned dead or revenants—and to let them go again after a while.

Several postwar sculptures and images that articulate a deep interest in *living* matter, and/or in giving (re)birth to the unmourned, were made by artists who, like Beckmann, had suffered significantly from gruesome battlefield experience, like the already mentioned sculpture *The Rock-Drill* by Jacob Epstein, which presents an embryo in the belly of a male figure made from a rock drill, the photo montages by Erwin Blumenfeld such as his *Self-Portrait*, which presents a naked man's lower body giving birth to a doll, or the famous photomontages by the Dadaists John Heartfield, George Grosz, Hannah Höch, or Raoul Hausmann. Indeed, these artworks seem to present a conscious attempt to 'stomach' the haunting images of war and death and the emotions they provoke. The double meaning (of 'stomach') here, is intentional, used with regard to a physical and simultaneously mental reckoning with psychological battlefield effects. Moreover, this double meaning hints at Freud's description of infantile sexual fantasies ("cloacal theory"), which focused on regressive (anal) birth imaginations that not only keep children busy but often appear in the aftermath of shock and trauma.[20]

Let me summarize my investigation so far. In light of Rickel's vampire theory of the *in*-corporation of the unmourned—leading to all the undead, ghosts, vampires, and revenants populating our minds—Beckmann's sculpture *Adam and Eve* has to be read as birth fantasy or *ex*-corporation to be regarded as the result of a successful mourning process. The achievement of a successful mourning process might seem at first glance similar to the achievement of emotional detachment, or coolness. But mourning is a deep and complex emotional process. As such, this artwork with its birth fantasy can be considered the result of a successful way of dealing with the terrors of war. The sculpture's success is double. First, it represents successful mourning. But it is also an example of successful productivity—a birth-giving—and all the more poignant because, ironically and sadly, the next war was already at the door.

Be that as it may, even if one does not want to engage psychoanalytic concepts, one will discern the meaning and effect of this dark sculpture incarnating a huge Adam holding new life in his hand and offering motherly care and warmth. This sculpture is a response to war per se. Thus, what we see here is a materialization (and thus visualization) of battlefield images and their concomitant emotions; and, at the same time, the sculpture emerges from a successful way of dealing with the horrors of war (at least it represents an attempt to gain detachment or coolness). It is an image against the taking of life—for the creation of new life.

Jünger's Vision of Optical Distancing and Emotional Detachment or Coolness

Like Beckmann, Ernst Jünger was also highly interested in questions of organic life or *living* matter. He was keen to learn more about the perceptive capacities of living beings, about hearing and tactile perception, but most of all about vision. He tried to think organic matter and technical devices together, for example in optical technology. Actually, he sought to describe optical devices as machine-like extensions of the human senses that could then be used as weapons. In his perspective, a camera's eye becomes an extension of the human eye, and acquires the status of a perpetrator. Jünger's description of an extreme development of artificial organs of perception, for example the camera, becomes a means to render the act of seeing as a conscious act of aggression or even of assault ("seeing is an act of attack"[21]). The act of seeing, then, has to be situated in the context of overcoming any weakness and thus also *beyond* the feeling of pain, fear, or mourning as shown in his famous text "On Pain" ("Über den Schmerz") published in 1934.

In Jünger's earlier works however, e.g. in his 1929 book *The Adventurous Heart* (*Das Abenteuerliche Herz*) he had presented a somewhat different perspective on emotions. In this text, emotions, mind, and body were still thought of as a unity. Or, to quote Derek Hillard, "as late as the 1920s Jünger saw the body in a close relationship with key cognitive dimensions in the context of pain."[22] Hillard continues:

> Here the body has a story to tell with pain as its voice, to the extent that the mind rests in the body, from which vantage point emotional narratives of guilt and responsibility are constructed and become legible. Because these feelings trace themselves to pain, the conduits between body and the mind require preservation. In Jünger's comment on guilt from *The Adventurous Heart* lies the insight that pain should be seen not as purely sensory. In this sense, that work curiously resonates with [...] contemporary views of pain, which include affective dimensions.[23]

Written from a somewhat different perspective then, the later essay "On Pain" becomes "a kind of anaesthesia against feeling."[24] As Hillard correctly states, "Jünger's notions of disembodied pain [. . .] wind up critiquing what he earlier valorized."[25] And Hillard continues:

> By limiting pain to the body, now cut off from the mind, feelings such as guilt are blocked. A certain emotion is at work in "On Pain," one closely aligned with fear, a cool yet emotionally driven anti-pathos, not unrelated to the phenomena examined by Lethen in *Cool Conduct*.[26]

Hillard hints at Lethen's remarks about the 'survival mode,' which has to be acquired by the modern subject in order to construct a 'cool persona,' protecting him or herself against the overwhelming and threatening processes of modernization.[27] According to Hillard, one can conclude, that in Jünger's earlier works

> the mind guides the body in a technologically extended form. As the seat of emotion, the body forges the interaction with the machine while the mind uses the extended body as a joyful instrument. In these works, the mind cools and guides emotion and body, so as to *reclaim experience*, which gets extended through technology.[28]

It is striking that in both versions of *The Adventurous Heart* (the first published in 1929, the second in 1938), there is a certain urge for the moment of existential, deadly threat—the fascination with the instant of dying. I interpret this urge as the articulation of a deep-rooted longing for highly increased intensity of perception and emotionality. At the same time, I discern the wish to make such complex, existential life experiences representable—in this case via the medium of the literary text.[29] I consider this articulation as an extreme counterpoint to the motif of giving birth, which was common during that time. Both extremes, however, are rooted in the same motivation, namely, the longing for the experience of an ever-increasing perceptive intensity. In this context, the contemporary concepts of vitalism come to mind, as they were permeated with this idea of intensified perception. They could rely, among other constructions, on Henri Bergson's concept of "élan vital." This notion describes a mental energy that dominates all living organisms (as opposed to mere matter), and that advances human development. This force cannot be rationalized, but is intuitive. It manifests itself in all acts of (artistic or scientific) creation. True, Jünger, like the futurists Umberto Boccioni and F.T. Marinetti, shared the urge for life intensity, expressed in notions like "élan vital," but we have to clearly distinguish Jünger's perspective from the surrealist's point of view on the relationship between intuition and intellect. In Jünger's texts, it is always the commando center of rationality and intellect that is in control of body and intuition. The question remains how such intellectual and emotional complexity can be represented. Is it possible to represent it at all?

Recent research on Jünger has demonstrated how he finally succeeded in his search for representability. As mentioned above, he turned to imaginary and optical registers. As a response to the new invisibility and complexity of things that had become common in the era of modernism with its scientific, technical, and cultural achievements, he developed the concept of optical distancing. This was intended to support a certain emotional distance or process of emotional detachment, which, at the same time, was meant as a specific rhetoric of *real* presence. The concept's aim was a literary project that fantasizes the optical control of everything. The decisive cross-border moment— the moment of utmost almost deadly danger—serves as his exemplum par excellence. It is a highly charged event—similar to giving birth.

Thus, the mind, that is, in Jünger's words, the "command-heights," has to objectify this shock moment. Again, Jünger is elaborating a rhetoric of distancing. As demonstrated by Claudia Öhlschläger, he does this by focusing on the technical aspects of optical devices made for increasing optical distance, as well as by supporting an imaginary of bodily physicality. This ever-increasing emotional distance or detachment shall serve to allow insights as well as overviews, where single details seem to increasingly disappear, and contingency seems to win over providence.[30]

This fixation of perception on the surface, the seeing from a long distance, in Jünger's perspective, will lead to deeper insights, empowering the viewer to survey the complexity of things. His operative term here is "stern discipline," which is directed towards the stratification, survey ("Vermessung"), arrangement, and finally the (visual) assault of living targets. In Jünger's view, the artificial eye of the "photo apparatus," or camera, is *the* incarnation of such a marshalling and classifying way of seeing and the act of optical distancing.

In this view, seeing from a camera's eye's perspective becomes his weapon and an act of assault—a means by which he would regain the ability to grasp the complex world, or at least to render it more explicable again. In describing his bird's-eye view

of the world, or perspective from the heights, Jünger uses the term "Höhenblick," which denotes the process of optical distancing and the reduction of complexity. In Jünger's theory, optical devices serve as a new tool for seeing open areas from a distance, and for surveying the world of modernity anew.[31]

The microscope as well as the plane allows the realization of his envisioned mental commando heights or center ("geistige Kommandohöhe"[32]), to which is attributed the modern human being's ability to free himself from pain, which does not disappear, but remains under control or is, even, objectified. In Hillard's words: "The mind is a 'command center' that objectifies, isolates, and dominates the body so that pain and emotional responses do not destroy it."[33] Physical pain is objectified by a visual capacity that can build on an ever-increasing distance. The emotionless or 'cool' individual is able to distance himself from any pain or, as Hillard puts it, "the mind exerts an ever-increasing ability to see oneself as an object."[34] And by doing this, by relying on this "emotional self-control"[35] or cool capacities, the modern writer in Jünger's sense will be able to finally *present* the painful or even deadly moments of a human being in a neutral, objectified way.[36] In this sense, Jünger's works, like Beckmann's, were nourished by painful and gruesome war images.

Jünger's Drones

Jünger, however, was not only a soldier and writer but also an entomologist. According to Niels Werber, Jünger, who was always "an eager collector of insects and a student of biology," maintained a ceaseless focus on his biological interests during wartime: "even in the trenches he followed his hobby and yet during his sojourns in military hospitals he pursued his studies."[37] So far, most researchers have ignored "the sociological and epistemological implications of his entomological knowledge."[38] Usually, Jünger's interest in insects is attributed to his "cold character" and his "aesthetics of terror."[39] But as soon as one engages in a close reading of his texts, one discerns a deep-rooted interest in everything organic, especially in very small living beings that can be observed from a bird's eye perspective. Already Jünger's business card makes his priority quite clear, as it reads "cand. zool. Ltn. a. D."[40]

Obviously, Jünger wanted to be recognized as an academic and candidate of zoology, and as a person of military rank and knowledge: "a Lieutnant a. D." (meaning: lieutnant being no longer on duty). This intersection between military and biological knowledge characterizes Jünger's textual world.[41] In his novel *Heliopolis*, several passages in the famous chapter entitled "The Apiary" ("Das Apiarium") focus on the military or battlefield potential of the bees' world, their gruesome and often bloody contests. This potential is particularly evident in the passages about the murder of the queen, the duel between queens, or the account of the drone battle.[42] While the bees' state is an analogy for the human state, there is a difference between human being and bee: bees, having no awareness or insight, are not culpable.[43] Human battlefields, by contrast, must be linked to guilt even if their dramas are acted out according to an eternal law and are thus necessary.[44] A transgression from bee to human being or better: the human being's technical or military device in this text is the regent's missile flying through the air, which is also an image for distant seeing and killing without (too much) pain caused by the feeling of guilt.[45]

The entomologist's fascination with the capacity of distant seeing/seeing from a distance, noted above, is actually incorporated by insects, to be more precise:

by bees, especially the drone. What is a drone? Encyclopedia entries about drones link them directly to vision, fertilization, and destruction. We read sentences such as the following:

> Drones are *male* honey bees which are the product of an unfertilized egg. Unlike the female worker bee, drones do not have stingers and do not participate in nectar and pollen gathering. A drones' primary role is to mate with a fertile queen.[46]

They are endowed with huge eyes, "twice the size of those of worker bees and queens,"[47] and they possess an oversized abdomen. Furthermore, "drones must be able to fly fast enough to accompany the queen in flight."[48] In addition to their striking optical and powerful physical capacities, drones are also extraordinary genitors, since they have a double reproductive function: "They convert and extend the queen's single unfertilized egg into about 10 million genetically identical male sperm cells. Secondly, they serve as a vehicle to mate with a new queen to fertilize her eggs."[49] After carrying out these services, the drones will just die or, according to Mark L. Winston: "Mating occurs in flight, which accounts for the need of the drones for better vision, which is provided by their large eyes. Should a drone succeed in mating he soon dies."[50]

This sheds some light on Jünger's fascination with insects and distant vision. Or, as Werber convincingly argued, it is not too farfetched to see the connection between the animal drone and today's military drone or unmanned aerial vehicle (UAV).[51] In fact, contemporary entomologists such as Bert Hölldobler and Edward O. Wilson regard drones as a sort of flying weapon. In their book *Journey to the Ants* they state: "Males [. . .] are drones in the modern technological sense, flying sperm-bearing missiles constructed only for the instant of contact and ejaculation."[52] Certainly a sentence like "'Drones are homing in on the target" can simultaneously describe male bees as well as UAVs.[53] Both drones share the same mode of vision: no lingering centralized view from above but a facetted and centerless view.

The engineers who build artificial drones are obviously using the entomologists' knowledge of the well organized and disciplined life of bees and ants, including their division of labor, specialization, organization, and communication. The algorithms on which the functions of military drones rely, were actually derived from the entomology of bees, especially from the preoccupation with what has become known as swarm intelligence.

It would go beyond the scope of this chapter to discuss in detail how algorithms work or function. Instead, I would like to highlight this link between organic living matter, the drone bee, and the technical weapon, the military drone. In a way, both of them are used as a sort of device either to create new life or to take existing lives—both in order to preserve or extend their own genetic material. From an evolutionary biological standpoint, the male bee is a "gene machine" whose only job is to transfer genetic material. This function is comparable to that of "drones in the modern technological sense," which are directed by a "selfish gene (Richard Dawkins)" that compels them to protect, defend, and preserve their own nation.[54]

Jünger, of course, did not foresee the military drone used today in Afghanistan or Pakistan, but he was fascinated with machine-like beings such as glass bees, described in his science fiction novel of the same name *The Glass Bees (Gläserne Bienen*, 1957). The novel's protagonist is stunned by the machine-like creatures' well-coordinated and exact movement, and he muses about a possible central command center behind

their precise executions. And he is fully aware of the awesome power condensed in the bee swarm. Soon he will experience the following: If the glass bees are attacked, they produce a sperm-like fluid or deadly poison while shattering into thousands of shards of glass. In a comparable mode, the latest generation of UAVs consists of a multitude of small drones that build a swarm capable of performing effective self-control, described in one aerospace publication as "effective swarm attack and defense."[55] It is important to remember in this context that Jünger's "construct of the body [. . .] aimed to isolate the bodily modes."[56] Jünger, in his later works, treated the body as "the compliant means of presentation. As stuff and medium, it means that from which intelligible content can emancipate itself."[57] Like Jünger's artificial glass bees, the modern military drone then, in contrast to World War I weapons, is unmanned, and controlled by remote and distant manpower. No real bodies are "deployed and sacrificed in battle" any longer— at least not on the drone owner's side. The process of distancing from the living target, and thus the process of objectifying pain, empathy, or moral responsibility has reached a point where even remote manpower will soon be replaced by technical power.

Conclusion

The contexts in which I examined the visualization of warfare in this contribution were the following. During the interwar period, intellectuals, artists, and writers evidenced a deep-rooted longing for increased intensity of perception and emotional life. At the same time, they were confronted with overwhelming images of war, shell shock, and war trauma at a time already characterized by the ever-increasing complexity and invisibility of things. The cultural crisis caused by the physical, psychological, and social consequences of World War I, as well as industrial modernity, was also a male crisis. Featuring wide discussions of new issues, e.g. on gender equality or on human perception, the crisis led to increased reflection on virility, masculinity, and the nature of and appropriate response to human perception and emotions. On the one hand, an obsession with organic matter and with the giving or taking of life can be discerned. On the other hand, there was a strong urge to overcome emotions such as mourning, and to acquire emotional detachment or coolness (e.g. by converting one's own mind into a command center, permitting, not a panoramic view, but rather, a precisely targeted and distant view).

I conclude by returning to the questions posed at the beginning of this chapter. We should be careful to use the word 'coolness' in the context of creativity during the interwar period, but rather speak of creating a *protective shield* that provides for emotional detachment in order to save the human mind from shock or trauma of war images. The individual who wants to 'stay cool,' saving himself from being overwhelmed by too many different feelings and thoughts is nonetheless still swamped with emotions even if they remain hidden. The act of visualization, or creation, as a mode of, or even a guide to cool behavior in Lethen's sense, then, is complex. It should always be differentiated since there are also emotions that could threaten or heat up the mind, soul, and body of the individual; and these emotions are the reason for the modern male subject's construction of a "cool armor," a sort of protective shield, allowing him to remain an autonomous and self-controlled subject, a cool, virile man in the traditional sense, who has to survive somehow in a modernized world.[58] We must also differentiate between visualization of war after a successful

mourning process and, on the other hand, an unsuccessful mourning or unmourning. That is, either working through all the sad and angry emotions on the one hand (as is probable in Beckmann's case) or, on the other hand, the visualization as an act of optical and at the same time emotional distancing or emotional detachment (for Jünger), which would instead indicate an unsuccessful mourning.

Notes

1 The context of these observations is described in depth in Christine Kanz, *Maternale Moderne: Männliche Gebärphantasien zwischen Kultur und Wissenschaft 1890–1933* (München: Fink, 2009).

2 See Mathilde Beckmann, *Mein Leben mit Max Beckmann*, trans. Doris Schmidt (München: Piper, 1983), 18ff. At the end of 2014, news circulated through various media channels that several important works by Beckmann had been discovered in the Munich flat of art collector Cornelius Gurlitt. Since then they have been the subject of intense scrutiny both by the German police and art historians inquiring about their provenance and sale during the Nazi period.

3 See Roberto Zapperi, *Der schwangere Mann: Männer, Frauen und die Macht*, trans. Ingeborg Walter (München: Beck, 1984), 11.

4 See Laurence A. Rickels, *Aberrations of Mourning: Writing on German Crypts* (Detroit: Wayne State University, 1988).

5 Beckmann, *Mein Leben mit Max Beckmann*, 40.

6 I borrow this notion of psychic pregnancy from Rickel's following note in the English version of his book on mourning: "In 1914 an Expressionist painter could confide to his diary that he had long carried this war inside him, such that inwardly it was no concern of his" (Rickels, *Aberrations of Mourning*, 326).

7 See Max Beckmann, "Vielleicht doch ein Programm. Beitrag im Faltblatt zur Ausstellung im Kunstverein Hamburg, Februar 1914." In Max Beckmann, *Die Realität der Träume in Bildern. Schriften und Gespräche 1911 bis 1950*, edited by Rudolf Pillep (München: Piper, 1990), 16.

8 See Beckmann, *Max Beckmann: Leben und Werk*, 113f.

9 Thus Max Beckmann, who before the war was a highly successful portrait painter working in a conventional idiom, turned to Expressionism only in the midst of this pile up of corpses in place of combat. In 1914 an Expressionist painter could confide to his diary that he had long carried this war inside him, such that "inwardly it was no concern of his."

(In Rickels, *Aberrations of Mourning*, 326)

10 Peter Beckmann, "Nachwort" in Max Beckmann, *Briefe im Kriege* (Berlin: Cassirer, 1916), 73–74.

11 Ernst Simmel, *Kriegs-Neurosen und Psychisches Trauma: Ihre gegenseitigen Beziehungen dargestellt auf Grund psychoanalytischer, hypnotischer Studien* (München: Otto Nemmich, 1918).

12 Simmel, *Kriegs-Neurosen*, 83.

13 Rickels, *Aberrations of Mourning*, 22.

14 Max Beckmann, "Letter from 21 April 1915," in *Briefe im Kriege*, 46.

15 Beckmann, "Letter from 21 April 1915," in *Briefe im Kriege*, 46.

16 Beckmann, "Letter from 18 April 1915," in *Briefe im Kriege*, 43.

17 Beckmann, "Letter from 28 April 1915," in *Briefe im Kriege*, 49f.

18 See Freud's explanation regarding the traumatic neurosis experienced by many after World War I. He sees this as a consequence of the destruction of the protective shield ("äußere[n] Reizschutz[es]") due to the threatening and overwhelming incidents on the battlefield. In Sigmund Freud, "Hemmung, Symptom und Angst," *Studienausgabe*, vol. 6, edited by Alexander Mitscherlich, Angela Richards, and James Strachey (Frankfurt am Main: Fischer, 1969–1975), 272.

19 Beckmann, "Letter from 27 April 1915," in *Briefe im Kriege*, 50.

20 See Freud, "Hemmung, Symptom und Angst," 271.
21 "Das Sehen ist [. . .] ein Angriffsakt." Ernst Jünger, "Über den Schmerz" in *Sämtliche Werke*, vol. 7 (Stuttgart: Klett-Cotta, 1980), 182.
22 Derek Hillard, "Ernst Jünger's Literature of Pain, or the Troubles of Detaching the Mind from Feeling." *Monatshefte* 106, (2014): 54–72, 62.
23 Hillard, "Ernst Jünger's Literature of Pain," 62.
24 Ibid.
25 Ibid.
26 Ibid.
27 Helmut Lethen, *Verhaltenslehren der Kälte: Lebensversuche zwischen den Kriegen* (Frankfurt am Main: Suhrkamp, 1994), 43.
28 Hillard, "Ernst Jünger's Literature of Pain," 62.
29 Compare the following passages with Kanz, *Maternale Moderne*, 363.
30 See Claudia Öhlschläger, *Abstraktionsdrang: Wilhelm Worringer und der Geist der Moderne*. (München: Fink, 2005), 202.
31 See Öhlschläger, *Abstraktionsdrang*, 176.
32 Jünger, "Über den Schmerz," 146.
33 Hillard, "Ernst Jünger's Literature of Pain," 63.
34 Ibid., 63.
35 Ibid., 63.
36 See Kanz, *Maternale Moderne*, 364, footnote 26.
37 Niels Werber, "Jüngers Bienen," *Zeitschrift für deutsche Philologie* 130 (2011): 245.
38 Ibid.
39 Ibid.
40 Ibid., 256.
41 Ibid., 256.
42 Ernst Jünger, *Heliopolis: Rückblick auf eine Stadt* (Tübingen: Heliopolis Verlag, 1949), 247.
43 See Jünger, *Heliopolis*, 247.
44 Ibid., 248.
45 Ibid., 249.
46 Drone (bee), accessed October 9, 2016, https://en.wikipedia.org/wiki/Drone (bee).
47 Ibid.
48 Ibid.
49 Ibid.
50 Mark L. Winston, *The Biology of the Honey Bee* (Cambridge: Harvard University Press, 1991), 41.
51 See also Niels Werber, "Drohnen," *POP. Kultur und Kritik* 4 (2014): 20. Translations are mine.
52 Bert Hölldobler and Edward O. Wilson, *Journey to the Ants*, cited in Werber, "Drohnen," 20.
53 Werber, "Drohnen," 20.
54 Ibid.
55 *Aviation Weekly & Space Technology*, June 8, 2012, cited in Werber, "Drohnen," 20–21.
56 Hillard, "Ernst Jünger's Literature of Pain," 65.
57 Ibid.
58 Lethen's arguments are based on Helmuth Plessner's book *Grenzen der Gemeinschaft: Eine Kritik des sozialen Radikalismus* from 1924. Plessner was positive regarding "cool" aspects such as anonymity, distraction, or mobility, defining them as part of modern possibilities of self-realization. See Lethen, *Verhaltenslehre der Kälte*, 8.

Bibliography

Beckmann, Mathilde. *Mein Leben mit Max Beckmann*. Translated by Doris Schmidt. München: Piper, 1983.
Beckmann, Max. *Briefe im Kriege*. Berlin: Cassirer, 1916.
——. *Die Realität der Träume in Bildern. Schriften und Gespräche 1911 bis 1950*. Edited by Rudolf Pillep. München: Piper, 1990.

Drone (Bee), https://en.wikipedia.org/wiki/Drone_(bee) (accessed October 9, 2016).

Freud, Sigmund. "Hemmung, Symptom und Angst." In *Studienausgabe*, vol. 6., edited by Alexander Mitscherlich, Angela Richards, and James Strachey, 227–308. Frankfurt a. M.: Fischer, 1969–1975.

Hillard, Derek. "Ernst Jünger's Literature of Pain, or the Troubles of Detaching the Mind from Feeling." *Monatshefte* 106 (2014): 54–72.

Jünger, Ernst. *Heliopolis: Rückblick auf eine Stadt*. Tübingen: Heliopolis Verlag, 1949.

——. "Über den Schmerz." In *Sämtliche Werke*, vol. 7, 143–191. Stuttgart: Klett-Cotta, 1980.

——. *Gläserne Bienen*. Stuttgart: Klett-Cotta, 1990.

Kanz, Christine. *Maternale Moderne: Männliche Gebärphantasien zwischen Kultur und Wissenschaft (1890–1933)*. München: Fink, 2009.

Lethen, Helmut. *Verhaltenslehren der Kälte: Lebensversuche zwischen den Kriegen*. Frankfurt am Main: Suhrkamp, 1994.

Öhlschläger, Claudia. *Abstraktionsdrang: Wilhelm Worringer und der Geist der Moderne*. München: Fink, 2005.

Rickels, Laurence A. *Aberrations of Mourning: Writing on German Crypts*. Detroit: Wayne State University Press, 1988.

Simmel, Ernst: *Kriegs-Neurosen und Psychisches Trauma: Ihre gegenseitigen Beziehungen dargestellt aufgrund psychoanalytischer, hypnotischer Studien*. München: Otto Nemmich, 1918.

Werber, Niels. "Jüngers Bienen." *Zeitschrift für deutsche Philologie* 130 (2011): 245–260.

——. "Drohnen." *POP. Kultur und Kritik* 4 (2014): 19–23.

Winston, Mark. *The Biology of the Honey Bee*. Cambridge, MA: Harvard University Press, 1991.

Zapperi, Roberto. *Der schwangere Mann: Männer, Frauen und die Macht*. Translated by Ingeborg Walter. München: Beck, 1984.

Part II

Emotional Technologies

4 Flat Emotions

Maps and Wargames as Emotional Technologies

Anders Engberg-Pedersen

Introduction

In 1824, the Prussian Lieutenant Georg Heinrich Rudolf Johann Freiheer von Reiswitz was summoned by Prince Wilhelm, then commanding general of the Third Battalion in the Prussian army. The prince had heard of a new "Kriegs-Spiel"—a wargame originally invented by Reiswitz's father. Reiswitz junior had since worked to improve the game and now the prince wanted a demonstration of the device. Intrigued by the game and convinced of its usefulness, Prince Wilhelm promised to recommend it to the King as well as to the Head of the General Staff, General Müffling. And, indeed, a few days later, Reiswitz was ordered to military headquarters. This time, however, the immediate reception was somewhat cool. Surrounded by the officers of the general staff, Müffling declared: "'Gentleman, Herr Lieutenant Reiswitz wants to show us something new.'"[1] Lieutenant Dannhauer, Reiswitz's friend who relates the story, writes that the inventor "was undeterred by the somewhat chilly reception" and proceeded to place a topographical map on the table. Somewhat baffled by the presence of a map, Müffling exclaimed: "'Your game is played on an actual military map and not on a chessboard?'"[2] Reiswitz set up the game and, with everything in place, two officers were chosen to play against one another and the game began. Less interested in the events of the game, however, Dannhauer instead turned his attention to General Müffling. For as the game develops, he undergoes a noticeable transformation. Dannhauer writes:

> It's fair to say that the old Herr, who had been so cold at the beginning, grew warmer and warmer with each move as the maneuver developed, and in the end exclaimed enthusiastically: "That is no ordinary game, that is a war school. I must and will give it my warmest recommendation to the army."[3]

The scene has now become established as a key moment in the history of warfare and media.[4] The genealogy of wargames is usually traced back to a 50-year period from 1780 to 1830, and for media studies Dannhauer's account stands out prominently because it offers an evocative description of a novel technology and its adoption by the military. The topographical map that Reiswitz, Dannhauer, Müffling, and the other officers of General Staff were poring over during the demonstration and the pieces they could manipulate and move across its surface served as useful tools to train officers

in the art of war. Playing Reiswitz's *Kriegs-Spiel* along with those of numerous other inventors, they could practice the complex skill of moving their corps across an actual terrain at both a tactical and a strategic scale. The games of the period therefore form a natural starting point for a history of the increasingly intricate simulations of the world at war: of the reach of weapons, of the affordances and limitations of the terrain, of the entire operative logic of warfare. In this history, the primary concern has been to chart the development of the relation between the simulation and actual warfare. Which changes were introduced to minimize the difference between the board and the terrain? When did the figures lose their likeness to those of chess? How might the pervasive uncertainties of war be modeled by the introduction of dice and what are the effects of contingency for the calculations and decisions that are part and parcel of the management of large-scale war? Examining all these parts of the device, media historians have traced the stages and developments of a technology designed to help individuals control and manage warfare by way of operations on a map.

Yet, Dannhauer's narrative also marks the origin of a different history. Turning away from the procedures on the map, he begins to describe the transformation in Müffling's reaction to the game and correlates the two directly. From his initial chilly reception of Reiswitz, Müffling is heated up with every new move the officers make on the map in front of him and in the end, seemingly as a consequence of the heat it has generated, he offers his warmest recommendation of the game. While the two officers playing the game were operating on the map, the map itself performed some kind of operation on Müffling.

In this chapter I would like to follow Dannhauer's gaze and redirect our eyes from the map to its users. Instead of considering the referential links that connect the map to the territory, game maneuvers to military operations, and the changing nature of these referential links, I suggest that we look in the other direction: what do maps and games do to the emotional state of the players? Which operations do they perform on the people who use them? Over and above their role as tools for the management of military events out in the world, I examine the ways in which military maps and wargames function as emotional technologies. Inviting players to project themselves into the representation, the map in the Prussian *Kriegsspiel* constructs a simulation that transforms passive spectators into active agents and allows them to live vicariously a life of passions and emotions across the flatness of its surface. Evoking a range of emotional states and intensities from boredom and fatigue to tension, frustration, excitement, and fear, the wargame served both as a tool to generate an emotional investment in order to secure an unflagging interest in its pedagogical lessons, as well as a means to manage and train the emotions for the actual experience on the battlefield.[5] Sketching the beginnings of a history of wargame emotions, the chapter examines the early dialectic between rational strategizing and emotional investment and between education and entertainment that also structure contemporary virtual reality training scenarios. It thereby seeks to complement the widespread understanding of the wargame as a tool of reason. Situating the invention of the wargame in its cartographic context, I first show how this understanding relies on a set of assumptions about the nature of the military map that the widespread mapping endeavors around 1800 brought to the fore. Against this background I then consider the wargame as an emotional technology by examining the contextual traces in documents that evince the guiding intentions behind the games as well as the actual praxis of playing them.

The Metapicture of Military Maps

That Reiswitz in 1824 placed a topographical map on the table and not an isomorphic chessboard comes as no surprise if we consider the mapping enterprise during and following the Napoleonic Wars. While cartography and war have long been associated and Machiavelli in his treatise *Art of War* from 1521 recommends maps as an aid to the commander, it is not until 1800 that military cartography became an indispensable tool of war. The new mobile large-scale warfare of the Napoleonic period required spatial knowledge of a heretofore unseen kind and led to the founding of cartographic bureaus across Europe. As Max Eckert wrote in his now classic study on the history of cartography: "Around 1800, the cartographic revolution begins."[6] A key figure in this revolution was Napoleon himself. Constantly in need of new maps for his conquests, his military efforts spurred the procurement and production of ever more cartographic material. In Paris, he commissioned maps from the central map institution, the *Dépôt de la guerre*, and in several of his various residencies he furnished map rooms in which he could plan his campaigns.[7] When he was in the field his waggon was transformed into a mobile office stuffed with the topographical material available, so he would have the requisite maps at his fingertips at all times.[8] The character of these maps can be seen in the sheet from the *Topographical Survey of the Rhineland under Tranchot and von Müffling* below (Figure 4.1).

The importance of the military topographical map around 1800 as well as their entry into the larger social imaginary can be gleaned from contemporary depictions of Napoleon. Whether in foreign satirical drawings or in the official propaganda of imperial glory, innumerable illustrations of the period depict Napoleon poring over a military map (Figure 4.2). Such depictions not only reveal the ubiquity of the military map during the Napoleonic Wars, they also reinforce a certain picture *of* military cartography. In these illustrations of maps, the referential function yields to their symbolic function. More than the graphical rendering of the topography of a given territory, the paintings, engravings, and illustrations of Napoleon with his graphical, military paraphernalia transformed the military map into an emblem of military might, at once the instrument and visual manifestation of imperial power.

As second-order representations the illustrations of maps helped construct a certain picture of cartography. Given the ubiquity of the link between Napoleon and maps, we might say that such map images establish a 'metapicture' of military cartography. In *Picture Theory* W.J.T. Mitchell has defined metapictures as "pictures of pictures," i.e. self-reflexive pictures that interrogate their own status *as* pictures. A variation of this understanding can be found in his more recent *Cloning Terror*, in which a metapicture is conceived as a "master metaphor . . . of image-making itself."[9] In the present context, we might fruitfully extend this notion beyond the problem of self-questioning reflexivity. While map illustrations of the period do depict another representation (the map) and thereby at least implicitly raise the question of their relation to one another, it is not only the reflexive conception of metapictures that concerns me here. As Wittgenstein reminds us, representations, whether linguistic or visual, can construct mental pictures that capture our imagination and stake out the limits of how we think about a given phenomenon.[10] As medial metapictures, the illustrations of maps also construct a mental metapicture, a frame and set of assumptions about what maps are and what they do. Once inside another representation, the military map loses its actual function and gains a purely symbolic status that concerns the general nature of

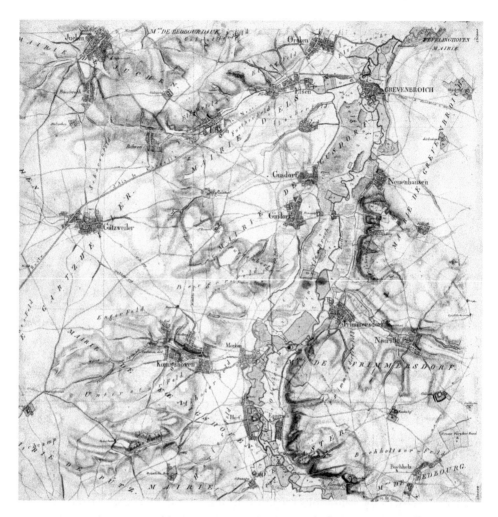

Figure 4.1 In 1801 Napoleon commanded one of the topographers from the *Dépôt de la guerre*, Jean Joseph Tranchot, to map the Rhineland at a scale useful for military operations. In the same period, Freiherr von Müffling, who would later be so impressed with the merger of topographical maps and the wargame, himself carried out trigonometric surveys and acquired Tranchot's unfinished maps after the Treaty of Paris of 1815. Under his tutelage the mapping enterprise continued and reached completion in 1828 with a map series of 264 individual sheets at a scale of 1/20.000.

Source: *Topographic Survey of the Rhineland by Tranchot and von Müffling 1801–1828*, sheet 59, Grevenbroich.

military maps as such. When we look at illustrations of military maps and consider the context in which they appear, what then are the powers and virtues they ascribe to the map?

The image in Antoine-Vincent Arnault's account of Napoleon's political and military life is particularly illustrative because of its setting. Imprisoned, the future emperor is seemingly denied all the opportunities he will need to ascend the throne.

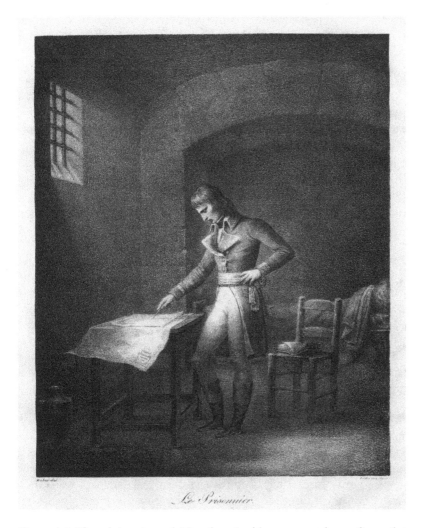

Le Prisonnier

Figure 4.2 Though imprisoned, Napoleon is able to escape the confines of time and space
with the aid of the map on which he plans his future campaign in Lombardy.
Leaving out all topographical details, the engraving transforms the map into
a metapicture of its basic functions: the visibility, comprehensibility, and
manageability of warfare.

Source: "Le Prisonnier" in Arnault, A.V. *Vie politique et militaire de Napoléon*, vol. 1. Paris: Chez Émile
Babeuf, 1822. Staatsbibliothek zu Berlin.

His gaze blocked by the thick prison walls, he has no knowledge of what goes on
beyond them, and the small cell deprives him of agency on the world stage. And
yet, the map precisely offers a surrogate that compensates for all three. The map
in the engraving holds out an implicit promise of visibility, comprehensibility, and
manageability. A promise the accompanying text merely replicates. Temporarily
imprisoned on the suspicion of being a supporter of Robespierre, Arnault tells us,
Napoleon plans the invasion of Italy:

> Never one to despair, Bonaparte, far from renouncing his system spent his time in prison perfectioning his military campaign. His eyes glued to a map, he descended in his imagination on this beautiful Lombardy, which he would soon conquer in reality.[11]

The text highlights the degree to which the map becomes synonymous with the triad of seeing, understanding, and planning. Reduced to his eyes, Napoleon is virtually transported to Lombardy where he surveys the territory, applies his system of thought, and plans his military campaign. The engraving, however, blurs the concrete topographical and contextual details and reveals only that Napoleon is looking at a map of Italy. Eliminating the specifics, it transforms the map into a metapicture of its basic functions. The painted map becomes the graphic representation not of Lombardy, but of the visibility, comprehensibility, and manageability of warfare.[12]

This metapicture of cartography was not entirely new. Non-military cartography had long been associated with control and calculated planning. As instruments of governance, maps had been used for a range of strategic purposes from taxation to disease management to city development.[13] Nor was the metapicture uncontested. In the past decades several historians of cartography have done much to debunk the conception of cartography as an accurate science, but even at the time military thinkers and topographers voiced critiques of the accuracy, usefulness, and power of the military map.[14] Carl von Clausewitz, for one, thought that while maps were useful and indispensable for the military commander, they did not capture the fundamental complexity of warfare. The uncertainty of intelligence, the impact of unforeseen events, and the scale of military operations made warfare into a phenomenon that evaded the government of maps—a point the Russian painter Vasily Vasilyevich Vereshchagin later illustrated well in his painting of Napoleon at Gorodnya during his disastrous retreat from Moscow 1812 (Figure 4.3).

Moreover, empirical reality could rarely live up to the ideality of the metapicture. In spite of the development of triangulation during the Enlightenment, the formalization of cartographic language in France in 1803, and the boost in resources for the development of military cartography across Europe during and after the wars, actual maps were often very poor, inaccurate, not based on precise geodetic measurements, or simply lacking entirely. As the Director of the *Dépôt de la guerre*, General Calon, put it, "the majority of the maps we have conquered and collected from foreign nations are highly flawed because they have been made only through approximation or from more or less reliable memoirs."[15] Nevertheless, Napoleon's obsession with the map, the competing mapping enterprises his own endeavors spurred across Europe, and the subsequent representations in paintings and engravings crystallized, propagated, and popularized this metapicture of military cartography. In spite of its practical difficulties and actual shortcomings, the war map suggested that by offering a view of the world it made future military battles and campaigns comprehensible and enabled their planning and implementation.

Reiswitz's choice of the topographical map as playing board therefore points to the wargame's *raison d'être*. The complex military calculus in the form of devising tactical plans, carrying out operative maneuvers, and managing contingencies and chance events could now be taught and trained in advance. From this point of view, the invention of the modern wargame marks a significant point in the rationalization of war. In the idiom of Charles Sanders Peirce wargames are often described as tools for abductive reasoning.[16] Wargames, in other words, seek to temper the violence and

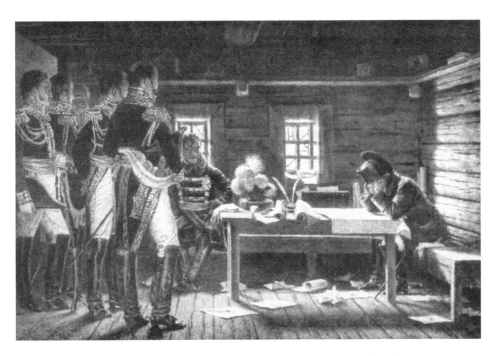

Figure 4.3 At the center of Napoleon's war council, the map seems to have lost its power as a tool to manage war and now displays only the lack of options available and the failure of the entire campaign.

Source: Vasily Vasilyevich Vereshchagin. "In Gorodna. To Break Through or To Retreat." 1887–1895.

chaos of war with their dice, grids, and rulesbooks and thereby transform warfare into a rational endeavor subject to simulation, planning, testing, and control—and all on the flat surface of the map. In his preface to the first of these games, Johann Christian Ludwig Hellwig's *Attempt at a Tactical Game Based on Chess to Be Played by Two or More Persons* (*Versuch eines aufs Schachspiel gebaueten taktischen Spiels von zwey und mehreren Personen zu Spielen*), Hellwig presented his invention as a training device meant to "visualize the principal and most important events in war" such that "the young warrior" will have a "tool with which he will be brought closer to his vocation."[17] To penetrate the secrets of military science one had to work through a hefty rulebook of almost 200 pages.

At the turn of the century the inventor Georg Venturini further emphasized the enlightened rationality of the simulations when he reflected on the wargame and its visualization of the scientific principles of war:

> In 1797 I published a small book on a *new wargame* I had invented. I had worked on its development without interruption for four years because of my conviction that only *such* an instrument could most easily enlighten the novice and his otherwise so convoluted and chaotic ideas of the operational science [*Feldherrnwissenschaft*] about the development, the coherence, the onset and effect of large operations. This conviction has been strengthened repeatedly through experience.[18]

As these two samples show, the wargame follows the parameters staked out by the metapicture of the war map, and its history has also been written as the development of increasingly sophisticated inventions by which inventors have sought to rationalize warfare with technology.[19] "Wargames are," as a recent book states, "ordered and rationalized spaces, wherein rules and procedure—sculpted out of algorithmic steps and probabilistic curves—reign supreme."[20] As tools of reason, both the tactical and the ludic map seek to impose an order on a notoriously elusive phenomenon in order to obtain some measure of control.

Emotional Technologies

Whatever the success of such attempts, the focus on the link between rationality and maps has come at the expense of a consideration of the emotional valences of military cartography.[21] Symbolic tools of navigation and long-distance management, military maps, and their graticules seem to block out any kind of emotional investment. Indeed, in the metapicture of military cartography the mathematical basis that grounds its scientific validity appears to rely on an exclusion of any affect that might contaminate the logic of its operations. A noteworthy example of the separation of military maps and emotions can be found in a passage from Ernst Jünger's *Storms of Steal* (*In Stahlgewittern*). Debriefed by a superior officer after a dangerous mission into the enemy trenches during World War I, Jünger writes:

> The General Staff Officer of the division received me in his office. He was quite liverish and I noticed to my annoyance that he tried to hold me responsible for the outcome of the mission. When he put his finger on the map and asked questions such as "Why did you not turn right in this trench?" I realized that a jumble in which concepts such as right and left no longer exist was beyond him. For him everything was a map, for us it was a passionate experience of reality.[22]

Separating the passionate reality of war Jünger had himself experienced in the field from the cool, disembodied cartographic gaze he is presented with in the office of his superior officer, Jünger reinforces the metapicture of the military map as an objective, rational object whose emotional valences are as flat as the map itself. The map may accurately depict the terrain he traversed, but the emotions through which his experience and spatial orientation were filtered are a terra incognita beyond representation.

In spite of the sharp distinction, however, emotions are not entirely absent from the scene. Not only is the superior officer "liverish," when he taps the map and seeks to blame Jünger for the unhappy outcome of the mission, Jünger is engaged emotionally. Where Müffling became increasingly enthused with Reiswitz's wargame as it progressed, Jünger is annoyed by the officer's failure to distinguish between the order of the map and the situated experience of trench warfare. As Jünger's and Dannhauer's accounts suggest, maps and wargames are not simply tools of reason, objects on which officers can perform operations to test their strategy. They are themselves agents that perform operations on their users interpellating them and evoking a range of emotions. But to notice these emotions, to complement the metapicture of the military map and see that the map also functions as an emotional technology, we need to zoom out from the map and pay attention to the context in which the map appears. In other words, the map does not end at the borders of its physical dimensions. In a tentative

but accurate definition by Christian Jacob: "A map is defined perhaps less by formal traits than by the particular conditions of its production and reception, and by its status as an artifact and as a mediation in a process of social communication."[23] Almost in spite of themselves, the two scenes above reveal map effects that arise only when they include the users in the loop and enter a process of communication. Severed from the human beings and practical engagements that surround them, war maps might easily pass for the objects of reason that their totalizing, disembodied gaze suggests, but this reductive approach obscures what is just as important: what maps do.

Speaking not of maps, but of images in general, Hans Belting has bemoaned that

> in dealing with technological images, it is still customary to concentrate on the technology, on the methods by which they are produced, rather than on the relationship between the medium and the beholder and his [or her] experience of a new kind of image.[24]

Belting argues instead for an "anthropology of images" that supplements the analysis of the technological object itself with "the way it is put to use by a culture."[25] A similar approach might offer a new perspective on military maps and wargames. For far from barring emotions, military maps invite projection and immersion, and while virtually immersed its users experience a range of emotional states. Since the map does not contain any emotion but serves as a catalyst for them, we must attend to the contextual documents and representations for clues about how the maps were used, which pedagogical intentions guided the design of wargames, and how the players responded to them.

The Vehicle of Learning

Since the invention of the modern wargame, their design has been structured by a dialectic of entertainment and education. As Hellwig explains in his preface, the game should train the officer in the art of war, but at the same time it should do so in an entertaining fashion.[26] Striking the balance between realism and gameplay, however, was not an easy task. The more closely the game approximated the phenomenon it simulated, the greater the number of rules and instructions and the greater the tedium of playing. To distinguish himself from "the large heap of mindless, miserable, and harmful" games on the market, Hellwig went for realism, but he understood that the intricacies of his game meant that only those with sufficient "patience and skill" would make their way through the rule book.[27] Johann Allgaier, who published his own, simpler wargame in 1796, commended Hellwig for creating "a true imitation of war," yet "by imitating everything in too great detail and representing visually everything that takes place in war, he precisely made the game exasperating and off-putting for all."[28] Rectifying these errors, Allgaier simplified the game and thereby transformed the emotions it elicited. Now the potential buyer could play a game that was "easy, quick, and entertaining."[29]

While the inventors noted the tension between gameplay and realism, between the entertainment value of a mere game and the seriousness of its purpose, the emotional effect it generated was regarded as a key element in the learning process. For Georg Venturini, mentioned earlier, the objective was clear: to teach young officers the operational science. But he worried that the two traditional fields of military

science—the study of history and the study of geography—would deter potential students: "As significant and important as these two sciences are, I am nevertheless convinced that already their large, encyclopaedic names will discourage many from the zealous study of the science of war." With his wargame Venturini therefore sought to lure the novice into the study of war "under the attractive guise of a game" in order to "generate more interest in its more difficult parts."[30]

The Bavarian lieutenant, Wilhelm Freiherr von Aretin, who published yet another wargame in 1830, was of a similar opinion. In his *Strategonon: Attempt to Visualize the Conduct of War in a Game* (*Strategonon: Versuch, die Kriegführung durch ein Spiel anschaulich darzustellen*), he recommends that the traditional medium for the teaching of military science—the text—be exchanged for the new one—the game. For Aretin, the most efficient pedagogical praxis does not consist in,

> long, tiresome, half-understood lectures you try to have the students memorize and that are soon forgotten; rather, you should show and teach them the rules of warfare in an entertaining and vivid manner. This sharpens their mind incomparably more and gives them pleasure at the same time. Playing, they thereby learn everything and understand the content of the lecture much more easily once it has been elucidated in this manner, compared to if they had to leaf through books for hours on end and really had to make an effort to grasp what their teacher was saying.[31]

The boredom, complexity, and opacity of books gives way to the fascination, the transparency, and the immediacy of the game. Visualizing the operative logic of war, wargames generate emotions that tether the attention of the players to the board and keep them immersed in the learning activity. The emotions function simply as a catalyst, but a catalyst necessary for the process of learning. While Venturini would become increasingly wary of the associations surrounding the latter, ludic part of the term 'wargame' given their potential as serious instruments of military training, the emotional effects of playing were central to their pedagogical efficacy.[32] Once equipped with a wargame, this was the claim, the science of war became child's play—as easy and as fun.

Training Emotions

It was one thing for the war map to evoke emotions, but was it possible to train them? Might the topographical map or the pieces and rules that complement it in the wargame operate on the emotions just as they were intended to operate on the rational, calculating mind of the player? For some, the answer was no. In 1825, Ludwig Freiherr von Welden, then a colonel in the Austrian army and former director of its topographical bureau, published his *Essay on the Production and Use of Maps for the Practical Elucidation of Various Theories of the Art of War* (*Entwurf für die Verfertigung und Benützung der Plane zur praktischen Erläuterung mehrerer Theorien der Kriegskunst*). As the title indicates, von Welden advocated the use of topographical maps and drawings to visualize and test basic tenets of contemporary military theory. Overlaying the accompanying maps with a grid, the readers might themselves construct a simple "game space" for this purpose.[33] For von Welden, however, only a part of the elements of war are subject to calculation:

Since we do not consider the moral forces because they are not subject to calculation, then we will first treat the main part of the higher theory of warfare, which consists in the ability to bring together the majority of the physical forces at the decisive point.[34]

Welden's exclusion of all moral (psychological) forces from the military calculus, however, goes against the trend. The period around 1800 saw the development of a discourse within military theory on the central role of the emotions. These ideas find their most influential articulation in Clausewitz's *On War* (*Vom Kriege*).[35] In his famous trinity, a "blind natural drive" that manifests itself in the form of "hatred and enmity" ranges alongside chance and politics when he sums up the fundamental nature of warfare. For a full anthropological theory of war, Clausewitz states, the *emotions* are just as important as are the *imagination* in dealing with chance and the *understanding* in negotiating the relationship between war and politics.[36] Traditionally military theory has ignored them because of their elusive nature, but Clausewitz is quite explicit about their importance:

> Should theory abandon him [the soldier] here and complacently move ahead with absolute arguments and rules? Then it is useless for life. Theory must also take the human element into consideration and grant courage, audacity, even temerity their place. The art of war has to do with living and moral forces.[37]

Clausewitz's theory of war therefore includes extensive discussions of the role of emotions such as courage and fear, as well as basic character traits such as melancholia, determination, and perseverence.[38] On the battlefield, the dangers and myriad impressions that impact the sensory apparatus of the soldier will give rise to emotions of such intensity that they might easily overpower all cognitive abilities. Two kinds of courage are therefore necessary. On the one hand, the courage not to be overwhelmed by personal danger, and on the other, "the courage to calculate with uncertainties" and to act on imperfect knowledge.[39] At once a potential liability and a potential bulwark against the violent impressions and the pervasive uncertainty of military action, the emotions ought to form the bedrock of any theory that claims to address war as it unfolds in practice and not just as it is imagined by the strategist on the drawing board. Thus, as Clausewitz writes elsewhere, the "courage of despair is just as much an object of the military calculus as is any other variable," and "whoever does not want to calculate with all these things, will never be a good general."[40]

Given the prominent role of the psychological and emotional aspects of war in the military theory of the time, might they be trained with symbolic means far from the battlefield in the safety of one's study? Clausewitz appears to have been wary of wargames because they focused on the material and not the moral forces of war.[41] Like his contemporaries General Scharnhorst and Otto August Rühle von Lilienstern he instead believed in the power of texts. Whether historical or fictional, texts, he claimed, offer the kind of simulated experience and "living representation"[42] that might prepare the soldier's psychological state and inoculate it against the dangers and violent impressions of actual warfare.

Yet, at least two contemporary inventors claimed that the wargame had a similar function. One of them, Johann Ferdinand Opiz, is an important figure in that he is

the first to introduce contingency into the wargame. He included dice and thereby allowed the officers to train in an epistemic environment that approximated the state of knowledge in war much more closely than any previous wargame. But thereby the game also trained the second kind of courage that Clausewitz would later describe in *On War*—the courage to act in such a deficient epistemic environment. In an encomium that precedes the explanation of the rules, an officer who has played the game praises the fact that you cannot always rely on your knowledge, your experience and your fearlessness (*"Unerschrockenheit"*), because chance events constantly disrupt the plans and maneuvers attempted on the board.[43] That fear and fearlessness should even play a role in a game was apparently such a novel idea, that the officer felt compelled to include an explanatory footnote. It reads,

> Do not be surprised by the expression: fearlessness. That is also necessary in our game; for every player has ambition and desires the best result for himself. Yet, since he must really strain his mental powers to their utmost in order to carry out his plans and still, in spite of all his prudence, cannot be certain that he will reach his goal, then he must expose his figures to various dangers, yes even march courageously into them.[44]

The simulation of randomness and danger first generates the fear that the player then learns to handle and transform into fearlessness as the game progresses. For the officer, the game functions as an anaesthetic offering the player an emotional inoculation through repeated virtual exposure to the emotion that would otherwise, as Clausewitz put it, deprive anyone of "the ability to make an immediate decision."[45]

In his *Strategonon*, Aretin claimed that the game would not only visualize the rules and principles of the art of war, train the officer's ability to predict maneuvers in future wars, and help him read military maps. It would also train his emotional response to battle: "It will further teach him that necessary quality in a warrior, cold-bloodedness, because it is difficult to remain cold–blooded in the heat of the game, especially when an unexpected loss occurs."[46] For Aretin, too, the two-dimensional board at once serves as an emotional catalyst and as a tool to keep them flat: it heats them up to cool them down. Coldbloodedness, fearlessness, and courage, the desiderata of military training, thereby emerge as the effects of a two-dimensional technology that operates on the emotional apparatus of the players. In this the function of the wargame both resembles and deviates from Aristotle's analysis of the relation between fiction and the emotions in the *Poetics*. In his aesthetic theory, Aristotle famously argues that tragedy by generating fear and pity lead to a their cathartic purging.[47] The wargame has a similar impact on the player, but it forms part of a training regime designed to instill an emotional numbness that will preempt fear from arising in an actual military situation in the future. The wargame is a technology for keeping violent emotions flat and reducing their intensity: fear is tempered, emotional heat reduced to coolness.

While early wargames targeted players' cognitive and emotional apparatus individually, they could also be used to forge a collective emotional bond. This was particularly important in the wake of the Napoleonic Wars when the feeling of unity and common purpose that the soldiers had experienced in the preceding years was beginning to fade. In his history of the 24th Infantry Regiment, the Prussian officer Franz von Zychlinski describes the regiment's emotional state after the war.

The flames of martial enthusiasm had been extinguished. Will it be possible in peacetime to warm up the soldiers for their task such that through the awareness of it they will coalesce into an innerly unified whole? Will we succeed in infusing the officers, in whose hands lie the continued reformation and vitalization of the military profession, with such a high opinion of their vocation that it will produce a feeling of heartfelt kinship?[48]

To improve the emotional situation, the senior officers decided to make use of Reiswitz's wargame—the early prototype invented by Reiswitz senior. The game was thereby transformed into a memory device, a ludic technology repurposed to revivify and reheat the collective emotions of the past. Instead of flattening emotions, the wargame should produce them as intensely as possible. In this instance, however, the emotional technology malfunctioned miserably. Thwarted by the complexities of Reiswitz's rules and poor instruction by the senior officers, the younger officers quickly tired of the game. Unable to immerse themselves into the simulated world, the game produced only disinterest rather than the unity of an emotional community and it was ultimately abandoned.[49]

Digital Emotions

As these early markers of an alternative history of the modern wargame suggest, the period around 1800 saw the tentative beginnings of the military simulation of emotions. Maps and games served primarily as tools of reason, but they also conjured the emotions as a vehicle of learning and as objects in their own right. To operate successfully in the field, soldiers should first go through a virtual but real emotional training: project yourself onto the map, submit to the cognitive and emotional operations performed on you by the game, and your whole mental and emotional apparatus will be prepared for the experience of actual warfare. This was the idea folded into the dice, the figures, and the maps of the wargame.

The two-dimensional simulation of emotions has only developed slowly over the past 200 years. Tactical and strategic interests drove the second wave of inventions toward the end of the nineteenth century as well as the third wave after World War II. But the year 1977 marks a turning point. At a conference organized by the Department of Defense, game developer Jim Dunnigan argued that the design of wargames should involve its users to a greater extent. They needed to engage the players at an emotional level luring them into the game. Dunnigan, who designed hobby games for entertainment, was subsequently hired as a consultant to the US military. As Sharon Gamari-Tabrizi notes, this coalition between the military and the entertainment industry meant that wargame designers "became ever more sensitive to the requirement for emotionally appealing game scenarios and rules."[50]

Yet, very few games sought to include the psychological aspect of war as an independent variable. An exception was *Call of Cthulhu*, which was released 1981—a year after PTSD was first recognized as a mental illness category and included in the third edition of the *Diagnostic and Statistical Manual of Mental Disorders* published by the American Psychiatric Association. It was a role-playing game based on H.P. Lovecraft's horror stories and took into consideration the emotional and psychological impact of war experience. Tracking the mental health of the players with a point system, the trauma of combat, torture, and pain could reduce them to

a state of insanity.[51] But together with a few others, *Call of Chtulhu* remained the exception to the rule.

Technological developments in the 1990s, however, would pave the way for a new emotional management system. With the evolution of first-person shooter games, the two-dimensional, cartographic representation of the ludic world gave way to situated, perspectival simulations that brought the player directly into the thick of things.[52] The computer wargame could thereby present directly the images of violence that literary and historical texts had until then generated only indirectly in the reader's imagination. A key attraction of first-person shooter games was and is the emotional effects generated by these images. Their utility for the recruitment and training of soldiers was therefore obvious to the military and has contributed to the porous borders between the military and the entertainment industry in past decades.[53]

Concerted efforts to utilize the new digital technology, however, and make of the emotions the object of a carefully controlled training regimen only began to take form in 1999. That year saw the founding of the Institute for Creative Technologies (ICT) at the University of Southern California. A collaboration between the military, psychologists, film makers, software programmers, and game designers, the ICT has since developed a number of interactive immersive virtual reality wargames and scenarios such as *Full Spectrum Warrior* and *Flatworld* to train, prepare, and process the potential and actual emotional stress of war. Exchanging the map for the liquid crystals of the flat-panel screen, these sophisticated contemporary wargames share the rationale of their analogue predecessors developed 200 years ago. Only now the emotions have moved from the periphery to center stage as part of an elaborate emotional management system. Seeking to cultivate Opiz's "fearlessness," the explicit goal of one of ICT's products is to develop "stress resilience." *STRIVE*, or, *Stress Resilience in Virtual Environments* consists of six training scenarios with, in the words of the project leader, "advanced gaming development software, cinematically designed lighting and sound and narrative that maximizes character development and emotional engagement as well as clinical appropriateness."[54] Immersing its users in a virtual combat zone and exposing them, in a controlled fashion, to a traumatic incident such as the death of a child or the loss of a comrade, the scenarios are designed to offer an emotional inoculation. The emotional register and capabilities that the resilience training regime currently trains includes, among others, "adaptability," "empathy," and "hardiness."[55] Conversely, other scenarios such as Virtual Reality Exposure Therapy, or, VRET, seek to help soldiers who already suffer from PTSD. Rendering the traumatic incident as faithfully as the technology will allow, the training scenario first charges the soldiers emotionally as they relive the trauma. Subsequent repetitions are then intended to gradually lower the emotional response until they reach a state of stability.[56]

With virtual worlds such as STRIVE and VRET what began as a secondary objective of the early wargame has today become their primary purpose. In this way the wargame, while operating directly on the emotions, subjects them to the same process of management and control that it imposed on the rational part of the mind. Both as a powerful psychological force to be evoked and as a potential danger to be quelled, the emotions have entered into the military calculus just as Clausewitz advocated, but now as the central variable in a high-tech apparatus whose digital screens and head-mounted-displays serve as the military's tools to manipulate emotional states. Inducing and flatlining them, these latest inventions have extended the reach of the two-dimensional simulation to include not just how soldiers think about war, but how they feel about it, and thereby

they inscribe the emotions in the history of the continued rationalization of war. If the metapicture of the military map that underlies the development of the wargame excluded the emotions as a phenomenon lying outside its dominion, it nevertheless reasserts itself when the contemporary wargame transforms the emotions into units of calculation and rational government. Making visible, comprehensible, and manageable the emotions of war, contemporary wargames reinforce the metapicture with their attempt to extend the ideal functions of the map from the external space of war to the internal emotional landscape of its users.

The consequences are potentially dire. Just as around 1800 the metapicture of the military map suffered from practical and empirical flaws, the success of contemporary emotional technologies is still being evaluated and remains unclear.[57] But the problem that faces us today is less potential flaws in the system or the inefficiency of the technology; it is the consequences of its potential success. Today we must ask what the expansion and realization of the metapicture might entail. Whether the emotional formatting of soldiers, the flattening of their emotional range and intensity, or the production of resilient numbness do not remove a dimension of human experience that is fundamental to preventing that war becomes anything other than the action of last resort. Creating emotionally truncated human beings in the image of the image of control, contemporary virtual training scenarios point to a potential shift in the balance between diplomacy and military engagement. Once war is no longer to be feared, the military option may be preferable to the give and take of diplomatic negotiations. But perhaps there is a lesson to be learned from the very emotions that inventors from Opiz and Aretin to the researchers at the ICT are trying to quench. Fear is a rational emotional response to impending war, trauma a sensible reaction to its actuality. One may hope that the individual and operational benefits of flatlining soldiers' emotions does not dull the collective understanding of why it is we fear war in the first place.

Notes

1 Ernst Heinrich Dannhauer, "Das Reißwitzsche Kriegsspiel von seinem Beginn bis zum Tode des Erfinders 1827," *Militair-Wochenblatt* 56 (1874): 529.
2 Ibid.
3 Ibid.
4 Aside from Dannhauer, see, for example, Peter P. Perla, *The Art of Wargaming* (Annapolis, MA: The United States Naval Institute, 1990); Philipp von Hilgers, *Kriegsspiele: Eine Geschichte der Ausnahmezustände und Unberechenbarkeiten* (München: Wilhelm Fink Verlag, 2008); Philip Sabin, *Simulating War: Studying Conflict through Simulation Games* (London/New York: Continuum, 2014); Jorit Wintjes, "Europe's Earliest *Kriegsspiel*? Book Seven of Reinhard Graf zu Solms' *Kriegsregierung* and the 'Prehistory' of Professional War Gaming," *British Journal for Military History* 2, no. 1 (2015); Pat Harrigan and Matthew G. Kirschenbaum, eds. *Zones of Control* (Cambridge, MA: MIT Press, 2016).
5 As Jesper Juul has discussed, pain itself is often one of the attractions of playing games. See Jesper Juul, *The Art of Failure: An Essay on the Pain of Playing Video Games* (Cambridge, MA: MIT Press, 2013).
6 Max Eckert, *Die Kartenwissenschaft*, vol. 1 (Berlin und Leipzig: Walter de Gruyter & Co., 1921), 441. For an overview of the cartographic developments in Europe against the background of the Napoleonic Wars see chapter 5 in Anders Engberg-Pedersen, *Empire of Chance: The Napoleonic Wars and the Disorder of Things* (Cambridge, MA: Harvard University Press, 2015). For a national analysis, see Stig Svenningsen, "Mapping the Nation for War: Landscape in Danish Military Cartography 1800–2000," *Imago Mundi* 68, no. 2 (2016): 196–211.
7 See Baron Agathon-Jean-François Fain, *Mémoires du Baron Fain* (Paris: arléa, 2001).
8 For a vivid description of Napoleon's obsession with maps, see Otto Freiherr von Odeleben, *Napoleons Feldzug in Sachsen im Jahr 1813* (Dresden: Arnoldische Buchhandlung, 1816).

9 W.J.T. Mitchell, *Cloning Terror: The War of Images, 9/11 to the Present* (Chicago: The University of Chicago Press: 2011, xiv).

10 See Ludwig Wittgenstein, *Tractatus Logico-Philosophicus; Tagebücher 1914–1916; Philosophische Untersuchungen* (Frankfurt am Main: Suhrkamp, 1984), 300.

11 A.V. Arnault, *Vie Politique et Militaire de Napoléon*, vol. 1 (Paris: Chez Émile Babeuf, 1822), 7.

12 Military theorist Antoine-Henri Jomini would later go so far as to claim that "strategy is the art of waging war upon the map"—a conception of the map that the illustration captures well. Antoine-Henri Jomini, *Tabelau Analytique des Principales Combinaisons de la Guerre* (St. Petersburg: Bellizard, Libraires de la Cour, 1830), 50.

13 For earlier uses of cartography as instruments of governance, see David Buisseret, ed. *Monarchs, Ministers, and Maps: The Emergence of Cartography as a Tool of Government in Early Modern Europe* (Chicago: University of Chicago Press, 1992).

14 See e.g. J.B. Harley, "Deconstructing the Map," *Cartographica* 26, no. 2 (1989): 1–20; Christian Jacob, *The Sovereign Map: Theoretical Approaches in Cartography Throughout History*, trans. Tom Conley, ed. Edward H. Dahl (Chicago and London: The University of Chicago Press, 2006); Denis Wood, "Cartography is Dead (Thank God!)," *Cartographic Perspectives* 45 (2003), 4–7; Robert Stockhammer, *Kartierung der Erde: Macht und Lust in Karten und Literatur* (München: Wilhelm Fink Verlag, 2007).

15 Calon quoted in Henri Marie Auguste Berthaut, *Les Ingénieurs Géographes Militaires, 1624–1831*, vol. 1 (Paris: Imprimerie du Service Géographique, 1902), 163.

16 See Harrigan and Kirschenbaum, *Zones of Control*, xvii.

17 Johann Christian Ludwig Hellwig, *Versuch eines aufs Schachspiel gebaueten taktischen Spiels von zwey und mehreren Personen zu Spielen* (Leipzig: Siegfried Lebrecht Crusius, 1780), xi, xix.

18 Georg Venturini, *Darstellung eines neuen Kriegesspiels zum Gebrauch für Officiere und Militärschulen: Mit einem großen Plan* (Leipzig: bey Johann Conrad Hinrichs, 1804), 1.

19 See e.g. Perla, *The Art of Wargaming*; von Hilgers, *Kriegsspiele*; Harrigan and Kirschenbaum, *Zones of Control*.

20 Harrigan and Kirschenbaum, *Zones of Control*, xxvii.

21 In general the intertwinement of emotions and cartography has received little notice. Already Madeleine de Scudéry's *Clélie* (1654–1660) included the now famous *Carte de Tendre*, which maps the stages of an emotional journey toward a possible amorous relationship. In the twentieth century, situationist Guy Debord developed this link further when he invented the discipline of "psychogeography" i.e. "the study of the precise laws and specific effects of the geographical environment, consciously organized or not, on the emotions and behavior of individuals." As part of the project he, and fellow situationist Asger Jorn, published two maps entitled *Psychogeographical Guide to Paris: Discourse on the Passions of Love*. See Guy Debord, *Guide Psychogeéographique de Paris: Discours sur les Passions de l'Amour*, ed. le Bauhaus Imaginiste (Denmark: Permild & Rosengreen: 1956); and Denis Wood, "Lynch Debord: About Two Psychogeographies," *Cartographica* 45, no. 3 (2010): 186–187. For recent critical engagements with emotional cartographies, see Giuliana Bruno, *Atlas of Emotion: Journeys in Art, Architecture, and Film* (New York/London: Verso, 2002), and John K. Noyes, "Goethe and the Cartographic Representation of Nature around 1800," in *Literature and Cartography: Theories, Histories, Genres*, ed. Anders Engberg-Pedersen (Cambridge, MA: MIT Press, 2017).

22 Ernst Jünger, *In Stahlgewittern* (Stuttgart: Klett-Cotta, 2014), 196.

23 Jacob, *The Sovereign Map*, 21.

24 Hans Belting, *An Anthropology of Images: Picture, Medium, Body*, trans. Thomas Dunlap (Princeton: Princeton University Press, 2011), 27.

25 Belting, *Anthropology*, 28.

26 The subtitle of his second edition of the game from 1803 highlights the dialectic: *An Attempt to Vizualize the Truth of various Rules in the Art of War in an Entertaining Game*. See Johann Hellwig, *Das Kriegsspiel: Ein Versuch die Wahrheit verschiedener Regeln der Kriegskunst in einem unterhaltenden Spiele anschaulich zu machen* (Braunschweig: Karl Reichard, 1803).

27 Hellwig, *Versuch*, xviii, xvii.

28 Johann Allgaier, *Der Anweisung zum Schachspiel zweyter Teil*, vol. 2 of *Neue theoretisch-praktische Anweisung zum Schachspiel* (Wien: Franz Joseph Rötzel, 1796), preface, no page number.

29 Allgaier, *Anweisung*, preface, no page number.

30 Georg Venturini, *Beschreibung und Regeln eines neuen Krieges-Spiels, zum Nutzen und Vergnügen, besonders aber zum Gebrauch in Militair-Schulen von Georg Venturini, herzoglich Braunschweigischen Ingenieur-Lieutenant* (Schleswig: bey J.G. Röhß, 1797), xiv–xv.

31 Wilhelm Freiherr von Aretin, *Strategonon: Versuch, die Kriegführung durch ein Spiel anschaulich darzustellen* (Ansbach: Dollfuß, 1803), xi–xii.

32 Georg Venturini, *Darstellung eines neuen Kriegsspiels zum Gebrauch für Offiziere und in Militärschulen*, 2.

33 Ludwig Freiherr von Welden, *Entwurf für die Verfertigung und Benützung der Plane zur praktischen Erläuterung mehrerer Theorien der Kriegskunst* (Wien: Anton Strauß, 1825), 6.

34 Welden, *Entwurf*, 13.

35 Related ideas can be found in Otto August Rühle von Lilienstern's *Aufsätze über Gegenstände und Ereignisse aus dem Gebiete des Kriegswesens* (Berlin: Ernst Siegfried Mittler, 1818), and in the work of Heinrich von Kleist, in particular the play *Der Prinz von Homburg*. For an examination of the role of the emotions in Clausewitz's thought see Ulrike Kleemeier, "Moral Forces in War," in *Clausewitz in the Twenty-First Century* eds. Hew Strachan and Andreas Herberg-Rothe (Oxford: Oxford University Press, 2007), 107–122.

36 Carl von Clausewitz, *Vom Kriege* (Bonn, Dümmler 1980), 213, see also 208.

37 Clauswitz, *Vom Kriege*, 208.

38 See in particular chapters 3–7 in volume 3.

39 Clausewitz, *Vom Kriege*, 1176.

40 Clausewitz, "Historische Briefe über die großen Kriegsereignisse 1806, 1807," in *Verstreute kleine Schriften*, ed. Werner Hahlweg (Osnabrück: Biblio Verlag, 1979), 116; Clausewitz, "Bemerkungen über die reine und angewandte Strategie des Herrn von Bülow oder Kritik der darin enthaltenen Ansichten," in *Verstreute kleine Schriften*, 82.

41 See Carl von Clausewitz, *Schriften—Aufsätze—Studien—Briefe*, vol. 2, part 2, ed. Werner Hahlweg (Göttingen: Vandenhoeck & Ruprecht, 1966/1990), 655–656.

42 Clausewitz, *Vom Kriege*, 369. For the importance of preparing soldiers for the experience of war, see also 265–266.

43 Johann Ferdinand Opiz, *Das Opiz'sche Kriegsspiel, ein Beitrag zur Bildung künftiger und zur Unterhaltung selbst der erfahrensten Taktiker* (Halle: Hendels Verlag, 1806), 22–23.

44 Opiz, *Das Opiz'sche Kriegsspiel*, 22–23n.

45 Clausewitz, *Vom Kriege*, 254.

46 Aretin, *Strategonon*, xxxii.

47 Aristotle, *Poetics*, tr. Richard Janko (Indianapolis: Hackett, 1987), 7.

48 Franz von Zychlinski, *Geschichte des 24sten Infanterie-Regiments, Zweiter Teil* (Berlin: Mittler's Sortiments-Buchhandlung, 1857), 196.

49 The "general merriment" (199) that did ensue had nothing to do with Reiswitz's game, but with the fact that the officers found the alcohol in the adjacent kitchen more interesting than the simulation of war.

50 Sharon Gamari-Tabrizi, "Wargames as Writing Systems," in *Zones of Control*, eds. Harrigan and Kirschenbaum, 337.

51 A. Scott Glancy, "The 'I' in Team. War and Combat in Tabletop Role-Playing Games," in *Zones of Control*, eds. Harrigan and Kirschenbaum, 71–80, 74–75.

52 See Glancy, "The 'I' in Team." Many of these games include maps of the fictional world the player moves around in and, as Stephan Günzel has noted, thereby bring together in a single representation the two main modes of spatial representation in the history of European imagery: perspective and map projection. See Stephan Günzel, *Egoshooter: Das Raumbild des Computerspiels* (Frankfurt am Main: Campus Verlag, 2012).

53 See for example Roger Stahl, *Militainment, Inc. War, Media, and Popular Culture*, (New York and London: Routledge, 2010).

54 Institute for Creative Technologies. 2015, accessed July 25, 2016, http://ict.usc.edu/prototypes/strive/.

55 Ibid.

56 For a detailed analysis of the ICT and their virtual scenarios see Anders Engberg-Pedersen, "Technologies of Experience: Harun Farocki's *Serious Games* and Military Aesthetics," *Boundary 2*, 44, no. 4 (Fall 2017): 155–178.

57 For a trenchant critique, see David J. Morris, *The Evil Hours: A Biography of Post-Traumatic Stress Disorder* (Boston/New York: Houghton Mifflin Harcourt, 2015). According to the ICT the effects of the immersive treatment are currently being tested and assessed in controlled trials.

Bibliography

Allgaier, Johann. *Der Anweisung zum Schachspiel zweyter Teil*, vol. 2 of *Neue theoretisch-praktische Anweisung zum Schachspiel*. Wien: Franz Joseph Rötzel, 1796.

Aretin, Wilhelm Freiherr von. *Strategonon: Versuch, die Kriegführung durch ein Spiel anschaulich darzustellen*. Ansbach: Dollfuß, 1803.

Aristotle. *Poetics*. Translated by Richard Janko. Indianapolis: Hackett, 1987.

Arnault, A.V. *Vie Politique et Militaire de Napoléon*, vol. 1. Paris: Chez Émile Babeuf, 1822.

Belting, Hans. *An Anthropology of Images: Picture, Medium, Body*. Translated by Thomas Dunlap. Princeton: Princeton University Press, 2011.

Berthaut, Henri Marie Auguste. *Les Ingénieurs Géographes Militaires, 1624–1831*, vol. 1. Paris: Imprimerie du Service géographique, 1902.

Bruno, Giuliana. *Atlas of Emotion: Journeys in Art, Architecture, and Film*. New York/London: Verso, 2002.

Buisseret, David, ed. *Monarchs, Ministers, and Maps: The Emergence of Cartography as a Tool of Government in Early Modern Europe*. Chicago: University of Chicago Press, 1992.

Clausewitz, Carl von. *Schriften—Aufsätze—Studien—Briefe*, vol. 2, edited by Werner Hahlweg. Göttingen: Vandenhoeck & Ruprecht, 1966/1990.

——. *Verstreute kleine Schriften*. Edited by Werner Hahlweg. Osnabrück: Biblio Verlag, 1979.

——. *Vom Kriege*. Bonn: Dümmler 1980.

Dannhauer, Ernst Heinrich. "Das Reißwitzsche Kriegsspiel von seinem Beginn bis zum Tode des Erfinders 1827." *Militair-Wochenblatt* 56 (1874): 527–532.

Debord, Guy. *Guide Psychogéographique de Paris: Discours sur les Passions de l'Amour*. Edited by le Bauhaus Imaginiste. Denmark: Permild & Rosengreen: 1956.

Eckert, Max. *Die Kartenwissenschaft*, vol. 1. Berlin und Leipzig: Walter de Gruyter & Co., 1921.

Engberg-Pedersen, Anders. *Empire of Chance: The Napoleonic Wars and the Disorder of Things*. Cambridge, MA: Harvard University Press, 2015.

——. "Technologies of Experience: Harun Farocki's *Serious Games* and Military Aesthetics." In *Boundary 2*, 44, no. 4 ((Fall 2017): 155–178.).

Fain, Baron Agathon-Jean-François. *Mémoires du Baron Fain*. Paris: arléa, 2001.

Gamari-Tabrizi, Sharon. "Wargames as Writing Systems." In *Zones of Control*, edited by Pat Harrigan and Matthew G. Kirschenbaum, 331–353. Cambridge, MA: MIT Press, 2016.

Glancy, A. Scott. "The 'I' in Team: War and Combat in Tabletop Role-Playing Games." In *Zones of Control*, edited by Pat Harrigan and Matthew G. Kirschenbaum, 71–80. Cambridge, MA: MIT Press, 2016.

Günzel, Stephan. *Egoshooter: Das Raumbild des Computerspiels*. Frankfurt am Main: Campus Verlag, 2012.

Harley, J.B. "Deconstructing the Map." *Cartographica* 26, no. 2 (1989): 1–20.

Harrigan, Pat and Matthew G. Kirschenbaum, eds. *Zones of Control*, Cambridge, MA: MIT Press, 2016.

Hellwig, Johann Christian Ludewig. *Versuch eines aufs Schachspiel gebaueten taktischen Spiels von zwey und mehreren Personen zu Spielen*. Leipzig: Siegfried Lebrecht Crusius, 1780.

——. *Das Kriegsspiel: Ein Versuch die Wahrheit verschiedener Regeln der Kriegskunst in einem unterhaltenden Spiele anschaulich zu machen*. Braunschweig: Karl Reichard, 1803.

Hilgers, Philipp von. *Kriegsspiele. Eine Geschichte der Ausnahmezustände und Unberechenbarkeiten*. München: Wilhelm Fink Verlag, 2008.

Institute for Creative Technologies. http://ict.usc.edu/prototypes/strive/ (accessed July 25 2015).

Jacob, Christian. *The Sovereign Map: Theoretical Approaches in Cartography Throughout History*. Translated by Tom Conley. Edited by Edward H. Dahl. Chicago and London: The University of Chicago Press, 2006.

Jomini, Antoine-Henri. *Tableau Analytique des Principales Combinaisons de la Guerre*. St. Petersburg: Bellizard, Libraires de la Cour, 1830.

Jünger, Ernst. *In Stahlgewittern*. Stuttgart: Klett-Cotta, 2014.

Juul, Jesper. *The Art of Failure: An Essay on the Pain of Playing Video Games*. Cambridge, MA: MIT Press, 2013.

Kleemeier, Ulrike. "Moral Forces in War." In *Clausewitz in the Twenty-First Century*, edited by Hew Strachan and Andreas Herberg-Rothe, 107–122. Oxford: Oxford University Press, 2007.

Mitchell, W.J.T. *Cloning Terror: The War of Images, 9/11 to the Present*. Chicago: The University of Chicago Press: 2011.

Morris, David J. *The Evil Hours: A Biography of Post-Traumatic Stress Disorder*. Boston/New York: Houghton Mifflin Harcourt, 2015.

Noyes, John K. "Goethe and the Cartographic Representation of Nature around 1800." In *Literature and Cartography: Theories, Histories, Genres*, edited by Anders Engberg-Pedersen. Cambridge, MA: MIT Press, 2017.

Odeleben, Otto Freiherr von. *Napoleons Feldzug in Sachsen im Jahr 1813*. Dresden: Arnoldische Buchhandlung, 1816.

Opiz, Johann Ferdinand. *Das Opiz'sche Kriegsspiel, ein Beitrag zur Bildung künftiger und zur Unterhaltung selbst der erfahrensten Taktiker*. Halle: Hendels Verlag, 1806.

Perla, Peter P. *The Art of Wargaming*. Annapolis, MA: The United States Naval Institute, 1990.

Rühle von Lilienstern, Otto August. *Aufsätze über Gegenstände und Ereignisse aus dem Gebiete des Kriegswesens*. Berlin: Ernst Siegfried Mittler, 1818.

Sabin, Philip. *Simulating War: Studying Conflict through Simulation Games*. London/New York: Continuum, 2014.

Stahl, Roger. *Militainment, Inc. War, Media, and Popular Culture*. New York and London: Routledge, 2010.

Stockhammer, Robert. *Kartierung der Erde: Macht und Lust in Karten und Literatur*. München: Wilhelm Fink Verlag, 2007

Svenningsen, Stig. "Mapping the Nation for War: Landscape in Danish Military Cartography 1800–2000." *Imago Mundi* 68, no. 2 (2016): 196–211.

Venturini, Georg. *Beschreibung und Regeln eines neuen Krieges-Spiels, zum Nutzen und Vergnügen, besonders aber zum Gebrauch in Militair-Schulen von Georg Venturini, herzoglich Braunschweigischen Ingenieur-Lieutenant*. Schleswig: bey J.G. Röhß, 1797.

——. *Darstellung eines neuen Kriegsspiels zum Gebrauch für Offiziere und in Militärschulen*. Leipzig: bey Johann Conrad Hinrichs, 1804.

Welden, Ludwig Freiherr von. *Entwurf für die Verfertigung und Benützung der Plane zur praktischen Erläuterung mehrerer Theorien der Kriegskunst*. Wien: Anton Strauß, 1825.

Wintjes, Jorit. "Europe's Earliest *Kriegsspiel*? Book Seven of Reinhard Graf zu Solms' *Kriegsregierung* and the 'Prehistory' of Professional War Gaming." *British Journal for Military History* 2, no. 1 (2015): 15–33.

Wittgenstein, Ludwig. *Tractatus Logico-Philosophicus; Tagebücher 1914–1916; Philosophische Untersuchungen*. Frankfurt am Main: Suhrkamp, 1984.

Denis Wood, "Cartography Is Dead (Thank God!)," *Cartographic Perspectives* 45 (2003), 4–7.

Wood, Denis. "Lynch Debord: About Two Psychogeographies." *Cartographica* 45, no. 3 (2010): 185–200.

Zychlinski, Franz von. *Geschichte des 24sten Infanterie-Regiments, Zweiter Teil*. Berlin: Mittler's Sortiments-Buchhandlung, 1857.

5 The Paradox of Total Immersion

Watching War in Nineteenth-Century Panoramas

Kathrin Maurer

Introduction

> Child with his mother in the panorama. The panorama presents the Battle of Sedan. The child finds it all very lovely. "Only it's too bad that the sky is so dreary." "That's what the weather is like in war," answers the mother."[1]

Walter Benjamin's commentary on Anton von Werner's monumental war panorama painting *The Battle of Sedan* (1883) grasps its key mode of perception: total immersion. Mother and child are standing *in* the panorama; the painting surrounds them, and from this enclosed space *within* the picture, they fantasize about war. War is beautiful, except for the weather, unfortunately the sky above the battlefield is cloudy.

This chapter investigates the nineteenth-century war panorama as a form of total immersion into the imaginary and spectacular world of war. Media historian Oliver Grau describes immersion as "mentally absorbing, and [as] a process, a change, a passage from one mental state to another."[2] Psychologically speaking, immersion refers to a state of consciousness when a person is surrounded by a total, engrossing, virtual environment, and where the awareness of the self is diminished.[3] In recent scholarship, immersion has been discussed in the context of electronic interactive media art, which can merge with the viewers, thus bodily, sensually, and affectively enfolding them into the world of the artwork itself.[4] These immersive contemporary art forms did not first occur with the advent of twentieth-century cyberspace. Their archetypes can already be found in nineteenth-century visual-aesthetic media.[5]

Analyzing the visual immersive technology of the nineteenth-century war panorama, this chapter explores how the panorama staged, conveyed, and mediated the viewer's experience of war. In doing so, I argue that the panorama as a medium is inherently paradoxical: On the one hand, it absorbs the audience into a collective experience or war. It builds a "community" of spectators, and it trains, disciplines, and prepares viewers for the wars to come. By militarizing audiences, propagating nationalism, and by immersing the audience into national battles, the panorama represents the history of military combat under the auspices of futurity. On the other hand, due to its specific optical technologies, the panorama also conserves and freezes the history of war. Panoramas paintings show the history of combat from an all-encompassing bird's eye perspective as a static image that is already finished. In the following, I will show that this paradoxical structure of the panorama—this simultaneity between historical futurity and finitude—is symptomatic of the challenges inherent to representing modern warfare as a total spectacle during the nineteenth century.[6] By discussing the panorama's

immersive optical technologies and its power to build military communities, I will unfold one side of the paradox: The panorama represents war history within a teleological frame referring to a state of national and military superiority in the future. Having shown this "modern" quality of the panorama, however, I will demonstrate that it also can portray the past in a "pre-modern" fashion by exploring its features of a-chronicity and stasis.[7] This paradoxical structure of the panorama will be read as a symptom for the challenges to represent the changing qualities of warfare in the nineteenth century within the aesthetic discourse. Before demonstrating the different sides of the paradox, however, a brief overview of the medium's history is in order.

The Panorama as Mass Medium of the Nineteenth Century

A panorama, aiming to provide an all-encompassing visual experience, relies on a wide field-of-view. In the 1780s, Irishman Robert Barker experimented with this perspective, creating large-scale paintings that suggested a 360-degree view, and that could completely encircle the spectator. In contrast to earlier panoramic art, such as the painted ceilings of the Baroque Period, the Merian Engravings, and Vedute paintings of the seventeenth century, the panoramas of the nineteenth century deployed perspective in a completely new fashion. Instead of organizing the panoramic view around one focal point (such as the focus on the sovereign in the Baroque stage sets), nineteenth-century panoramas aimed to convey a multiplicity of simultaneous viewpoints, without substantially distorting the perspective. This new omnidirectional experience of perspective could be achieved by connecting, for example, eight individual pictures constituting puzzle pieces of an entire painting (each having a central one-point perspective and thematically related to the others). The trick was to connect all these pictures along their side edges, to bend the whole construction into a cylinder, and to make some corrections to any distortions of perspective. The result was a painting that encircled the viewer and in theory provided infinite viewpoints on the events or landscape being represented.[8]

Barker acquired a patent for his invention in 1787, and only a few years later he exhibited a panoramic painting entitled *Cities of London and Westminster* (1792). He displayed this work in a specially constructed rotunda in his backyard on Castle Street in London. The exhibit not only brought him, finally, the acceptance of Sir Joshua Reynolds, a founding member of the Royal Academy of Arts, but also started the trend for panoramas as public spectacles. Panoramas became popular attractions designed for mass entertainment, accessible to the larger public for a small entrance fee. Not only did customers from the British Isles flock to these optical sensations; the genre also boomed in Germany and France. Around 1800, Johann Adam Breysig experimented with a circular perspective and the representation of gardens. Johann Friedrich Tielker created city panoramas of Moscow in 1806, and the German architect Karl Friedrich Schinkel showed a panorama of Palermo in 1808.[9]

During the second half of the nineteenth century, the production of panoramas became a large-scale industry. Its boom was partly due to the stock market's discovery of the panorama as a lucrative form of entertainment. In Belgium, in particular, many so-called panorama joint-stock companies were founded, and their investors anticipated a quick profit. By the turn of the century, however, panorama-fever had faded, and most of these companies were bankrupt.[10] During the medium's heyday,

the thematic scope of panoramas ranged from cityscapes to travel attractions to war. Panoramic representations of tourist attractions, such as the Alps, the Pyramids, or the deserts of North Africa were very popular. The *Panorama of the Monumental Grandeur of the Mississippi Valley* (1850) by John J. Egan invited people on adventurous tours down the major rivers in the United States of America while visitors remained safely seated in the auditorium. The experience of pleasantness, comfort, and entertainment constitutes a central aspect of panoramic traveling. On their virtual journeys, the viewers could enjoy images of Native Americans going about their daily life or were treated to spectacular vistas of the Rocky Mountains. Aside from these picturesque tourist motifs, panoramas also displayed various military battles. Important examples of such war panoramas include: the grand 1822 panorama of *The Battle of Waterloo* by Henry Aston Barker, son of Robert Barker, the medium's inventor; the 1811 historical panorama *Gibraltar* by Hull painter William Barton; and the work of military painter Colonel Jean-Charles Langlois, famous for his portrayals of war-time scenes, such as the 1827 *Battle of Navarino*. In the early decades of the nineteenth century, many of these war panoramas had already toured Germany, with displays in Leipzig, Berlin, Hamburg, Frankfurt, and Munich.[11] This form of popular entertainment depicted historical events, battles, and war heroes, thus spectacularizing the representation of war. Professional painters in Germany also crafted war panoramas, and the genre gained increasing popularity during the Founding Epoch *(Gründerzeit)*. One exemplary, highly popular war panorama was Anton von Werner's *The Battle of Sedan* (1883), which will serve in this chapter as a case study to exhibit the paradoxical structure of this mass medium. The following section will unfold the one side of the paradox—the aspect of futurity—by demonstrating its manipulative technology, which can immerse the audience into a virtual battle for the Prussian nation.

Total Immersion: Panorama as Presence

Anton von Werner's *Sedan-Panorama* opened in Berlin on September 1, 1883—the anniversary of the Battle of Sedan. Since 1871, the date had been designated a national holiday, marked by festivals, marches, theater plays, and parades. This decisive Franco-Prussian battle, which resulted in the capture of Napoleon III and France's capitulation to the German Empire, constituted a key moment in Prussian history. The spectacle of the anniversary was topped by the inauguration of the *Sedan-Panorama*, an event that was attended by the entire Prussian military elite and even by the frail, but rather enthused, Kaiser Wilhelm I. As Werner notes in his autobiography, "The emperor was extremely chatty [. . .]. He remained at the panorama for about an hour and a half."[12]

The *Sedan-Panorama*, primarily financed through the panorama stock exchange,[13] cost an exorbitant sum of 1 million Goldmarks to produce, making it the most expensive painting of its kind. Although profits from industrial panorama art were unpredictable and sometimes disappointing, the *Sedan-Panorama* turned out to be a lucrative exception. Visitors flocked to view this spectacle of war; it became a site for patriotic pilgrimage, and a money-making machine.

Werner attained the status of a pop star artist. He did not paint much of the panorama personally. Rather, he directed a crew of over a dozen artists who worked according to his orders and ideas.[14] Since his art affirmed the ideology of the Prussian Regime, Werner played an important role in the cultural politics of the Wilhelminic era.

His paintings were commissioned by the government, and Bismarck even appointed him the supervisor of the German art section at the Paris World Fair in 1878. Werner's glorification of the military, his naturalistic and heroic style, as well as his passion for war scenes made him an ideal creator of political propaganda art.

The gigantic screen of the *The Battle of Sedan* (15 m × 115 m) was exhibited in an enormous rotunda on Panoramastrasse, close to the Alexanderplatz in Berlin. The street still exists today. Due to the lack of visitors at the beginning of the twentieth century, however, the rotunda was demolished in 1908. The painting became part of the private property of Wilhelm II, was then donated to the National Gallery in Berlin, and eventually disappeared during the Second World War (see Figures 5.1 and 5.2). At the height of its popularity during the last two decades of the nineteenth century, however, people crowded into the panorama and, for the price of one Goldmark, they could see not only the painting, but also additional dioramas of war scenes; and they could visit the restaurant hall in the basement, where they would be entertained by a live military orchestra. In order to view the main picture, the audience had to pass through a hallway in the basement, climb up a spiraled staircase, and then step onto a ring-like platform. Only the canvas was illuminated. Standing in the dark, visitors found themselves in the middle of the Floing plateau, a commune in the Ardennes department in Northern France, where the battles between the Prussian infantry and the French cavalry had taken place. Different scenes of combat between the enemy armies were visible and all were geographically, temporally, and historically reconstructed with utmost precision. Eye-catching vistas showed clashes between the French cavalry and Prussians troops as well as views of the surrounding territory.

Once on the platform, the audience was immediately drawn into these events of war. Due to electric lighting, the illuminated canvas exuded radiance. Its luminosity became what Grau calls a "source of the real"[15] and the painting suggested the "presence of a second world."[16] This presence effect was further enhanced by the spherical presentation: panoramas have no frame. The absence of a frame also means that the construction makes no implicit comparison between the reality of the painting and the existence of an outside world. Thus, the viewer is completely immersed in the picture. He or she merges with the artwork, becoming a part of it. This loss of framing experienced by viewers when watching a painting with panoramic features was also noted by writer Heinrich von Kleist in his musings on Casper David Friedrich's

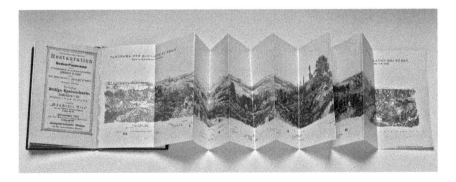

Figure 5.1 Anton Werner, Eugen Bracht, Ludwig Pietsch. *Panorama der Schlacht Sedan.*
Source: Berlin: Photographische Gesellschaft, 1885.

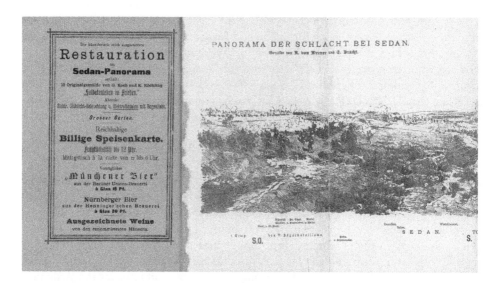

Figure 5.2 Anton Werner, Eugen Bracht, Ludwig Pietsch. *Panorama der Schlacht Sedan.*
Source: Berlin: Photographische Gesellschaft, 1885.

painting *The Monk by the Sea* (*Der Mönch am Meer*, 1808/1810). Kleist observed that when looking at the image, the viewer's experience is "as if one's eye-lids had been sliced away."[17] Kleist's rather painful analogy communicates the powerful emotional effects of a frameless horizon, which in turn can completely immerse the viewer into the picture. Without eyelids, you can no longer keep your distance from the seen. You are overwhelmed. Or, put differently, the panorama pretends to be the real, and the character of the image as a simulacrum seems to be suspended. Due to the painting's omnidirectional perspectivism, the viewer also experiences spatial depth arising from the expansion of the horizon and optical deception. The surrounding *faux terrain* at the bottom of the picture supported the 3D effect. Three-dimensional objects identical to those that appeared in the painting were placed on the platform at the painting's bottom edge, furthering the viewer's experience of being immersed in a "second reality." Props such as weapons, tools, brushes, stones, and soldiers' cooking utensils suggested that the audience was "really there," inside the picture and fully engrossed in an actual experience of war. This impression of "being there" was also enhanced by the rotation of the panorama platform. The balcony, on which the audience stood, revolved and was powered by an engine. Thus, the visitors did not even have to move on their own, but were almost magically transported through the painting.

Newspapers of the time reported the visual effects of the *Sedan-Panorama* on its audience. Note these comments from the *Vossische Zeitung* from September 2, 1883:

> The open trenches and the artillery battery placements with all the scattered tools, freshly tilled fields, the remains of the bivouac fire-places and the traces of the troops' stay; the broken and abandoned guns, the baggage carts, and props of all kinds; the distant garden walls, hedges, the paths and tunnels, the quarries and water dams placed in the gorge around Floing. Everything seems so close that you could touch it. The landscape's "distance effect" is wonderful.[18]

This passage confirms, as do many similar eyewitness statements, that the *Sedan-Panorama* aimed to create a total illusion, in which the audience merged with picture and the war became hyper-realistically present. Grau sees the panorama as a clear forerunner of simulative virtual art. Indeed, he considers the panorama to be the medial archetype of computerized cyberspace aesthetics.[19] His analysis of the early medium's immersive qualities usefully emphasizes the representational structure of this technology of seeing. Together with its lightning effects as well as its acoustic background music, it was clearly a forerunner of simulation art. Aside from its simulatory effects, however, the particular *ways* in which panoramas imagined and represented war must also be shown in order to understand its "history making" purposes and its quality of futurity.

The Panorama: Training for Future Wars

Walter Benjamin compared the panorama to a "windowless house,"[20] in which, as with a singular monad, the viewer can no longer relate what he or she sees to anything external. The panorama acts like a magical medium, one that does not simply purport to show a version of the real, but *is* the real itself. This denial of the panorama's status as a representation, however, does not negate its constructedness and artificiality. On the contrary, this schizophrenic gesture of hiding its craftedness even highlights the panorama's staged and fantasmatic modes of showing war—a mechanism that Werner's contemporaries had already recognized. Art critic Richard Muther was contemptuous of Werner's capabilities as an artist:

> If realism consisted of the sober, dry illustrations of fragments of reality [...], then Anton von Werner would surely deserve a lengthier discussion. In his genre pictures of military life everything is in its proper place and has been polished until it shines, in a true soldierly fashion: typical Prussian art.[21]

According to Muther, Werner constructs an idealized historical reality in ways that make it seem real and authentic. Werner's idyllic image of war does not share the visual complexity of the work by the famous painter Adolph Menzel, whose oils about the Prussian Empire often feature some ironic puns, intricate light effects, as well as contradictions. The visual doctrine of the *Sedan-Panorama* did not allow any room for meta-reflections on its aesthetics, the painting does not challenge the viewer intellectually. Rather, it manipulates him or her into a fantasy of war. As Muther states, the *Sedan-Panorama* produces a generic image of war, in which everything stands in its right place, conveying order, accuracy, and historical correctness. The panorama of war is not sublimely beautiful, but rather picturesque.

As mentioned above, panoramic paintings often portrayed travel attractions, and the audience could enjoy breathtaking sights without ever leaving home. Like tourists on the hunt for the extraordinary, panorama visitors wanted to witness the spectacle of war in their leisure time. At the same time they wanted to feel safe and comfortable. It is important to note that the *Sedan-Panorama* did not portray the brutality and violence of war in a graphic fashion. Werner's painting did not feature any blood. There were no soldiers in pain. You could not see the wounded or the dead. The fantasy of war was sanitized and sober. As drone warfare does today, panoramas enabled the illusion of a "clean" war. Although drone pilots can also experience PTSD, they only see the dying on a screen, and they are not involved in physical combat. Similar to

the panorama audience who watches the war spectacle from a safe elevated balcony, drone pilots do not put themselves at risk.

Although the panorama's war fantasy is nurtured by a vision of bloodless war, the *Sedan-Panorama* still exerted political power, promoting Prussian patriotism, militarism, and imperialism. Werner's panorama was not the first to be instrumentalized for political ideology. In France, Napoleon Bonaparte had discovered the panorama as an instrument of propaganda when he visited a panorama depicting the battle of Wagram, in which his forces had decisively defeated the Austrian army.[22] The painting glorified his victory, and its monumentality reflected Napoleon's delusions of grandeur. Deeply affected by the sight, Napoleon ordered several panoramas, but the French army's defeat and his ensuing abdication as Emperor swept these plans away.

The panorama exerts its governmental power in a manner similar to that of the panopticon. Jeremy Bentham's construction, developed in 1785 and thus preceding Barker's invention of the panorama by several years, represented a new form of the prison, in which inmates' cells were arranged in a circle around one watchtower. From his position in the tower, a prison guard could see everything, theoretically exercising a complete surveillance of the cells while himself remaining invisible and unseen.[23] The panoramic gaze bears some similarities to the panoptic gaze. As Oettermann writes, "in the panorama, the observer is schooled in a way of seeing that is applied to prisoners in the panopticon."[24] Similarly to the panopticon, the panorama's audience is controlled by a centralized state authority. Although there is no elevated sovereign in the picture (the emperor was not visible in the *Sedan-Panorama*), the state's totalitarian power is still exerted by the all-encompassing nature of the painting itself. The omnipresence of war overwhelms the visitors visually, turning them into "virtual" participants in it—as soldiers, patriotic fighters, and individual warmongers. The panorama not only aims to eliminate the distance between representation and reality, it also intends to dissolve viewers' potential emotional distance from and reservations about war. Visitors to panoramas get close to the fighting: they see everything, and, by being a part of the picture, they become an "active" participant in the battlefield.

The invisible state power inherent to the panopticon becomes in the panorama a spectacle embodied in the fantasy of warfare as national expansion. The Prussian Wars were grounded in the idea of a German national community that needed to be built, protected, and expanded. Without this vision, the imperialist wars in 1870/1871 could not have been conducted. The panorama was an important instrument in the maintenance of a grandiose fantasy of national unity. According to Benedict Anderson, nations are built through "imagined national communities," in which images of enemy and ally determine the nation's framings and boundaries.[25] In this light, the *Sedan-Panorama* deployed a rather interesting medial technique. Instead of caricaturizing the enemy through the use of one-dimensional "othering" features (as was often the case in Pro-Prussian illustrated history books), the French troops in the *Sedan-Panorama* simply remained faceless. They had no individualized features at all. Only the Prussians soldiers are rendered with reliance on photographs, portraits, and historical sources. They do not appear as an anonymous hoard. This erasure of faces was a specific war training strategy of the *Sedan-Panorama*. In this context, training is not understood as a disciplining process of a military regimen, but more as a training or schooling of a specific military gaze, namely the development of a de-sensitized and non-emphatic

perception of the enemy. One can easily project aggressive fantasies onto empty faces that function as "screens" onto which nationalist and chauvinistic propaganda can be applied. A faceless de-humanized enemy is also less likely to evoke emotions of empathy.

During this time, many panoramas conveyed the idea of German imperialism and militarism also by means of a colonializing gaze. This was notably the case in the so-called travel panoramas that invited the viewer to journey to exotic and distant countries. Dolf Sternberger's *Panorama or Views of the Nineteenth Century* (*Panorama oder Ansichten vom 19. Jahrhundert*, 1938)[26] reveals the panoramic perspective on the Middle East to be a vehicle for imperialist ideology. Behind the picturesque surface lies a powerful colonialist perspective—one that appropriates another culture's "otherness" into the aesthetics of the pleasant and the cliché. As Sternberger suggests, through this gaze, parts of the Middle East blend into or seem just adjacent to European landscapes (as an "expanded south"[27]). Unknown territories appear as known lands, and, by means of the picturesque, are familiarized, coming to form a collective colonial fantasy. Susanne Zantop has developed this notion as a form of collective desire for colonial mastery.[28] The desire for colonial mastery entails sexual and cultural stereotypes of a "purely imaginary and wish-fulfilling nature."[29] Promoting colonial fantasies was essential to building the ideological frames for overseas ventures and military interventions. One can simply think of Emperor Wilhelm II's speech to the German Marine Corps in 1901, the so-called *Hunnenrede* ("Hun Speech") delivered before going off to suppress the Chinese Boxer Rebellion. Emperor Wilhelm made use of an abundance of racist stereotypes, and these clichés appeared in the travel panoramas for decades. Similar to today's computer training programs, in which soldiers are immersed in the virtual reality of war, where they learn to recognize the enemy, the panoramas of the nineteenth-century shaped militarized communities. Harun Farocki's video installations *Serious Games* (2009) brilliantly illustrates these processes of immersion and the ways that visual simulation technologies collectively create and stereotype the enemy. Of course, it is important to note that the panoramas do not train military personnel, but rather a civilian audience. Nevertheless, they do train the perception of the enemy and his or her cultural features.

Having explored the visual and emotional technologies of nineteenth-century war panoramas, we can conclude that they functioned as tools of war preparation. Panoramas were used to shape national communities, to glorify battles, and to produce enemies. Their intended audiences were civilians, the young, and lower-income people. In other words, although the panorama was a leisure medium that recorded historical events, it also intended to "make history." Werner's *Sedan-Panorama* is as much located in the future as it is in the past. His monumental staging of the war documents a battle, but its encompassing theatricality also projects an image of a future Germany as an imperialist world power. Together with the Wilhelminic era's other military spectacles—festivals, parades, statues, and marching bands—the panorama appealed to future generations and served as the drumbeat of wars to come. Aside from this dynamic aspect, however, the medium also entails a type of paradoxical "brake" or stasis that served to counteract these mobilizing and community-shaping processes. The following section will unfold the other side of the paradox, namely a type of "pre-modern" vision of history intrinsic to the medium of the panorama.

Panorama: Pre-Modern Vision of History?

Not all spectators of nineteenth-century panoramas were equally convinced of their power of illusion. Some remained rather skeptical about the panorama's virtual ambitions. One of these was Kleist, whose comments on Friedrich's paintings have been noted above. Full of anticipation, Kleist visited Johann Adam Breysig's *Panorama of Rome* in Berlin in 1800 and recorded his observations in a letter to Wilhemine von Zenge:

> Since the aim of the whole is to make the spectator believe that he is outdoors, nothing must be visible to remind him of this deception. Very different arrangements would be necessary for this deception to succeed. [...] At the door, the visitor is politely requested to imagine that he is standing on the ruins of the imperial palace in Rome. This requires considerable effort, first of all because you have to pass through a dark corridor and then climb some stairs, and then you find yourself standing on a floor of sturdy pine planks, which, as we all know, bear very little resemblance to Carrara marble.[30]

Kleist was rather unimpressed by in the medium's illusionary power. He criticizes the panoramic representation's staged quality, its craftedness, as well as its campy tackiness. In order to make the illusion even slightly possible, the viewer had to actively stimulate his or her own power of imagination. For Kleist, the medium of the panorama belongs more to tricksters, the circus, or the fair rather than it does to the realm of aesthetics. Of course, one has to take into consideration that Breysig's panorama was a very early exemplar, and its representational techniques were not as developed as those of the photo-realistic and electrically illuminated *Sedan-Panorama*. Nevertheless, the panorama's general capacity for representing war in a "realist" fashion was frequently questioned.

When French art connoisseur Aubin Louis Millin visited the *Panorama of Toulon* in the first decade of the nineteenth century, he noted: "Is there anything more absurd [. . .] than marines, who lift their paddles without moving their boat; soldiers who incessantly load canons without ever coming to an end?"[31] According to Millin, the panorama's central shortcoming is its lack of movement; the soldiers' stillness, petrified in mid-gesture, destroys the effect of illusion. While viewers are expected to believe that the boat is moving on the sea, the fact that the vessel remains static is impossible to overlook. Jonathan Crary, in his analysis of nineteenth-century visuality holds a different view. For Crary, the panorama does entail movement, the medium's filmic potential ensured by spectators turning their bodies and moving their heads as they view the painted scenes.[32] Tracing the aspect of a type of "pre-modern" form of history in the panorama, I argue, however, that the spectator's roving gaze is much more a part of the total immersion process by which the viewer gets completely enclosed into a still and static picture. The viewer is drawn into a total, all-encompassing view of the historical scene. This scene, however, remains motionless. Whereas in a cinema, the fixed viewer watches a moving sequence, the rotating and moving viewer of the panorama watches a relentlessly revolving and repetitive, but ultimately static screen.

This lack of a sequential narrative structure certainly does not preclude a "realist" mode of representation. Ekphrastic poetics, photography, or historical paintings can fix reality in a static form while nonetheless providing a high degree of "realist" external referentiality. These media, however, are not apt to show the passage of historical

time or to provide a temporal mimesis to the viewer's lived experience. Already Georg Büchner's figure Lenz (in the eponymous novella of 1839) lamented the loss of life, when he compared the realist painter with Medusa's gaze in his conversation about anti-idealist art within the text. And theories of photography point to the close relation between the photographic image and death. According to Barthes, photographs always show a world that is already lost forever; a moment that has passed and cannot be brought back.

Similarly to these cases of visual ekphrasis, the *Sedan-Panorama* also froze historical time against the dynamics of historical storytelling. The narrative form embodies what is the essential feature of representing modern history, since, during the rise of historicism, the past was often understood as a developmental process. In contrast to pre-modern eschatological models, history was seen by scholarly historicists and novelists as a continuous process with a *telos* in the future. But, in the *Sedan-Panorama*, the soldiers and their horses are frozen. They do not point towards an open future. Rather, history has already happened and is finished. The last brush stroke of the painter has completed the picture of the past. Although the panorama represents a secular medium of mass culture, its manner of presenting war as a historical event certainly has the quality of a pre-modern and eschatological understanding of the past. The panorama projects a God-like perspective on history, in which the past is not only complete, but also seen in an all-encompassing mode. Already in the sixteenth-century the panoramic view was compared to the omniscient eye of God. The German theologian and mystic Jacob Böhme characterized Adam's gaze in paradise in the Bible as one that entails panoramic qualities. Adam's "seeing was day and night with open eyes without eyelashes, there was no sleep for him, and in his soul was no night: because his eyes incorporated the power of God, and he was complete and perfect."[33] Adam's gaze has access to all places and times of the world. It is an omniscient gaze. Omniscience embodies precisely the perspective that the nineteenth-century panorama aimed to achieve for the viewer. In a panorama, the audience's gaze is widened to a 360-degree format, simulating a super-human point of view. This religious coding of the view in the panorama also makes sense when you think about how the visitor moved in the architectural structure of the panorama: leaving profane daylight, passing through a dark tunnel, climbing up a staircase onto a high balcony, and—above the clouds, so to speak—being immersed by supernatural light.

The God-like vision of omniscience excludes time as an essential ingredient of history. The *Sedan-Panorama* conserves a decisive moment, the victory of the Prussians over the French, from above. This gigantic overview image musealizes the past. It points backwards rather than forward into the future. Uwe Hebekus has connected the panoramic vision of history to the pre-modern theological figure of *apokatastasis*, which can be understood as a restoration of an original state of history.[34] This precludes a cyclical and typological state of history, in which the course of the past is already prefigured within a model of religious eschatology. When the panorama's optics thus are considered as religious in aspiration and effect, the panorama can be seen to promote or encode the view that history is pre-ordained, always unfolding within a closed horizon. When the panorama is viewed in this way, it ceases to be a training ground for wars to come. They can be seen as embodying a wistful obsolescence, their vision of history decisively static and eternal, and therefore anti-modern. Benjamin characterizes these anachronistic aspects of the panoramas when he characterizes them as "aquariums of distance and the past."[35] For him, their magical worlds

stir a longing for "returning home."[36] In his view, panoramas are not media to pre-pare future soldiers for the great historical victories of imperial Germany, but rather outdated technologies of seeing. Benjamin's expression of a "return home" hints at a longing for a return to a religious experience of history. Or, as it will be shown in the next section, it embodies nostalgia for pre-modern forms of warfare.

Panorama as Paradox

The above discussion of the panorama's optical technologies, their emotional immer-sive impact on the audience, and their community-building effects has covered two contrasting interpretations of the war panorama. On the one hand, the war panorama works as a political military medium, which initiates its viewer into warfare by means of total immersion. The panorama is thus a medium capable of propelling history into the future—shaping national communities that will collaborate in waging wars. On the other hand, the panorama also displays anachronistic tendencies. Instead of pushing history forward, its pre-modern form of reckoning history is already out of fashion during its boom time. How can one understand these paradoxical tendencies with respect to the representation of warfare?

First of all, the medium of the panorama clearly illustrates the imaginary quality of modern warfare beginning in late eighteenth-century Europe. Jan Mieszkowski has used the concept of the "Napoleonic war imaginary"[37] to describe the spectacular-ization of modern warfare. Already in the nineteenth century, popular media and literature had turned war into a form of mass entertainment. Ever since the Napoleonic wars, a correlation between viewing and making war had blurred distinctions between the experience and the representation of war—a phenomenon that we more often associ-ate with the wars of the twentieth and twenty-first century. The panorama is clearly a part of this spectacularization process. The *Sedan-Panorama* was subject to media hype of unprecedented proportions. Its paradoxical structure fits into the Prussian propaganda machine. Its mobilizing, future-oriented vision went hand in hand with the instrumentalization of a religious and typological understanding of the German past. Many historians and politicians of the Wilhelminic era posited a seamless con-nection between German mythology and the Prussian Empire. Myths like Barbarossa, the reign of Charles the Great, Frederick II, and Arminius, to name but a few, were seen as the typological forerunners of the Prussian Empire.

Aside from the panorama painting's mytho-historical aspects, there is another, second dimension to this medium's paradoxical quality. The panoramic spectaculari-zation of historical battles also points to the challenge of representing modern wars. This might seem ironic, since the spectacle of war appears to make war represented everywhere. But that is precisely the problem. War is everywhere for the spectators, but—as Mieszkowski has argued—mostly in the realm of the imaginary.[38] Since war became a popular media event for the mass audience, it developed into an affair that was constructed by the media and minds of the people. Already in 1832, Carl von Clausewitz had noted a shift in the conduct of warfare from the Enlightenment to modernity, which in turn also affected the modes of representing war. Eighteenth-century warfare was often regarded as something measurable, calculatory, and systematic. War followed the laws of rationalism and geometry, and the conflicts were frequently executed by a noble officer corps and a small number of troops. With the shift from cabinet wars to the Napoleonic revolutionary wars of the people,

the nature of warfare changed. It was no longer a systematic exercise, but rather an unpredictable, passionate engagement characterized by emotions, probability (rather than certainty), and contingency.[39] In other words, according to Clausewitz, from the nineteenth century forward, war was no longer an isolated action but rather a strategic play dependent on the people, the government, as well as the military leaders. Thus, the war on paper and the war in *realitas* did not always coincide; there was a representational gap. Clausewitz describes this phenomenon through the notion of friction: "Friction is the only conception which in a general way corresponds to that which distinguishes real war from war on paper."[40] By friction, Clausewitz meant not only the loss of warfare's previously calculable nature, but the difficulty of accurately observing and representing war and warfare within available frameworks for political discourse, aesthetic media, and theorizing about war. When war can no longer be rationally mapped on paper, the possibility of representing it becomes more complex and ambiguous. The simultaneity of hyper-realism and phantasm of the war in the panorama exemplifies these representational challenges.

In addition, the panorama not only records this war's imaginary quality, but, precisely through its geometrical design, its optical calculation and strategic perspectivism, it also exhibits a desire to preserve a pre-Napoleonic concept of war. The panorama embodies the fantasy of conducting war according to mathematical rules and optical measures. Its hyperrealism aims to counteract the uncertainty and complexity of modern warfare—what Clausewitz called "the fog of war." In this sense, although Benjamin did not connect the panorama's nostalgic elements with warfare, his aperçus about the panorama nevertheless pointed to some decisive changes in the perception of war and history: Panoramas express the desire to order war within a closed horizon; and they organize war within a geometrically calculated space in which a central super-observer (for example a God-like sovereign) seems to be able to steer it all.

The panorama's fantasy of controlling war and its representation, however, was not easy to realize. The decline of the *Sedan-Panorama* demonstrates this failure. Due to a lack of visitors it gradually disappeared and its military protagonists faded into obscurity. It seems that the panorama was surpassed by its own ambitions to show war as an orderly, non-contingent affair. The visual quality of World War I, in which air wars emerged and the enemy often stayed invisible in the trenches for a long time, could not be grasped by the aesthetics of the panorama. In addition, newer generations wanted to see films. Thus, the panorama was superseded by competing media technologies. Due to its technological limitations and its clear-cut propagandistic functions, the war watchers in a panorama were not supposed to self-reflect on its own representational parameters.

Today's panorama art on war engages with these representational questions (such as its power of immersion, its simulation effects, as well as its war training intentions) and experiments with the meta-perspectives that were missing in the archetype from the nineteenth century. One of the most remarkable and most 'panorama-like' pieces of the 1990s was Maurice Benayoun and Jean-Baptiste Barrière's 1997's installation *World Skin, a Photosafari in the Land of War*. This virtual art installation shows a panorama of battles, in which the visitors can experience war in a hermetically sealed room. Viewers wear specially constructed glasses that make the environment three-dimensional. As in the panorama, viewers are immersively absorbed into the scene. The artists worked with computer graphics, virtual reality programs, and with CAVE technology. CAVE is an automatic immersive environment where a projector in a

room-sized cube produces a form of virtual surrounding. The visitors of this panorama are absorbed into a war zone on a large projection screen in 3D animation and video. There is, however, a decisive difference from the nineteenth-century archetype of the war panorama. In *World Skin*, the visitor has a camera and can take pictures of what he or she chooses. These pictures are not stored invisibly in their cameras. Rather, they appear as white cut-outs on the projection screens. Thus, the viewers are interactively involved in the medial representation of war, in which the camera becomes a weapon and an instrument of violence, a tool to make people vanish. This interactive aspect is completely lacking in the *Sedan-Panorama*. Whereas the visitors of *World Skin* can reflect about the destructive power of images, the viewer in the nineteenth-century medium is passively immersed into the display of the battle and urged to become a potential soldier. On the contrary, Benayoun and Barrière's war panorama aims to free the audience from its war affirming position, and attempts to make them into protesters against war. Thus, *World Skin* becomes an example of highly self-referential art that is not naïvely about war but really about how spectators might experience this complex and explicitly interactive work.[41]

Canadian photographer Jeff Wall has also used a panoramic perspective in the context of representing war. Unlike Benayoun and Barrière's *World Skin*, Wall's remarkable photograph, *Restoration*, explicitly reflects on an actual nineteenth-century panorama and wonders how it could be viewed today. His photographic panorama *Restoration* experiments with a nineteenth-century Swiss panorama painting depicting Swiss volunteers providing emergency assistance to French troops after their loss to German forces in 1871. The original panorama, finished in 1891, was painted by Eduard Castres (himself a Red Cross volunteer in the Franco/Prussian campaigns), with the help of other artists, including realist painter Ferdinand Hodler. The panorama was entirely restored in 2004, and you can still visit it today. Wall's *Restoration*, a photograph taken in panoramic view displays the conservators as well as parts of the original panorama.[42] *Restoration* plays with panoramic powers of illusion, and thus develops self-reflexive moments that question photographic realism, the empirical status of photography, and the limits on its ability to portray "reality." These concerns also underlie Wall's 1992 photograph *Dead Troops Talk*, in which dead soldiers take up absurd and ironic poses and make exaggerated gestures in what is purportedly a "typical" war scene. Certainly nineteenth-century panoramas did not engage in this kind of iconoclastic complexity. Visitors to the *Sedan-Panorama* were not provoked to think critically about the representation of war. Only its paradoxical structure and the story of its decline point to the problems of representing the modern spectacle of warfare in the medial framing of the panorama.

Notes

1 Walter Benjamin, *The Arcades Project*, trans. Howard Eiland and Kevin McLaughlin (Cambridge, MA: The Belknap Press by Harvard University Press, 1999), 58. German translation: "Kind mit seiner Mutter im Panorama. Das Panorama stellt die Schlacht bei Sedan dar, das Kind findet alles sehr schön: 'Nur schade, dass der Himmel so trüb ist.' 'So ist das Wetter im Krieg.' erwidert die Mutter," in "Das Passagenwerk," *Walter Benjamin: Gesammelte Schriften*, ed. Rolf Tiedemann, vol. 5.1. (Frankfurt am Main: Suhrkamp, 1982), 156.
2 Oliver Grau, *Virtual Art: From Illusion to Immersion*, trans. Gloria Custance (Cambridge, MA: The MIT Press, 2003), 13.

3 See, for example, Wallace Sadowski and Kay Stanney, "Presence in Virtual Environments," in *Handbook of Virtual Environments: Design, Implementation and Applications*, ed. Kay Stanney (Mahwah, NJ: Lawrence Erlbaum Associates, 2002), 791–806.

4 See also the following works: Roy Ascott, *Telematic Embrace: Visionary Theories of Art, Technology, and Consciousness* (Berkeley: University of California Press, 2001); Margaret Morse, *Virtualities: Television, Media Art, and Cyberculture* (Bloomington: Indiana University Press, 1998; Mary Anne Moser et al. eds., *Immersed in Technology: Art and Virtual Environments* (Cambridge, MA: MIT Press, 1996).

5 Grau, *Virtual Art*, 24–190.

6 My analysis builds on Grau's theory of immersion as well as on his writings on the *Sedan-Panorama*. Whereas Grau shows in which ways the *Sedan-Panorama* can be understood as an archetype of virtual art, I focus on the inherent paradoxes of immersion in nineteenth-century panoramas with respect to their representation of warfare.

7 For an exploration of the panorama as a "pre-modern" vision of history, see also Kathrin Maurer, *Visualizing the Past: The Power of the Image in German Historicism* (Berlin: Walter de Gruyter, 2013).

8 I owe this description to Oettermann, who explains the infinitude of the viewpoints in greater detail with a mathematical analogy: "As the polygonal base approaches the shape of a perfect circle (and the picture approaches as a cylinder), the number of points in sight (n) approaches infinity: they blend to form the line of the horizon," Stephan Oettermann, *The Panorama: History of a Mass Medium*, trans. by Deborah Lucas-Schneider (New York: Zone Books, 1997), 31.

9 On the history of the panorama see also Heinz Buddemeier, *Panorama, Diorama, Photographie: Entstehung und Wirkung neuer Medien im 19. Jahrhundert* (München: Fink, 1970); Ralph Hyde, *Panoramania! The Art and Entertainment of the All-Embracing View* (London: Trefoil Publications, 1988).

10 See Grau on the industrialization as well as the stock exchange of the panorama in: *Virtual Art*, 103–105.

11 Stephan Oettermann, "Die Reise mit den Augen: 'Oramas' in Deutschland," *Sehsucht: Das Panorama als Massenunterhaltung des 19. Jahrhunderts*, ed. Marie-Louise von Plessen and Ulrich Giersch (Frankfurt am Main: Stroemfeld/Roter Stern, 1993), 44.

12 "Der Kaiser war außerordentlich gesprächig, er verweilte etwa anderthalb Stunden im Panorama," in Anton von Werner, *Erlebnisse und Eindrücke* (Berlin: Mittler, 1913), 340. English translation Oettermann, *The Panorama*, 263.

13 See Oettermann, *Das Panorama*, 205.

14 See Grau's findings of the costs of the *Sedan Panorama* in *Virtual Art*, 99–101.

15 See Grau's chapter on Werner's political impact during Wilhelminic Germany in *Virtual Art*, 99–100.

16 Grau, *Virtual Art*, 97.

17 "als ob einem die Augenlider weggeschnitten wären." Heinrich von Kleist, "Empfindungen vor Friedrichs Seenlandschaft," in *Heinrich von Kleist: Sämtliche Werke und Briefe*, vol. 2, ed. Helmut Sembdner (München: Hanser, 1961), 327.

18 Die aufgeworfenen Schützengräben und Batterieplacements mit dem ganzen, in Unordnung herumgestreuten Apparat von Werkzeugen, die frisch aufgegrabenen Ackerflächen, die Reste der Bivouakfeuer und die sonstigen Spuren des Aufenthalts lagernder Truppen, die zerbrochenen verlassenen Geschütze, Bagagewagen und Requisiten aller Art, ferner die verlassenen Gartenmauern, Hecken, die Wege und Gänge, Steinbrüche und Abfangdämme für Sturzwasser, wie sie in der nach Floing heruntergehenden Schlucht angelegt sind. Alles das ist zum Greifen natürlich. Wundervoll ist geradezu die Fernwirkung der Landschaft.
 (In *Vossische Zeitung Berlin*, 2 September, 1883)

 Article about the opening of the *Sedan-Panorama*, I found this reference in Oettermann, *Das Panorama*, 210.

19 Grau, *Virtual Art*, 96–139.

20 German Translation: "fensterloses Haus," in Benjamin, "Das Passagenwerk," 661.

21 "Wenn Realismus in nüchterner trockener Illustration von Wirklichkeitsfragmenten bestünde [. . .], so wäre Anton von Werner gewiss eine längere Betrachtung zu widmen. [. . .]

In Werners Genrebildern aus Kriegsleben steht alles spiegelblank und richtig am Platze, soldatisch propper,—typische Preussenkunst." Richard Muther, *Geschichte der Malerei im 19. Jahrhundert*, vol. 2. (Leipzig: Grethlein, 1909), 531. English translation: Oettermann, *Das Panorama*, 267.

22 Oetterman, *Das Panorama*, 120.

23 Jeremy Bentham, "The Panopticon Letters," in *The Panopticum Writings*, ed. Miran Božovič (London: Verso, 1995), 31–95.

24 Oettermann, *The Panorama*, 41.

25 Benedict Anderson, *Imagined Communities: Reflections on the Origin and Spread of Nationalism* (London: Verso, 1991)

26 Dolf Sternberger, "Panorama oder Ansichten vom 19. Jahrhundert," *Schriften*, vol. 5 (Frankfurt am Main: Insel, 1991).

27 "erweiterter Süden," Sternberger, *Panorama*, 66.

28 Susanne Zantop, *Colonial Fantasies: Conquest, Family, and Nation in Precolonial Germany, 1770–1870* (Durham: Duke University Press, 1997).

29 Zantop, *Colonial Fantasies*, 3.

30 Denn da es nun doch einmal darauf ankommt, den Zuschauer ganz in den Wahn zu setzen, er sei in der offenen Natur, so dass er durch nichts an den Betrug erinnert wird, so müssten ganz andere Ansichten getroffen werden. [. . .]. Am Eingang wird man höflichst ersucht sich einzubilden man stünde auf den Ruinen des Kaiserpalasts. Das kann aber wirklich, bis man durch einen dunklen Gang hinaufgestiegen ist bis in die Mitte, nicht ohne große Gefälligkeit geschehen.
 (Kleist, "Brief vom 16. August 1800 aus Berlin am das Stiftsfräulein
 Wilhemine von Zenge in Frankfurt/Oder," in *Heinrich von Kleist.
 Sämtliche Werke und Briefe*, ed. Heinrich Sembdner (München:
 Deutscher Klassiker Verlag, 1961), 518–519)

 English translation according to Oettermann, *The Panorama*, 199.

31 "Peut-on en effect imaginer quelque chose de plus absurd [. . .]; des matelots qui relèvent toujours leurs rames sans faire advancer leur bateau; des soldats qui clouent toujour les canons sans avoir jamais fini." In Aubin Louis Millin, "Panorama" in *Dictionaire des Beaux Arts*, vol. 3. (Paris: de l'Imprimerie de Crapelet, 1806), 41. I owe this reference to François Robichon, "Die Illusion eines Jahrhunderts: Panoramen in Frankreich," in *Sehsucht: Das Panorama als Massenunterhaltung des 19. Jahrhunderts*, ed. Marie Louise von Plessen (Stroemfeld/Roter Stern: Frankfurt am Main, 1993), 52–63.

32 "One was compelled at least to turn one's head (and eyes) to see the entire work." Jonathan Crary, *Techniques of the Observer: On Vision and Modernity in the Nineteenth Century* (Cambridge, MA: MIT Press, 1992), 113. This roving gaze is reminiscent of train travel, as Wolfgang Schivelbusch has argued and thus also has filmic features. Wolfgang Schivelbusch makes this connection between train traveling and panoramic paintings in his book *The Railway Journey: The Industrialization of Time and Space in the Nineteenth-Century* (Berkeley: University of California Press, 1986).

33 "sein [Adams] Sehen war Tag und Nacht mit aufgesperrten Augen ohne Wippern, in ihme war kein Schlaff, und in seinem Gemüthe keine Nacht: denn in seinen Augen war die Göttliche Kraft, und er war gantz und vollkommen," Jacob Böhme, "De tribus principiis, oder Beschreibung der Drey Principien Göttliches Wesens," *Jacob Böhme: Sämtliche Schriften*, vol. 2, ed. Will-Erich Peuckert (Stuttgart-Bad Cannstadt: frommann-holzboog, 1960), 107.

34 Uwe Hebekus, *Klios Medien: Die Geschichtskultur des 19. Jahrhunderts in der historistischen Historie bei Theodor Fontane* (Max Niemeyer: Tübingen, 2003), 71.

35 "Aquarien der Ferne und der Vergangenheit," Benjamin, "Berliner Kindheit um Neunzehnhundert," in *Walter Benjamin. Gesammelte Schriften*, vol. 6.1 (Frankfurt am Main: Suhrkamp, 1972), 241.

36 "Rückkehr ins Zuhause", Benjamin, "Berliner Kindheit," 241.

37 Jan Mieszkowski, *Watching War* (Stanford: Stanford University Press, 2012), 5.

38 Mieszkowski, *Watching War*, 1–29.

39 See also the discussion of Clausewitz in Anders Engberg-Pedersen's *Empire of Chance: The Napoleonic Wars and the Disorder of Things* (Cambridge, MA: Harvard University Press, 2015).
40 Carl von Clausewitz, *On War*, trans. Colonel J.J. Graham (London: Routledge, 1966), 78. German translation: "Friktion ist der einzige Begriff, welcher dem ziemlich allgemein entspricht, was den wirklichen Krieg von dem auf dem Papier unterscheidet." Clausewitz, *Vom Kriege* (Frankfurt am Main: Ullstein, 1980), 77.
41 Grau, *Virtual Art*, 237–240.
42 See also the discussion of Wall's *Restoration* in Mieszkowski, *Watching War*, 91–94.

Bibliography

Anderson, Benedict. *Imagined Communities: Reflections on the Origin and Spread of Nationalism*. London: Verso, 1991.
Ascott, Roy. *Telematic Embrace: Visionary Theories of Art, Technology, and Consciousness*. Berkeley: University of California Press, 2001.
Benjamin, Walter. "Berliner Kindheit um Neunzehnhundert." In *Walter Benjamin: Gesammelte Schriften*, edited by Rolf Tiedemann, vol. 4.1, 235–304. Frankfurt am Main: Suhrkamp, 1972.
———. "Das Passagenwerk." In *Walter Benjamin: Gesammelte Schriften*, edited by Rolf Tiedemann, vol. 5.1, 9–654. Frankfurt am Main: Suhrkamp, 1982.
———. *The Arcades Project*. Translated by Howard Eiland and Kevin McLaughlin. Cambridge, MA: The Belknap Press by Harvard University Press, 1999.
Bentham, Jeremy. "The Panopticon Letters." In *The Panopticum Writings*, edited by Miran Božovič, 31–95. London: Verso, 1995.
Böhme, Jacob. "De tribus principiis, oder Beschreibung der Drey Principien Göttliches Wesens." *Jacob Böhme: Sämtliche Schriften*, vol. 2, 1–493, edited by Will-Erich Peuckert. Stuttgart-Bad Cannstadt: frommann-holzboog, 1960.
Buddemeier, Heinz. *Panorama, Diorama, Photographie: Entstehung und Wirkung neuer Medien im 19. Jahrhundert*. München: Fink, 1970.
Clausewitz, Carl von. *On War*. Translated by Colonel J.J. Graham. London: Routledge, 1966.
———. *Vom Kriege*. Frankfurt am Main: Ullstein, 1980.
Crary, Jonathan. *Techniques of the Observer: On Vision and Modernity in the Nineteenth Century*. Cambridge, MA: MIT Press, 1992.
Engberg-Pedersen, Anders. *Empire of Chance: The Napoleonic Wars and the Disorder of Things*. Cambridge, MA: Harvard University Press, 2015.
Grau, Oliver. *Virtual Art: From Illusion to Immersion*. Translated by Gloria Custance. Cambridge, MA: The MIT Press, 2003.
Hebekus, Uwe. *Klios Medien: Die Geschichtskultur des 19. Jahrhunderts in der historistischen Historie bei Theodor Fontane*. Tübingen: Max Niemeyer, 2003.
Hyde, Ralph. *Panoramania! The Art and Entertainment of the All-Embracing View*. London: Trefoil Publications, 1988.
Kleist, Heinrich von. "Brief vom 16. August 1800 aus Berlin am das Stiftsfräulein Wilhemine von Zenge in Frankfurt/Oder." In *Heinrich von Kleist: Sämtliche Werke und Briefe*, vol. 2, 515–522, edited by Heinrich Sembdner. München: Deutscher Klassiker Verlag, 1961.
———. "Empfindungen vor Friedrichs Seenlandschaft." In *Heinrich von Kleist: Sämtliche Werke und Briefe*, vol. 2, 327–328, edited by Helmut Sembdner. München: Hanser, 1961.
Maurer, Kathrin. *Visualizing the Past: The Power of the Image in German Historicism*. Berlin: Walter de Gruyter, 2013.
Mieszkowski, Jan. *Watching War*. Stanford: Stanford University Press, 2012.
Millin, Aubin Louis. "Panorama." In *Dictionaire des Beaux Arts*, vol. 3, 38–41. Paris: de L'Imprimerie de Crapelet, 1806.

Moser, Mary Anne, ed. *Immersed in Technology: Art and Virtual Environments*. Cambridge, MA: MIT Press, 1996.

Morse, Margaret. *Virtualities: Television, Media Art, and Cyberculture*. Bloomington: Indiana University Press, 1998.

Muther, Richard. *Geschichte der Malerei im 19. Jahrhundert*, vol. 2. Leipzig: Grethlein, 1909.

Oettermann, Stephan. "Die Reise mit den Augen: 'Oramas' in Deutschland." In *Sehsucht: Das Panorama als Massenunterhaltung des 19. Jahrhunderts*, edited by Marie-Louise von Plessen and Ulrich Giersch, 42–51. Frankfurt am Main: Stroemfeld/Roter Stern, 1993.

——. *The Panorama: History of a Mass Medium*. Translated by Deborah Lucas- Schneider. New York: Zone Books, 1997.

Robichon, François. "Die Illusion eines Jahrhunderts: Panoramen in Frankreich." In *Sehsucht: Das Panorama als Massenunterhaltung des 19. Jahrhunderts*, edited by Marie Louise von Plessen, 52–63. Frankfurt am Main: Stroemfeld/Roter Stern 1993.

Sadowski, Wallace and Kay Stanney. "Presence in Virtual Environments." In *Handbook of Virtual Environments: Design, Implementation and Applications*, edited by Kay Stanney, 791–806. Mahwah, NJ: Lawrence Erlbaum, 2002.

Schivelbusch, Wolfgang. *The Railway Journey: The Industrialization of Time and Space in the Nineteenth-Century*. Berkeley: University of California Press, 1986.

Sternberger, Dolf. "Panorama oder Ansichten vom 19. Jahrhundert." In *Schriften*, vol. 5, 1–199. Frankfurt am Main: Insel, 1991.

Werner, Anton. *Erlebnisse und Eindrücke*. Berlin: Mittler, 1913.

Werner, Anton, Eugen Bracht, and Ludwig Pietsch. *Panorama der Schlacht Sedan*. Berlin: Photographische Gesellschaft, 1885.

Zantop, Susanne. *Colonial Fantasies: Conquest, Family, and Nation in Precolonial Germany. 1770–1870*. Durham: Duke University Press, 1997.

6 Post-Traumatic Stress Disorder in Drone Operators

Relying on Uncertainty in Omer Fast's *5,000 Feet is the Best* (2011)

Svea Braeunert

Drones are considered a game-changer in warfare. Models such as the MQ-9 Reaper and the MQ-1 Predator are unmanned planes equipped with hellfire missiles and a gimbal with sensors and cameras. They allow crews to stay in their home countries and engage in action from afar, thereby multiplying the sites where war takes place. Instead of being deployed in the target regions, pilot and sensor operator fight on screen where they collect data, track individuals, and zoom in on targets. Their tasks are classic screen operations, i.e. actions that are undertaken through the manipulation of data and digital images on screen. Screen operations, as we currently witness them in drone warfare but also in other fields such as surgery, manufacturing or architectural planning, are realizations of Harun Farocki's hypothesis that images have entered a state in the twenty-first century where they do not solely *show* things but also *do* things.[1] In the case of drone warfare, their main task is to track and target individuals or their corresponding patterns of life.

With the proliferation of screen operations, images have received a new quality. They are active agents that can have a deep effect on those working with them. This is at least suggested by drone operators who suffer from post-traumatic stress disorder (PTSD). PTSD is an interesting phenomenon because it troubles assumptions about drone warfare and exposes some of its paradoxes, including an image of the drone as disembodied, unmanned, and removed. The mental condition proposes that although drone operators may be shielded from physical danger, they are nevertheless exposed to psychic risks; and part of their psychic vulnerability seems to come from the drone's visuals. Yet while PTSD is a clinical condition whose specifics in regard to drone warfare are only slowly examined, the following argument is not primarily invested in a clinical reading but in a cultural interpretation. It does not present empirical data, medical trials, or even case studies. Instead, in a first step it looks at a select number of these studies and interprets their findings through the lens of visual culture, art criticism, and political philosophy. In a second step, the argument is refined and complicated by looking at an artwork dealing with PTSD in drone operators, namely Omer Fast's semi-documentary *5,000 Feet is the Best* (2011). The film completes the transposition from a clinical into a cultural field by telling the story of PTSD as a story of cultural trauma that is concerned with troubling representation and evoking uncertainty on the side of the viewer.

The objective of a cultural reading of PTSD in drone operators is to explore some of the changes the use of drones may bring about, including the effect images and screen operations can have on the viewer's imagination, altering long-received notions that an increase in distance results in a decrease of one's inhibition to kill. The idea,

particularly in the second part of the essay, is furthermore to address drone warfare as an issue at the intersection of aesthetics and politics, therefore understanding it as "a regime of figuration, a way of seeing, and, therefore, a modality of thought."[2] This includes asking: What kind of vision is drone vision? How is it connected to certain techniques and technologies? In what ways does it enable the waging of war from afar, including the conditioning of emotions and the cultural framing of potential targets? What is drone warfare's larger cultural and political context? How does it affect not just the communities that are targeted but also the communities from which wars are waged? And what role can art play in understanding and countering some of these dynamics, as they are bound to scopic regimes and visual cultures of conflict?

The Psychic Effects of Waging War on Screen

When the drone program was launched in the early 2000s, it was assumed that operators would not develop symptoms of PTSD because they were sheltered from physical danger and could stay home with their families and social communities. "In the language of public health, primary prevention of combat PTSD requires elimination of the source of the injury, which is to say, elimination of combat."[3] Drones promised to do away with combat by creating physical distance between operators and targets, thereby keeping soldiers safe from bodily harm. Yet it became clear that traditional understandings of combat were no longer appropriate for drone warfare, because even though drone crews were physically protected, some of their members were nevertheless suffering psychologically. It was through a 2011 Air Force study that the phenomenon of PTSD in drone operators was first prominently discussed. The study differentiates between operational stressors and combat stressors, arriving at the surprising conclusion that operational factors had a more significant impact on soldiers than those directly related to combat. "Operational stressors are defined as those related to sustaining operations. These include issues such as available manpower, equipment, and general resources needed to accomplish occupational tasks and objectives."[4] In other words, operational stressors are about the working conditions of remote warfare. They are concerned with "long hours, low manning, shift work, human-machine interface difficulties, geographical location of work, concerns regarding career profession and incentives."[5]

Operational stressors include factors more in line with work than with traditional understandings of combat, giving war an everyday dimension. It is an understanding that ties in with the fact that drone crews stay home while waging war. "For a new generation, 'going to war' doesn't mean shipping off to some god-forsaken place to fight in a muddy foxhole but a daily commute in your Toyota Camry to sit behind a computer screen and drag a mouse,"[6] Peter Singer says. Work descriptions such as this have earned operators the nickname "combat commuters."[7] However, while it was assumed at first that staying home would help drone personnel cope with war, a number of them actually found juggling the different roles and responsibilities challenging. One of them says: "To go to work, and to do bad things to bad people, and then when I go home and go to church and try to be a productive member of society, those things don't necessarily mesh well."[8]

In addition to the mingling of military and civilian duties, emphasizing the labor dimension of drone warfare also connects the phenomenon of PTSD in drone operators to a general discussion about whether or not one can be traumatized by witnessing

events on screen. The American Psychiatric Association acknowledged the increasing impact of screen media by stating in its fifth edition of the *Diagnostic and Statistical Manual of Mental Disorders* that factors causing PTSD must not result from exposure to "media, pictures, television or movies unless work-related."[9] Taking into account the importance of operational stressors, drone warfare clearly constitutes such a work-related exposure to images on screen that can have a traumatizing effect on those not just watching them but also using them as tools.

The visual impact of drone warfare is accounted for under the rubric of combat stressors. Combat stressors are defined as those that involve ISR (intelligence, surveillance, reconnaissance) and weapon-deployment missions that are in direct support to combat operations. For many operators, combat-related stressors include (a) precision targeting and destroying enemy combatants and assets where mistakes may come at a high price; (b) exposure to hours of live video feed and images of destruction to ensure combatants have been effectively destroyed or neutralized; (c) making critical decisions regarding the identifications of enemy combatants and providing effective force protection to ground troops to reduce casualties of friendly forces and civilian bystanders; and (d) the unique demand for RPA operators to simultaneously juggle one's war fighter role while having to sustain one's domestic roles and responsibilities.[10]

As the list of combat stressors makes clear, drones are changing the experience of war. The stress is not on one's physical vulnerability anymore but on decisions, actions, and forms of witnessing mediated by screens. The persistence of stress factors reveals "that any attempt to achieve invulnerability in turn engenders a corresponding vulnerability."[11] In the case of drone warfare, the vulnerability is transferred from body to mind, as what is affected first and foremost are the sense of vision and the imagination. The shift is part of a general trend towards a proliferation in screen operations. Screen operations not only renegotiate the relationship between humans and machines, but they also alter forms and understandings of proximity and distance: spatially, physically, and psychologically. Therein, the proliferation of screens also has a profound effect on the waging, experience, and representation of war.

Visual Proximity and Physical Distance

Two standard texts discussing the role of proximity and distance in regard to a person's willingness to engage in violence are from the pre-drone age: Carlo Ginzburg's *Killing a Chinese Mandarin* (1994) and Dave Grossman's *On Killing* (1995). Their central hypothesis is that killing becomes easier the further removed one is physically, socially, or culturally from the victim. They are interested in the responsibility of the senses, the function of technological interfaces, and the interaction between senses and technology. Deliberating these aspects, Ginzburg emphasizes the importance of vision, quoting the following passage from Denis Diderot's *Letter on the Blind, for the Use of Those Who See* (1749):

> Since the blind are affected by none of the external demonstrations that awaken pity and ideas of grief in ourselves, with the sole exception of vocal complaints, I suspect them of being, in general, unfeeling toward their fellow men. [...] Do we ourselves not cease to feel compassion when distance or the smallness of the object produces the same effect on us as lack of sight does on the blind? [...] I feel

quite sure that were it not for fear of punishment, many people would have fewer qualms at killing a man who was far enough away to appear no larger than a swallow than in butchering a steer with their own hands. And if we feel compassion for a horse in pain though we can crush an ant without a second thought, are these actions not governed by the selfsame principle?[12]

In the argument that follows, Ginzburg turns to a figure that in nineteenth-century France became known as killing the mandarin, which was falsely connected to Jacques Rousseau after Honoré de Balzac had accredited it to him in *Old Goriot* (1835). Its central question is whether killing a Chinese mandarin becomes easier and can be carried out with little to no moral constraints because the mandarin is both geographically and culturally removed and no relation or likeness—be it physical, visual, or emotional—can be established to him. Ginzburg then updates the idea of killing a mandarin by mentioning modern warfare:

In the most widespread version of the story, the Chinese mandarin can be killed simply by pressing a button; this is a detail more consistent with modern warfare than with the traditional attribution of the story to Rousseau. Airplanes and missiles have proved the truth of Diderot's conjecture, that it would be much easier to kill a human being if he or she would look no larger than a swallow. Bureaucratic progress went in the same direction, creating the possibility of dealing with large groups of human beings as if they were mere numbers, which is also a most effective way of distancing them.[13]

Drone warfare too is often imagined as pressing a button from afar in order to administer a kill that is not primarily directed at humans made out of flesh and blood but at abstract figures composed out of data. Taking the story of the Chinese mandarin and combining it with Diderot's *Letter on the Blind*, Ginzburg arrives at an image of modern war that is based on controlling the senses. He understands war vision mediated by weapons and technology to create a similarly distancing effect as being blind. It removes the relational aspect from the act of seeing, furthers abstraction and miniaturizes the object, so that shooting someone becomes akin to crushing an ant—an act that is only possible because one cannot properly relate to the crushed object/subject.

Grossman discusses similar aspects in regard to the act of killing in war. Convinced "that there is a direct relationship between the emphatic and physical proximity of the victim, and the resultant difficulty and trauma of the kill,"[14] he charts a graph covering the spectrum from maximum range (bomber, artillery) to sexual range. "'Maximum range' is defined as a range at which the killer is unable to perceive his individual victims without using some form of mechanical assistance—binoculars, radar, periscope, remote TV camera, and so on."[15] Important factors of a kill at maximum range are that one cannot see or hear the victim, that the victim cannot see oneself, and that one cannot say with certainty that one is responsible for the kill. Maximum range thus furthers dehumanization; it is based on distancing oneself from one's actions and targets. A close range kill, on the contrary, confronts the killer with the humanity of the victim. "When one looks an opponent in the eye, and knows that he is young or old, scared or angry, it is not possible to deny that the individual about to be killed is much like oneself."[16]

Drones trouble the connection between proximity, distance, and the management of emotions. On the one hand, they physically remove operators from the battlefield, increase geographical distance, and separate combatants from their weapon. On the other hand, distance is no longer coupled with blindness, since the drone is designed first and foremost as a vision machine. "Physical distance no longer necessarily implies perceptual distance,"[17] writes Grégoire Chamayou.

> This new combination of physical distance and ocular proximity gives the lie to the classic law of distance: the great distance no longer renders the violence more abstract or more impersonal but, on the contrary, makes it more graphic, more personalized.[18]

Drone technology creates new forms of intimacy often referred to as being only 18 inches away from the battlefield, which corresponds to the distance between the operator's eye and screen, suggesting that it may be the relation between screen, eye, and joystick that is relevant when thinking about the new configuration of proximity and distance in drone warfare.

But what can one actually see through a drone's eye-view? Although there is little doubt that images are an important factor in drone warfare, there is some debate about what they show. While there are reports, including statements by former sensor operator Brandon Bryant,[19] that stress the haunting description and graphic immediacy of drone vision, others describe the drone's images as ambiguous and undefined. Fast's interview partner for instance recounts that

> at about seven miles you can see the buildings, you can see cars and you can tell there's somebody. You couldn't tell if they're male or female or any other characteristics. But you can tell that there is a person.[20]

Chamayou has suggested that this kind of abstraction is not a technical flaw but an intentional configuration meant to enable killing. He writes:

> The resolution, although detailed enough to allow the operator to aim, is not good enough to distinguish faces. All that the operators can see are little figures blurred into facelessness. [...] This figurative reduction of human targets helps to make the homicide easier. [...] It shows just enough to make it possible to take aim, but not enough to get a clear view.[21]

In regard to drone operators developing PTSD, the image's low-definition can be interpreted in two ways. On the one hand, one can say that even though drone warfare may create a sense of "ocular proximity," its images allow operators to distance themselves because they are technological abstractions that do not show human beings but figures—a form of distancing Grossman describes as "mechanical distance, which includes the sterile Nintendo-game unreality of killing through a TV screen, a thermal sight, a sniper sight, or some other kind of mechanical buffer"[22] and is today usually referred to as Play Station mentality.[23] On the other hand, however, it is well known from abstract art that it is often the non-representational images that call on a viewer's imagination and draw them in emotionally. Precisely because it is not clear at first sight what is shown, the viewer fills in the gaps with his or her own phantasies,

mentally occupying the image. When these non-representational images have real-life references in war and violence, they can take on a haunting quality. Abstraction is therefore by no means a form of safeguarding against the psychological impact images can have—especially if these images are active participants in the waging of war.

Drone operators suffering from PTSD testify to the importance of images in (this) war. Still it is crucial to note that they are psychologically affected not just by what they see but also by what they do, since they have to watch the effects of their own deeds. After an attack, drone crews are often ordered to stay on site for battle damage assessment. When the intelligence the attack was based on was flawed or when civilians were involved, this can be a daunting task; and even when an attack has gone according to plan, guilt and doubt may arise in drone crews. It is the guilt of having killed in an asymmetrical war, in which only one side is exposed to lethal danger. It is the guilt of having violated a system of valor that is still built on the reciprocity of chivalry. And it is the guilt of administering deadly strikes on the basis of intelligence that has repeatedly erred and that defines all men over the age of 16 as potential combatants. As a former operator said:

> If you weren't told any different you would think it was just five to a dozen guys sitting around a camp fire. You have to take it on faith that these guys were tracked to this point, that they know these guys are Taliban.[24]

If you lose that faith, moral uncertainty and emotional instability may result. There are many ways in which these states of mind can manifest; and there are just as many ways in which they can be addressed. Nevertheless, there is a discernable trend to equate drone warfare's moral and psychological uncertainties with its visual uncertainties, thereby emphasizing the importance of images. Two decades after the pictorial turn, drone warfare is realizing its hypothesis that images do not solely show things, but also want and do things. Given their central role in the war's operations, questioning images can hence become a means to question the war itself; something art is well equipped to do. It explores drone warfare on the level of its images and visual politics. In that regard, PTSD is an interesting phenomenon for art and visual studies, because it asks about the emotional effect images can have and troubles long-held assumptions about the connection between physical and emotional distance, suggesting that images create new forms of intimacy and precariousness that are based on vision.

Unsettling Certainty in Fast's Semi-Documentary

Omer Fast's artist film *5,000 Feet is the Best* (2011) is one of the most widely received artworks to explore the phenomenon of PTSD in drone operators. The video's "starting point was a series of conversations with the sensor operator of an unmanned aerial vehicle"[25] who suffers from PTSD and shares a number of traits with Brandon Bryant although his identity within the film is concealed. Fast condensed and translated parts of his conversation with the operator into a 30-minute video loop that follows the format of the semi-documentary. Part fiction and part documentary, it explores fundamental paradoxes of drone warfare as they play out in the equally fundamental tension that defines the relationship between trauma and representation. Or as T.J. Demos puts it: "Fast's piece [. . .] translates psychic effects into representational problems.

In [. . .] exploiting the confusion between fact and fiction, it captures the contemporary phenomenology of virtual combat."[26]

In order to achieve this effect, the video works with two forms of filmic presentation and comprises three themes that are each repeated three times: fiction-like episodes that follow a dream logic, documentary-like episodes that combine interview sequences with aerial views, and scenes in a hotel room and corridor that function as transitional spaces between the fictional and the factual. The fictional sequences are highly staged and tell stories that border on the absurd. The first is about a boy who was given a train-set by his father who abandoned him as a child. The boy grew up to be a man who loved trains and learned all about them by watching people work in train yards. One day he decides to pretend to be a train conductor; he gets himself into the uniform and in the driver's cab and has a successful working day. Nobody notices the *as if* in his game. Still he gets arrested once he is home, because he had to break into his house after forgetting his keys. The second story is about a couple that plays a scheme at the Luxor hotel and casino in Las Vegas. It involves the woman seducing men; she brings them up to her room where they are surprised by her partner enacting the role of the jealous husband. The man is thrown out of the room in anger and without his pants. Afterwards his credit card details are copied and he is returned his pants or given a pair that look just like them. The various kinds of pants are stored in the bathroom, so that there is always a right copy at hand to switch them around. While the first two stories are linked to drone warfare solely by an associative imagination, the third episode is more immediately connected to the topic. It tells the story of a suburban family in California that goes on a road trip. They drive along highways, pass checkpoints controlled by the Chinese provisional authorities, and eventually end up on a dirt road where they encounter men digging a hole in the ground. The men carry rifles and seem to bury a roadside bomb. A drone watches the scene overhead. It eventually fires a missile at the three potential suspects and also hits the family as collateral damage. Still, the family steps out of the car and walks down the road, so that the video can loop back and start from the 'beginning'.

Interspersed with the three episodes filmed in a decisively fictional register are sequences documenting parts of the interview Fast conducted with the sensor operator. The operator's face is blurred and his voice is altered to protect his identity but also to create the impression that viewers are watching documentary footage. The operator talks about the drone's functions and operational capacities, the set-up of the ground control station, his daily routines, and the long-term psychological challenges. In the process, he presents the drone's view as omnipotent and sharp—a claim that is supported by the film's aerial views. The operator says:

> Five thousand feet is the best. We love it when we're sitting at five thousand feet. You have more description. Plus, at five thousand feet, I could tell you what type of shoes you're wearing. From a mile away! I could tell you what type of clothes a person's wearing and if they have a beard, their hair color and everything else. So there are very clear cameras on board.

He furthermore claims that it was the high-definition and visual description that traumatized him. After all,

there's horror sides to working the Predator. You see a lot of death. You know, you see it all. As I said I could tell you what type of shoes you're wearing from that far away. Hell, it's pretty clear about everything else that's happening.

However, *5,000 Feet is the Best* does not reenact drone warfare's potentially horrific images to visualize the operator's experience. Instead, the film shows aerial views of American landscapes, which I will discuss later on; and it finds stories that are indirectly linked to the emotional reality of the operator's experience, thereby mimicking the psychoanalytic concept of the talking cure. The film hence translates a primarily visual condition that is the drone into a psychological condition that is the operator suffering from PTSD, which is again translated into a textual or narrative condition. This narrative condition is played out in the seemingly absurd and far-fetched stories about a wannabe train conductor and a deceptive couple in Las Vegas. They deny a straightforward legibility, thus unsettling the viewer. The unsettling takes place through the metonymic character of the stories that displace the topic of drone warfare; but it also takes place in setting up a tension between text and image—what you see does not necessarily correspond to what you hear—and in mixing fact and fiction.

One subtle way in which the film mixes fact and fiction is through the reality fragments placed within the film's dream sequences. They originate in the hotel corridor into which the actor-operator steps after each talking-session to escape the situation and smoke a cigarette. It is here that he first encounters the man who will later become the train conductor; it is here that he sees a pair of trousers hung outside the door for the cleaners; and it is here that the maid gives him the bottle of pills he takes throughout the interview. Aspects from different fictions are thus woven together, turning one fiction into a reality fragment for another fiction. Parts of the stories, however fictitious, are hence not just prompted by reality fragments but are also partially anchored in reality: the reality of the film. Combining fact and fiction, Fast's storytelling suggests that everything is connected with everything else and could eventually become important. As a result, a paranoid or forensic viewing is furthered, which is set on uncovering hidden connections yet can never be entirely sure of itself or the material it deals with.[27] It is based on a radical uncertainty that serves to distance reality by estranging it. In the end, reality, including the reality of drone warfare, seems just as strange as a dream or fiction.

Working with notions of uncertainty and exploring the porous realm between fact and fiction, Fast is part of a current trend in art and theory to rethink forms of realism and modes of documentation. It is a trend that is particularly discernable in video art employing a semi-documentary format to address traumatic histories and experiences.[28] It corresponds to Jacques Rancière's claim that "writing history and writing stories come under the same regime of truth,"[29] which

> is not a matter of claiming everything is fiction. It is a matter of stating that the fiction of the aesthetic age defined models for connecting the presentation of facts and forms of intelligibility that blurred the border between the logic of facts and the logic of fiction.[30]

In *5,000 Feet is the Best*, this blurring of fact and fiction not only comes to the fore in the film's combination of interview sequences with highly staged scenes and realistic aerial views, but it also takes place in the way in which the film adheres

to the model of the Freudian talking cure by telling words for images and giving narrative for information. The stories that result are far-fetched and absurd; but they are nevertheless anchored in reality, thereby suggesting that sometimes reality, even more so than fiction, has an excessive character and cannot be grasped easily. This is specifically true in our contemporary political moment when reality has become so absurd at times that the documentary forms addressing it have to do the same, i.e. they have to look at fictional rather than factual modes of expression (or do away with that divide altogether) to 'get it right'.

Hito Steyerl is invested in a similar logic and specifies it in regard to the uncertainty that comes out of the documentary images of contemporary wars. Engaging with documentary pictures that have barely any representational quality because they are so abstract, blurry or undefined, she claims that they nevertheless show "a deeper characteristic of many contemporary documentary pictures: the more immediate they become, the less there is to see. The closer to reality we get, the less intelligible it becomes."[31] Therefore, Steyerl sees an "uncertainty principle"[32] at work in current dealings with documents, which she asks viewers not to understand as "some shameful lack, which has to be hidden," but to see it instead as "the core quality of contemporary documentary modes as such." For "the only thing we can say for sure about the documentary mode in our times is that we always already doubt if it is true."[33] Uncertainty and doubt are productive counter-forces to a political culture that puts ever more belief in images and data. The uncertainty principle of the semi-documentary turns against these belief-systems by unsettling the viewer. In *5,000 Feet is the Best*, the unsettling takes place in a de-coupling of words and images, in the placing of random clues that let viewers draw paranoid connections, and in evoking the question: "What does this have to do with being a drone operator?"

Taking the experience of a sensor operator suffering from PTSD as his basis for dealing with drone warfare, Fast acknowledges the importance of images and the role they play in shifting psychic burdens and bringing the supposedly distant war close. But instead of focusing his artistic explorations solely on the visual realm, he also translates the uncertainty of vision into the unreliability of the film's narrative. In order to do so, he relies on the unreliability of trauma, i.e. he employs trauma as something that can be brought to bear upon artistic representation in times of increased contingency. Trauma troubles representation. Its historical connections only come to the fore in fragments and symptoms that are the result of shifts and displacements. Therefore, uncertainty is inherent to trauma in the way it is inherent to contemporary documents. Employing it as an aesthetic category allows Fast to mingle fact and fiction and unsettle a political constellation operating on claims of certainty.

Displacement and Identification

Demos has pointed out that uncertainty "invites the entrance of the engaged spectator, by setting up a situation of indeterminacy that demands a certain interpretive agency. [. . .] We are asked to participate—aesthetically, affectively, conceptually—in the making sense of these new conditions."[34] The figure of the engaged spectator who completes the image through her knowledge and imagination is enforced in *5,000 Feet is the Best* through a displacement of sites that invites identification on the side of the viewer. Although the film "is about the endless war that always occurs somewhere else—Iraq, Afghanistan, Pakistan—[it] takes place entirely within the United States,"[35]

showing US sites and landscapes, including a suburb in the Nevada desert, a small town in New England, and the Las Vegas strip.

Yet what seems like a displacement at first is actually in line with the visual, spatial, and cultural politics of drone warfare. The film sets up a relational geography between the US and its battlefields in the Middle East that lets viewers see the similarity in landscapes. "A lot of it actually looks like the Las Vegas desert," Fast's interview partner said. "A lot of flat land. A lot of shrubs. Small patches of trees. That's what we're usually working with."[36] Beyond the likeness in landscapes, however, relational geography also points to the fact that contemporary wars do not merely take place elsewhere; instead, a lot of their communication and infrastructure is based in America. The drone program makes these connections palpable, because it places operators and analysts in the US, thereby creating an infrastructure that literally brings the war home.

Stationed in the US and often living off base, drone operators embody the changing conditions of contemporary wars. They turn the drone's remoteness into an uncomfortable closeness, its otherness into familiarity. Also, their presence brings military into civilian life and troubles distinctions between war and peace, replicating a state where war is no longer circumscribed; it is potentially everywhere and has neither a clearly defined beginning nor end. Caroline Holmqvist wonders about the effects this expansion will have on society, taking operators suffering from PTSD as a case in point:

> If drone operators are not as shielded from the realities of war as is generally assumed, what might they be bringing into the wider communities of which they are part? To what extent are their experiences theirs alone, and to what extent do we see them seeping out in a wider social corpus?[37]

These questions are important not only because operators and veterans suffering from PTSD do affect the communities they live in and closing our eyes to their suffering is unjust and irresponsible, but also because drones have the potential to cause far-reaching changes that will have an impact on everyone. Chamayou asks: "To what do [drones] lead, not only in terms of their relation to the enemy but also in terms of the state's relation to its own subjects?"[38] His question applies to military and to civilian drone usage alike, because both have the power to affect our being in the world— perceptually, spatially, and emotionally.

Fast alludes to the civilian and self-referential aspects by showing images of a drone war that takes place in the US (e.g. see Figure 6.1). Apart from getting at the domestic site of remote warfare, the displacement serves to overcome the cultural and emotional distance of a war supposedly happening elsewhere. It is a strategy of evoking empathy and creating attention by turning the power dynamics around and wondering what it would be like to live under drones. The turnaround becomes manifest in the third episode that tells the story of a drone attack on a family in California. The episode not only juxtaposes a tale about a family in the tribal region of Waziristan with American landscapes, but it also introduces a third actor, which are the Chinese provisional authorities. The fact that the occupation is Chinese is a distant reminder of the nineteenth-century idea of killing a Chinese mandarin from afar; only now the Chinese mandarin is killing us: with a drone whose black and white feed displays a technical image that is illegible (unless you know Mandarin). It rightfully makes Liz Kotz wonder: "Whose nightmare is this?"[39]

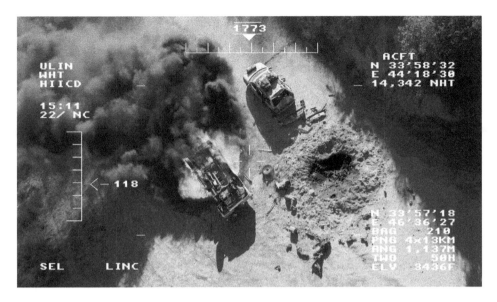

Figure 6.1 Still from Omer Fast *5,000 Feet is the Best* (2011).
Source: Courtesy of Omer Fast and Arratia Beer, Berlin.

It is a very apt question, because there is yet another twist to the visual logic applied by Fast, which has to do with the visual identification the drone offers. Derek Gregory has pointed out that operators talking about intimacy and identification usually do not refer to the local population but to coalition forces on the ground.

> When officers at Creech argued that "the amount of time spent surveilling an area" from a UAV creates "a greater sense of intimacy" than is possible from conventional aircraft, they were describing not their familiarity with the "human terrain" of Afghanistan but their identification of—and crucially *with*—American troops in the battlespace [...] When a Predator pilot claimed that "I *knew* people down there," it was not local people he claimed to "know": "Each day through my cameras I snooped around and came to recognize the faces and figures of our soldiers and marines." [40]

The connection between drone operators in the US and coalition forces in the Middle East is addressed in *5,000 Feet is the Best* as a case of select and privileged vision, which becomes manifest in the *Light of God*. "It's our laser targeting marker," the operator explains. "We just send down a beam of laser and when the troops put on their night-vision goggles they'll just see this light that looks like it's coming from heaven. Poof! Right on the spot. Coming out of nowhere from the sky! It's quite beautiful." The *Light of God* is symptomatic for the drone's scopic regime because it is based on an understanding of vision that is communal and one-sided. Only one's own side can see the laser beam by using special technical gear. The other side is blind to what will potentially become lethal to them. The ability to see is hence coupled with the ability to dominate and kill. Plus, the laser beam creates a sense of community

between the far-away operators and the troops on the ground. Gregory sees this iden-
tification as highly problematic because it privileges one's own point of view and has
a tendency to negate ambiguity and escalate difference. Commenting not just on the
Light of God but also on drone warfare's general scopic regime, he writes: "In this
new military optic, both points of view are always 'ours.'"[41] It creates "a techno-
cultural system that renders 'our' space familiar even in 'their' space—which remains
obdurately Other."[42]

Fast reenacts the one-sidedness of the drone's visual field by situating *5,000 Feet
is the Best* in the US. He thereby offers a peculiar and potentially troubling view onto
drone warfare that could be said to suppress the experience of people in the target
regions who are suffering under the ubiquitous presence and lethal threat of drones.
Instead of telling their stories, Fast concentrates on the stories of drone operators. And
instead of showing landscapes in the Middle East or Africa, he shows sites in the US.
Yet far from shielding viewers from uncomfortable questions and encounters, he actu-
ally turns on them, asking them about their views and identifications. We are these
viewers. And we are the ones who are asked: How do we look at this war? In what
ways are we implied by it? What are our responsibilities and neglects? How will it
shape us? Kotz suggests:

> The work constructs a domestic viewer, for whom the war is distant, something
> that happens only on TV and in the newspaper. With its idealized American land-
> scapes, *5,000 Feet is the Best* is arguably addressed to an American viewer for
> whom these scenes are deeply familiar and evocative. [...] These landscapes tug at
> us, drawing us into the story through their simple and deep familiarity. Quietly,
> quickly, war and normal life converge.[43]

The familiarity of the scenes is appealing and appalling at the same time. It asks us to
identify with what we see and to also potentially identify with the story and position of
the drone operator. In that, the film points to the cultural reduction and one-sidedness
of drone vision but it also points to the phenomenon of PTSD as a domestic issue that
brings the war home and forces communities to deal with the ramifications of a war
they may rather want to forget about. By placing it in a wider social context, the film
replicates the idea of psychologists and cultural theorists that traumatic stories need
to be communalized, because "unhealed combat trauma [. . .] destroys the unnoticed
substructure of democracy, the cognitive and social capacities that enable a group of
people to freely construct a cohesive narrative of their own future."[44] In an attempt to
communalize the operator's experience, the film puts us in a position of listening to
him and viewing his vivid imaginations, thereby asking us to engage with it and make
its metonymies part of our mental, emotional, and political order. We may want to
resist the identification, but the familiar images pull us in. And then we realize that
they put a demand on us. Or as Jonathan Shay writes:

> Without emotion in the listener there is no communalization of the trauma. To
> achieve trust, listeners must respect the narrator. [...] Respect, embodied in this
> kind of listening, is readiness to be changed by the narrator. The change may be
> small or large. It may be simply learning something not previously known, feeling
> something, seeing something from a new perspective, or it may be as profound as
> a redirection of the listener's way of being in the world.[45]

Listening to someone else's trauma is connected to the aesthetic effect of uncertainty. It can unsettle us, shift our point of view, and let us rethink commonly held believes. It addresses us on the level of experience: others and ours. Fast realizes this emotional transfer through a cultural transfer. Situating drone warfare in the heart of everyday America, he offers an uncomfortable identification that is both shield and assault. It asks us to relate to drone operators suffering from PTSD and see their experience as ours, thereby turning their psychological vulnerability into a collective condition that shapes the community.

Notes

1 See Harun Farocki. *Eye/Machine I–III* (2001–2003) double-channel videos, 65 min. total, Harun Farocki Film Production.
2 Nathan K. Hensley, "Drone Form: Word and Image at the End of Empire," *e-flux journal 72* (2016): 3, accessed April 27, 2016, www.e-flux.com/journal/drone-form-word-and-image-at-the-end-of-empire.
3 Jonathan Shay, *Achilles in Vietnam: Combat Trauma and the Undoing of Character* (New York: Scribner, 2003), 196.
4 Wayne Chappelle, Amber Salinas, and Kent McDonald, *Psychological Health Screening of Remotely Piloted Aircraft (RPA) Operators and Supporting Units* (Wright-Patterson Air Force Base, 2012), 2, accessed May 13, 2014, www.dtic.mil/dtic/tr/fulltext/u2/a582856.pdf.
5 Chapelle et al., *Psychological Health Screening*, 1.
6 Peter Singer quoted in Medea Benjamin, *Drone Warfare: Killing by Remote Control* (London, New York: Verso, 2013), 87.
7 Scott Fitzsimmons and Karina Sangha, "Killing in High Definition: Combat Stress among Operators of Remotely Piloted Aircraft," *Canadian Political Science Association* (2013), 8, www.cpsa-acsp.ca/papers-2013/Fitzsimmons.pdf (accessed September 3, 2014).
8 Chris Chambliss quoted in Benjamin, *Drone Warfare*, 94.
9 American Psychiatric Association, "Post-Traumatic Stress Disorder: Fact Sheet," 2013, accessed June 19, 2017, www.aging.pa.gov/publications/policy-procedure-manual/Documents/PTSD%20Fact%20Sheet.pdf. Thanks to Jan Mieszkowski for pointing this out to me.
10 Chappelle et al., *Psychological Health Screening*, 3.
11 Grégoire Chamayou, *Drone Theory* (London: Penguin, 2015), 74.
12 Denis Diderot quoted in Carlo Ginzburg, "Killing a Chinese Mandarin: The Moral Implications of Distance," *Critical Inquiry* 21 (1994): 51.
13 Ginzburg, "Killing a Chinese Mandarin," 56.
14 Dave Grossman, *On Killing: The Psychological Cost of Learning to Kill in War and Society* (Boston, New York: Little, Brown & Company, 1995), 97.
15 Grossmann, *On Killing*, 107.
16 Ibid., 118.
17 Chamayou, *Drone Theory*, 116.
18 Ibid., 117.
19 Matthew Power, "Confessions of a Drone Warrior," *GQ*, October 23, 2013, accessed October 28, 2013, www.gq.com/news-politics/big-issues/201311/drone-uav-pilot-assassination. Brandon Bryant was the first operator to publicly speak about his experience in the US drone program. His testimonies gave the public important information on the operations of a largely classified war, the functioning of drones and the global communication and infrastructure system they rely on, earning him the international whistleblower award in 2015. Also, he was one of the co-signers of the letter addressed to President Obama, Secretary of Defense Carter, and CIA Director Brennan, in which former operators criticized the US drone program. The letter was published online in November 2015, www.documentcloud.org/documents/2515596-final-drone-letter.html.
20 "Brandon" in "Recorded Interview Extracts," in *Omer Fast: 5,000 Feet is the Best* (Berlin: Sternberg Press, 2012), 109. The former operator Fast talked to as part of his research for *5,000 Feet is the Best* remains anonymous, but he shares some characteristics with Brandon Bryant. Fast also gave him the first name "Brandon" in the interview he reprinted as part of the artist book.

21　Chamayou, *Drone Theory*, 117–118.

22　Ibid., 160.

23　The catchphrase is a nod to the military entertainment complex, evidenced by the military's use of games as recruitment and training tools and the modeling of the drone controller on the Play Station. Also, assuming that operators are prone to developing a Play Station mentality to killing continues the argument on the phenomenon of so-called killer games that are seen as perpetuating violence due to emotional numbing and an inability to differentiate between game and reality.

24　Chad Bruton quoted in Chris Woods, *Sudden Justice: America's Secret Drone Wars* (London: Hurst & Company, 2015), 171.

25　"Email from Omer Fast. February 4, 2012," in *Omer Fast: 5,000 Feet is the Best* (Berlin: Sternberg Press, 2012), 42.

26　T.J. Demos, "War Games: A Tale in Three Parts," in *Omer Fast: 5,000 Feet is the Best* (Berlin: Sternberg Press, 2012), 80.

27　For the concept of a forensic viewing of art see Ralph Rugoff, "More than Meets the Eye," in *Scene of the Crime*, ed. Ralph Rugoff (Los Angeles, Cambridge: Hammer Museum, MIT Press, 1997), 59–108.

28　See Sabine Eckmann, *In the Aftermath of Trauma: Contemporary Video Installations* (Chicago: Mildred Lane Kemper Art Museum, University of Chicago Press, 2014).

29　Jacques Rancière, *The Politics of Aesthetics: The Distribution of the Sensible* (London, New York: continuum, 2004), 38.

30　Rancière, *The Politics of Aesthetics*, 38.

31　Hito Steyerl, "Documentary Uncertainty," *Re-visiones* 1 (2011) [Reprint], accessed January 27, 2017, www.re-visiones.net/spip.php%3Farticle37.html.

32　Steyerl, "Documentary Uncertainty."

33　Ibid.

34　Demos, "War Games," 86.

35　Liz Kotz, "Bringing the War Home," in *Omer Fast: 5,000 Feet is the Best* (Berlin: Sternberg Press, 2012), 54.

36　"Brandon" in "Recorded Interview Extracts," 96.

37　Caroline Holmqvist, "Undoing War: War Ontologies and the Materiality of Drone Warfare," *Millennium—Journal of International Studies* 41 (2013): 543.

38　Chamayou, *Drone Theory*, 15.

39　Kotz, "Bringing the War Home," 60.

40　Derek Gregory, "From a View to a Kill: Drones and Late Modern War," *Theory Culture Society* 28 (2011): 200.

41　Ibid., 207.

42　Ibid., 201. Gregory is talking about the effect of high-resolution images in this instance, but the effect is similar for the light of god and the drone's scopic regime in general.

43　Kotz, "Bringing the War Home," 55.

44　Shay, *Achilles in Vietnam*, 181.

45　Ibid., 189.

Bibliography

American Psychiatric Association. "Post-Traumatic Stress Disorder: Fact Sheet," 2013. www.aging.pa.gov/publications/policy-procedure-manual/Documents/PTSD%20Fact%20Sheet.pdf (accessed June 19, 2017).

Benjamin, Medea. *Drone Warfare: Killing by Remote Control*. London, New York: Verso, 2013.

Chamayou, Grégoire. *Drone Theory*. London: Penguin, 2015.

Chappelle, Wayne, Salinas, Amber, and McDonald, Kent. *Psychological Health Screening of Remotely Piloted Aircraft (RPA) Operators and Supporting Units*. Wright-Patterson Air Force Base, 2012. www.dtic.mil/dtic/tr/fulltext/u2/a582856.pdf (accessed May 13, 2014).

Demos, T.J. "War Games: A Tale in Three Parts." In *Omer Fast: 5,000 Feet is the Best*, 77–87. Berlin: Sternberg Press, 2012.

Eckmann, Sabine. *In the Aftermath of Trauma: Contemporary Video Installations.* Chicago: Mildred Lane Kemper Art Museum, University of Chicago Press, 2014.

Fast, Omer. "Pleasure and Pain: Omer Fast interviewed by Marcus Verhagen." *Art Monthly* 330 (2009): 1–4.

——. "Email from Omer Fast. February 4, 2012." In *Omer Fast: 5,000 Feet is the Best*, 42. Berlin: Sternberg Press, 2012.

——. "Recorded Interview Extracts." In *Omer Fast: 5,000 Feet is the Best*, 89–123. Berlin: Sternberg Press, 2012.

Fitzsimmons, Scott, Sangha, Karina. "Killing in High Definition: Combat Stress Among Operators of Remotely Piloted Aircraft." *Canadian Political Science Association*, 2013. www.cpsa-acsp.ca/papers-2013/Fitzsimmons.pdf (accessed September 3, 2014).

Ginzburg, Carlo. "Killing a Chinese Mandarin: The Moral Implications of Distance." *Critical Inquiry* 21 (1994): 46–60.

Gregory, Derek. "From a View to a Kill: Drones and Late Modern War." *Theory Culture Society* 28 (2011): 188–215.

Grossman, Dave. *On Killing: The Psychological Cost of Learning to Kill in War and Society.* Boston, New York: Little, Brown & Company, 1995.

Hensley, Nathan K. "Drone Form: Word and Image at the End of Empire." *e-flux journal* 72 (2016). www.e-flux.com/journal/drone-form-word-and-image-at-the-end-of-empire/ (accessed April 27, 2016).

Holmqvist, Caroline. "Undoing War: War Ontologies and the Materiality of Drone Warfare." *Millennium—Journal of International Studies* 41 (2013): 535–552.

Kotz, Liz. "Bringing the War Home." In *Omer Fast: 5,000 Feet is the Best*, 49–61. Berlin: Sternberg Press, 2012.

Power, Matthew. "Confessions of a Drone Warrior." *GQ*, October 23, 2013. www.gq.com/news-politics/big-issues/201311/drone-uav-pilot-assassination (accessed October 28, 2013).

Rancière, Jacques. *The Politics of Aesthetics: The Distribution of the Sensible.* London, New York: continuum, 2004.

Rugoff, Ralph. "More than meets the Eye," In *Scene of the Crime*, ed. Ralph Rugoff, 59–108. Cambridge, MA: Hammer Museum, MIT Press, 1997.

Shay, Jonathan. *Achilles in Vietnam: Combat Trauma and the Undoing of Character.* New York: Scribner, 2003.

Steyerl, Hito. "Documentary Uncertainty," *Re-visiones* 1 (2011) [Reprint]. www.re-visiones.net/spip.php%3Farticle37.html (accessed January 27, 2017).

Woods, Chris. *Sudden Justice: America's Secret Drone Wars.* London: Hurst & Company, 2015.

7 Towards a Poor Cinema

The Performativity of Mobile Cameras in New Image Wars

Katarzyna Ruchel-Stockmans

Introduction

Throughout the 2011 protests and the ensuing conflicts across North Africa and the Middle East, the most common form of picture making was amateur video taken on mobile cameras and instantly uploaded to the Internet. The ubiquity of independent and grassroots reporting disseminated through social media platforms spurred some commentators to enthusiastically embrace the new technologies as the main carriers of social change. While the grim realities of war and unrest in the region quickly belied that optimism, the question of the impact of citizen journalism on the representation of conflict remains unresolved. In his 2012 installation and lecture-performance *Pixelated Revolution*, the Lebanese artist Rabih Mroué investigated videos circulated by Syrians caught in the daunting military conflict that followed the uprising of 2011. Seeing that many videos show soldiers charging the citizen journalists who continue to film despite the imminent peril, Mroué observed a significant change in the status of the image. For participants, the act of filming conflict with mobile cameras holds a promise that may be stronger than the risk of death. At the same time, Mroué notes, the practice of citizen journalism, especially with its hand-held camera, unedited image, and natural sound, remarkably resembles the cinematic principles of the Danish group of filmmakers *Dogme 95*.[1] The particular affinity of mobile camera images with this cinematic tradition invites an analysis of this novel form of visualizing in film. While the wide availability of such amateur footage led to its use by 'older' journalistic media such as television and online news platforms, some recent films have been made almost exclusively of video footage created by participants and witnesses.

My aim here is to examine three films on the revolutions and ensuing military conflicts in Arab countries that stand out as compelling investigations of the changing status of the amateur image: Peter Snowdon's *The Uprising* (2013), Talal Derki's *Return to Homs* (2013), and Oussama Mohammed and Wiam Simav Bedirxan's *Silvered Water, Syria Self-Portrait* (2014). All three films are characterized by their extended use of mobile camera footage—often shaky, blurry, and of poor quality—whose strength lies in having been made in the midst of the events. Significantly, these films are not so much documentaries analyzing the political situation and reasoning behind the conflict, but rather experimental investigations of the role and impact of amateur reporting in visualizing war. My aim in this chapter is to examine the significance of such a cinematic approach to vernacular videos by citizen journalists to how conflict is perceived and represented.

While the novelty and the rapid spread of amateur reporting are often recognized as significant to the changing nature of visualizations of war, I begin by tracing a

genealogy of what can be called the imperfect image. Juxtaposing iconic and imperfect images will help to delineate a tradition of blurred and deficient images, which paradoxically prove relevant in rendering violent events. While such representations hold the promise of bringing the spectator closer to the depicted events, they also remain opaque and, more importantly, lead to a certain theatralization in the protagonists' comportment. The cinematic experiments set forth by Snowdon, Derki, Mohammed, and Bedirxan marvel in the unprecedented possibilities offered by this footage but also expose the perils of amateur recording.[2]

Iconic versus Imperfect Images of War

One of the central issues raised in this volume is the question of why some war images provoke emotional responses that can affect the political situation at hand. Historically, there is a basic distinction between two ways of visualizing war. The first tends towards images that are visually powerful, and the second towards images that are, or claim to be, more real. In the first case it is often argued that some images have a particular iconic significance, while it matters less how they are made. In this approach, a painting by Piero della Francesca, a series of drawings by Francisco Goya, the photo of the Viet-Cong execution by Eddie Adams, or the image of the disfigured face of Muammar Gaddafi, are often named in the same breath.[3] Some are paintings or drawings, some are photographs. Their power is sought (and often discovered) in certain iconographic characteristics: elements of composition, pose, and gesture that bear a resemblance to deeply entrenched representations of pain.[4] Whether they are paintings, etchings, or video stills (as is the case of Gaddafi's death portrait), these iconic images are seen as partaking in a universal visual repertoire of human misery. More often than not, they evoke Christian representations of crucifixion, the motherhood of Mary, or the martyrdom of saints, even if the depicted subjects or the image-makers themselves do not belong to the Judeo-Christian tradition.[5]

The second approach to images of war highlights their indelible bond to the real. This line of reasoning usually goes back to the much discussed indexicality or 'truth value' of photography: the technique of image making that not only represents a subject or event but contains its actual trace.[6] Lens-based images are authoritative (and persuasive) because they are stenciled off the real, which means that they are taken at a particular moment in time and space. Their anchoring in reality doesn't necessarily imply that they have to be representational or, to be more precise, that they are exemplary representations. In fact, some of the most powerful images of war hardly show anything, as is the case with the much discussed four photographs taken inside Auschwitz by the Sonderkomando. As Georges Didi-Huberman argued, these blurry, awkwardly framed photographs provide evidence of the atrocity because they were made despite immense obstacles.[7] Taken by camp prisoners who were forced to carry dead bodies from the crematoria to makeshift burning sites, the images provide a unique insight into the Nazis' process of committing mass murder. These blurry and fragmented photographs are remarkable because, as Didi-Huberman posits, they came into being "in spite of all."[8]

In terms of their formal qualities, the Sonderkommando photographs are not an isolated case. There are other examples of blurred and badly framed pictures, which, taken together, evidence a propensity towards an aesthetics of the imperfect image.[9] This aesthetics implies low definition and scant representability of

the image, which stems from a desire for the real. Robert Capa, with his D-Day photographs is, presumably unintentionally, the godfather of the whole line of imperfect images.[10] Taken in the midst of the events, the shaky pictures from the sea, showing soldiers reaching the Normandy beach, convey a first-hand experience of the battle. Their grainy quality and "sardine's angle" yielded a particularly arresting representation of war.[11] The 2007 winner of the World Press Photo contest in the Spot News category is an even less 'representational' photograph of a violent event. The picture taken by John Moore, documenting the violent assassination of the Pakistani opposition leader Benazir Bhutto in 2007, was made at the very moment when an explosion blurs the vision, leaving only vague silhouettes among patches of smoke and fire visible in the frame.[12]

A programmatic formulation of the principles for the making of imperfect images can be found in Allan Sekula's *Waiting for Tear Gas* (1999–2000). Walking with his camera among the protesters during the global justice demonstrations in Seattle, Sekula produced a series of images taken from the perspective of a participant. Photographing the demonstrations and riots, he followed a set of self-imposed rules which he called "anti-journalism: no flash, no telephoto lens, no gas mask, no auto-focus, no press pass and no pressure to grab at all costs the one defining image of dramatic violence."[13] Many of the resulting photographs are poorly lit, blurred, and accidentally framed, yet it is precisely this formal and technical imperfection that testifies to the transformation of a camera into a witness.

Images as Events

Imperfect images convince the viewer not so much because of their iconic power, but because they convey an experience of a particular event. They not only suggest, through their visual (representational) elements, how a situation looked, but they also give a concrete idea of what Ariella Azoulay has called "the event of photography," or at least of its first modality. The photograph is a trace of an encounter between the camera, its operator, and the photographed persons.[14] The photographer's trembling hand, inopportune points of view, or a lack of control, are implicitly present in the image. The immense difficulty of even making such a picture, as is most clear in the case of the four Auschwitz photos, is present as a visual trace within the image. These photographs are thus an irrefutable form of witnessing corroborated by the poor quality and the representation's limited visual information. The blurry, awkwardly framed pictures remind the viewer of the conditions of their making—in the midst of catastrophic events.

With the subsequent development and proliferation of amateur video, such non-professional 'moving images' became synonymous with unaltered and direct registration of events. Two prominent examples of such accidental video witnessing, the Zapruder film and the Rodney King tapes, demonstrated how low definition and shaky images can fulfill the promise of an unmediated document. Yet, at the same time, both cases of amateur video also led to the shattering of the myth of documentary directness. Although unquestionably authentic, they failed to deliver indisputable legal proof of what 'really' happened.[15]

While these were still isolated cases of the use of cameras by accidental witnesses, the ubiquity of mobile devices in the first decades of the twenty-first century has led to a profusion of such first-person accounts.[16] Such video testimonials range from

documentation of virtually any everyday occurrence to reports of military conflicts and war. The 2011 events initially referred to as the Arab Uprisings, which were followed by violent conflicts in different parts of the region and outside of it, were accompanied by a remarkable increase in amateur video reporting. At the outset, these developments fostered optimistic visions of a new democratizing tendency that linked the amateur with concepts of autonomy and emancipation. Inevitably, these visions soon gave way to a disillusioned reassessment of the impact of the new media formats, novel social formations, and convergence cultures on actual political conflicts.[17]

Of low resolution, shaky, and often showing little of the events they are meant to record, these video clips purport to grant the viewer direct access to the scene. As they provide little visual information and thus require viewers' interpretative involvement, they appear to be a "cool medium" in Marshall McLuhan's sense.[18] Quite literally extensions of the human body, the small mobile cameras are susceptible to the camera operator's movement. The footage thus recorded shows the participant's point of view, usually without any embellishment or preconceived scenario. At the same time, it is important to insist that the Internet age's amateur documentarian is not the serendipitous witness who just happened to be there at the right moment. The cameras steer and provoke participants to take action in order to record it. As Simon Hawkins noted with respect to the revolution in Tunisia, the mass protests were initially randomly recorded, the images disseminated by a large number of spontaneously participating citizens. In the protests' later phase, however, these same citizens moved towards creating rather than simply recording events.[19] While the events at hand were still being registered by participants and witnesses, they were also, to a larger or smaller extent, performed for the cameras.[20]

Image Wars

The emergence of anonymous and grassroots reporting from conflict zones, in particular from the ongoing war in Syria, is a very complex and often opaque phenomenon still awaiting deeper analysis. It is also important to assess the relatively new type of amateur-produced images in relation to another development in the visualization of war, namely the efforts of those in power to control and restrict representations of conflict (what can thus be called the top-down image of conflict in an ongoing war of images).[21] In the second half of the twentieth century, the journalistic freedom and independence characterizing representations of the Vietnam War gave way to the carefully chosen and sanitized war images of the 1990s. Jean Baudrillard famously quipped that the Gulf War of 1991 never took place because the images that flooded the television screens worldwide were too unreal and abstracted from the actual combat.[22] By 2003, as Nicolas Mirzoeff notes, the imagery of war had become a "smart weapon," assuming a performative function in tandem with, and in support of, military technology.[23] This means the image declares the reality of what it claims to depict. Showing victory, for example in a picture of triumphant soldiers cheered by the local population in Iraq, the image instills the conviction that this victory is also a fact.[24] The appearance of uncontrolled and uncontrollable amateur imagery, however, whether within the military (such as the infamous Abu Ghraib photographs, and extreme examples of war trophy image traffic) or in the streets, substantially changed the landscape of war representations. The predominantly anonymous, ephemeral videos disseminated on

the Internet have the visual qualities of the raw and imperfect image discussed above. At the same time, they also share a similarity with the weaponized image, as they tend towards performativity.

Camera and Performativity

Performativity emerges here as a complex category. In the philosophy of language, performative utterance—or speech act—not only names things but also has a distinctive agency. In other words, the utterance does something in the world, rather than just representing it. When, in particular circumstances, two people say to each other "I do," or when a judge utters "I sentence you . . .", these words make happen what they state: a marriage or a sentence. The "weaponized image" in Mirzoeff's sense also claims to do what it shows. A central example is the missile viewfinder's screen shot, which depicts its target and visualizes its subsequent destruction. In 1991, this image was not just "operational" in the sense given to this term by Harun Farocki in his meditation on images of war. Farocki considered the missile viewfinder's technical image as belonging to the machine's very operation.[25] Such an "operative image" is not representational, as it does not need to be viewed by anybody in order to be effective. When these viewfinder images were broadcast worldwide by mainstream news media in 1991, they served as a proof that the invasion of the Gulf was a war fought with surgical precision and without collateral damage. The effectiveness of imaging was measured by the degree to which the international Western public accepted the version of the war the images purported to document. When these viewfinder images were used by the media, they contributed to the further unfolding of what Ariella Azoulay has spoken of as "the event of photography." The circulation of images can trigger responses, shape opinions and inspire actions in ways their makers do not intend and cannot predict.

The amateur camera held by the participant in a mass protest assumes an agency in the situation at hand. The camera's role as an actor becomes evident when those who are being filmed—usually soldiers or police—deliberately target the camera operator in an attempt to prevent the making of the footage or the photograph.[26] The camera images also have a performative quality in the sense that they are a form of activism. They are a tactic in the staging of image events meant to shape public opinion or stir others to action.[27] Images can be recontextualized by their subsequent circulation; they can also be purposefully misattributed, in order to counter or reverse their initial or intended effects. The immense and unruly archive of Internet images poses significant challenges to historians.[28] Here, it seems especially important to investigate how amateur videos have come to be seen as a form of historiography that partakes of both art and documentary.[29]

New Videograms for a Revolution: *The Uprising*

The Uprising (2013) by Peter Snowdon is composed entirely of found footage gleaned from the Internet. Devoid of any comment or voice over, *The Uprising* tells an imaginary story solely by means of montage and intertitles. The film is thus made entirely in the post-production phase, with the Internet fulfilling the role Sergiej Trietriakov dreamed of—that is, a situation in which anonymous and amateur filmmakers deliver a virtually unlimited number of visual facts, allowing multiple points of view on particular events.[30]

Although categorized as a documentary, the film does not attempt to reconstruct the specific histories embedded in the different video fragments. Images from Syria, Libya, Bahrain, Egypt, and Tunisia intermingle to form a new whole. Even when the footage is subtitled, it is virtually impossible for the viewer to reconstruct the original context of which the images are only fragmentary impressions.

Most fragments used in the film appear one after the other without being edited. Even when the camera suddenly pans into the sky or falls to the ground the footage remains unaltered. The only organizing device is the use of intertitles, which divide the diverse visual material into seven days. Starting from "Seven days ago," the chapters proceed backwards, to "Yesterday" and, finally, "Today." In the montage of various clips, the viewers can see protests erupt, escalate, and eventually sink into violence. Yet there are also moments of celebration and intense collective emotion, as well as private reflection and commentary by—often female—activists. Gradually, disappointment and resignation take over, accompanied by increasingly graphic images of the dead and wounded. The story ends with the perceived failure of the protests, which are interpreted as the first day before the professed start of the imagined uprising. The different episodes from various countries throughout North Africa and the Middle East are thus inscribed in a new narrative of an expected global revolution, even if the outlines of that narrative are only sketched and suggested, rather than clearly defined.

The absence of commentary or voice-over heightens the spectators' visceral responses to the images themselves. The various interrelated but distinct fragments demand an affective viewing, and draw attention to the images' formal qualities. At some points, the film turns very graphic, especially when people are shot at in front of the camera, while others start to panic or cry at the sight of their fellows falling dead or wounded. At the same time, most of these short fragments are of a very low resolution, which instills a certain distance between the viewer and the sometimes gruesome contents.

Several characteristics of this footage come to the fore. First of all, the camera's perspective is often that of a protester who moves along with the crowd and is not granted any privileged perspective. In fact, the citizen journalist has little command over the camera's point of view. The film's spectators are thus impelled to identify with the position of an anonymous participant, and are thus placed in the middle of the events. As there is always a lot of elbowing and pushing in the crowd, the camera moves as well, yielding a jerky and unstable image. When the camera operator starts to run, or fails to escape the security forces' bullets, the camera also accelerates, tilts, gets off kilter, and eventually falls to the ground (see Figure 7.1).

In one of these gripping moments, the camera slips out of its owner's hand, offering a close-up of blood-stained clothes. The image doesn't always show, in any conventionally representative way, what is happening in a given moment. It can be argued that the image shows little but at the same time promises to provide more than just a representation of the event. It allows the spectator to see and experience the situation in a way that is analogous to participation. The shaky images are sometimes dizzying or nauseating, while the dramatic responses and emotions in the bystanders' voices and gestures convey the sense of turbulence and chaos characteristic of violent events.

The act of filming is explicitly present in many of the fragments shown in *The Uprising*. At one point, the cameramen engage in a conversation with police, warning them that their cameras are rolling. In another scene, when an agitated crowd faces the armed and shielded guards, a media activist defiantly refuses to put away his camera and calls out: "Kill me, I won't stop filming." In an uneasy analogy to a

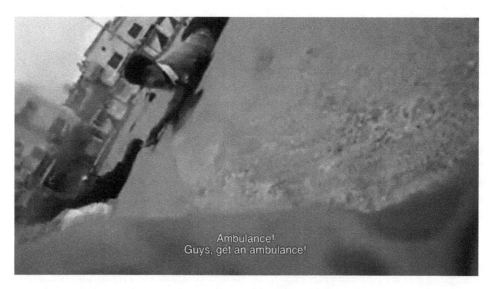

Figure 7.1 A film still from *The Uprising* (2013) by Peter Snowdon ["Ambulance! Guys, get an ambulance—the camera gets off kilter" 21:55].

Source: Courtesy of Peter Snowdon. Original video: مجزرة ازعر—دعب اعد بعد صلاة الجمعة, uploaded by izraadaraa, April 22, 2011. www.youtube.com/watch?v=Td0jLCkaoz0.

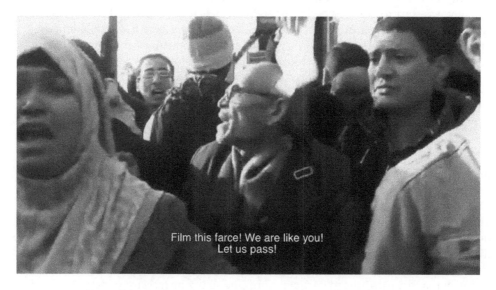

Figure 7.2 A film still from *The Uprising* (2013) by Peter Snowdon ["Film this farce! We are like you! Let us pass!" 16:39].

Source: Courtesy of Peter Snowdon. Original video: "Egypt's Freedom Revoluton, Day 2," uploaded by FreedomRevolution25, 26 January 2011. www.youtube.com/watch?v=ElQV6nCzH30.

weapon, the camera seems to trigger more audacious attitudes among the unarmed protesters, and the anticipation of a violent response carries with it a potential of stronger, more convincing images. At another time and place, the crowd encourages

the media activists among them, calling them to register and disseminate the images of the quelled revolution (see Figure 7.2).

In another instance, a woman shouts something out, but, upon noticing the camera, becomes extremely agitated, as if compelled by the presence of the device to assume an even more outspoken role. In other, nonthreatening situations, a group of youngsters in the Syrian city of Homs demonstrate their home-made bazooka, testing and firing off vegetables while commenting jokingly about their contribution to the protests. For them, the revolution and the resulting civil war becomes a game, and the nearby camera is an occasion for a performance of belligerence.

The Uprising can be considered the radical conclusion of a development that arguably started with the 1992 film, *Videograms of a Revolution*. The latter is a found footage film, made by Harun Farocki and Andrej Ujică, that shows the mass protests and the resulting fall of the Ceausescu regime in 1989 Romania. Already in a pre-Internet era, the events were filmed so extensively that it became possible for the filmmakers to construct a filmic narrative from the wealth of video fragments shot by unrelated camera operators. This highly mediated situation has resulted in two interrelated developments. On the one hand, one observes how the camera triggers people into action, such as going out into the streets to protest and to record that protest on film. On the other hand, participants begin to behave in a theatrical manner, assuming particular roles while treating the streets and squares as a kind of scene or a film set. As they acknowledge the presence of the camera, they are propelled to take action. At the same time, their gestures become more and more self-conscious.[31] Yet *Videograms*, although made entirely out of found footage, still contain a reflexive and at times investigative commentary of the voice-over. *The Uprising* dispenses with any direct guidance through the visual material, establishing an anonymous collective as the film's main protagonist. The series of events unfolds as if it was scripted by an all-seeing director assigning camera operators to different positions and locations, just as Farocki and Ujică envisioned it in *Videograms*.

At the very end of the film—one of the few moments when the original footage is more noticeably edited—an inconspicuous out-of-town scene shows a gathering of people and, in the distance, smoke from explosions. The clip is accompanied by a calm but passionate female voice calling the viewers to join the revolution. After seeing the revolutions in North Africa and the Middle East erupting and ending, the viewers of the film are now urged to begin the real uprising. The soundtrack for this spoken message is taken from a vlog (video blog) by a charismatic young woman, Asmaa Mahfouz, who played a significant role in the initial stages of the 2011 Egyptian protests.[32] The message is edited in such a manner that the specific plea to join the demonstrations on Tahrir Square is transformed into a universal call for radical change. It seems to suggest that, although these revolts failed to reach their initial goals, they revived the dream of a collective struggle for freedom and emancipation. Tellingly, the film's opening and closing shots are of a tornado approaching a small town. The much awaited revolution is then perhaps of the same order as that of an uncontrollable, natural disaster.

Singing for the Revolution: *Return to Homs*

Unlike *The Uprising*, Talal Derki's *Return to Homs* (2013) is set in one particular place – the city of Homs, dubbed "the cradle of the Syrian revolution." Starting from a moment of collective optimism during the mass protests of 2011, Derki's film portrays

local resistance against the government. It traces the outbreak of the civil war, which ultimately resulted in the horrid destruction of the city and its population. The film also differs from *The Uprising* in that its narrative not only develops chronologically in one place and time, but also follows a limited number of identifiable protagonists. The filmmaker Talal Derki appears in person, initiating and coordinating the cinemato-graphic work of a number of amateur cameramen and activists. While *The Uprising* is a found footage film, made solely from audiovisual material gleaned from the Internet, *Return to Homs* was designed and coordinated from the beginning as a film combin-ing footage made by Derki and footage delivered by activists and amateur reporters.[33]

The film's main protagonist is the singer and former goal keeper of the junior national football team, Abdul Baset al-Sarout, who became the charismatic leader of the Homs protests. Next to him, the activist and amateur journalist Ossama al-Homsi appears both as the film's second protagonist and a cinematographer.[34] He thus films al-Sarout, but is also being filmed in his activities as a reporter by other, unidentified camera operators. *Return to Homs* sheds light on the popular protests against the regime as they are quickly and violently suppressed by army forces. As a result, the protesters take up arms and engage in a hopeless and as far as the film can show—between 2011 and 2013—also endless war.

Abdul Baset al-Sarout is portrayed through different recordings of public and semi-private activities. The film shows his rise as a much loved singer of anti-Assad songs, performed in a festive atmosphere of inspired protest infused with optimism and an overwhelming conviction that the will of the people must prevail. As the film is planned in advance, and develops together with the events, it contains a mixture of premeditation and spontaneity. In interior scenes showing a "home-based media center," al-Sarout's numerous collaborators and friends are seen recording, analyzing, and commenting on the various videos they disseminate on the Internet.[35] In the film, we thus see two sides of the activities of citizen journalists: the act of filming and the sharing of material, while that same material is the source of our understanding of the war in and around Homs. Moreover, not only do we follow the protesters from the position of a subject intermingling in the crowd (in the vein of the footage shown in *The Uprising*), we are also allowed a more privileged view from the tops of the surrounding buildings. And as there is usually more than one camera present, we are offered different points of view on the same scene. *Return to Homs* shows the reality of the civil war from the perspective of citizen-activists, but also demonstrates how that reality is an intrinsically staged event that also simultaneously stages itself. Reality and fiction merge, and become indistinguishable, forming a novel world, one that is always already mediated.

The possibility of following particular people and their life stories in a war-time situation for a sustained period of time creates an illusion of the reality being fictional-ized. It is a documentary style that comes close to a fiction film in Jean-Luc Godard's sense.[36] But the intentions of the director are to some extent thwarted by the events that form the backdrop of the main story. The activist al-Homsi disappears halfway through the film. After a while, we are alerted to the fact that he probably has been captured at a checkpoint and is presumably in army custody.

Towards the end of the film, Al-Sarout is shown seated, resting on the floor of a corridor in a half-devastated house, holding a machine gun. Visibly accustomed to the sounds of war, he dozes off despite the noise of the shootings and explosions. In a moment of doubt, he confesses to have grown weary of the constant struggle.

And although he and his group keep fighting, even after everybody else seems to have abandoned the city, the general tone of the film evolves from an initial optimism or even euphoria of a collective action to the despondent perseverance of a handful of individuals.[37]

The Uprising used exclusively found and mostly anonymous footage (some of which has already been removed from the Internet), opting for a firm anchoring in the reality of the struggle and the strength of its visual traces. Remarkably, *The Uprising* transformed these clips by means of a fictionalized montage, which concludes on a note of hope. *Return to Homs* departs from more interventionist, docu-fictionalized premises. Yet, in the end, it moves towards a rather somber image of the civil war.

Perhaps the most striking quality of *Return to Homs* is its soundtrack. While the film follows real people who struggle and die for revolutionary ideals, and works within a similar poor aesthetics of a hand-held amateur camera, it, very surprisingly, turns into a musical. This is not an added effect of post-production but a diegetic soundtrack. Al-Sarout and his entourage sing continuously, even after the mass protests have long been superseded by a perfidious war. They sing at gatherings, during breaks between the fighting, or in long moments of waiting and killing time. Music is an unexpected accompaniment of that dreadful existence, and helps to connect Al-Sarout with the rest of the country as his songs are disseminated on the Internet.[38] It becomes clear that there is so much singing because there are cameras to register it for a larger audience. Again, it is the presence of the camera that transforms the fights into an ongoing performance.

Poetic Confrontation: *Silvered Water*

Silvered Water, Syria Self-Portrait (2014) by Oussama Mohammed and Wiam Simav Bedirxan, the most recent of the three pictures discussed here, examines the Syrian revolution from the perspective of its failure, at the moment when emancipatory ideals degenerated into a senseless civil war and violent stalemate. This film combines the cinematic strategies of found footage gleaned from YouTube and sequences made specifically for this film by the two directors. These diverse visual fragments are composed to tell a personal story, but also to reflect on the possibility of cinema in the face of the so-called YouTube revolution. It becomes apparent that both the rise of citizen journalism and its negative double, the violence of terrorist and torture videos, seem to have challenged the basic premises of cinema itself.

The story is told by the filmmaker Oussama Mohammed, who escaped from the war-torn Syria to Paris, and who suffers from an ensuing inability to film. Horrified by the surge of violence, he is forced to observe from a distance as his compatriots sink into barbarity. While the viewers hear his melancholy yet inquisitive voice, they see vague or blurry videos he found on YouTube, showing moments of panic, corpses, blood, and, most startlingly, acts of torture. Mohammed reflects on the juxtaposition between "images of violence" and "violent images." On the one hand, he finds numerous visual documents that are intended to bear witness to atrocity; on the other, he becomes aware of the growing repertoire of truly perplexing images made to enact atrocity as such. He delves into that latter collection to include a video showing the mental and physical abuse of a young boy, or another one with tortured men who are forced to perform denigrating acts in front of the camera. Unlike Snowdon or Derki, Mohammed presents the citizen videos within a broader perspective of participant

generated footage. It soon becomes clear that several possible options for a new poor cinema emerge from the disarray of the mobile phones' ever-growing Internet archive. The democratizing, emancipatory cinema of the ordinary citizen exists side by side with the cinema of the perpetrator, the torturer, and the zealous pro-regime soldier.

When Mohammed comes to the realization that an amateur documentary footage of the Syrian war can take the form of a musical—an insight that must have been shared by many viewers of *Return to Homs*—he immediately corrects that assumption. The form of musical appearing at this point in time is not restricted to rebel citizen journalists. Perpetrators make musicals, too. As a result, there is a clash between the musical of the victim and the musical of the perpetrators. The former can be found in the songs performed by resistance fighters, a déjà-vu of *Return to Homs*, the latter in the songs that glorify Bashar al-Assad and in triumphant cries of regime's soldiers.

While reflecting on these incommensurable, yet visually similar models of online image making, Mohammed receives a message from a woman in besieged Homs. A Kurdish amateur filmmaker named Simav (in Kurdish: *Silvered Water*) requests his advice on filming the events happening around her. Her question is the beginning of collaboration and a friendship between the exiled film director and the citizen journalist who experiences the war first hand. Simav's initial compulsion to film and to document what she witnesses becomes the main reason for her to stay in the besieged city. She thus delivers pictures of the horrors taking place in Homs and becomes a partner in the dialogue on cinema.

After having survived the near complete destruction of the city, she launches a school for the few children who remain. Yet the rare moments of happiness and bliss, in which we see children laughing and playing, end in an unanticipated way. It is not a pro-Assad soldier, but an uncle of one of her pupils, who disrupts the joyful episode. He demands the school's closure because Simav is not wearing the Islamic black veil. This episode demonstrates how some of the insurgents adopt radical Islamist positions. Simav, a liberal woman of Kurdish origin, now also dreads their rage and violence. One of the clandestinely filmed events is the harassment of two women by masked Islamic fighters in the street in front of Simav's apartment. Recounting this incident during the ongoing conversation with the exiled filmmaker Ossama, Simav returns to the primary motivation for her personal engagement in the struggle: a free country that accepts all of its citizens. At this point, the film returns to the initial idea of a collective struggle for freedom, which pervades two previous films.

Silvered Water investigates the entanglement of the aesthetics and politics of amateur footage. Like a rhythm, we hear the click of a video camera punctuating the film. Some fragments, such as the torture videos, also return rhythmically—at different intervals—as if they were a musical theme, a horrifying refrain or a stubbornly recurring nightmare. At one point, Mohammed examines these torture videos in terms of their cinematographic rationale. He notes how the cameraman instructs one of the perpetrators to alter his tactics for an enhanced effect—enhanced in terms of its efficacy or the scale of the inflicted pain—and in terms of its cinematic force. The performance of the real torture merges with the onscreen performance. At the beginning of the film, Mohammed recalls how, while he was still in Syria, a boy snatched a camera from him and started to film protests in the streets. He instructed the boy to keep the image as immovable as possible to achieve a better effect. Later on, after having watched so many torture and execution videos, he realized that the perpetrators often leave the

camera in a fixed position, perhaps in order to participate in the act themselves, but unwittingly also achieving a perfectly stable image.

Comparing the videos of perpetrators with those of the witnesses and victims makes painfully clear that the emancipatory struggle inscribed in the project of imperfect images is far from being resolved. The amateur video documenting a historical event appeared as a forceful proposition, countering what Nicholas Mirzoeff called a weaponized image of war. Yet, if the accidental footage by a witness could oppose the top-down and controlled images of war, it soon became clear that the spontaneous and uncoordinated, anonymous documents of the struggle against oppressive regimes are subject to cooptation and imitation by those in power.

Poor Cinema's Uncertain Futures

This analysis of poor cinema began with a consideration of amateur videos by citizen journalists from the Arab uprisings of 2011. These videos can be seen as part of a broader tendency towards a more direct representation of war, which I called imperfect images. The reduced quality, insufficient lighting and flawed framing of such images are an inevitable result—but also a welcome visual trace—of the very conditions in which they were made. Imperfect images promise to bring the viewer closer to the depicted events, while, through their form and aesthetics, their nature as mediations remains conspicuous. Yet, as virtually everybody owns a mobile camera, everybody becomes an actor and a maker of images. Unsurprisingly, this easily accessible and abundant footage made its way to the cinema. Its transposition to an older medium obscures some of the intrinsic characteristics of these videos, such as their ephemeral existence on the Internet and their velocity, which invite sharing and distracted viewing on small, often mobile screens.[39] As part of a film, they are transferred to a big screen and inserted into a narrative. Yet this migration to the cinema makes apparent how challenging these images are as visualizations of war. The three films analyzed here demonstrate that imperfect images can be approached in cinema in various ways. *The Uprising* by Peter Snowdon consists solely of found footage gleaned from the Internet, thus paying tribute to the often anonymous and unrecognized witnesses to and reporters from the various uprisings in the Middle East and North Africa. As the diverse fragments are woven together without authorial voiceover or context, they, on the one hand, purvey a visceral experience of the violent events of which they are a trace, while, on the other hand, they also to a large extent lose their anchoring in the concrete time and place. At the same time, they demonstrate the extent to which amateur videos become performative. The act of filming indelibly alters the situation filmed. Remarkably, the protagonists assume particular roles at the scene of the filming (see Figure 7.3).

Such effects of the event of photography are also discernible in Talal Derki's film *Return to Homs*. Providing a glimpse into the life of a limited group of activists who later become fighters in the Syrian uprising, the film unravels the dim reality of the military conflict through a collaborative effort between the filmmaker and a number of cinematographers who are also protagonists in the film. Most of the footage, especially at the later stages of filming, also constitute imperfect images. Surprisingly, the reality it registers shows many similarities to a musical. In many ways, *Silvered Water* by Oussama Mohammed and Wiam Simav Bedirxan, combines the approaches of the two first films, adding an authorial reflection on the future of cinema. Created in

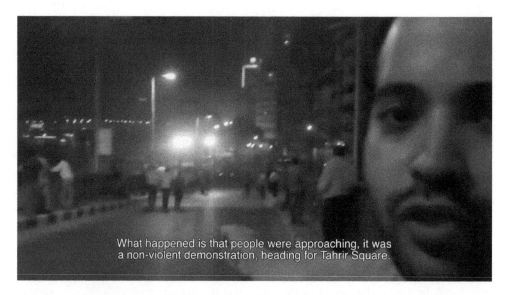

Figure 7.3 A film still from *The Uprising* (2013) by Peter Snowdon. ["What happened is that people were approaching, it was a non-violent demonstration, heading for Tahrir Square." A man points towards the end of the street with military trucks. 1:07:50].

Source: Courtesy of Peter Snowdon. Original video "Shubra—Maspero march, October 9 2011—Graphic," by Sarah Carr, uploaded October 11, 2011. www.youtube.com/watch?v=FaxNz3fJhhw.

collaboration between the exiled Mohammed and the amateur Bedirxan as she was stranded in Homs, it intertwines imperfect images made by the two authors in Homs and Paris with anonymous footage gleaned from the Internet. While reflecting on the possibility of making a musical based on that documentary footage, Mohammed confronts the question of new image wars. As imperfect images by witnesses and participants in the war are produced on all sides of the conflict, the musical of the victims is challenged by the musical of the perpetrators.[40] The promise of poor cinema's emancipating power is thus actively threatened by its sinister counterpart.

The Uprising, *Return to Homs*, and *Silvered Water* originate in the atmosphere and energy of mass movements, but at the same time bring different perspectives on amateur videos. While these images offer a blurry, shaky, and utterly unprivileged view, they are seen, at least initially, as peaceful means of political change. These videos and the films made out of them follow, to a lesser or a greater extent, the idea of a struggle in and through visual means alone. A camera is thus an alternative and not a supplement to a gun. In that sense, this cinema wants to distance itself from a whole range of other amateur generated visual material that sides with the perpetrators. It cannot be denied that amateur footage is produced equally profusely as a means of spreading and intensifying violence. Inadvertent witnesses, participants, but also soldiers on different sides of military conflicts worldwide, produce and disseminate images made in the midst of the events. The aesthetics of poor cinema is a site of struggle for the imperfect image as it strives to be a common and accessible means to counter, and not so much to support, the incessantly evolving machinery of war.

Notes

1 Rabih Mroué, "The Pixelated Revolution," *Image(s), Mon Amour: Fabrications* (Madrid: CA2M Centro de Arte Dos de Mayo, 2013), 380.

2 There are significant differences between the three films' modes of production. Snowdon's *The Uprising* is an experimental film made as part of his doctoral research in the arts at the University of Hasselt and produced on a low budget. Derki's *Return to Homs* and Mohammed and Berixan's *Silvered Water* were both produced by Orwa Nyrabia and Diana El Jeiroudi, and can be said to emerge from the local situation they portray. Yet what unites them, and what is of the main interest here, is their usage of vernacular videos made by citizen journalists.

3 This selection of iconic images was proposed by Bart Verschaffel in a lecture on November 7, 2014 in FOMU Photography Museum in Antwerp. A shorter version of this argument can be found in Bart Verschaffel, "The Depiction of the Worst Thing: On the Meaning and Use of Images of the Terrible," *Image & Narrative* (2013): 5–18, accessed June 20, 2016, www.imageandnarrative.be/index.php/imagenarrative/article/view/340. For broader analyses of iconic images, see, for example, Robert Hariman and John Louis Lucaites, *No Caption Needed: Iconic Photographs, Public Culture, and Liberal Democracy* (Chicago: University of Chicago Press, 2007) and Gerhard Paul, *Bilder, die Geschichte schreiben: 1900 bis Heute*, (Göttingen: Vandenhoeck & Ruprecht, 2011).

4 In this vein, W.J.T. Mitchell analyzed one of the Abu Ghraib photos entitled *Iraqui prisoner on leash held by Lynndie England* (2003) as a merging of three typological images from the Passion of Christ. See W.J.T. Mitchell, *Cloning Terror: The War of Images, 9/11 to the Present*, (Chicago and London: University of Chicago Press, 2011), 137–159.

5 On the critique of the universalizing effects of turning images, especially photographs into icons see Martha Rosler, "In, Around, and Afterthougths (on Documentary Photography)," in Richard Bolton, ed. *The Contest of Meaning:Critical Histories of Photography* (Cambridge, MA: MIT, 1989), 303–340.

6 This striving to a more 'real' representation is not limited to photography. Jean-François Chevrier sees it also in a painting by William Turner depicting a sea storm Jean-François Chevrier, "The Tableau and the Document of Experience," in Thomas. Weski, ed. *Click Double Click: The Documentary Factor* (Munich and Brussels: Haus Der Kunst and BOZAR, 2006), 56.

7 Georges Didi-Huberman, *Images in Spite of All: Four Photographs from Auschwitz*, trans. Shane B. Lillis (Chicago and London: The University of Chicago Press, 2008).

8 The proposition of Didi-Huberman taps into the heated discussion of whether an atrocity of such an immense scale as the mass extermination of Jews during Nazism can (and should) at all be represented. The director of the monumental film *Shoah* (1985), Claude Lanzmann, famously argued that no archival images can provide a commensurate visual representation of the Holocaust, and should therefore be avoided. See Claude Lanzmann, "Holocauste, La Représentation Impossible," *Le Monde*, March 3, 1994 1, 7. This discussion, which cannot be fully explored here, should, however, be seen in its historical context. The publics in the 1980s might have been overexposed to the numerous images from the camps taken at the moment of liberation, while, in subsequent decades, the compassion fatigue caused by such imagery might appear as a myth. On the myth of compassion fatigue, see David Campbell, "The Myth of Compassion Fatigue," in *The Violence of the Image: Photography and International Conflict*, ed. Liam Kennedy and Caitlin Patrick (London and New York: I.B. Tauris, 2014), 97–124. For a reassessment of the Lanzmann–Didi-Huberman debates see Karoline Feyertag, "The Art of Vision and the Ethics of the Gaze: On the Debate on Georges Didi-Huberman's Book *Images in Spite of All*," in *European Institute for Progressive Cultural Policies*, 2008, accessed July 3, 2016, http://eipcp.net/transversal/0408/feyertag/en; Zoltán Kékesi, *Agents of Liberation: Holocaust Memory in Contemporary Art and Film Documentary*, (Budapest: Central European University Press, 2015).

9 Such aesthetics can be defined broadly as encompassing what Hito Steyerl termed the poor image. I extend that formulation, and therefore choose to talk about imperfect images. For Steyerl, poor image is first and foremost a digitally produced and infinitely reproduced image typical for the era of the Internet. While Steyerl's definition emphasizes the poor

image's qualities of low resolution and ease of circulation, that definition can be extended to all images, digital or analogue, which hold so little visual information that they "tend towards abstraction." See Hito Steyerl, "In Defense of the Poor Image," *e-flux journal* 10 (2009), accessed May 12, 2014, www.e-flux.com/journal/view/94.

10 Capa is the unintentional godfather of the imperfect image because of the controversy around the blurred character of his D-Day photographs. Many historians see the blur in the images as a visual trace of the perilous moment in which they were taken. See Gerhard Paul, *Bilder des Krieges—Krieg der Bilder: Die Visualisierung des Modernen Krieges* (Paderborn: Ferdinand Schöningh Verlag, 2004), 302. Capa convincingly states in his memoir that his film rolls were badly developed, and, as a result, most of his photos were lost, and the remaining frames got heat-blurred. See Robert Capa, *Slightly out of Focus* (New York: Pickle Partners, 2015), 182. War photography historian Susan D. Moeller supports the explanation given by Capa on the technical damage to the film roll and states:

> ironically the photographs may have gained aesthetic power in the process. The heat made the surviving images blurred and grainy—exactly the view that the world had of the gritty battle for France. They were considered the best of the invasion.

See Susan D. Moeller, *Shooting War: Photography and the American Experience of Combat* (New York: Basic Books, 1989), 199. Whatever the truth behind these stories, the D-Day photographs began to serve as a model representation of the fear and uncertainty of combat. One well-known example of the influence of these photographs on the representations of D-Day is Steven Spielberg's film *Saving Private Ryan* (1998).

11 Moeller, *Shooting War*, 198.

12 Adam Broomberg and Oliver Chanarin, "Unconcerned But Not Indifferent," *Foto 8*, 2008, accessed June 4, 2010, www.foto8.com/live/unconcerned-but-not-indifferent/.

13 Breitwieser, Sabine, ed, *Allan Sekula: Performance under Working Conditions*, Vienna: Generali Foundation, 2003, 312–313.

14 This is the photographic event's first modality as described by Azoulay. The second modality has to do with the circulation of images and their intervention in the various other situations. A photograph can become a piece of evidence, a rhetorical tool, a sentimental souvenir; and as such it can act a part in history Ariella Azoulay, *Civil Imagination: A Political Ontology of Photography* (London: Verso, 2012), 26–27.

15 On the Zapruder film, see Øyvind Vagnes, "Eternally Framed," in *Zaprudered: The Kennedy Assassination Film in Visual Culture*, (Austin: University of Texas Press, 2011), 46–68; Stella Bruzzi, *New Documentary: A Critical Introduction* (London and New York: Routledge, 2000), 11–39; on the Rodney King tapes, see Avital Ronnell, "Television and the Fragility of Testimony," *Public*, 9, no. 1 (1994): 155–165; Frank P. Tomasulo, "'I'll See It When I Believe It': Rodney King and the Prison-House of Video," in *The Persistence of History: Cinema, Television, and the Modern Event*, ed. Vivian Sobchack (New York and London: Routledge, 1996), 69–88.

16 There are undoubtedly many differences between amateur video recordings from the pre-digital era and the ubiquitous digital imagery produced today. I bracket these differences here in order to point to the mainly aesthetic and formal characteristics of all of these images.

17 The term "convergence culture" was coined by Henry Jenkins, *Convergence Culture: Where Old and New Media Collide* (New York: NYU Press, 2006). The role of images in the Arab uprisings was analyzed by Lina Khatib, *Image Politics in the Middle East: The Role of the Visual in Political Struggle* (London and New York: I.B. Tauris, 2013); Pnina Werbner, Martin Webb, and Kathryn Spellman-Poots, eds., *The Political Aesthetics of Global Protest: The Arab Spring and Beyond* (Edinburgh: Edinburgh University Press and The Aga Khan University, 2014); Jeffrey S. Juris, "Performing Politics. Image, Embodiment, and Affective Solidarity during Anti-Corporate Globalization Protests," *Ethnography*, 9, no. 1 (2008): 61–97; Juris, "Embodying Protest: Culture and Performance within Social Movements," in *Conceptualizing Culture in Social Movement Research*, ed. Britta Baumgarten, Priska Daphi, and Peter Ullrich (London: Palgrave Macmillan, 2014), 227–247. For a more critical examination of the role of the amateur generated media content see Maximillian T. Hänska-Ahy

and Roxanna Shapour, "Who's Reporting the Protests?," *Journalism Studies*, 14, no. 1 (2013) 29–45; James Harkin, "Good Media, Bad Politics? New Media and the Syrian Conflict," *Reuters Institute for the Study of Journalism Fellow Papers*, 2013, accessed June 20, 2016, http://reutersinstitute.politics.ox.ac.uk/publication/good-media-bad-politics-new-media-and-syrian-conflict.

18 Marshall McLuhan, *Understanding Media: The Extensions of Man* (London: Routledge, 1964). I thank W.J.T. Mitchell for directing my attention to the relevance of McLuhan to the theoretical framing of this new type of image.

19 Simon Hawkins, "Teargas, Flags and the Harlem Shake: Images of and for Revolution in Tunisia and the Dialectics of the Local and the Global," in *The Political Aesthetics of Global Protest: The Arab Spring and Beyond*, ed. Pnina Werbner, Martin Webb, and Kathryn Spellman-Poots (Edinburgh: Edinburgh University Press and The Aga Khan University, 2014), 31–52.

20 On the performativity of the 2011 mass protests see also Katarzyna Ruchel-Stockmans, "The Revolution will be Performed: Cameras and Mass Protests in the Perspective of Contemporary Art," *Acta Universitatis Sapientiae: Film and Media Studies* 10 (2015): 7–23.

21 W.J.T. Mitchell describes the period after 2001 as the outbreak of a quantitatively and qualitatively new war of images: "Our time has witnessed, not simply *more* images, but a *war* of images in which the real-world stakes could not be higher." Mitchell, *Cloning Terror*, 2. While I follow the analysis of that period presented by Mitchell in *Cloning Terror*, my understanding of image wars requires an extension of that concept to earlier visualizations of conflict.

22 Jean Baudrillard, *La Guerre du Golfe n'a pas eu Lieu* (Paris: Galilée, 1991).

23 Nicholas Mirzoeff, "The Banality of Images," *Watching Babylon: The War in Iraq and Global Visual Culture* (Abingdon and New York: Routledge, 2005), 67–115.

24 The mutual influences between military developments and image making have been investigated by Paul Virilio, *War and Cinema: The Logistics of Perception* (London and New York: Verso, 1989); Harun Farocki, "War Always Finds a Way," *Gagarin* 21 (2010): 60–72; Ralf Beil and Antje Ehmann, eds., *Serious Games. Krieg Medien Kunst/War Media Art* (Ostfildern: Hatje Cantz, 2011).

25 Harun Farocki, "War Always Finds a Way," 60–72.

26 In some cases, the presence of the camera can mitigate the violence against the camera owners, as is the case with amateur reporters collaborating with the B' Tselem archive. More often than not, the presence of the camera will unleash more aggression. See Alisa Lebow, "Shooting with Intent: Framing Conflict," in *Killer Images: Documentary Film, Memory and the Performance of Violence*, ed. Joram Ten Brink and Joshua Oppenheimer (New York and London: Wallflower Press, 2012), 41–62.

27 On the tactics of staging of image events, see Kevin Michael DeLuca, *Image Politics: The New Rhetoric of Environmental Activism* (New York and London: Routledge, 1999).

28 Some of the difficulties in approaching this visual material by historians are discussed by Uğur Ümit Üngör, "Mass Murder on Youtube: How Should We Look at Syrian Video Clips?," *Your Middle East*, 2015, accessed September 1, 2016, www.yourmiddleeast.com/culture/mass-murder-on-youtube-how-should-we-look-at-syrian-video-clips_29961.

29 On the idea of artist as historian and the historiographic turn in art see Mark Godfrey, "The Artist as Historian," *October* 120 (2007): 140–172; Dieter Roelstraete, "After the Historiographic Turn: Current Findings," *e-flux journal*, 6, no. 5 (2009), accessed March 6, 2010, www.e-flux.com/journal/view/60; and Katarzyna Ruchel-Stockmans, *Images Performing History. Photography and Representations of the Past in European Art after 1989* (Leuven: Leuven University Press, 2015).

30 Mikhail Yampolsky, "Reality at Second Hand," *Historical Journal of Film, Radio and Television*, 11, no. 1 (1991): 161–171.

31 For a discussion of *Videograms of a Revolution* in terms of performativity see Katarzyna Ruchel-Stockmans, "Televised Image in/as History. *Videograms of a Revolution* and the Visibility of the 1989 Changes," in *Visualisierungen des Umbruchs: Strategien und Semantiken von Bildern zum Ende der Kommunistischen Herrschaft im Östlichen Europa*, ed. Ana Karaminova and Martin Jung (Bern: Peter Lang, 2012), 47–68.

32 For an analysis of Asmaa Mahfouz' role in the uprising in Egypt, see Melissa Wall and Sahar El Zahed, "The Arab Spring "I'll Be Waiting for You Guys": A Youtube Call to Action in the Egyptian Revolution," *International Journal of Communication*, 5 (2011): 1333–1343.

33 In the early stages of filming, Derki travelled to Homs with a professional camera, which had to be dismantled and hidden in the car's chassis. When such travels were made virtually impossible after the military conflict escalated and the city was under siege, the filmmaker had to resort to small mobile cameras carried by local activists and fighters. See Mark Jenkins, "Syrian Filmmaker Orwa Nyrabia Speaks About His New Film, *Return to Homs*," *Washington Post*, April 22, 2014, accessed June 12, 2016, www.washingtonpost.com/lifestyle/style/syrian-filmmaker-orwa-nyrabia-speaks-about-his-new-film-return-to-homs/2014/04/22/4cf240a0-ca3a-11e3-95f7-7ecdde72d2ea_story.html?utm_term=.67dd9d6ebd20.

34 Ossama al-Homsi is a pseudonym recently revealed to belong to Osama al-Habaly, an activist and a member of the Abounaddara film collective who has been missing since 2012. See Jason Stern, "Two Years and No Word of Osama Al-Habaly," *CPJ Committtee to Protect Journalists*, 2014, accessed June 20, 2016, https://cpj.org/blog/2014/08/two-years-and-no-word-of-osama-al-habaly.php.

35 Although it is not that clear from the film alone, Al-Sarout did manage to gain a broader recognition in Syria. His performances in front of local crowds in Homs are regularly disseminated and followed in other parts of the country James Montague, "Keeper of the Revolution," *Slow Journalism: Delayed Gratification*, 2012, accessed June 20, 2016, www.slow-journalism.com/keeper-of-the-revolution.

36 I refer here to the observation by Jean-Godard on the affinities between documentary and fiction:

> All great fiction films tend towards documentary, just as all great documentaries tend towards fiction. [...] One must choose between ethic and aesthetic. That is understood, but it is no less understood that each word implies a part of the other.

See *Godard on Godard: Critical Writings by Jean-Luc Godard*, ed. Jean Narboni, Tom Milne, and Annette Michelson (New York and London: Da Capo, 1972), 132.

37 The film avoids political questions, telling the story as Al-Sarout and his people would want to tell it themselves, and not devoid of romantic and heroic undertone. For example, the whole question of Al-Sarout heading a Salafi rebel group, which he is at pains to deny in numerous online videos, is not addressed in the film. As Max Fisher states, "the politics matter, but are often outside the rebels' field of view, and so beyond the film's as well." See Max Fisher, "Return to Homs: The Syria Documentary That Just Won Big at Sundance," *Washington Post*, January 28, 2014, accessed June 20, 2016, www.washingtonpost.com/news/worldviews/wp/2014/01/28/return-to-homs-the-syria-documentary-that-just-won-big-at-sundance.

38 Notably, Al-Sarout features in the 2012 documentary *Syria: Songs of Defiance* by Yasir Khan, where he is shown as one of the main protest leaders in Syria who use songs to propagate the revolutionary spirit (the documentary was broadcast on Al-Jazeera on March 15, 2012).

39 It should be noted that the short film format has also gained new currency. For example, the Abounaddara collective from Syria, gathering anonymous filmmakers and activists in the war-thorn country, exclusively produces short films that are made available online. The collective proposed to call their practice "emergency cinema." See Abounaddara, "Portfolio by Abounaddara. "The Enemy Is Indifference," *Bomb Magazine*, 2015, accessed September 8, 2016, http://bombmagazine.org/article/55861028/portfolio/.

40 As Siegfried Kracauer noted, the structure of a musical can paradoxically have a particular reality effect. By isolating performances of songs from the narrative, "musicals prefer a fragmentarized whole to a false unity," thus exposing the tension between the formative and the realistic elements in cinema Siegfried Kracauer, *Theory of Film: The Redemption of Physical Reality*, trans. Miriam Bratu Hansen (Princeton: Princeton University Press, 1997), 149. In the context of poor cinema, which proposes a new way of documenting reality, this affinity with the musical teases out a reflection on historical events manifesting themselves as a musical.

Bibliography

Abounaddara. Portfolio by Abounaddara. "The Enemy Is Indifference." *Bomb Magazine*, 2015. http://bombmagazine.org/article/55861028/portfolio/ (accessed September 8, 2016).

Azoulay, Ariella. *Civil Imagination: A Political Ontology of Photography*. London: Verso, 2012.

Baudrillard, Jean. *La Guerre du Golfe n'a pas eu Lieu*. Paris: Galilée, 1991.

Beil, Ralf, and Antje Ehmann, ed. *Serious Games: Krieg Medien Kunst/War Media Art*. Ostfildern: Hatje Cantz, 2011.

Breitwieser, Sabine, ed. *Allan Sekula: Performance under Working Conditions*. Vienna: Generali Foundation, 2003.

Broomberg, Adam, and Oliver Chanarin. "Unconcerned But Not Indifferent." *Foto 8*, 4 March, 2008. www.foto8.com/live/unconcerned-but-not-indifferent/ (accessed June 4, 2010).

Bruzzi, Stella. *New Documentary: A Critical Introduction*. London and New York: Routledge, 2000.

Campbell, David. "The Myth of Compassion Fatigue." In *The Violence of the Image: Photography and International Conflict*, edited by L. Kennedy and C. Patrick, 97–124. London and New York: Tauris, 2014.

Capa, Robert. *Slightly out of Focus*. New York: Pickle Partners, 2015.

Chevrier, Jean-François. "The Tableau and the Document of Experience." In *Click Double Click: The Documentary Factor*, edited by T. Weski, 51–61. Munich and Brussels: Haus Der Kunst and BOZAR, 2006.

DeLuca, Kevin Michael. *Image Politics: The New Rhetoric of Environmental Activism*. New York and London: Routledge, 1999.

Didi-Huberman, Georges. *Images in Spite of All: Four photographs from Auschwitz*. Translated by S.B. Lillis. Chicago and London: The University of Chicago Press, 2008.

Farocki, Harun. "War Always Finds a Way." *Gagarin* 21 (2010): 60–72.

Feyertag, Karoline. "The Art of Vision and the Ethics of the Gaze: On the Debate on Georges Didi-Huberman's Book *Images in Spite of All*." *European Institute for Progressive Cultural Policies*, 2008. http://eipcp.net/transversal/0408/feyertag/en (accessed July 3, 2016).

Fisher, Max. "Return to Homs: the Syria Documentary that Just Won Big at Sundance." *Washington Post*. January 28, 2014. www.washingtonpost.com/news/worldviews/wp/2014/01/28/return-to-homs-the-syria-documentary-that-just-won-big-at-sundance/ (accessed June 20, 2016).

Godard, Jean-Luc, Jean Narboni, Tom Milne, and Annette Michelson. *Godard on Godard: Critical Writings by Jean-Luc Godard*. Translated by T. Milne. New York and London: Da Capo, 1972.

Godfrey, Mark. "The Artist as Historian." *October* 120 (Spring 2007): 140–172.

Hänska-Ahy, Maximillian T., and Roxanna Shapour. "Who's Reporting the Protests?" *Journalism Studies* 14, no. 1 (2013): 29–45.

Hariman, Robert, and John Louis Lucaites. *No Caption Needed: Iconic Photographs, Public Culture, and Liberal Democracy*. Chicago: University of Chicago Press, 2007.

Harkin, James. "Good Media, Bad Politics? New Media and the Syrian conflict." *Reuters Institute for the Study of Journalism Fellow Papers*, 2013. http://reutersinstitute.politics.ox.ac.uk/publication/good-media-bad-politics-new-media-and-syrian-conflict (accessed June 20, 2016).

Hawkins, Simon. "Teargas, Flags and the Harlem Shake: Images of and for Revolution in Tunisia and the Dialectics of the Local and the Global." In *The Political Aesthetics of Global Protest: The Arab Spring and Beyond*, edited by Pnina Werbner, Martin Webb and Kathryn Spellman-Poots, 31–52. Edinburgh: Edinburgh University Press and The Aga Khan University, 2014.

Jenkins, Henry. *Convergence Culture: Where Old and New Media Collide*. New York: NYU Press, 2006

Jenkins, Mark. "Syrian Filmmaker Orwa Nyrabia Speaks About His New Film, *Return to Homs*." *Washington Post*, April 22, 2014. www.washingtonpost.com/lifestyle/style/syrian-filmmaker-orwa-nyrabia-speaks-about-his-new-film-return-to-homs/2014/04/22/4cf240a0-ca3a-11e3-95f7-7ecdde72d2ea_story.html (accessed June 12, 2016).

Juris, Jeffrey S. "Performing Politics: Image, Embodiment, and Affective Solidarity during Anti-Corporate Globalization Protests." *Ethnography* 9, no. 1 (2008): 61–97.

——. "Embodying Protest: Culture and Performance within Social Movements." In *Conceptualizing Culture in Social Movement Research*, edited by Britta Baumgarten, Priska Daphi and Peter Ullrich, 227–247. London: Palgrave Macmillan, 2014.

Kékesi, Zoltán. *Agents of Liberation: Holocaust Memory in Contemporary Art and Film Documentary*. Budapest: Central European University Press, 2015.

Khatib, Lina. *Image Politics in the Middle East: The Role of the Visual in Political Struggle*. London and New York: I.B. Tauris, 2013.

Kracauer, Siegfried. *Theory of Film: The Redemption of Physical Reality*. Translated by Miriam Bratu Hansen. Princeton: Princeton University Press, 1997.

Lanzmann, Claude. "Holocauste, la Représentation Impossible." *Le Monde*, March 3, 1994.

Lebow, Alisa. "Shooting with Intent: Framing Conflict." In *Killer Images: Documentary Film, Memory and the Performance of Violence*, edited by Joram Ten Brink and Joshua Oppenheimer, 41–62. New York and London: Wallflower Press, 2012.

McLuhan, Marshall. *Understanding Media: The Extensions of Man*. London: Routledge, 1964.

Mirzoeff, Nicholas. "The Banality of Images." In *Watching Babylon: The War in Iraq and Global Visual Culture*, 67–115. Abingdon and New York: Routledge, 2005.

Mitchell, W.J.T. *Cloning Terror: The War of Images, 9/11 to the Present*. Chicago and London: University of Chicago Press, 2011.

Moeller, Susan D. *Shooting War: Photography and the American Experience of Combat*. New York: Basic Books, 1989.

Montague, James. "Keeper of the Revolution." *Slow Journalism: Delayed Gratification*, March, 2012. www.slow-journalism.com/keeper-of-the-revolution (accessed June 20, 2016).

Mroué, Rabih. "The Pixelated Revolution." In *Image(s), Mon Amour: Fabrications*, 378–393. Madrid: CA2M Centro de Arte Dos de Mayo, 2013.

Paul, Gerhard. *Bilder des Krieges—Krieg der Bilder: Die Visualisierung des modernen Krieges*. Paderborn: Ferdinand Schöningh Verlag, 2004.

——. *Bilder, die Geschichte schreiben: 1900 bis heute*. Göttingen: Vandenhoeck & Ruprecht, 2011.

Roelstraete, Dieter. "After the Historiographic Turn: Current Findings." *e-flux journal* 6, no. 5 (2009). www.e-flux.com/journal/view/60 (accessed March 6, 2010).

Ronnell, Avital. "Television and the Fragility of Testimony." *Public* 9, no. 1 (1994): 155–165.

Rosler, Martha. "In, Around, and Afterthougths (on Documentary Photography)." In *The Contest of Meaning: Critical Histories of Photography*, edited by Richard Bolton, 303–340. Cambridge, MA: MIT, 1989.

Ruchel-Stockmans, Katarzyna. "Televised Image in/as History: Videograms of a Revolution and the Visibility of the 1989 Changes." In *Visualisierungen des Umbruchs: Strategien und Semantiken von Bildern zum Ende der kommunistischen Herrschaft im östlichen Europa*, edited by Ana Karaminova and Martin Jung, 47–68. Bern: Peter Lang, 2012.

——. *Images Performing History: Photography and Representations of the Past in European Art after 1989*. Leuven: Leuven University Press, 2015.

——. "The Revolution will be Performed: Cameras and Mass Protests in the Perspective of Contemporary Art." *Acta Universitatis Sapientiae: Film and Media Studies* 10 (2015): 7–23.

Stern, Jason. "Two Years and No Word of Osama al-Habaly." *CPJ Committtee to Protect Journalists*, 2014. https://cpj.org/blog/2014/08/two-years-and-no-word-of-osama-al-habaly.php (accessed June 20, 2016).

Steyerl, Hito. "In Defense of the Poor Image." *e-flux journal* 11 (2009). www.e-flux.com/journal/view/94 (accessed May 12, 2014).

Tomasulo, Frank P. "'I'll See It When I Believe It:' Rodney King and the Prison-House of Video." In *The Persistence of History: Cinema, Television, and the Modern Event*, edited by Vivian Sobchack, 69–88. New York and London: Routledge, 1996.

Üngör, Uğur Ümit. "Mass Murder on YouTube: How Should We Look at Syrian Video Clips?" *Your Middle East*, 2015. www.yourmiddleeast.com/culture/mass-murder-on-youtube-how-should-we-look-at-syrian-video-clips_29961 (accessed September 1, 2016).

Vagnes, Øyvind. "Eternally Framed." In *Zaprudered: The Kennedy Assassination Film in Visual Culture*, 46–68. Austin: University of Texas Press, 2011.

Verschaffel, Bart. "The Depiction of the Worst Thing: On the Meaning and Use of Images of the Terrible." *Image & Narrative* 3 (2013): 5–18. www.imageandnarrative.be/index.php/imagenarrative/article/view/340 (accessed June 20, 2016).

Virilio, Paul. *War and Cinema: The Logistics of Perception*. London and New York: Verso, 1989.

Wall, Melissa, and Sahar El Zahed. "The Arab Spring 'I'll be Waiting for You Guys:' A YouTube Call to Action in the Egyptian Revolution." *International Journal of Communication* 5 (2011): 1333–1343.

Werbner, Pnina, Martin Webb, and Kathryn Spellman-Poots, eds. *The Political Aesthetics of Global Protest: The Arab Spring and Beyond*. Edinburgh: Edinburgh University Press and The Aga Khan University, 2014.

Yampolsky, Mikhail. "Reality at Second Hand." *Historical Journal of Film, Radio and Television* 11, no. 2 (1991): 161–171.

Part III
Building Emotional Communities

8 Visualizing Community

A Look at World War II Propaganda Films

Hermann Kappelhoff

Media Emotions

Media can mobilize emotions in order to subordinate them to the political goals of state power. Nowhere is this statement more unquestionable and self-evident than in the representation of war by audiovisual media, whether this be war movies, war propaganda films, or war reporting on television. Indeed, there are only few cultural phenomena so closely linked to the idea that media forces reshape the feelings and sensations of concrete individuals and subordinate them to greater sociopolitical intentions. It is widely assumed that war and propaganda films can move individuals to change their political convictions, to neglect their material interests, even to give up their basic impulses at self-preservation and develop altruistic feelings and attitudes in relation to socio-political demands. They can generate demonizing distortions of the enemy, an uncritical hubris, patriotic feelings of community, and murderous hostility.

The propagandistic effectivity of audiovisual images has been proven time and again by numerous historical events from the media politics of the First World War to the Iraq War. But as much as we know about the political intentions and effects of such media politics, little is our knowledge about how media extend into an individual's concrete sensory structures and modes of interpreting the world. How are affective attitudes, which can define and change individual patterns of judgment and perception, conveyed through media experience? To approach an answer to this question, we have been working on a research project about the Hollywood war film genre for some time now. More than any other genre, it is the Hollywood war film that is most closely linked with the idea that cinema can mobilize the spectators' feelings in the service of overriding values and ideologies. Based on this assumption, our project thus seeks to carve out the genre's poetics of affect. In this essay I would first like to outline a few theses on the definition of the Hollywood war film. The second part discusses the key concept of a "sense of community" along with its theoretical background. And finally, I would like to concretize a few basic assumptions of our project by comparing a film by Frank Capra to a film by Leni Riefenstahl.

The War Film Genre

How can the Hollywood war film be defined, described, and analyzed? On the one hand, we can refer to a great number of well-documented, production-related facts in order to unlock the genre's media-historical origin and its further development. In this way it can be demonstrated how, over the course of the Second World War, the genre

emerged as the result of the interplay between war documentation and propaganda as Hollywood studios produced commissioned works on behalf of US governmental authorities and the military. And, furthermore, it can be shown how it developed alongside the history of subsequent wars.[1]

Another way of examining the genre relates to its mythopoetic function. 'War' in the war film is always more than a mere narrative subject. It encompasses an image archive of personal and collective memories as condensations of actual historical experiences. At the same time this subject is largely connected to phantasmatic elements. Military initiation rites, tragic guilt, and heroic acts, the sacrifice of the individual for the life of the community, the confrontation with the awareness of the individual's own death, the social state of emergency that destroys every possible form of civilian life—these particular phantasms mark the parcours of a mythological complex, a dimension of the Hollywood war film that could be specified as "Erinnerungsdichtung" in the sense of Freud, i.e. as confabulations of memory.[2]

Another way to define the war film genre would concern the corpus of films classified as one genre. That is, one could compile all those characteristics that would qualify a film as part of said corpus. In this regard, Jeanine Basinger's "anatomy"[3] of the Hollywood combat film might be the most systematic mapping of the genre's narratives: these involve a group of soldiers with a specific social composition, the intentions and goals to which the group members submit, the various iconographic signs of warfare the group is equipped with, as well as a set of plot episodes the group has to complete over the course of the film.[4] Each of these approaches will have to be acknowledged and included in order to fully comprehend the genre. Basinger summarizes that war films convey particular evaluative attitudes to the (historical) events of war and that they therefore have recourse to the historical information that the spectator already possesses.[5] She adds: "The tools of the cinema are employed to manipulate viewers into various emotional, cultural, and intellectual attitudes, and to help achieve all the other goals."[6]

Our questions are focused above all on these 'tools of manipulation' of emotional, cultural, and intellectual attitudes. We do, however, consider the term manipulation insufficient for our analysis. Indeed, it is not a matter of manipulating the emotions and attitudes that every individual spectator brings forth as his or her biological and intelligible essence. Rather, it is a question of cultural practices in which a feeling of belonging to a community is created and formed in the first place. The Hollywood war film genre is a striking example of such a cultural practice. It aims to produce an affective relationship to the political community and its history. It seeks to mobilize a feeling of belonging to a political community shared by many individuals. That is, it seeks to mobilize a sense of community, or a sense of commonality. This sense of community is not to be found at the level of the facts or emotions represented; it is not a matter of the contents. Rather, it structures the emotional evaluative attitudes and stances toward the moral-political issues and historical information communicated by the films.

Sense of Community

Feelings of community seem to describe a hybrid phenomenon, which incorporates psychic and physiological facts of individuals as much as it comprises affective bonds of social structures, i.e. a certain cultural and historical imprint, as well as ritual acts,

media practices, and aesthetic techniques that form and amplify these feelings. An analysis of this phenomenon should therefore not break it down to just one of these elements and reduce it to a solely psychological, sociological, or media-related matter.

In fact, we assume that feelings of community cannot be observed and understood outside the cultural practices that are defined by their goal of bringing forth and mobilizing precisely such a feeling. In this regard, we conceive the American war film genre as an exemplary cultural practice that promises to offer valuable clues about how to define and grasp the 'sense of community.' From this perspective, cinema's aesthetic mode of experience is put on a level with religious rituals, through which the individual sense of self is embedded into a commonly shared feeling.

A historical and analytical examination such as this certainly requires a conceptual and theoretical framework. We found it in the field of political philosophy, in particular within the discourse on concepts of community, common sense, and the sense of community.

Believing in the World

Let me very briefly sketch out some of the current theoretical debates that inform our work. The first of these is a theory of the political that problematizes the concept of community and connects it to categories of aesthetics and art theory. One prominent advocate of this approach is Jacques Rancière,[7] who formulated the idea of a commonly shared sensibility that is realized and modified through the experience of art. Further examples include the theories of Jean-Luc Nancy,[8] who considers the concept of community absorbed by the National Socialist 'Volksgemeinschaft' (people's community) and communism, but nonetheless discusses it as an acute problem of democratic societies. Coming from the tradition of American pragmatism, Richard Rorty attempts to conceive the sense of community as a dynamic element of an open society in a historical process, which must always configure itself anew as a community.[9] In pluralistic, democratic societies, the sense of community cannot rely on genealogically derived formations of community. Rather, it has to be manufactured as the affective agreement to commonly shared values in concrete cultural practices. For Rorty, community is the interminable process of a judgment of feeling that is unjustifiable, but that accounts for what can be commonly shared as values. It is the affect-based agreement to a set of common values, assessments, and attitudes. The sense of community is the appeal that this agreement demands.

What the aforementioned positions have in common is that they conceive community as a contingent dimension of the political instead of representing the idea of a given social affiliation, a pre-existing belonging. Furthermore, they all tie cultural practices of mobilizing community feelings more or less strongly to those of literature and the fine arts. A media practice that refers to the modeling of affective structures in which the object-world and the world of social and political relations become tangible as a commonly shared reality is not to be understood as a negotiation of perceptions and world views; it pertains to the belief in a commonly shared reality of sensations and moral values. In philosophy this belief has been associated with the concept of *sensus communis* (common sense).

In an earlier, very different context, Hannah Arendt developed a theory of the political that explicitly connects the sense of community with the mode of aesthetic experience. This becomes particularly apparent in her reading of Kant's *Critique of*

Judgment and her position towards his idea of *sensus communis*.[10] For Arendt, a spontaneous "feeling of belonging to the world" can be grasped in the aesthetic judgment of taste, an "extra sense . . . that fits us into a community."[11] If I experience something as beautiful, then I put my feeling in relation to others who experience the world of appearances in the same way. And if I judge an action as bad, then this judgment is based on the significant feeling of sharing my sensation with all those who belong, as I do, to the human community.

From this perspective, the sense of community is closely associated with the modes of aesthetic experience. For it is only at this level that the sense of community can connect up with a concrete bodily feeling of the self of individuals. Seen in this way, political discourse per se cannot be separated from the relevant media practices and aesthetic procedures. For it is only these practices that create the foundations of an affective sensation of community, which is not based on genealogy or social ties, but on political belonging.

It is precisely this interweaving of the subjective reality of a concrete sensation of the self with a feeling for the political community that designates the junction at which Hollywood cinema is connected to the political-historical events of war. The central question here is how historical experiences and the cultural phantasms of war are joined with the spectators' affective sensations in the aesthetic construction of genre cinema. For in war films not only the events represented, but also the spectators are historically situated. The films address a highly contingent and historically alterable sense of community. Thus they not only reveal the aesthetic strategies and poetic patterns employed to embed an individual sensation into a feeling for the community; they also unfold the historical changes of this feeling. From the mobilization of bellicosity via the mournful commemoration of the victims of war to angry condemnation and culpable shame, the history of the Hollywood war film illustrates the history of these changes based on political events.

But how do abstract principles, such as the political belonging to a highly heterogeneous society, connect to the spectators' individual affectivity? This question points to the specific films' poetics of affect and their aesthetic techniques. Precisely these poetic concepts and aesthetic strategies are foregrounded in our theoretical model where we make use of a concept of reception developed within neo-phenomenological film theory. This model is based on the hypothesis that spectators, in their experience of aesthetic perception, physically realize filmic modes of staging as a specific, affective rendition of the world. Usually film-historical research takes a different approach. There is a wide consensus that the war film has unlimited potential for mobilizing emotions. Yet the question regarding the aesthetic strategies and techniques of this mobilization has been answered with reference to its ideological function. The fact that war films seek to mobilize patriotic feelings in the first place is presented as already defining their ideology.

In the following, I would like to explain our alternative approach by means of a case study. I'd like to compare Frank Capra's *Why We Fight* series with a film by Leni Riefenstahl, *Day of Freedom—Our Armed Forces* from 1935. If the hypothesis that the question of the sense of community is realized at the aesthetic level as an affective attitude to the world is true, then Capra and Riefenstahl's directorial concepts would have to be radically different. Unless one were to claim in all seriousness that the films are based on a similar idea of society.

Riefenstahl: Media Technology as Fusion

Leni Riefenstahl's *Day of Freedom—Our Armed Forces* was commissioned for the National Socialist German Workers Party on the occasion of reintroducing the draft. It is therefore, exactly like Capra's film series, directed at the recruits that were to be committed to the war effort. Both films unfold the ethos of belonging to the singularity of the community, both target the pathos of self-sacrifice as the pledge of this belonging. And yet it is hard to imagine a greater contrast between their directorial methods.

Riefenstahl's film has a clear division. An epilogue shows a group of young men stripped to the waist at their morning wash. We see laughing faces, youthful bodies, the joy of morning. This is followed by an interlude showing soldiers on foot and on horseback. Through highly stylized camera perspectives and artfully orchestrated mists, they have traded in their everyday corporality for uniforms, riding poses, and shots from below (see Figure 8.1).

Following this we see the soldiers' deployment, marching into a kind of stadium rotunda; they march past the audience and the tribune of generals. The soldiers fall into the strict geometry of the Führer's review (see Figure 8.2). This is followed by a speech by Hitler to the newly recruited soldiers. In ornamental tirades, he continually varies the same metaphor. The young men can and should trade in their debased physical existences for their participation in a body that is equally abstract and heroic—the newly established corpus of the German man, the armed forces of the fathers.

What then follows are the steps of this transition, which is staged as the fusion of human material with technology. Once again we see soldiers—faceless beneath their helmets—marching past the grandstand. This proves to be the opening of a maneuver: infantrymen throwing themselves onto the ground and shooting. Then, in a more or less strict escalation, we see soldiers on motorcycles, in cars with cannons attached, then light track vehicles, armored cars, and finally tanks.

Figure 8.1 Faceless soldiers from below. Still from Leni Riefenstahl's *Day of Freedom—Our Armed Forces.*

Figure 8.2 The Führer's view. Still from Leni Riefenstahl's *Day of Freedom—Our Armed Forces.*

The attentive gaze into the heavens by the Nazi elite announces the final stage: the Luftwaffe. Through the elaborate rhetoric of dynamic montage sequences, an image of strictly methodical annihilation appears. The everyday body introduced at the beginning of the film is the object of a ritual dressing that obliterates it in the end. This obliteration forms the basis for the life of the troops, the marching line, the battalion, the division, the army, and the nation. But the emotional sensation that attempts to tie the spectators—in this case the soldiers themselves—to this community are based on a fundamental aesthetic mode of experience in the cinema, viz. the capacity to provide a dynamic element to the spectator's space of perception and sensation, extending far beyond the scope of everyday perception.

Here, this potential, which was celebrated by the avant-garde, is used to turn Hitler's position, far above the military review offered up to him, into an aesthetic experience for the movie spectator. From this perspective, the war itself becomes a spectacle of socialization. What is staged is the obliteration of everyday life as a solemn sensation of community, which the spectators can take part in through their aesthetic pleasure.

Capra: "What Put Us in the Uniform?"

It is this ideal of community, which can be grasped in the calculated staging of the images, that leads Capra to believe that the images could be turned against their creator.[12] The enemies' staging of themselves in the media should show American soldiers quite plainly what makes these enemies condemnable. And it should evoke precisely those highly dismissive feelings that ultimately form a reference point for the patriotic appeal. Having studied the opponent's propaganda, Capra conceives the first and second episode of the *Why We Fight* project decidedly as a counter proposal to Leni Riefenstahl's Nuremberg Rally film, *Triumph of the Will*. He develops

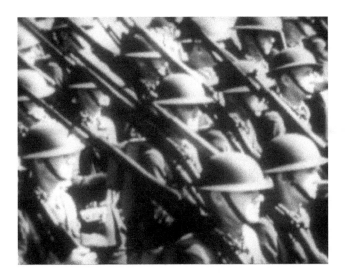

Figure 8.3 "Why are we on the march?" Still from Frank Capra's *Prelude to War*.

the montage of materials from newsreels, documentaries, and the opponent's propaganda into a deconstructive process that could be compared with the strategies of the found-footage film. The films, even in their individual episodes, look like a cinematographic analysis of the socialization rituals of fascist societies.

In the following I will concentrate on the first episode of the series, *Prelude to War*. The film opens with the question: "Why are we on the march? What put us in the uniform?" First and foremost this addresses the troops directly: the soldiers in the training camps and on their way in ships and planes that will take them to the most remote parts of the globe. At first the question is associated with the image of marching American soldiers: bright uniforms, music, casual marching, loose formations, and individual faces recognizable in the medium shots despite helmets and uniforms (see Figure 8.3).

Then, in a sharply polemical tone, which suggests that the question has actually been answered already, the film scans over possible answers. The theaters of war around the world are called up. The recognizable images from newsreels and their geographic placement trace out a mental movement for the audience, which is pursued and structured by the off-screen voice: Is it because of Pearl Harbor . . . ?! because of Poland, China, Russia?

The montage thus formulates a stream of associations in which weapons technology— images of explosions obscured by smoke, of cannons and grenades, of tanks and troop carriers pushing forward, of airplanes and bombings—is time and again placed in relation to images of destruction: detonating buildings and exploding landscapes, burning ships, scattering masses of people. Reinforced in the thundering of the noise of battle, the staging of the powers of weapons technology is related to its opposite, to images of vulnerable human bodies, injured children, the faces of horrified, desperate women and oppressed men.

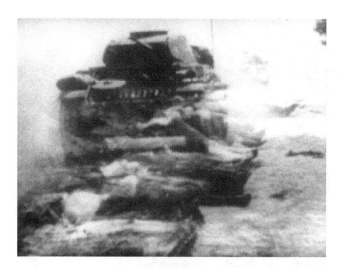

Figure 8.4 Ghostly tanks rolling over corpses. Still from Frank Capra's *Prelude to War*.

The staccato of the raging accusations is carried by a montage of pre-existing visual material, which is condensed into an affect-laden pathos formula. Divided by the calls from off-screen and the repeating explosions, the montage adds up, element for element, visual layer for visual layer, into a self-sufficient figuration of expression. This visual composition is based on the dense connection of various levels of movement according to a strictly implemented principle of combination. First, the opposition of light and dark sequences on the level of montage. Images of explosions, of landscapes scattering in a flash of light, are followed by images of spreading wads of smoke dimming out the light.

Second, the cross-fading, the swift transition, the fusion or layering of different images and image levels. The ghostly emerging tanks roll towards the spectators over burning ruins or lined up corpses (see Figure 8.4). In a series of cross-fadings they merge with the flashing shellfire, the smoke, and the flames to form a figuration of movement, which pervades all other images as continuous, morphological transformation.

Third, the strictly organized alteration of opposing directions of movement within the shot (vertical, horizontal, diagonal, from the foreground of the image to its background, or from left to right and vice versa). These changes translate the violence the voice-over speaks of into an audiovisual sensation, an experience of the increasing tension between antagonistic dynamics.

Fourth, the temporal structuring by means of symmetry and rhythm. The entire montage sequence is organized around a specific, recurrent motif: canons pointing skywards, appearing sometimes on the left and sometimes on the right side of the image only to burst in fulminating explosions. They structure the sequence like a colon, which is followed by the voice-over's speech.

As in a musical composition the spectator's perception itself gets organized as a strictly divided succession of conflictive sensations. For the spectator every moment of this process becomes a passing moment of an expressive movement unfolding in time.

This expressive movement, in turn, is at all times entangled with the identification of image motifs and their combinations, with the sense of the narrator's words, and the comprehension of the audiovisual formulas. The montage sequence forms an aesthetic experience that constantly short-circuits the process of rational understanding with the affective sensation, the sensuous experience of these dynamic compositional patterns.

What emerges, then, is the precious commodity that every propaganda film seeks to create: the impression that one can see, feel, and understand the world spoken of here in one and the same stroke. What emerges is evidence for the senses. The evidence that the world of which I am being told is visible there on the screen, and that everything that is visible there can be unlocked and assessed directly as an affective experience. It is this aesthetic evidence that gives the off-screen voice its power of persuasion.

In view of this process, Capra's film does not in fact differ from that of Leni Riefenstahl. But here, what is added into the cinematographic image is precisely the perspective that is cut out in Riefenstahl: the physical vulnerability of individual bodies forms the opposite pole to the destructive power of weapons technology. What is presented as a singular process of a power that rises by stages in Riefenstahl can be experienced by the spectator as the clash of completely dissimilar powers.

It is precisely this principle of the montage of opposing perspectives that also determines the entire construction of the film. For Capra introduces different cinematic modes of staging from sequence to sequence, of which the montage of association is only one variation. "What put us in the uniform?" The entire film attempts over and again to find an answer to its opening question, and it does so in ever-new modes of cinematic representation. The music, for example, changes to a spirited march. We see a typical cross-section montage, such as those we know from the films of Walter Ruttmann, or even the French avant-garde of the 1930s. We see a play with movement and form, reproduced a hundred times, shimmering steel and endless columns of uniform objects such as projectiles, airplanes, and tanks. The weapons industry's mass production becomes a metaphor for the power of American industrial production, and at the same time it becomes an image for the change brought to society by the war.

Another change in the music brings in a sweet-lyrical motif that predisposes us to a representational modality that we know from genre cinema: "This is a fight between the free world and the slave world." This strict dualism introduces a new mode of argumentation, the logic of melodramatic representation. Within this logic, the world only knows two poles: here the world of good, there the realm of evil. America is the virtuous innocence that is threatened by the plainly villainous.

In a few shots the founding of America is called up. The historical paintings of the revolution are accompanied by the memorials of the founding fathers, and the architecture representing the institutions that have emerged from this founding. Even in its most honorable forms the state institution is conceived of as a mere means of fulfilling the goal of political freedom. That this conception of the state is strictly opposed to that of the enemies is emphasized in the following sequences: the opening sequence is followed by a good 10 minutes, which are almost exclusively concerned with the "world of slaves," with Italy, Germany, and Japan.

The strategy is initially argumentative. The opening sequence speaks of societies that do not seek to solve their social and economic problems by means of politics, instead subjugating themselves to a leader. Documentary footage of the 1920s and early 1930s is called up as a series of recollection images of the great

social crises before the film moves on to images of militarized collectivization. The parallel montage of the appearances of Il Duce, the Tenno, and the Führer shows us the masses themselves as a faceless body responding to the ruler's theatrical speeches with the same ritual of submission. The triumph of the will of the state is completed in the grandiose celebration of an ecstatic experience of community, including every individual as a member of this body.

The sequences that follow spell out how this experience of community destroys the fundamental values of freedom. On the one hand, this concerns the realm of work. The propagandistic self-representation of the National Socialist state and its sociopolitical program become an image of subjection. On the other hand, it refers to religion. The hatred towards religion is presented as hubris on the part of state sovereignty turning the public space of politics into a stage for the leaders who represent themselves as divine rulers. Finally, this experience involves child education where the hubris of the state becomes most conspicuous.

The state, the leader, the emperor lay claim to the entire lives of individuals, to their physical working powers, their beliefs, and even to their children. Politics becomes the means to redeem this claim. In place of politics, the force of the state appears—terror. In order to enable the audience to grasp the opposition of terror and politics, Capra shifts the register of representation once more drawing on yet another mode of genre cinema. The sequence could easily come from a gangster film from the 1930s. This sequence is about the categorical difference between state terror and politics, and the film once again turns to its own social life, once again to America. Stage for stage the ideal of freedom is opposed to the fascist principle of communalization. In place of the freedom of religion we see the idolization of the leader. In place of political difference of opinion we see the beauty of staging state power. And in place of the interactions of everyday life we see the militarization of social life.

The fact that American virtue is crassly idealized will not have been overlooked, even in wartime. The question, then, is also not whether these representations sufficiently correspond to reality. What is much more important is what ideal of

Figure 8.5 Family melodrama. Still from Frank Capra's *Prelude to War*.

community is offered here in contrast to the fascist people's community, and which means are used to achieve this. Capra makes use of a genre that he was the undisputed master of at the time, proclaiming America's social ideal in the sentimental pathos of a family melodrama (see Figure 8.5).

This sentimental pathos marks the fundamental difference between *Prelude to War* and *Day of Freedom*. It opposes the values of the everyday lives of ordinary people and their personal pursuit of happiness to the heroic pathos of war society. This difference forms the basis for Capra's strategy of deconstructing the opponent's propaganda. In fact, Capra's cinematographic analyses seem precisely to capture the idea of community that the pathos of Riefenstahl's films is based on. In continually new variations, they show how state power is founded on the ritual negation of the individual. They show the formation of the masses into an ornamental representation of the power of their leader. They show the obliteration of the existence of the ordinary individual in favor of the military community. They show the military itself as the mode of fascist community building. Finally, they show how these films themselves take part in this spectacle, how they seek to include their spectators within this process of communalization.

Conclusion

Capra and Riefenstahl each propagate an ideal of community, but they could not be more opposed. And this opposition can be grasped in the most diverse staging techniques. Riefenstahl uses the avant-garde art of montage to construct a homogenous perceptual perspective. She aims to fulfill the idea of a heroic artwork, one that would allow the spectator to take part in the staging of the power of the state. She lets the spectator share the gaze of the leaders who, from up high, can relish the spectacle of war and the obliteration of individuals—the birth of a new people's community.

Capra, on the other hand, opposes Riefenstahl's calculated aesthetics of effect with an analytical potential of cinema. He multiplies the perspectives and standpoints by using montage to juxtapose highly heterogeneous modes of representation. Each of these modes has a different perspective, a different affective stance to the world: the montage of association, the cross-section montage, the mode of melodrama, and that of the gangster film. This multiplication of perspectives confronts the heroic self-representation of the fascist state with the clash between opposing subjective stances and affective positionings. Capra uses the representational modes of cinema to lay bare the ideal of community in the enemy's propaganda films and in the same stroke to mobilize the moral judgments of his contemporaries, and thus their sense of community.

Notes

1 See Thomas Doherty, *Projections of War: Hollywood, American Culture, and World War II.* New York: Columbia University Press, 1993.
2 See Sigmund Freud, "Meine Ansichten über die Rolle der Sexualität in der Ätiologie der Neurosen," in Sigmund Freud, *Gesammelte Werke*, vol. 5 (Frankfurt am Main. Fischer Verlag, 1999), 149–161. This also encompasses the relation of war and its rhetoric to a racist discourse of nation and history in Michel Foucault (Michel Foucault, *Society Must Be Defended: Lectures at the Collège de France, 1975–76*, trans. David Macey, New York:

Picador, 2003), or the ritualistic figuration of war as a social state of emergency, as in Roger Caillois (see Roger Caillois, "War and the Sacred," in Roger Caillois, *Man and the Sacred*, trans. Meyer Barash, New York: Free Press of Glencoe, 1959, 163–180).

3 Jeanine Basinger, *The World War II Combat Film: Anatomy of a Genre* (Middletown: Wesleyan University Press, 2003).
4 Basinger, *The Word War II Combat Film*, 56ff. and 67ff.
5 Ibid., 57.
6 Ibid.
7 See Jacques Rancière, *The Politics of Aesthetics: The Distribution of the Sensible*, trans. and introd. Gabriel Rockhill (London/New York: Continuum, 2004).
8 See Jean-Luc Nancy, *The Inoperative Community*, ed. Peter Connor, trans. Peter Connor, Lisa Garbus, Michael Holland, and Simona Sawhney (Minneapolis: University of Minnesota Press, 1991).
9 See Richard Rorty, *Contingency, Irony, and Solidarity* (New York: Cambridge University Press, 1989).
10 See Hannah Arendt, *Lectures on Kant's Political Philosophy*. Chicago: University of Chicago Press, 1992. In referring to Arendt's thoughts on the sense of community, I attempt to incorporate the historical alignments laid out in this concept—and also in her work on the American and French Revolution—and to link them to contemporary approaches that reconsider the experience of community. Among these approaches are Richard Rorty's concepts of "commonality" and "solidarity," or Stanley Cavell's "claim to community" as a mode of relying on the common ground of speech and act on the basis of post-Cartesian scepticism. See Hannah Arendt, *On Revolution* (New York: The Viking Press, 1963); Richard Rorty, *Achieving Our Country: Leftist Thought in Twentieth-Century America* (Cambridge, MA: Harvard University Press, 1998); Stanley Cavell, *The World Viewed: Reflections on the Ontology of Film* (Cambridge, MA: Harvard University Press, 1979); Stanley Cavell, *The Claim of Reason: Wittgenstein, Skepticism, Morality, and Tragedy* (New York/Oxford: Oxford University Press, 1979); Andrew Norris, ed., *The Claim to Community: Essays on Stanley Cavell and Political Philosophy* (Stanford: Stanford University Press, 2006).
11 Arendt, *Lectures on Kant's Political Philosophy*, 70.
12 "Triumph of the Will fired no gun, dropped no bombs. But as a psychological weapon aimed at destroying the will to resist, it was just as lethal . . . How could I mount a counter-attack against Triumph of the Will; keep alive our will to resist the master race?" in Frank Capra, *The Name Above the Title: An Autobiography* (Boston/New York: Da Capo Press, 1997), 328–332.

Bibliography

Arendt, Hannah. *On Revolution*. New York: The Viking Press, 1963.
——. *Lectures on Kant's Political Philosophy*. Chicago: University of Chicago Press, 1992.
Basinger, Jeanine. *The World War II Combat Film: Anatomy of a Genre*. Middletown: Wesleyan University Press, 2003.
Caillois, Roger. "War and the Sacred." In Roger Caillois, *Man and the Sacred*. Translated by Meyer Barash, 163–180. New York: Free Press of Glencoe, 1959.
Capra, Frank. *The Name Above the Title: An Autobiography*. Boston/New York: Da Capo Press, 1997.
Cavell, Stanley. *The Claim of Reason: Wittgenstein, Skepticism, Morality, and Tragedy*. New York/Oxford: Oxford University Press, 1979.
——. *The World Viewed: Reflections on the Ontology of Film*. Cambridge, MA: Harvard University Press, 1979.
Doherty, Thomas. *Projections of War: Hollywood, American Culture, and World War II*. New York: Columbia University Press, 1993.
Foucault, Michel. *Society Must Be Defended: Lectures at the Collège de France, 1975–76*. Translated by David Macey. New York: Picador, 2003.

Freud, Sigmund. "Meine Ansichten über die Rolle der Sexualität in der Ätiologie der Neurosen." In Sigmund Freud, *Gesammelte Werke*, vol. 5, 149–161. Frankfurt am Main: Fischer Verlag, 1999.

Nancy, Jean-Luc. *The Inoperative Community*. Edited by Peter Connor. Translated by Peter Connor, Lisa Garbus, Michael Holland, and Simona Sawhney. Minneapolis: University of Minnesota Press, 1991.

Norris, Andrew, ed. *The Claim to Community: Essays on Stanley Cavell and Political Philosophy*. Stanford: Stanford University Press, 2006.

Rancière, Jacques. *The Politics of Aesthetics: The Distribution of the Sensible*. Translated and introduced by Gabriel Rockhill. London/New York: Continuum, 2004.

Rorty, Richard. *Contingency, Irony, and Solidarity*. New York: Cambridge University Press, 1989.

——. *Achieving Our Country: Leftist Thought in Twentieth-Century America*. Cambridge, MA: Harvard University Press, 1998.

9 From Warrior Heroes to Vulnerable Boys

Debunking "Soldierly Masculinity" in Tim Hetherington's *Infidel* Photos

Thomas Ærvold Bjerre

The September 11 terrorist attacks on New York and Washington, DC heralded the beginning of the US-led "War on Terror." And while the wars in Afghanistan and Iraq have been fought with conventional weapons and led to tens of thousands of casualties,[1] machine guns, Hellfire missiles, and IEDs have not been the only means of fighting. We have also witnessed, in the words of W.J.T. Mitchell, "a war of images and the collective emotions associated with them."[2] A good part of these images have been grounded in cultural notions of traditional masculinity. After all, as Rebecca Adelman notes, "The stakes of representing masculinity are always higher during war than peace . . . and it would seem that the threat of terrorism raises them higher still."[3]

British photographer Tim Hetherington (1970–2011) played a central part in visualizing the war on terror. On assignment for *Vanity Fair* with journalist Sebastian Junger, Hetherington was embedded with the Second Platoon of Battle Company in the primitive outpost Restrepo in the Korengal Valley between September 2007 and August 2008. While several of the photos were printed in *Vanity Fair*,[4] the two also did news segments for ABC's *Nightline* and co-directed the documentary *Restrepo* (2010), a Sundance winner and Academy Award nominee. Furthermore, Junger wrote the non-fiction book *War* (2010) based on his Restrepo experience, and after displaying his Afghanistan photos in various exhibitions, Hetherington collected the photos in the book *Infidel* (2010).[5] It is the latter that is the focus here.

In its intimate portrayal of a group of young American soldiers, Hetherington constructs a narrative, not so much of the war in Afghanistan, but of brotherhood and bonding. In the context of the patriotic fervor surrounding the War on Terror, the narrative in *Infidel* challenges some of the prevailing cultural conceptions of the American soldier. In its one-sided focus on the experience of the American soldiers, however, it also inevitably plays into larger mythic narratives about dominant American military power and, indirectly, dominant American values.

In order to understand Hetherington's photos, and the type of narrative they tell, some context is necessary. The 9/11 attacks provoked an immediate "hypermasculinist and militaristic response,"[6] and the gendered framing was prevalent in the mainstream media coverage.[7] The masculinist response manifested itself in a myriad of ways, including numerous visual responses. One of the best-known examples of this are the photos of President Bush dressed in full military flight suit—and "more combat gear than a Tom Cruise stunt double"[8]—on the deck of USS Abraham Lincoln. Bush had co-piloted a navy jet that landed on the aircraft carrier prior to giving his highly orchestrated and televised "Mission Accomplished" speech that announced the end of major combat operations in Iraq. While *New York Times*

theater critic Frank Rich places the show in the contexts of Hollywood blockbusters like *Top Gun* and *Independence Day*, and Philip Hammond calls the moment a "triumph of media-military cooperation,"[9] it is also highly gendered. Not only does Bush's flight suit performance play into culturally accepted notions of masculinity—traits such as "'muscular,' 'strong,' 'hard,' 'brave,' and 'in control'"[10]—but there is an element of (over)compensation at work. Stephen J. Ducat interprets Bush's "virile bombast" as a response to what many consider his father's "greatest failure of manly determination—leaving Saddam Hussein in power."[11] But Bush Jr.'s "hyper-masculine posturing and triumphalist chest beating"[12] merely affirmed Adelman's assertion that war raises the stakes of representing masculinity. Or, put another way, by Susan Faludi: by September 12, US "culture was already reworking a national tragedy into a national fantasy of virtuous might and triumph."[13]

When it comes to visualizing the soldiers on the ground, no image sums up the attempt at heroization better than Luis Sinco's photo of Marine Lance Cpl. James Blake from the November 2004 assault on Fallujah. The photo shows a close-up of a soldier's dirt-smeared face framed by a strapped helmet. His slightly squinting eyes gaze towards the horizon, and a lit cigarette dangles from his mouth. Robin Andersen points to the photo's "striking resemblance" to familiar World War II depictions.[14] Immediately dubbed the Marlboro Marine, the photo appeared in more than 150 newspapers across the world,[15] but most prominent, and most telling of the way in which mainstream media drew upon the "culture of war and the icons of heroism"[16] was the November 10, 2004 front page of the *New York Post*. Here Sinco's photo of James Blake appeared beneath the huge headline "SMOKIN'." Below the photo is the tagline: "Marlboro Men kick butt in Fallujah."

While the *New York Post*'s tabloid approach may not be surprising, the response from more respected quarters of the media shows the extent to which the patriotic fever that swept the US in the wake of 9/11 led to a national mythmaking process that relied on comforting heroic narratives. The response to Sinco's photo by CBS's highly prominent and respected news anchor Dan Rather is certainly questionable. In an emotional and highly subjective speech to the CBS *Evening News* viewers, Rather called Sinco's photo "the best war photograph of recent years" and elaborated:

> For me, this one's personal ... This is a warrior with his eyes on the far horizon, scanning for danger. See it. Study it. Absorb it. Think about it. Then take a deep breath of pride. And if your eyes don't dampen, you're a better man or woman than I.[17]

Perhaps the embrace of the photo and the way journalists tapped into heroic myth when describing it should be seen in the context of the Abu Ghraib photos, some of which were disclosed to the public roughly six months prior to the "Marlboro Marine" photo.[18] The Abu Ghraib scandal presented a devastating challenge to "central assumptions and standard depictions of war in American culture," namely that "nobility and justice" are driving forces when America goes to war.[19] But much of the US media discourse surrounding the photos was steered towards a gendered interpretation of the scandal. As several scholars have argued, Pfc. Lynndie England soon became the focus of the controversy. With few exceptions, such as Seymour Hirsch's investigative pieces in *The New Yorker*, "mainstream news media seemed preoccupied with 'making sense' of the images of a woman torturer."[20] Dora Apel argues that

because England was "a petite female incongruent with the archetype of the warrior hero," it was easier for the media to define her "as a morally, professionally, and sexually 'fallen' white woman," an "archetypal rendering that shifted responsibility from the military onto England while preserving the military's patriarchal ethos and subordination of women."[21] In a similar vein, Robin Andersen argues that the images of England were seen as "disturbing departures" from the narrowly defined roles afforded women in the "conventional history of war narratives," and she concludes that the blame for torture was placed on the "dangers of female sexuality," specifically the "sexual deviance of Lynndie England."[22] In this light, the valorization of Sinco's "Marlboro Marine" photo can be seen as an attempt at a remasculinization of America, to use Susan Jeffords's term, in a time of crisis.[23]

Even with the disclosures of the Bush administration's orchestration of the "weapons of mass destruction" argument and the increasing descent into chaos and civil war-like conditions in Iraq, parts of the mainstream US media's construction of the war on terror was still based on what Stephen J. Dubner has referred to as a "hero hunt,"[24] an almost reflexive tendency to regress into mythic territory, one usually dominated by men. The November 12, 2012 issue of *Newsweek* was titled "The Heroes Issue" and the cover featured three soldiers from the Black Hawk crew of Dust Off 73 who "spent nearly 12 hours in the air, extracting 14 wounded and one soldier killed in action and flying three critical resupply missions during a three-day operation."[25] But Erik Sabiston, one of the soldiers on the cover, reacted against the heroic and gendered framing in a *Newsweek* opinion piece titled "I Am Not a Hero." Here Sabiston argues that the crew's most dangerous job was that of the medic Juliana Bringloe, who was "lowered. . . to the ground on a thin steel cable as bullets whistles past her." The fact that Bringloe is not in the cover photo with her three male crew members makes Sabiston "feel like a fraud . . . If anything," he asserts, "she should have been on the cover. By herself."[26]

Visualizing Brotherhood

It is in the context of the patriotic and jingoistic responses to 9/11 and the US-led wars in Afghanistan and Iraq that Hetherington's *Infidel* belongs. Hetherington's photos lend themselves well to an examination of war and masculinity. As Alan Huffman explains, one of the recurring themes in Hetherington's work was an examination of "how young men are attracted to and exploited by war."[27] Sebastian Junger has expanded on what he saw as Hetherington's "project": to document the "self-referential idea about war where soldiers in war see themselves in ways that are informed by images of other soldiers in war. And there's a conscious cycle of imitation going on."[28] Some of the photos in *Infidel* play on variations of traditional "soldierly masculinity," defined by Jon Robert Adams as "the particular brand of traditional male function associated with heroism—courage, suppressed emotion, strength, and clearheaded decisiveness."[29] Yet Hetherington also undermines that form of jingoistic machismo and presents a more nuanced but also a deliberate emotionally charged counter-narrative. To what extent the photos escape larger mythical structures relating to heroic manhood will be examined below.

Hetherington's subjective goal, as he explained in an interview with Mark Pitzke, was to embrace embedding in order to create "'intimate portraits,' which to him seem[ed] to be the only way 'to get the American public engaged.'" While Pitzke notes

that some reporters "frown on being embedded" because "they fear loss of distance, of objectivity,"[30] Hetherington does not comment on the vast amount of criticism of the embedment program and to what extent his project feeds into the criticism. According to Kate McLoughlin, the main criticism of embedding is that it is "a means for the military to control the media, hence its institution and encouragement by the Pentagon."[31] More specifically, Judith Butler has argued that embedded reporters "were offered access to the war only on the condition that their gaze remain restricted to the established parameters of designated action" and that they "looked only at certain scenes, and relayed home images and narratives of only certain kinds of action."[32]

But the question is whether Hetherington's images and visual narratives are contained within the "perspective established by military and governmental authorities,"[33] or whether they can be seen as ruptures in the master narrative. Hetherington would probably argue for the latter, as this elaboration suggests:

> I'm interested in the image being used to connect us, because it's not that we can present a political idea to someone in pictures and expect them just to get it, but we can connect them emotionally to a situation with which then they will maybe engage a bit further, have a tendency to understand or to try to examine politically what's happening.[34]

My vantage point for discussing how Hetherington's photos engage us emotionally is masculinities studies, which, as my discussion of the masculinist and heroizing response to 9/11 showed, offers a crucial perspective on the topic of war and photography. In terms of war, Susan Jeffords has argued that we cannot fully understand "war and its place in American culture without an understanding of its gendered relations."[35] The military is an obvious arena for studying masculinity, says Frank Barrett, because it is predominantly male, "but also because it plays a primary role in shaping images of masculinity in the larger society . . . Militaries around the world have defined the soldier as an embodiment of traditional male sex role behaviors."[36]

In terms of the relation between war and photography, Susan Moeller notes how photography, over the past hundred years, "has influenced America's impression of" war and "has helped to shift Americans' belief that war is a glorious calling to the belief that war is a necessary job to the belief that war is a murderous pursuit."[37] And these reinterpretations are almost always gendered, as Christina Jarvis notes: "wars and their cultural representations have . . . served as important catalysts for consolidating hegemonic masculinity."[38] Patricia Vettel-Becker has discussed "the way the imagery of war is intertwined with the ideology of masculinity" and argues that "both are predicated on violence and the subjugation of the feminine, which in war is encoded in the body and the territory of the enemy."[39]

Vettel-Becker's assertion is an adequate starting point from which to view *Infidel.* The first five images are of the Korengal Valley landscape in Afghanistan. The first two are empty of humans (pp. 4–7). In the third image, the lower left side shows the makeshift plywood sheds and living quarters of the Restrepo outpost (pp. 8–9), and in the fourth image, in the lower left side, an American soldier, dressed in cap, shorts, and shoes, sits on a wall of sandbags, his back slightly turned to us as he plays a guitar. A roll of barbed wire can be seen next to the sandbags (pp. 10–11). In the fifth landscape image, the center of the left side is taken up by an American soldier, posed with a gulf club, ready to strike (pp. 12–13).[40] The cumulative effect of the book's

first five photos, then, is one of US soldiers taking over the Afghan landscape. Seen in a visual context where the land has often been coded as feminine, this is an example of the above-mentioned "subjugation of the feminine" that Vettel-Becker sees as a staple of war photography. And it ties into Susan Moeller's claim that "perhaps the metaphor that twentieth-century war photography has most neatly embraced is that of the American frontier," especially the version—extensively formulated by Richard Slotkin—of the frontier as an arena for violent race war.[41]

But judging from their actions, the male conquerors are not belligerent; rather this is an almost leisurely takeover, one that certainly belies the reality of the mission behind the US presence in the Korengal Valley, dubbed "the valley of death" by Junger in his *Vanity Fair* articles. However, that reality is presented next, in Junger's four-page "Introduction," which tells us that "for a while almost a fifth of the combat in all of Afghanistan was taking place in the Korengal Valley." The record for numbers of firefights in one day was 13.[42] Yet the extreme level of violence is completely absent in the first two thirds of the book. Instead, Hetherington and Junger set the viewer up for a contemplation of brotherhood or male bonding. In the "Introduction," Junger places Hetherington's photographs in a specific ontological frame: "A platoon of combat infantry is a brotherhood, and that bond is expressed in ways that aren't acknowledged or really even permitted back home. That—not war—is the true topic of this book."[43] Immediately following the introduction we see a visualization of the brotherhood: over two pages are 48 thumbnail portraits of the platoon's soldiers identified by their last name (most posing in uniform before the American flag), all men of diverse ethnicities (pp. 18–19). The thumbnails are followed by a group shot of eight soldiers standing in formation and dressed in uniform. But the gaping yawn of the soldier on the right suggests boring routine rather than seriousness. Then follow 25 individual portraits of soldiers (pp. 22–49). The shots range from long shots to medium shots to extreme close-ups, and the soldiers are both in and out of uniform, some bare-chested. Then come 16 black-white illustrations of tattoos with the last name of the soldiers wearing them (pp. 50–65). The next section takes up most of the book (pp. 66–149) and comprises photographs of details from the soldiers' camp: pinups, signs, pictures on walls, insignias on uniforms, the latrine, and several soldiers in different stages of down-time, including a series of the soldiers wrestling and displaying a rough form of affection (pp. 124–135).

The first photograph I will analyze is part of this section, and it is one Hetherington has referred to as his "Man Eden picture" (pp. 86–87; see Figure 9.1).

The camera is looking down on nine bare-chested soldiers on a dirt hillside surrounded by trees. In the center of the frame are four of the soldiers engaged in physical labor, filling bags with dirt. Two of the men are holding shovels and two holding bags. The digging has left a slight hole in the ground, in which the two men wielding shovels are placed. On the left, four soldiers, one standing, three sitting, form a semi-circle around the working soldiers. And in the very right side of the frame, elevated slightly higher than the rest, thereby approaching the point of view of the camera, a soldier is leaning against a tree, his right arm and hand protruding forward in a gesture very similar to the hand of God in DaVinci's famous painting "The Creation of Adam" (pp. 1508–1512). Below the men, above the middle of the frame, is a valley dotted with trees and greenery. The opposite mountainside rises in the top of the frame.

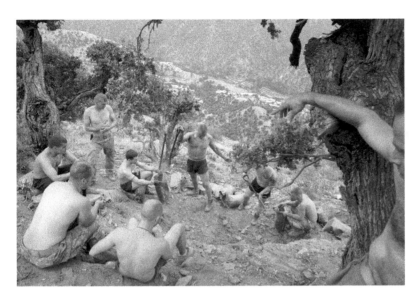

Figure 9.1 Afghanistan. Korengal Valley, Kunar Province. June 2008. Men from Second
Platoon dig earth for use as sand bags to reinforce parts of the Restrepo bunker.

Source: © Tim Hetherington/Magnum Photos.

Echoing Junger's framing of the photos, Hetherington has said of the picture that "it
really isn't a war photograph. It has a very pastoral scene to it, it kind of brings up ideas
of mediaeval paintings and indicated that the work was going in another direction."[44]
He elaborates on this in a commentary on the image in the *Infidel* book:

> I became less interested in photographing combat and more interested in the
> relationships that existed between the soldiers … After I saw this image, I
> thought more about the very male atmosphere that existed at the outpost. I saw
> that there was a special kind of bonding going on—something forged by the
> extreme circumstances.[45]

Hetherington then quotes his friend's grandfather, a World War II veteran, who
had said that "Only in war is it possible for men to demonstrate their love for one
another. It's the only place where society sanctions such behavior."[46] Indeed, as
Anthony Easthope asserts, discussing the masculine myth in popular culture, "[i]n
the dominant versions of men at war, men are permitted to behave towards each
other in ways that would not be allowed elsewhere, caressing and holding each
other, comforting and weeping together, admitting their love."[47] The theme of male
bonding also feeds back into the war photography trope of the American frontier
myth, discussed above. As Michael Kimmel has shown, in the popular imaginary,
the American frontier has been synonymous with a "homosocial sphere," one that
has been marked "by the startling absence of sexuality, of marriage, of families—
the virtual absence of women entirely."[48]

With this connection in mind, one way of approaching this photo—and several others in this book—is to see it as an update on the largely forgotten types of war photographs that Edward Steichen's US Naval Aviation Photographic Unit took of US Navy Men during World War II. A large selection of these have recently been collected in two books by Evan Bachner.[49] Also, Dian Hanson's *My Buddy: World War II Laid Bare* collects found photos of nude and semi-nude servicemen bonding in various ways.[50] These images did not fit into the paranoid Cold War atmosphere of the 1950s, in which the "effort to reinforce traditional norms seemed almost frantic," as William Chafe put it,[51] and where homosexuality and communism were easily linked—"both represented gender failure."[52] So while soldiers have been allowed to show love towards each other, the photographic record of that was kept locked away in the National Archives or in private drawers, proof that the 1950s were indeed "a decade of containment."[53]

When it comes to Hetherington's photo, not only does it document male bonding, but there is an interesting voyeuristic dynamic at work. We are watching several bare-chested soldiers who are watching four soldiers perform physical work. And this complicates matters. Since Laura Mulvey's seminal essay on visual pleasure,[54] many have grappled with the conflation of gender, sexuality, representation, and cinema but few have focused on the visual representation of men—perhaps because "the role of object-of-the-gaze is generally reserved for women."[55] Richard Dyer points out the instability produced when we look at "images of men that are offered as sexual spectacle"; an instability rooted in the fact that men as visual objects "does violence to the codes of who looks and who is looked at (and how), and some attempt is instinctively made to counteract this violation."[56] While this argument can certainly be applied to Hetherington's "Man Eden" photo, it should also be noted that the soldiers in the photo are not exactly being offered as sexual spectacle. And to complicate matters further, there is a much older tradition of representing the hero in epic as an object of the gaze, both erotic and otherwise.[57] In a more recent American context, Hollywood westerns and war films have been instrumental in fetishizing the heroic male body.[58] In a contemporary war context, Adelman notes how, in many "national contexts, including the US, there are a number of rituals, both institutionalized and informal, around the photographing of men in military dress."[59] But given the cultural controversy of gays in the military—especially in an American "Don't Ask/ Don't Tell" context—we cannot ignore, as Adelman argues, the way pictures like this may implicitly address, "the threat of the secretly gay soldier while ultimately relying on the assumption that only a real (read: straight) man would be tough enough for combat." After all, Adelman continues, "nonsexual bonding is seen as essential to military success."[60] And tied into this is also the potential threat experienced by male viewers, the production of "instability," as Dyer calls it.[61] Building on Dyer's observation, Steve Neale notes how "in a heterosexual and patriarchal society, the male body cannot be marked explicitly as the erotic object of another male look: that look must be motivated in some other way, its erotic component repressed."[62] The all-male military outpost that Hetherington documents is in many ways a microcosm of a heterosexual and patriarchal society.

Indeed, when we see this photo in the larger context of the photos surrounding it, it would almost seem that Hetherington is aware of this subliminal "threat." In fact, any "threat" of homosexual desire is neutralized by the previous photos: The six photos preceding the "Man Eden" photo all bear strong visual markers of traditional

heterosexual masculinity. The first two feature nude or partly nude centerfold girls hanging on the walls of the barracks (pp. 77–79). The third (pp. 80–81) shows two soldiers sitting on a bunk bed, looking at adult magazines, a third soldier standing on the left with a cigarette hanging from his lips. He is looking down at the magazine closest to him. The fourth photo (pp. 82–83) is almost a parody of hyper-masculinity: four soldiers sitting around a makeshift table, playing cards, three of them with a cigar in their hand.[63] Apart from the playing cards, the table is scattered with pictures of naked women. The fifth photo (p. 84) shows the December 2007 *Penthouse* Pet of the Month, nude, hung on a post, to the left a curled strip of flypaper, complete with dozens of dead flies. Hanging from the nail that holds the poster is a fly swatter. And the last photo before the "Man Eden" picture is of a wooden cut-out figure of a man with a large penis (p. 85). Nicknamed "Hesco Joe" by the soldiers,[64] the cut-out has a skull drawn on it and serves as a mascot for the soldiers. Placing the photo of the mascot next to the *Penthouse* Pet of the Month serves to highlight patriarchal idealization of certain types of femininity and masculinity. "Hesco Joe" becomes a caricature of virile warrior masculinity, a sign also of the juvenile "jack-ass" atmosphere that has been used to frame this new generation of US soldiers, nicknamed "Generation Kill" by Evan Wright.[65] However, that simplistic reading is complicated by the ways in which the figure plays into the above discussion about the disturbance created when the sexualized male body is put on display.

The physical work performed in the "Man Eden" photo is also an important element that frames it politically. In their analysis of Joe Rosenthal's iconic Iwo Jima photograph, Robert Hariman and John Louis Lucaites argue that the Marines in the photo may be seen as "the ideal work group."[66] Not only does this evoke visual analogies of "a community barn raising or putting one's shoulder to the wheel,"[67] but the image renders moot mute any notion of the horrors of the Iwo Jima experience, where nearly 6,000 US Marines lost their lives in the five-week battle, almost one-fourth of the total number of Marines killed in World War II.[68] As Hariman and Lucaites point out, one way of reading the photo is as an "image from a horrific battle [that] shows war as labor rather than killing . . . The labor is on behalf of a flag, of nation building, not the destruction of other cultures."[69]

To some extent we can also see the same analogy at work in the "Man Eden" photo, although the absence of the flag makes it less overtly patriotic, and the bare-chested men imbue the photo with more vernacular qualities. Also, unlike the Iwo Jima Marines who are viewed from slightly below, we are looking down at the soldiers in Hetherington's photo, suggesting a reversal of the power structure between viewer and object. This plays into the notion of the post-heroic age of warfare as proposed by Edward N. Luttwak and Anthony King[70] and perhaps suggests a more nuanced visual approach to US soldiers. But the idea of friendly, peaceful soldiers performing nation building on behalf of another culture is certainly present.[71] In this reading, the complete absence of weapons is also significant. Again, one could argue that this photo glosses over the reality of the US presence in Afghanistan and its effect on the Taliban not to mention the civilian population. Indeed, the photos following "Man Eden" supports the argument: After seven photos (pp. 127–136) of the soldiers roughhousing—displaying an extreme physical form of male bonding—the next picture shows five soldiers in a state of relaxation, one playing the guitar, one smoking a cigar, and one looking at his cellphone. The sky behind the Hesco walls is a pinkish hue of dusk. The next seven photos are all taken at night, six of them with a red

light (pp. 139–147). Nighttime is a time for playing *Guitar Hero* (pp. 139–140) and guitar (pp. 141–142), but Hetherington also points his camera at a sign, a tattoo on a shoulder, and a bullet on the floor (pp. 143–144). Following the nighttime images is a white double page displaying (traditionally manly) leisure reading: eight magazine covers (pp. 148–149), ranging from adult magazines like *Playboy* over *Tatoo* and *Guns & Ammo* to *Automobile* and *Stayton Sublimity*, a visitor guide featuring white water rafting on the cover.

After pictures that convey downtime, leisure, and other forms of non-combat, the next section signals a significant thematic and visual change. The photos beginning on page 150 are without the white border that has framed all the previous pictures. The photos now take up the entire page(s), and the subject matter stresses their all-encompassing nature: combat. The first of these photos depicts a group of eight soldiers posing in combat gear, armed and ready (pp. 150–151). The next (pp. 152–153) features seven men, six in uniform, firing a 155, one of the "heavy artillery guns that rained down shells on the Korengal."[72] The men are dwarfed by the enormous canon pointing upwards to the sky and emitting a plume of dark smoke that stands in sharp contrast to the white clouds above the ragged mountains.

The combat section consists of 24 photos (pp. 150–187), including a harrowing series depicting the death of one of the US soldiers and the reactions of his comrades (pp. 180–185). In fact, because Hetherington's focus on the trite everyday non-combat life of the platoon and on the bond between the soldiers establishes an intimate connection, the photos in the combat section have a much stronger emotional effect. The combat section ends with Hetherington's Award-winning World Press Photo of the Year (pp. 186–187; see Figure 9.2).

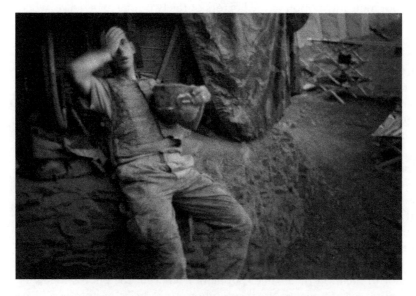

Figure 9.2 Afghanistan. Korengal Valley. 2007. A soldier from Second Platoon rests at the end of a day of heavy fighting at the 'Restrepo' outpost. The position was named after the medic Juan Restrepo from Second Platoon who was killed by insurgents in July 2007.

Source: © Tim Hetherington/Magnum Photos.

The photo tells a completely different story than the "Man Eden" photo. Gone are the buddies, the brotherhood, the bonding. In the left side of the frame is a lone unnamed soldier, leaning back on an embankment in a gesture of utter exhaustion.[73] The emptiness in the right side of the frame calls out to us, especially in the context of the now well-established theme of brotherhood and bonding. The emptiness is just that: an absence that evokes loss, death, darkness. With no one to lean on and no one who has "got his back," this soldier is on his own. The soldier and the photo are blurred and out of focus, which brings to mind Robert Capa's famous observation that "if you want to get good action shots, they mustn't be in true focus. If your hands tremble a little, then you get a fine action shot."[74] The blurriness can also be seen as a visual representation of the surreal nature of combat and something that further emphasizes the soldier's expression of exhaustion or shock. The gesture of his hand on his face is one of disbelief, as if he is thinking: "what have I done?" or "what am I doing here?" In his biography of Hetherington, Alan Huffman notes that the photo, "aside from a few details . . . could easily have been taken in Vietnam."[75] This links the photo and the larger narrative surrounding it to all the negative connotations surrounding the American involvement in Vietnam and effectively erases notions of peaceful and leisurely liberation alluded to in the first two thirds of *Infidel*. According to World Press Photo jury chairman Gary Knight, the "image represents the exhaustion of a man—and the exhaustion of a nation . . . It's a picture of a man at the end of a line."[76] The sense of fatigue, confusion, and defeat emanating from the soldier debunks any heroic notion of "soldierly masculinity," although it should be said that it fits into a well-established tradition of photographs of unnerved soldiers with the thousand-yard stare, most notably Don McCullin's famous photo "Shellshocked soldier, Hue, Vietnam, February 1968," a photo whose influence is certainly traceable in Sinco's afore-mentioned "Marlboro Marine"—if one strips away the jingoistic interpretations.

The next section consists of 14 pages of written testimonials by 14 of the soldiers (pp. 188–201). This is a somewhat curious break in the visual flow of the narrative. Apart from Junger's introduction, *Infidel* has been all visual material. One way of interpreting the written testimony is to place it within the frame of trauma theory. According to several trauma theorists, testimony—what Ann Whitehead calls a "highly collaborative relationship between speaker and listener"[77]—is crucial in order for trauma victims to work through their experience. Kristiaan Versluys points to the "need on the part of the traumatized to relieve anxiety through telling" and how this individual need feeds into a larger, "globalized need to comprehend, to explain, and to restore."[78] The testimony by the soldiers is perhaps all the more impressive given the patriarchal standards that traditionally have structured emotions as feminine. As Peter Schwenger has argued, by talking and opening up to another person, people make themselves vulnerable.[79] In the context of *Infidel*'s initial visual tale of Restrepo as a boisterous, carefree all-male reserve, the frank testimony of the soldiers adds an additional layer of nuance to Hetherington's construction of the soldiers and their experience. After the shocking and sobering combat section, the testimony section opens up a space for the soldiers to reflect on and give voice to their experiences at Restrepo—experiences that the viewer has shared vicariously by looking—in ways that do not fit into culturally accepted notions of soldierly masculinity.

In the final section of the book, Hetherington adds additional nuance to his depiction of soldiers: 15 photos of individual sleeping soldiers identified by

their last names conclude *Infidel* (pp. 202–231) and transform the soldiers into vulnerable boys (e.g. see Figure 9.3). Sebastian Junger has recounted Hetherington's explanation as to why he photographed the sleeping soldiers:

> This is how their mothers see them. This is the other side of them, and this is what their mothers see, and this is what the American public never gets to see because any nation is self-selecting the images it presents. And we want to see our soldiers as strong. We don't want to know that they're also these vulnerable boys.[80]

But Hetherington clearly wants us to see the soldiers as also that; vulnerable boys. It is a deliberate reaction against the heroic construction and self-selection represented in president Bush's "Mission Accomplished" photo-op and the jingoistic framing of Sinco's "Marlboro Man" photo.

The sleeping soldiers photos became part of an exhibition,[81] and Alan Huffman sees these photos, along with *Infidel*, the *Restrepo* film, and Jungers' *War*, as part of a larger agenda to "show a side of the soldiers that noncombatants could relate to, as well as to foster a sense of responsibility for helping reintegrate them into American life afterward."[82] Coming after the horror and shock of the combat photos, this is yet another stark contrast that elicits an emotional response. Although the tattered Louis L'Amour novel and the *Sports Illustrated* Swimsuit Issue next to PFC Mace (p. 206) are visual reminders of macho postures, the sense of serenity in the photos is far removed from the gung-ho bravado of the soldiers' leisurely macho performances in the first part of the book and to the traumatic combat section. Once again they are alone, off in their private sleep, perhaps dreaming of home, perhaps haunted by the war, as the photo project suggested. Photojournalist Chris Anderson sees in the pictures something "that get[s] at the sense of that these are just kids. To see them stripped down and asleep in wartime conveys this sense of sending off young men to die."[83]

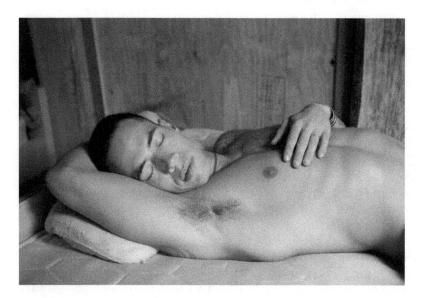

Figure 9.3 Afghanistan. Korengal Valley, Kunar Province. July 2008. Sergeant Elliot Alcantara sleeping.

Hetherington is deliberately subverting a particular patriotic discourse in the photos. Yet indirectly, the photos also activate conflicting narratives that complicate Hetherington's intentions: the "how their mothers see them" frame mentioned by Hetherington also brings forth the archetypal trope of the patriotic mother, a figure who is "supporting and caring . . . stoic, silent, and brave in the face of war."[84] And in the context of *Infidel*'s broader reliance on frontier metaphors, the mother frame calls forth associations of a powerful trope of American manhood, one Michael Kimmel defines as "the repudiation of the feminine, the resistance to mothers' and wives' efforts to civilize men."[85] These alternative narratives are at odds with each other, yet both feed into a conservative and patriotic interpretation of American history, one that clashes with Hetherington's more liberal intentions and creates a tension that belies the tranquility at the surface of the photos of the sleeping soldiers.

Conclusion

In a time of renewed patriotism, Hetherington's *Infidel* provides a corrective to America's "time-honored link between its sense of national self and the performance of American men at war."[86] While Hetherington never questions or problematizes his role as embedded reporter, the photos in *Infidel* still add up to a nuanced and complex visualization of young American soldiers. By constructing an up-close visual narrative that, in effect, forges an emotional community between the viewer and the soldiers, Hetherington presents a deliberate emotionally charged counter-narrative to the traditional and rigid depictions of the warrior hero. We experience the male soldiers as juvenile grunts performing macho masculinity *and* shell-shocked veterans *and* finally vulnerable "mothers' boys." The potential emotional power of the photos is a result of the cumulative effect of Hetherington's intimate moments with the soldiers. And while the emotional connection may obscure some of the underlying narratives in the photos, Hetherington's insistence on "variety and complexity"[87] inevitably creates cracks and fissures in the "male armor" surrounding the myth of the American soldier and forms a counter-narrative in the ongoing war of narratives that has been part of the global War on Terror long before the first shot was fired.

Notes

1 According to *Costs of War*, a study from Brown University, as of August 2016, approximately "370,000 people have been killed by direct war violence in Iraq, Afghanistan, and Pakistan . . . At least 210,000 civilians have been killed in the fighting" (Neta Crawford et al. "Human Costs." *Costs of War*. Watson Institute, International & Public Affairs. Brown University. http://watson.brown.edu/costsofwar/costs/human).

2 W.J.T. Mitchell, *Cloning Terror: The War of Images, 9/11 to the Present* (Chicago: The University of Chicago Press, 2013), 6.

3 Rebecca A. Adelman, "Sold(i)ering Masclinity: Photographing the Coalition's Male Soldiers," *Men and Masculinities* 11, no. 3 (April 2009): 275.

4 The two *Vanity Fair* articles (written by Sebastian Junger with photos by Hetherington) are: "Into the Valley of Death," *Vanity Fair* (January 2008) and "Return to the Valley of Death," *Vanity Fair* (October 2008).

5 After Hetherington was killed in Libya, Junger has documented the Restrepo experience in two additional documentary films, *Korengal* and *The Last Patrol*, both from 2014. He also directed a documentary about Hetheringon: *Which Way Is the Frontline from Here? The Life and Time of Tim Hetherington* (2013).

6 Cara Cilano, "Manipulative Fictions: Democratic Futures in Pakistan," in *From Solidarity to Schisms: 9/11 and After in Fiction and Film from Outside the US*, ed. Cara Cilano (Rodopi: Amsterdam, 2009), 210.

7 See Madeleine Bunting, "Women and War," *Guardian*, September 20, 2001, accessed January 6, 2012, www.guardian.co.uk/education/2001/sep/20/socialsciences.highereducation, as well as Susan Faludi, *The Terror Dream: What 9/11 Revealed about America* (London: Atlantic Books, 2007).

8 Frank Rich, *The Greatest Story Ever Sold: The Decline and Fall of Truth in Bush's America* (New York: Penguin, 2006), 89.

9 Philip Hammond, "Simulation and Dissimulation," *Journal of War and Culture Studies* 3, no. 3 (2011): 314.

10 Todd M. Reeser, *Masculinities in Theory: An Introduction* (Oxford: Wiley-Blackwell, 2010), 1.

11 Stephen J. Ducat, *The Wimp Factor: Gender Gaps, Holy Wars, and the Politics of Anxious Masculinity* (Boston: Beacon Press, 2004), 21. George Bush Sr., like many male US politicians before him, had struggled with a public that saw him as too feminine. The issue was summed up by an unflattering 1987 *Newsweek* cover of Bush Sr. with the headline "Fighting the Wimp Factor."

12 Ducat, *Wimp Factor*, 22.

13 Faludi, *The Terror Dream*, 289.

14 Robin Andersen, *A Century of Media, a Century of War* (New York: Peter Lang, 2006), 272.

15 Luis Sinco, "Two Lives Blurred Together by a Photo," *Los Angeles Times*, November 1, 2007, accessed January 6, 2016, http://articles.latimes.com/2007/nov/11/nation/la-na-marlboro11nov11.

16 Andersen, *A Century of Media*, 201.

17 Joel Roberts, "Mom Wants Icon Son to Return Safe," *CBS News*, November 15, 2004, accessed January 6, 2006, www.cbsnews.com/news/mom-wants-icon-son-to-return-safe/. Ironically, already in May 2002, Rather criticized American journalists' failure to ask tough questions because they were "cowed by patriotic fever." He also blamed himself, explaining that the jingoistic atmosphere created a fear of having "a flaming tyre of lack of patriotism put around your neck . . . [I]t is that fear that keeps journalists from asking the toughest of the tough questions." Rather also lashed out at the Bush administration for "Limiting access, limiting information to cover the backsides of those who are in charge of the war, [which] is extremely dangerous and cannot and should not be accepted." Matthew Engel, "US Media Cowed by Patriotic Fever, Says CBS Star," *Guardian*, 17 May 2002, accessed March 12, 2016, www.theguardian.com/media/2002/may/17/terrorismandthemedia.broadcasting.

18 Above-mentioned Dan Rather was part of the news team that broke the Abu Ghraib prison abuse story on CBS's *60 Minutes II* on April 27, 2004. The news team was awarded the 2004 Peabody Award for "a straightforward examination of an unwelcome and frightening aspect of the war in Iraq."

19 Andersen, *A Century of Media*, xvi.

20 Shannon. L. Holland, "The Enigmatic Lynndie England: Gendered Explanations for the Crisis at Abu Ghraib," *Communications and Critical/Cultural Studies* 6, no. 3 (September 2009): 247.

21 Dora Apel, *War Culture and the Contest of Images* (Piscataway, NJ: Rutgers University Press, 2012), 87.

22 Andersen, *A Century of Media*, xix.

23 Susan Jeffords discusses and analyzes the pervasiveness of patriarchal responses to the Vietnam War in her *The Remasculinization of America: Gender and the Vietnam War* (Bloomington, IN: Indiana University Press, 1989).

24 S.J. Dubner, "Looking for Heroes and Finding Them," *New York Times*, October 6, 2001, 23.

25 John Ryan, "Black Hawk Crew Honored for 3 Heroic Days," *Army Times*, April 23, 2012, accessed January 14, 2006, http://archive.armytimes.com/article/20120423/NEWS/204230311/Black-Hawk-crew-honored-for-3-heroic-days.

26 Erik Sabiston, "I Am Not a Hero," *Newsweek*, July 4, 2015, accessed January 14, 2006, www.newsweek.com/i-am-not-hero-350124.

27 Alan Huffman, *Here I Am: The Story of Tim Hetherington, War Photographer* (New York: Grove Press, 2013), 98.

28 Quoted in Sebastian Junger, *Which Way is the Frontline from Here? The Life and Time of Tim Hetherington* (Goldcrest Films International, 2013), DVD.

29 Adams, Jon Robert, *Male Armor: The Soldier-Hero in Contemporary American Culture* (University of Virginia Press, 2008), 9.

30 Marc Pitzke, "The Story Behind the World Press Photo of the Year: The Trauma of a Forgotten War," *Spiegel Online*, February 15, 2008, accessed January 6, 2016, www.spiegel.de/international/world/the-story-behind-the-world-press-photo-of-the-year-the-trauma-of-a-forgotten-war-a-535620.html.

31 Kate McLoughlin, "War in Print Journalism," in *The Cambridge Companion to War Writing*, ed. Kate McLoughlin (New York: Cambridge University Press, 2009), 15.

32 Judith Butler, *Frames of War: When Is Life Grievable?* (New York: Verso, 2009), 64. For further criticism of the embedment program, see Andrew M. Lindner, "Controlling the Media in Iraq," *Contexts* 7.2 (Spring 2008): 32–38.

33 Butler, *Frames*, 64.

34 Quoted in "Tim Hetherington on his Winning Photo," *World Press Photo*, accessed June 17, 2017, https://vimeo.com/67511633.

35 Jeffords, Susan, *The Remasculinization of America*, 182.

36 Frank J. Barrett, "The Organizational Construction of Hegemonic Masculinity: The Case of the US Navy," in *The Masculinities Reader*, ed. Stephen M. Whitehead and Frank J. Barrett (Malden, MA: Polity, 2001), 77.

37 Susan D. Moeller, *Shooting War: Photography and the American Experience of Combat* (New York: Basic Books, 1989), 22.

38 Christina S. Jarvis, *The Male Body at War: American Masculinity during World War II* (Dekalb: Northern Illinois University Press, 2004), 185.

39 Patricia Vettel-Becker, *Shooting from the Hip: Photography, Masculinity, and Postwar America* (Minneapolis: University of Minnesota Press, 2005), xiv.

40 Several associations are brought into play by the golfing soldier: In the 1972 pilot episode of the popular TV series *M*A*S*H**, two of the characters playing golf cause an explosion, when one of their shots lands in a mine field. *M*A*S*H**—both Richard Hooker's novel, Robert Altman's film adaptation, and the TV series (1972–1983)—framed the Korean war in the context of Vietnam and, in the tradition of Joseph Heller and Kurt Vonnegut, took an absurd and humorous approach to war. Absurdity is one interpretative context of the photo, and one that is played out in full by photographer Thomas Dworzak in his photo book *M*A*S*H*I*R*A*Q** (London: Trolley Books, 2007). Here Dworzak juxtaposes photos from his 2005 embedment with a US medical corps in Iraq with stills from the *M*A*S*H** TV series in order to reveal "the parallels of life at war, unchanged over the decades, the mad mixed with the small moments of sanity, that evolve from living in conflict, from Korea to Iraq" (Dworzak, cover). The project stresses the slippage between fiction and reality that also characterized Bush's "Mission Accomplished" speech and the broader mediation of the War on Terror.
 Another, more contemporary association to the golf photo is the clip made famous in Michael Moore's *Fahrenheit 9/11* (2004), of President George W. Bush addressing journalists while playing golf. "We must stop the terror," he asserts, before quipping: "Now watch this drive." In this context, Hetherington's golf photo plays into the larger critique of an incompetent and arrogant Bush administration's handling of the War on Terror.

41 Moeller, *Shooting War*, 21. See Slotkin's trilogy on the myth of the frontier in American history and culture: *Regeneration through Violence: The Mythology of the American Frontier, 1600–1860* (Middletown, CT: Wesleyan University Press, 1973), *The Fatal Environment: The Myth of the Frontier in the Age of Industrialization, 1800–1890* (Middletown, CT: Wesleyan University Press, 1985), and *Gunfighter Nation: The Myth of the Frontier in Twentieth-Century America* (Middletown, CT: Wesleyan University Press 1992).

42 Sebastian Junger, "Introduction," in Tim Heterington, *Infidel* (London: Boot, 2010), 16.

43 Junger, "Introduction," 17.

44 Tim Hetherington, Quoted in Junger, *Which Way*.

45 Hetherington, *Infidel*, 234.

46 Ibid.

47 Anthony Easthope, *What a Man's Gotta Do: The Masculine Myth in Popular Culture* (New York: Routledge, 1990), 66.

48 Michael Kimmel, *Manhood in America: A Cultural History* (New York: The Free Press, 1996), 61.

49 Evan Bachner, *At Ease: Navy Men of World War II* (New York: Harry N. Abrams, 2004) and *Men of World War II: Fighting Men at Ease* (New York: Harry N. Abrams, 2007).

50 Dian Hanson, *My Buddy: World War II Laid Bare* (Köln: Taschen, 2014).

51 Quoted in Wini Breines, *Young, White, and Miserable: Growing Up Female in the Fifties* (Boston: Beacon Press, 1992), 8.

52 Kimmel, *Manhood*, 236.

53 Ibid.

54 Laura Mulvey, "Visual Pleasure and Narrative Cinema," in *The Sexual Subject: A Screen Reader in Sexuality*, ed. Mandy Merck (New York: Routledge, 1996), 22–34.

55 Adelman, "Sold(i)ering," 267.

56 Richard Dyer, "Don't Look Now: The Male Pin-Up," in *The Sexual Subject: A Screen Reader in Sexuality* (New York: Routledge, 1992), 267.

57 Helen Lovatt, *The Epic Gaze: Vision, Gender and Narrative in Ancient Epic* (Cambridge University Press), 2013.

58 See Steve Neale, "Masculinity as Spectacle: Reflections on Men and Mainstream Cinema," in *Screening the Male: Exploring Masculinities in Hollywood Cinema*, ed. Steven Cohan and Ina Rae Hark (New York: Routledge, 1993), 9–19; and Robert Eberwein, *Armed Forces: Masculinity and Sexuality in the American War Film* (New York: Rutgers University Press, 2007).

59 Adelman, "Sold(i)ering," 267.

60 Ibid., 277.

61 Dyer, "Don't Look Now," 267.

62 Neale, "Masculinity as Spectacle," 14.

63 Cathy van Ingen has pointed to the "historic association" between card games, especially poker, and "men [and] masculinity." In Cathy van Ingen, "Poker Face: Gender, Race and Representation in Online Poker," *Leisure/Loisir: Journal of the Canadian Association for Leisure Studies* 32, no. 1 (2008): 3.

64 Hetherington, *Infidel*, 234.

65 In Roy Scranton, "Going outside *The Wire*: *Generation Kill* and the Failure of Detail," *City* 14, no. 5 (October 2010): 558–565, Scranton criticizes Evan Wright's "conceit that the men being written about represent a 'generation.'" That Wright characterizes these Marines as "representative of 'our doomed youth' (itself a hoary cliché) is simply mistaken," Scranton argues. He points to the fact that the Recon Marines Wright chronicles make up "less than two hundredths of a percent of the available military population, an elite volunteer unit in a volunteer military, a tiny, self-selected cadre" (560).

66 Robert Hariman and John Lucaites, "Performing Civic Identity: The Iconic Photograph of the Flag-Raising on Iwo Jima," *Quarterly Journal of Speech* 88 (2002): 368.

67 Hariman and Lucaites, "Performing," 369.

68 David M. Kennedy, *The American People in World War II* (1999. New York: Oxford University Press, 2004), 406.

69 Hariman and Lucaites, "Performing," 369.

70 Luttwak's premise is that in the post-Cold War society, Western powers have found it increasingly difficult to accept the loss of military lives as meaningful. King's supplement is that new training methods have changed the tactical dynamics in the militaries and have replaced the individual-masses binary with collective professionalism. See Edward N. Luttwak, "Toward Post-Heroic Warfare," *Foreign Affairs* 74, no. 3 (May–June 1995): 109–122; and Anthony King, "The Word of Command: Communication and Cohesion in the Military," *Armed Forces & Society* 32, no. 4 (July 2006): 493–512.

71 This is also one of the ways Hollywood has depicted US soldiers fighting the war on terror, as seen especially in Kathryn Bigelow's *The Hurt Locker* (2009) and Paul Greengrass's *Green Zone* (2010) where the idea of the good soldier lives on.

72 Hetherington, *Infidel*, 238.

73 The official caption reads:

> Korengal Valley, Afghanistan. Brandon Olson, Specialist of Second Platoon, Battle
> Company of the Second Battalion of the US 503rd Infantry Regiment sinks onto an
> embankment in the Restrepo bunker at the end of the day. The Korengal Valley was the
> epicenter of the US fight against militant Islam in Afghanistan and the scene of some of
> the deadliest combat in the region.
> ("Collections 2008 Photo Contest," *World Press Photo*, accessed January 6, 2016,
> www.worldpressphoto.org/collection/photo/2008/general-news/tim-hetherington/03)

74 Quoted in Mary Warner Marien, *Photography: A Cultural History*, 4th ed (London: Laurence
King, 2014), 301. Capa's comment regarding his famous photo *Death of a Loyalist Soldier*
(1936) also applies to another of his famous pictures, the Omaha Beach picture *The Face in
the Surf* (1944). Capa's 1947 autobiography was titled *Slightly Out of Focus*.
75 Huffman, *Here I Am*, 99.
76 "British Photographer Tim Hetherington Wins Premier Award," *World Press Photo*, 7
February 2008, accessed January 6, 2016, www.worldpressphoto.org/news/2008-02-07/
british-photographer-tim-hetherington-wins-premier-award.
77 Anne Whitehead, *Trauma Fiction* (Edinburgh: Edinburgh University Press, 2004), 7.
78 Kristiaan Versluys, *Out of the Blue: September 11 and the Novel* (New York: Columbia
University Press, 2009), 4.
79 Peter Schwenger, *Phallic Critiques: Masculinity and Twentieth-Century Literature* (Boston:
Routledge & Kegan Paul, 1984), 44.
80 Quoted in Junger, *Which Way*.
81 The photos of the sleeping soldiers were part of Hetherington's video installation *Sleeping
Soldiers*, shown first at the 2009 New York Photo Festival. In *Time*'s "LightBox," Paul
Moakley describes the installation:

> Viewers at the Photo Festival were instructed to stand close to a set of three large
> video screens. The three-channel work features layered images of soldiers from a U.S.
> Airborne Infantry platoon based in the Korengal Valley during periods of combat and
> while at rest. Intimate photographs of soldiers sleeping are paired with video footage
> depicting their often violent day-to-day work. Detailed editing and sound design by
> Magali Charrier help echo the surreal and brutal realities of war—realities these men
> all too often carry into their only moments of peace. Sleeping Soldiers' unique format
> allows viewers to engage in their own dreamlike, immersive experience, evoking critical
> consideration of the strains of war placed upon the men engaged in the conflict.
> (Paul Moakley, "Standing Close to Tim Hetherington's
> Sleeping Soldiers." "LightBox," *Time*, May 29, 2011,
> accessed February 10, 2016, http://time.com/11170/
> standing-close-to-tim-hetheringtons-sleeping-soldiers)

An example of the installation can be seen here: https://vimeo.com/18395855.
82 Huffman, *Here I Am*, 97.
83 Quoted in Junger, *Which Way*.
84 Karen L. Slattery and Ana C. Garner, "Mothers of Soldiers in Wartime: A National News
Narrative," *Critical Studies in Media Communication* 24 (2007): 429.
85 Kimmel, *Manhood*, 60.
86 Adams, *Male Armor*, 2.
87 Reeser, *Masculinities in Theory*, 2.

Bibliography

Adams, Jon Robert. *Male Armor: The Soldier-Hero in Contemporary American Culture.*
University of Virginia Press, 2008.
Adelman, Rebecca A. "Sold(i)ering Masculinity: Photographing the Coalition's Male Soldiers."
Men and Masculinities 11, no. 3 (April 2009): 259–285.

Andersen, Robin. *A Century of Media, a Century of War*. New York: Peter Lang, 2006.

Apel, Dora. *War Culture and the Contest of Images*. Piscataway, NJ: Rutgers University Press, 2012.

Bachner, Evan. *At Ease: Navy Men of World War II*. New York: Harry N. Abrams, 2004.

——. *Men of World War II: Fighting Men at Ease*. New York: Harry N. Abrams, 2007.

Barrett, Frank J. "The Organizational Construction of Hegemonic Masculinity: The Case of the US Navy." In *The Masculinities Reader*, edited by Stephen M. Whitehead and Frank J. Barrett, 77–99. Malden, MA: Polity, 2001.

Breines, Wini. *Young, White, and Miserable: Growing Up Female in the Fifties*. Boston: Beacon Press, 1992.

"British Photographer Tim Hetherington Wins Premier Award." *World Press Photo*, 7 February 2008. www.worldpressphoto.org/news/2008-02-07/british-photographer-tim-hetherington-wins-premier-award (accessed January 6, 2016).

Bunting, Madeleine. "Women and War." *Guardian*, 20 September, 2001. www.guardian.co.uk/education/2001/sep/20/socialsciences.highereducation (accessed January 6, 2012).

Butler, Judith. *Frames of War: When Is Life Grievable?* New York: Verso, 2009.

Cilano, Cara. "Manipulative Fictions: Democratic Futures in Pakistan." *From Solidarity to Schisms: 9/11 and After in Fiction and Film from Outside the US*, edited by Cara Cilano. Rodopi, Amsterdam, 2009.

"Collections 2008 Photo Contest." *World Press Photo*. www.worldpressphoto.org/collection/photo/2008/general-news/tim-hetherington/03 (accessed January 6, 2016).

Crawford, Neta. C., et al. "Human Costs." *Costs of War*, August 2016. Watson Institute, International & Public Affairs. Brown University. http://watson.brown.edu/costsofwar/costs/human (accessed January 6, 2016).

Dubner, S.J. "Looking for Heroes and Finding Them." *New York Times* (October 6, 2001), 23.

Ducat, Stephen J. *The Wimp Factor: Gender Gaps, Holy Wars, and the Politics of Anxious Masculinity*. Boston: Beacon Press, 2004.

Dworzak, Thomas. *M*A*S*H*I*R*A*Q**. London: Trolley Books, 2007.

Dyer, Richard. "Don't Look Now: The Male Pin-Up." In *The Sexual Subject: A Screen Reader in Sexuality*, 265–276. New York: Routledge, 1992.

Easthope, Anthony. *What a Man's Gotta Do: The Masculine Myth in Popular Culture*. New York: Routledge, 1990.

Eberwein, Robert. *Armed Forces: Masculinity and Sexuality in the American War Film*. New York: Rutgers University Press, 2007.

Engel, Matthew. "US Media Cowed by Patriotic Fever, Says CBS Star." *Guardian* 17 May, 2002. www.theguardian.com/media/2002/may/17/terrorismandthemedia.broadcasting (accessed March 12, 2016).

Faludi, Susan. *The Terror Dream: What 9 / 11 Revealed about America*. London: Atlantic Books, 2007.

Hammond, Philip. "Simulation and Dissimulation." *Journal of War and Culture Studies* 3.3 (2011): 305–318.

Hanson, Dian. *My Buddy: World War II Laid Bare*. Köln: Taschen, 2014.

Hariman Robert, and John Louis Lucaites. "Performing Civic Identity: The Iconic Photograph of the Flag-Raising on Iwo Jima." *Quarterly Journal of Speech* 88 (2002): 363–392.

Hetherington, Tim. *Infidel*. London: Boot, 2010.

Holland, Shannon. L. "The Enigmatic Lynndie England: Gendered Explanations for the Crisis at Abu Ghraib." *Communications and Critical/Cultural Studies* 6, no. 3 (September 2009): 246–264.

Huffman, Alan. *Here I Am: The Story of Tim Hetherington, War Photographer*. New York: Grove Press, 2013.

Jarvis, Christina S. *The Male Body at War: American Masculinity during World War II*. Dekalb: Northern Illinois University Press, 2004.

Jeffords, Susan. *The Remasculinization of America: Gender and the Vietnam War.* Bloomington: Indiana University Press, 1989.

Junger, Sebastian. "Introduction." In Tim Hetherington, *Infidel*, 14–17. London: Boot, 2010.

———, dir. *Which Way is the Frontline from Here? The Life and Time of Tim Hetherington.* Goldcrest Films International, 2013.

Kennedy, David M. *The American People in World War II.* 1999. New York: Oxford University Press, 2004.

Kimmel, Michael, *Manhood in America: A Cultural History.* New York: The Free Press, 1996.

King, Anthony. "The Word of Command: Communication and Cohesion in the Military." *Armed Forces & Society* 32, no. 4 (July 2006): 493–512.

Lindner, Andrew M. "Controlling the Media in Iraq," *Contexts* 7, no. 2 (Spring 2008): 32–38.

Lovatt, Helen. *The Epic Gaze: Vision, Gender and Narrative in Ancient Epic.* Cambridge University Press, 2013.

Luttwak, Edward N. "Toward Post-Heroic Warfare." *Foreign Affairs* 74, no. 3 (May–June 1995): 109–122.

McLoughlin, Kate. "War in Print Journalism." *The Cambridge Companion to War Writing*, ed. Kate McLoughlin. New York: Cambridge University Press, 2009.

Marien, Mary Warner. *Photography: A Cultural History, 4th ed.* London: Laurence King, 2014.Mitchell, W.J.T. *Cloning Terror: The War of Images, 9/11 to the Present.* Chicago: The University of Chicago Press, 2013.

Moakley, Paul. "Standing Close to Tim Hetherington's Sleeping Soldiers." "LightBox." *Time*, 29 May 2011. http://time.com/11170/standing-close-to-tim-hetheringtons-sleeping-soldiers/ (accessed February 10, 2016).

Moeller, Susan D. *Shooting War: Photography and the American Experience of Combat.* New York: Basic Books, 1989.

Mulvey, Laura. "Visual Pleasure and Narrative Cinema." In *The Sexual Subject: A Screen Reader in Sexuality*, edited by Mandy Merck, 22–34. New York: Routledge, 1996.

Neale, Steve. "Masculinity as Spectacle: Reflections on Men and Mainstream Cinema." *Screening the Male: Exploring Masculinities in Hollywood Cinema*, edited by Steve Cohan and Ina Rae Hark, 9–19. New York: Routledge, 1993.

Penner, James. *Pinks, Pansies, and Punks: The Rhetoric of Masculinity in American Literary Culture.* Bloomington: Indiana University Press, 2011.

Pitzke, Marc. "The Story Behind the World Press Photo of the Year: The Trauma of a Forgotten War." *Spiegel Online*, February 15, 2008. www.spiegel.de/international/world/the-story-behind-the-world-press-photo-of-the-year-the-trauma-of-a-forgotten-war-a-535620.html (accessed March 12, 2016).

Reeser, Todd M. *Masculinities in Theory: An Introduction.* Oxford: Wiley-Blackwell, 2010.

Rich, Frank. *The Greatest Story Ever Sold: The Decline and Fall of Truth in Bush's America.* New York: Penguin, 2006.

Roberts, Joel. "Mom Wants Icon Son to Return Safe." *CBS News*, November 15, 2004. www.cbsnews.com/news/mom-wants-icon-son-to-return-safe/ (accessed January 6, 2006).

Ryan, John. "Black Hawk Crew Honored for 3 Heroic Days." *Army Times*, April 23, 2012. http://archive.armytimes.com/article/20120423/NEWS/204230311/Black-Hawk-crew-honored-for-3-heroic-days (accessed January 14, 2006).

Sabiston, Erik. "I Am Not a Hero." *Newsweek*, July 4, 2015. www.newsweek.com/i-am-not-hero-350124 (accessed January 14, 2006).

Schwenger, Peter. *Phallic Critiques: Masculinity and Twentieth-Century Literature.* Boston: Routledge & Kegan Paul, 1984.

Scranton, Roy. "Going Outside *The Wire*: *Generation Kill* and the Failure of Detail." *City* 14, no. 5 (October 2010): 558–565.

Sinco, Luis. "Two Lives Blurred Together by a Photo." *Los Angeles Times*, November 1, 2007. http://articles.latimes.com/2007/nov/11/nation/la-na-marlboro11nov11 (accessed January 6, 2016).

Slattery, Karen L. and Ana C. Garner. "Mothers of Soldiers in Wartime: A National News Narrative." *Critical Studies in Media Communication* 24 (2007): 429–445.

Slotkin, Richard. *Regeneration through Violence: The Mythology of the American Frontier, 1600–1860*. Middletown, CT: Wesleyan University Press, 1973.

——. *The Fatal Environment: The Myth of the Frontier in the Age of Industrialization, 1800–1890*. Middletown, CT: Wesleyan University Press, 1985.

——. *Gunfighter Nation: The Myth of the Frontier in Twentieth-Century America*. Middletown, CT: Wesleyan University Press 1992.

"Tim Hetherington on his Winning Photo." *World Press Photo*, June 2, 2013. https://vimeo.com/67511633 (accessed June 16, 2017).

van Ingen, Cathy. 2008, "Poker Face: Gender, Race and Representation in Online Poker." *Leisure/Loisir: Journal of the Canadian Association for Leisure Studies* 32, no. 1 (2008): 3–20.

Versluys, Kristiaan. *Out of the Blue: September 11 and the Novel*. New York: Columbia University Press, 2009.

Vettel-Becker, Patricia. *Shooting from the Hip: Photography, Masculinity, and Postwar America*. Minneapolis: University of Minnesota Press, 2005.

Whitehead, Anne. *Trauma Fiction*. Edinburgh: Edinburgh University Press, 2004.

10 Visualizing War in the Museum

Experiential Spaces, Emotions, and Memory Politics

Stephan Jaeger

Visualizing War in the Museum

If war is represented in a museum and if the museum intends to visualize war, an immediate representational challenge occurs.[1] Jay Winter argues

> that all war museums fail to represent 'the war,' because there was then and is now no consensus as to what constituted the war […]. They never describe war; they only tell us about its footprints on the map of our lives.[2]

Winter maintains that war museums will always fail in a kind of pseudo-realism if they claim that they can "bring the visitor into something approximating the experience of combat."[3] Instead museums should resist the realistic-mimetic temptation and emphasize that the museum is a site of interrogation and contestation so that the visitor understands the links between past and a present shaped by the consequences of war.[4] The visualization of war in the museum would then be either misleading by pretending to solve the impossible representational task of a museum re-envisioning past experience, or it visualizes something structural or abstract, something the visitor clearly recognizes as a new, simulated reality of the past, instead of anything real that simply mimetically copies the past.[5]

My main argument throughout this chapter is that museums can create poietic spaces,[6] i.e. spaces that do not simply depict, document, or even reconstruct the past, but allow for—usually in a non-mimetic way—structural experiences of war. These structural experiences are realized as building emotional communities between visitor, the museum installation, and the simulated past. All military history museums aim to generate authenticity, but the form of authenticity varies between reconstructive authenticity, claiming that the past can somehow accurately be represented through historical reconstruction, and structural, simulated authenticities that are created as poietic spaces. The latter only come into being in the actual act of visualizing and representing war in the museum. This article is structured in the way that it moves from a case study of simplistic reconstructive authenticity to case studies with intensified degrees of simulating authenticity. Visualization and narrative are inextricably intertwined in this process, and their use can restrict the interpretation of the past as much as it can enable multiple interpretations through the visitor. The image has always played an important role in war and military history, but its use, whether as autonomous work and as stepholder for a cognitive argument, a moral argument, or an emotional or aesthetic effect, has become more important in recent years, since images serve as

major components of modern multimedia and digitized installations and war exhibition designs in general. Pictures in general allow humans to gain access to the world, they make worlds and do not merely mirror them.[7]

Whereas the immediacy effect of museums is clearly lower than in other media discussed in this volume such as photography or film,[8] it has the advantage of combining various media to visualize war including text, objects, photography, film, multi-media installations, and artwork. Consequently, there is a wide range of representational techniques that are situated somewhere between Winter's dichotomy of structural, self-reflexive interrogation, and pseudo-realism. This becomes even more evident when one asks how war and military history museums use visualization to emotionalize the visitor or more generally in the context of this volume how visualization and technology are used to build emotional communities between subject and object. Thomas Thiemeyer has used Marshall Mc Luhan's framework of hot and cool media to describe the difference between museums that steer the visitor's emotions and those that rely on the visitor's participation.[9] Hot media, which for McLuhan includes photography, is so detailed that the visitor only passively perceives the one version of the past represented. In contrast, cool media, such as cartoons, have little visual information and require the active engagement of the visitor using his own imagination.[10] The latter allows distance between recipient and historical subject matter; the former seduces the visitor into following a pre-described path to understand the past. Consequently, Thiemeyer is as critical as Winter of any form of pseudo-realism, of representations that suggest authenticity via sensual evidence. Instead he highlights the value of actual objects and the need for historiographical source criticism and contextualization of images and objects. Unlike Thiemeyer, Paul Williams sees cool media as mainly illustrative, but he similarly argues that "we can call those objects that may lack self-evident attachment to the narrative at hand, but possess a high emotional quotient and hence lend themselves more easily to emotive spectacle, 'hot.'"[11] Therefore, as soon as a museum constructs an emotional path for the visitor, often towards the political or didactic message that underlies the exhibition, via simulated authenticity, reduced visitor flexibility, and high narrativity—i.e. the museum highlights one master narrative—the visitor becomes passive in experiencing such an "emotive spectacle."

A perfect example of 'hot media' is shown by Péter Apor in his analysis of the permanent exhibition in the House of Terror in Budapest (since 2002)[12] how "the dominance of audiovisual spectacle and the disorderly mixture of original and replica, authentic and scenery"[13] overwhelms the visitor emotionally. The emotional feeling of "the authenticity of the experience of the past irrespective of the authenticity of individual objects"[14] enforces a "surreality of a presence"[15] that prevents interpretative freedom for the visitor. In contrast to such an emotional overwhelming of the visitor, the majority of recent theoretical approaches highlights the representational potential in the museum to force the visitor out of her/his comfort-zone, showing its cool media qualities.[16] This tension between 'hot' and 'cool' in the medium of the museum itself needs to be further analyzed. The question whether highly emotive representations of war only restrict the freedom of the visitor as Thiemeyer or Winter argue, or whether they also allow for more dynamic reactions by the visitor requires a much closer examination what opportunities in building emotional communities and freedoms museum exhibition can use in visualizing war for the visitor, as will be discussed through five case studies of mostly recent museum installations in this chapter.

Recent studies of Holocaust and trauma representation in museums, particularly memorial museums, have enriched the scholarly discussion of visualization modes that can overcome the limitations of verbal narrative and show the complexity of how museums can construct and steer visitor emotions:

> We are not simply watching the event but rather how it was experienced by the witness at that moment, as overwhelming, as something that could not fully be taken in, but can only be testified to belatedly and through the fantasy elements of memory.[17]

This leads to different concepts of secondary witnessing of trauma, especially in regard to Alison Landsberg's concept of 'prosthetic memory,' which implies that mass media such as film and experiental museums can create sensuous and bodily felt memories that do not come from lived experience, but from engagement with mediated representations.[18] Landsberg's concept has created significant scholarly controversy, including criticism of her assumption that these memory acquisitions create empathy and solidarity, which transcends traditional barriers of 'race,' class, ethnicity, nationality, and religion.[19] Silke Arnold de-Simine has furthered Landsberg's observation on empathy and the museum; she sees spectacle as the vehicle that allows the visitor to experience the traumatic past from a distance.[20] In other words, though exhibitions relate to collective and public forms of remembrance, "they thrive on modes of relating to the past that are based on the spectacle which elicits an individuated response and negates the relational quality of the encounter."[21] However, it can be argued that the visualization of war does not necessarily connect to trauma, since such concepts imply at least the empathizing with concrete historical persons or groups, even if mimetic forms of visualization are supplemented by symbolic forms. A more differentiated study on the visualization of war in contemporary museums and of how museums produce experiences of war and consequently construct emotional political communities is needed to understand the numerous ways that visitors can become part of emotional communities that either allow individual experiences or are manipulated towards one collective experience, reducing the visitor to a passive recipient. The choice of the World Wars[22] is particularly useful in demonstrating different techniques of war visualization in the twenty-first century, since both wars allow for a tension between universal messages about war and violence, and specific master narratives that highlight the enemy structure of war and, usually on the victorious side, argue for the necessity and essential goodness of the war mission.

Reconstructive Authenticity

In the National Museum of Military History in Diekirch, Luxembourg, the visitor finds a small diorama scene of a US Army Nurse on the spiral staircase between the permanent exhibition's first and second floor. She is sitting on a box in a half tent that opens up to the viewer, wearing nylon socks, and has manicured red fingernails. In her hands she holds a brochure in Luxembourgish entitled "Do you know Luxembourg?" and utensils such as soap, a drinking bottle, and a blanket complete the scene. Her alert gaze is directed somewhat towards the visitor, but since the visitor is climbing the stairs the mannequin appears to glance into the distance. The caption identifies the nurse as Second Lieutenant Lois Gates from 53rd Field Hospital and describes

the role of nurses during the battles and liberation of Luxembourg. Underneath and next to the diorama are several photo frame sets that include photos of the friendly looking nurse Gates who is helping injured soldiers. One photograph in particular depicts an almost identical scene to the diorama; only the background looks considerably more disorderly, and the nurse seems to be using her GI helmet for a footbath. This scene is exemplary of the technique of the museum (opened in 1984). The photograph is translated into an aestheticized scene. The chaos of the original photo has disappeared, female modeling features are emphasized, and the Luxembourg brochure symbolically connects the American liberators and the people of Luxembourg. Nurse Gates is functionalized to counterbalance the grim spirit of the battles in Luxembourg, especially after the German counterattack in the Battle of the Bulge in December 1944. The museum, which narrates some exemplary war scenes through dioramas, but mostly concretely references specific historical events or people, represents 'still images' of the war. This form of visualization—a reconstructive authenticity via realistic scenes, vaguely connected through a certain chronological unfolding—is a standard but outdated representational method for war museums of the 1980s and 1990s, still extremely popular in the Ardennes region. The visitor gets lost in symbolic historical scenes that reconstruct and often—as in Diekirch—politicize military history. Since the diorama simply presents a static scene, trying to imitate one past moment in time, the viewer cannot imagine developed individual or collective perspectives; the flexibility for visitor interpretation is low because of the reconstructive authenticity, and the visualization of war is highly politicized, since the master narrative of the good Luxembourg people who were liberated and defended freedom remains unquestioned throughout the museum.

The visualization of war as the reconstruction of an allegedly correct past might help the visitor to remember specific historical facts or exemplary scenes, which makes it easier to understand the different elements of war. A visitor of the Military History Museum in Diekirch will remain passive, watching constructed examples of the war, authenticated through sheer mimesis of objects. Even reconstructive museum installations that pretend to put the visitor into a position to experience a historical situation, as the old World War exhibitions of the Imperial War Museum in London attempted with the reconstruction of a trench or an air war shelter, [23] will be closer to a playful trick whose function is to attract the visitor via entertainment than bringing him or her closer to experiencing the war and empathizing with real historical people. Consequently, such reconstructive approaches are unable to build emotional communities.

Multimedia Visualization and Political Master Narrative

In recent years, museums have developed considerably more sophisticated techniques of visualizing the war and emotionalizing[24] and possibly manipulating the museum visitor. Digital technology, as well as an extensive use of techniques from theatre, film sets, and architecture have given historical museums considerably more opportunities to visualize war and engender emotions in the visitor. One effect can be demonstrated in an example from the American National World War II Museum in New Orleans (founded in 2000 as American D-Day museum and constantly expanded since). It features several elaborate multimedia installations that are aimed at allowing the visitor to experience war. In particular, a 4-D film produced, directed, and narrated by Tom

Hanks in the Solomon Victory Theater that opened in 2009 as the museum's signature piece shows the multimedia effect of visualizing war and how it is used to trigger the visitor's emotions and convince her/him of a political message. The narrative, about 13 minutes of introduction, and 35 minutes of main film between the attack on Pearl Harbour and VJ-Day, introduces the visitor to the main events of the war from an American perspective. The movie theatre engages the visitor in four senses: audio-visual, smell through sudden fog, and tactile senses through vibrating seats in a few moments such as the drop of the nuclear bombs or the first American combat experience in North Africa. Three-dimensional objects such as the watchtower of a German concentration camp appear to grow out of the stage; the visitor seems directly in the action of flying bombers against Germany and Japan. The voice of Tom Hanks, full of pathos, narrates a series of events, supported by propaganda voices from governments of both sides and voices from letters and diaries of Americans, in particular veterans and two war correspondents. The illusion of simulated reality is not broken at all. Every line works towards emotionalizing the visitor in 'hot-media style' towards the message that American soldiers "saved humanity from the darkest of futures" via sacrifice and courage with their "blood, tears, and innocence," a "struggle for freedom that took them and the world beyond all boundaries." The film relies on superlatives such as the largest "in all of human history." A fighter pilot describes how terrible the air-war against Germany was, but sees it as necessary; the use of nuclear bombs must not even be questioned: they saved countless American lives, so they are part of the narrative; celebratory American parades and cheering are heard immediately after. The 4D-visualization manipulates the viewer into forgetting the constructedness of the narrative. The atmosphere of the fighting and of collective American emotions is authentically staged, the viewer might believe the secondary narrative to be real history. The story about the democracy in the US, which was somehow unprepared for war, does not know any shades. Therefore, it cannot go beyond the historical time of the war years and the war, and consequently cannot represent the war's aftermath or other perspectives. There is no room for other narratives or for the visitor to find their own interpretations. Consequently, visualizing war means emotionalizing the visitor to overwhelm his or her senses, similar to Apor's argument above, so that she or he shares a collective authentic experience of the war that confirms the political status-quo of the master narrative about the war. There is no attempt for "active memory work"[25] or a dynamic collaboration of history and memory, but the museum's and film's success[26] is based on emotionalizing the one and only existing master narrative, reaffirming the collective memory.[27]

Synthesized Multiple Voices and Multimedia Visualization

The Imperial War Museum London, which reopened after extensive renovations in July 2014, uses similar didactic multi-media installations to steer the emotions of the visitor. Its narrative-visualized set-up, however, combines the creation of a structural open experiential space[28] with the suggestion of real experience that claims a clear interpretation of history. Instead of the zero-focalization employed in New Orleans, the museum utilizes a multiperspectival, but closed representation of the past through the combination of images, texts, objects, and multimedia installations. The renovation has concentrated on the new First World War Galleries that spread in a u-shape around the museum's atrium on the ground floor. The museum uses most recent

museum technology very effectively. Two multi-media installations can demonstrate the fine line between immersing the audience in a simulated experience[29] and manipulating the audience to an allegedly real experience, the latter showing how visualization can be politicized.

The first section that deals with the beginning of the actual war is entitled "Shock." The section's introductory panel closes with the words: "Neither side achieved a decisive victory. The horrific numbers of casualties caused by modern weapons came as a terrible shock." The theme of this section is that soldiers prepared for a chivalrous war with colorful uniforms, lances, and swords, which stands against machine gun bullets and shrapnel balls from modern artillery. The section highlights the expectations by all sides that the war would be won quickly. Its main installation is a simulation projection: one sees the bluish-white silhouettes of eight soldiers from an un-identified army storming forward with their guns on a field full of grass and flowers (see Figure 10.1). In the one-minute installation the silhouettes begin to be filled by black shadows of quickly charging soldiers. At first, it seems that the soldiers are making progress, but then to the increasing soundscape of an exploding shell, splintering casing and the whistle of shrapnel,[30] they are stopped and all fall. They spout blood and make unnatural movements with their heads and bodies. In the end, it becomes silent and all the dead bodies seem to merge within the field before the cycle starts again. The installation is enhanced by one of the large objects in the exhibition because it almost looks like the soldiers are running into a French 75 mm quickfiring field gun.

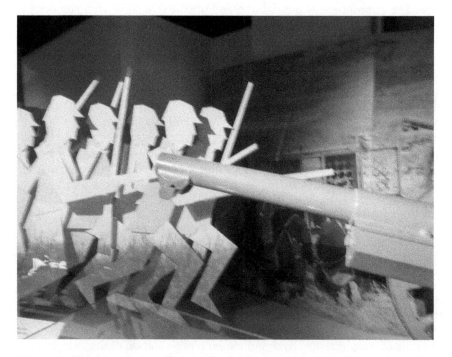

Figure 10.1 Multimedia Installation "Shock," First World War Galleries, Imperial War Museum, London.

Source: @ Imperial War Museum, 2014.

Supported by iconic photographs and authentic objects, the digital projection visualizes the horrific shock effect of modern warfare, the ill-fated enthusiasm of all war parties at the beginning of the war, the dead masses, the defeat of humans by technology, and the metamorphosis back to nature after seemingly senseless death. In particular, the soundscape makes it seem almost like empathy of the real, but, at the same time, no specific historical scene is referenced, and the perspective remains more abstracted than in the previous case of the museum in New Orleans. Humans stand against the machinery that they created themselves. Therefore, the Imperial War Museum can stage an abstract simulated experience that brings a particular moment of warfare in World War I close to the visitor. In other words unlike a reconstructive authenticity, an aesthetic authenticity is visualized when an abstract principle of war with mimetic resemblance to reality is experienced by the visitor.[31]

At the same time, the museum's main panels ask didactic questions in order to explain the causes, results, and effects of the war in a rather simplistic way. Another example of a multimedia visualization of war in the First World War Galleries can clarify how the Imperial War Museum links image and narrative, as well as how a simulated experience receives a political undertone that forecloses interpretative gaps and openings of the visitor's experiences. Right in the Centre of the First World War Galleries, the exhibition presents an extensive and multi-layered exhibition of the Battle at Sommes in summer and fall 1916. Again, the museum uses the set-up of heavy military equipment to symbolically set the stage for the battle. On the gray surface that marks all the installations of the Western Front throughout the museum, mirroring the structure of trenches, brief quotations from British soldiers remembering a wide array of emotions generated by the battle are displayed, including hatred of the enemy, love of war, the demoralization of men, and calling the battle murder. An original British 9.2 inch howitzer points at the installation of a German machine gun and its symbolically scattered bullets. The main installation is a round table that displays one object: a helmet with a bullet hole that missed the soldier wearing it. The table, surrounded by benches in a half circle, displays aestheticized footage and brief anecdotes of the battle in text and audio from British soldiers in approximately an eight-minute loop. The anecdotes and quotations include all kinds of positions; however eventually the fighting and enduring soldiers win over the ones that doubt the war or view the Sommes as a massacre of innocent soldiers. On the wall behind the installation, a three-minute film of aestheticized war images displays the landscape of the battle. It is almost impossible for the visitor to listen to the soldiers' voices and watch the film at the same time.

If the viewer considers the information panels that accompany the installation of the Sommes, it becomes clear that the museum chooses to guide emotions in a direction that justifies the offensive. First, the reason for the heavy British losses at the beginning of the offensive is explained, then the long duration of the battle, in particular the British goal to relieve the pressure on the French at Verdun and General Haig's conviction that a long battle would wear the Germans down. The second panel ends with the sentence: "British and Empire forces improved their planning, tactics, and use of artillery as the fighting continued. But the battle sank into a muddy stalemate." This corresponds to the wall screen installation. The soldiers' quotations and footage authenticate the representation of the Sommes offensive. The starting point of the film leads the viewer to a direct comparison of the Sommes region's landscape and its poppy seeds, wild flowers, and rolling hills with the English country side: "It might be

Kent, if it wasn't Piccardy." Then the film stages nature being overtaken by soldiers, fighting, and artillery in black-and-white footage: "God's lovely earth wrecked beyond recognition," before the transformative nature of mud wins over: "The contrast is far more a question of ourselves v. the weather than English against Germans. Mud is now victorious." Most interesting is the dominance of text in an installation that uses two films and numerous images. The text becomes, however, truly effective only through the visualization. The quotations come alive through the blurry trench and attack scenes, constantly disappearing into fog. The sharp contrast of the beautiful landscape turned in a muddy field emotionalizes the viewer to feel the courage of the soldiers and the harshness of the elements they were fighting in. The quotations allow for an apparent multiperspectival experience of many voices, but ultimately all these emotions are bundled and closed in one voice. As the wall film ends with the words "We shall win through however in time," the third panel ask the question "Had the battle achieved anything?" and answers:

> The British learned bloody but vital lessons in how to fight big land battles. British generals […] believed the soldiers would do better next time. For the Germans, the losses on the Somme came as a huge shock. […] They did not want to face such a battle again.

What starts out as a simulation of modern warfare and humanity, increasingly uses the simulation of atmosphere to emotionalize the visitor to accept the British course and success of the war. Criticism is sheltered within the many voices that accept the battle as necessary and strategically correct. The simulated experience becomes increasingly British. One could argue that the focalization of the British is one of the reasons why a multi-layered exhibition using the newest technology and multi-media visualization fails to theorize about the lessons learned from the war, either by Britain or by the world in general. The viewer will understand the sacrifice of the British soldiers and the success of their generals for strategic reasons. Since the visitor does not gain any interpretative power through the extensive visualizations, in the end, one must conclude that images and visualization seem to exist to provide the emotional backing for the cognitive understanding of the war. By themselves they seem to fit the cool media frame and are fairly open for individual experiences within a community. Unlike the National World War II Museum in New Orleans, the multiple voices present in the displayed quotations and the audio installation also allow for building emotional experiences in more individualized ways. Yet through its increasingly British perspective and its tendencies towards didactic closure, the multimedia visualization of war is highly politicized, however this politicization does not take place via its extensive visualization techniques, but via textual means that are used to structure and frame an overarching master narrative.

The Spatial-Geological Visualization of War and Humanity

The In Flanders Fields Museum in Ypres redesigned its permanent exhibition in 2012.[32] It takes the opposite approach to the Imperial War Museum by de-emphasizing the national perspective and the 'us versus them' structure of World War I. The museum, in accordance with the city of Ypres that is designated as a 'Peace city,' fashions itself as a peace museum. Consequently, the human impact of war is much more significant than

strategic decisions or the roles of different sides. For instance, whereas the Imperial War Museum stages the first gas attack by the Germans in another multi-media panorama that supports the British argument regarding how gas became a legitimate tool of warfare as instigated by the Germans, the In Flanders Fields Museums focuses on the division of the horrors for the soldiers and the cynicism that followed the development of this new tool of warfare. That Germans introduced it is not particularly relevant.

The installations that symbolize the so-called three Battles of Ypres and the Ypres Salient demonstrate precisely how war can be visualized so that the visitor experiences its essence without the repetition of propagandistic elements of warfare. This is achieved particularly through a spatial-geological visualization. The first Battle of Ypres is shown through a digital table shaped like an eight with a corresponding ring of projected original photographs from the Ypres Salient above it (see Figure 10.2). The table shows a geological map of the Ypres Salient. Four different colors for the French, British, Belgian, and German forces mark the positions of the armies; they move forward and backward through the battle in October/November 1914. The visitor experiences the map and geology of the city including the absurdity of the minimal gains of either party during the first Battle of Ypres. The photos—without being specific as to what they depict—authenticate the map experience. The aerial perspective prevents the visitor from siding with one party.

The visualization of the Ypres Salient as such is the centrepiece of the museum, right next to the entry into the bell tower of the cloth-hall (that symbolically marks Ypres on all maps and is widely visible as goal to be reached from the German viewpoint during the whole war). The installation looks like a half zeppelin, which is open to one side

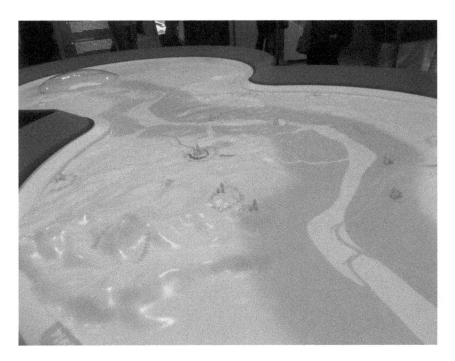

Figure 10.2 Digital installation war fronts in First Battle of Ypres.
Source: Flanders Fields Museum, Ypres (Belgium). Photo by author, July 2014.

forming a theatre, reflecting the shape of the Ypres Salient (see Figure 10.3). Again the visitor is put in an observation position, similar to the reconnaissance flights of zeppelins or balloons during the war. The installation features five curved screens that occasionally melt into each other. Underneath is an aerial map of the Salient; the part to which the projections on the screen relate lights up. The projections are a montage of original photographs and footage, aerial views of the landscape today with markers of the events and frontline, and historical maps used during the battle. Voices from soldiers' journals and letters from all parties in their original four languages accompany the matching images, maps, and landscape impressions. The program runs chronologically; the dates and the relevant flags of each frontline are shown at the bottom of the screen. Whereas the use of gas in the second Battle of Ypres is described from the German and the French side in journal narratives, most of the installation's run has no voice since not much seems to have happened in the two years after the Second Battle, at least not visibly above ground. The observer's gaze goes over the landscape; today's landscape is shown in color while the historical maps are presented in black and white. The observer perceives a visualization of space, almost digging into the landscape to understand the nature of the Ypres Salient in a construct between past and present. How to interpret the visualization remains open.

The third Ypres Battle installation gives a very concrete impression of the battle in a movie theater. Soldiers run continuously up the muddy hill in projected footage to somber music, while three witnesses, one doctor and two nurses, one young and inexperienced, one old and cynical, describe their experiences of the war.[33] The voices read from journals and diaries from three Americans, but for the viewer the context is not

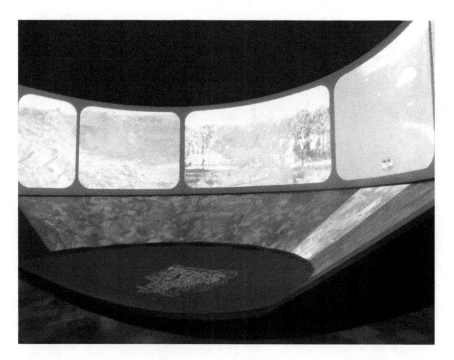

Figure 10.3 Multimedia installation Ypres Salient.
Source: Flanders Fields Museum, Ypres (Belgium). Photo by author, July 2014.

immediately clear. Instead, the voices seem to transcend nations and specific historical events. In the simulated footage of movement up the hill, the actual war is reduced to one infinite slow-motion moment. It seems that the third Battle of Ypres is less about the fighting in the mud of Passchendaele and other places, but more about the effects of the war, its horror, shallowness, absurdities, and the contrast between hope and cynicism. A fourth installation later in the exhibition is called "Flanders' Earth" wherein the battle is approached directly from an aerial perspective and the blackened rings of an oak tree demonstrate how it was recorded by nature. Together the installations allow for a spatialization of the war that leads the visitor from the past through the present into the future.[34] The technique of appropriating the tensions between past and present in the gaze of the visitor is distinctively more future-oriented than in the Imperial War Museum. The visitor can understand the lessons from the war not historically or strategically but only in the overlap of time, culture, and nature. The Ypres Salient can then become more than a reminiscent sign of the past. Visualization creates an experiential space in particular through its present and past link to the landscape. This allows for the reduction of the temporal and mental elements of narrativity so that war merges with nature and the museum reinforces the message of moving from the historical war experience towards peace and commemoration.

The Visualization of War Crimes via Photography

Finally, the Topography of Terror Documentation Centre, which opened in Berlin in 2010, on the ground of the former headquarters of the Secret State Police (Gestapo), the SS and the Reich Security Main Office, almost exclusively uses photographs to visualize war, with minimal audio and video footage.[35] This shows that emotional communities in war visualization are often built via multi-media technology, but other earlier media or technologies such as photography might be as effective in simulating historical experience and creating emotional responses. The building of the Topography of Terror is extremely somber, which is reflected by the permanent exhibition that mainly primarily comprises walls with short text panels, photographs, quotations by historians and perpetrators as well as printed documents that authenticate the structural topics and contents of the photographs. Though the exhibition displays a soft temporal structure by describing the Nazis seeking power in section 1, the terror in the German Reich in section 3, the terror in the occupied countries during the war in section 4, and the aftermath of the war and the trials in section 5, the exhibition is organized structurally by perpetrator groups, victim groups, and victim countries. It is extremely careful in preventing the development of empathy with the perpetrator[36] and in avoiding the simulation of atrocities. But the exhibition goes considerably beyond simply displaying and authenticating the structure of the terror.

Whereas individual topics mostly seem exemplary, they provide an overview; the visualization via photographs creates an aesthetic effect that emotionalizes the visitor through repetition.[37] For example, throughout the exhibition photos about public spectacles are shown: people watching the destructions of synagogues, the shaming of so-called traitors to the German people, and mass executions. The visualization of war here is performed as an implicit aesthetic montage effect; the visitor realizes how public the discrimination and the daily terror were. The photographs allow the visitor to experience a constructed gaze, which exemplifies what the public and the perpetrator eye could see. For example, a montage shows different phases

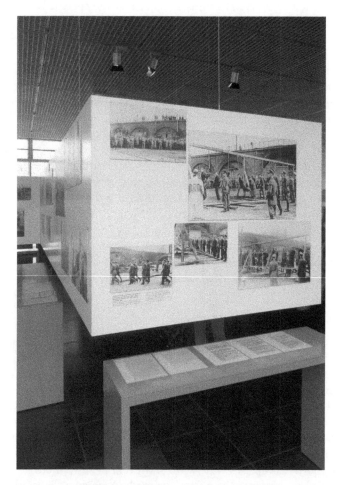

Figure 10.4 Photos and documents of forced "foreign laborers" execution in Cologne
Ehrenfeld, Topography of Terror (*Topographie des Terrors*), Berlin
(Germany).

Source: Photo by author, July 2014.

and angles from the execution of 11 forced "foreign laborers" by Gestapo officials
in Cologne Ehrenfeld in October 1944, which corresponds to the several public
humiliations presented in the public shaming images while the different forces of
Nazi terror are introduced (see Figure 10.4). The montage is also supported by
interview protocols pertaining to the execution.

Though the topic of the section is forced laborers in Germany, the brutality and
publicity of the examples constructs a public gaze, and challenges the visitor to emo-
tionally react to the picture and self-reflexively take a stand against the humiliations
and atrocities. One feels like the German public witnessing discriminations of different
kinds throughout the Third Reich and the war.[38] Another motif that is predominant
throughout the exhibitions is laughing. The perpetrators constantly—partly staged for
portrait purposes—seem to love and enjoy life in this set of photographs. Again, war

or atrocities in war manifest as an aesthetic impression on the visitor. The narrativity in the Topography of Terror seems low, yet the visualization of war is presentist and effective in emotionalizing the visitor. Photography suggests authenticity, even if it is an illusion.[39] The montage of themes throughout the exhibition allows the museum to remain fairly laid-back and factual; the visitor again experiences an aesthetic space. S/he has no way of escaping the terror or the public display of it, no way not to acknowledge the paradoxes of the terror politics in the German Reich and in the occupied territories, so that an emotional experience of a constructed past emerges. Since there is neither an explicit, overarching message nor a strong narrative, the exhibition relies on a presentist-documentary approach[40]—the documents guarantee that the context of the images is clear and authenticated. The political trajectory remains open, though one can assume that through the Topography's constructed-gaze montages, most visitors are steered towards emotions such as abhorrence and shame, and possibly to a cognitive and moral questioning of the terror.

Conclusion

All twenty-first-century exhibitions analyzed in this chapter construct poietic spaces that simulate the past through visualization and emotionalize the museum visitor. With the exception of the static reconstructive authenticity created in the late twentieth-century exhibition in Diekirch, war is never simply reconstructed in the four museums discussed in this chapter. There are four different forms of authenticity, even though there are overlaps between them: an emotionally manipulative narrative authenticity (New Orleans), an atmospheric-didactic authenticity based on synthesized multiple perspectives (London), a spatial-geological authenticity (Ypres), and a photographic-self-reflexive montage authenticity (Berlin). Returning to McLuhan's terminology, museums can clearly operate in a hot media style (a clear emotional steering of the visitor) or in a cool media style (allowing distance between visitor and object to allow a variety of more individualized emotional experiences), but they all rely on techniques of building emotional communities. They make different choices in terms of how text-image relations work: closed perspectives, zero-focalized, such as in New Orleans, or with more ambiguities as in London, eventually reducing visualization to a technique of controlling and manipulating the viewer's emotions. Perspectives that keep narrative and visualization effect more in balance such as in the In Flanders Fields Museum can guarantee a more open experiental effect, though arguably it is possible to read the path to reconciliation or peace as just as politicized as the 'good war' message in the National World War II Museum in New Orleans. Therefore, the Topography of Terror's low narrativity approach that clearly highlights image over text is intriguing. On the one hand, it avoids the obvious direct manipulations of emotions in the structural experiences of the other examples; on the other, it almost reproduces the alluring and emotionally manipulative feature of photography to suggest an impossible authenticity. Here one sees why McLuhan sees photography as an example of hot media, whereas in the medium museum it can construct in intricate tension between hot and cool media in emotionalizing its visitors.

Despite the emotional and political effect of each war visualization analyzed in this chapter, it is important to note that those representations that construct an experiential space, which surpasses the ideological structure of the war and avoids repeating the 'us versus them' structure have a better chance to provoke critical

thinking and independent aesthetic reactions, as well as independent cognitive and moral conclusions by the visitor. This can be seen in the In Flanders Fields Museum and in the Topography of Terror. If a historically specific past is not simply authenticated through simulated visualizations as in London or New Orleans, but if it is performed in more abstract principles, the visitor might be able to get beyond the politicization inherited by every representation of war.

Notes

1 The research for this article was supported by the Social Sciences and Humanities Research Council of Canada (SSHRC). I am grateful to Erin Johnston-Weiss for her helpful comments.
2 Jay Winter, "Museum and the Representation of War," in *Does War Belong in Museums? The Representation of Violence in Exhibitions*, ed. Wolfgang Muchitsch (Bielefeld: transcript, 2013), 23.
3 Winter, "Museum," 36.
4 Ibid., 37.
5 For other analyses of how war museums simulate past experiences, see Stephan Jaeger, "Temporalizing History toward the Future: Representing Violence and Human Rights Violations in the Military History Museum in Dresden," in *The Idea of a Human Rights Museum*, ed. Karen Busby, Adam Muller, and Andrew Woolford (Winnipeg: University of Manitoba Press, 2015); and Stephan Jaeger, "Between the National and the Transnational: European Memory of the Second World War in the 21st Century Museum by Example of Germany and Poland," in *Usable Pasts and Futurities: The Changing Place of Europe in Global Memory Culture*, ed. Christina Kraenzle and Maria Mayr Palgrave (Basingstoke: Palgrave Macmillan, 2016).
6 See Stephan Jaeger, "Poietic Worlds and Experientiality in Historiographic Narrative," *Towards a Historiographic Narratology*, ed. Julia Nitz and Sandra Harbert Petrulionis, special issue *SPIEL* (Siegener Periodicum zur Internationalen Empirischen Literaturwissenschaft) 30, no. 1 (2011): 30–36.
7 W.J.T. Mitchell, *What Do Pictures Want? The Lives and Loves of Images* (Chicago: The University of Chicago Press, 2005), xiv–xv.
8 See Stephan Jaeger, "Historical Museum Meets Docu-Drama: The Recipient's Experiental Involvement in the Second World War," in *Exhibiting the German Past: Museums, Film, Musealization*, ed. Peter M. McIsaac and Gabriele Mueller (Toronto: University of Toronto Press, 2015) for film; and Thomas Thiemeyer, *Fortsetzung des Krieges mit anderen Mitteln: Die beiden Weltkriege im Museum* (Paderborn: Schöningh, 2010), 290–308, for photography and film in world war exhibitions.
9 Thiemeyer, *Fortsetzung des Krieges*, 247.
10 Marshall McLuhan, *Understanding Media: The Extensions of Man* (New York: McGraw-Hill Book Company, 1965 [1964]), 22–23.
11 Paul Williams, *Memorial Museums: The Global Rush to Commemorate Atrocities* (Oxford: Berg, 2007), 33.
12 The House of Terror represents the fascist and communist regimes in twentieth-century Hungary in an experiental and way, generally highlighting Hungarian victimhood.
13 Péter Apor, "An Epistemology of the Spectacle? Arcane Knowledge, Memory and Evidence in the Budapest House of Terror," *Rethinking History* 18, no. 3 (2014): 332.
14 Apor, "An Epistemology," 338; cf. also Eva Ulrike Pirker and Mark Rüdiger, "Authentizitätsfiktionen in populären Geschichtskulturen: Annäherungen," in *Echte Geschichte: Authentizitätsfiktionen in populären Geschichtskulturen*, ed. Eva Ulrike Pirker et al. (Bielefeld: transcript, 2010) for the differentiation of these two kinds of authenticity in museums; and Jaeger, "Historical Museum Meets Docu-Drama."
15 Pirker and Rüdiger, "Authentizitätsfiktionen," 340.
16 For example Silke Arnold-de Simine, *Mediating Memory in the Museum: Trauma, Empathy, Nostalgia* (London: Palgrave Macmillan, 2013), 2; Thiemeyer, *Fortsetzung des Krieges*, 249; Susan Crane, "Memory, History and Distortion in the Museum," *History and Theory* 36, no. 4 (1997): 33.

17 Arnold-de Simine, *Mediating Memory*, 104.
18 Alison Landsberg, *Prosthetic Memory: The Transformation of American Remembrance in the Age of Mass Culture* (New York: Columbia University Press, 2004); cf. Alison Landsberg, *Engaging the Past: Mass Culture and the Production of Historical Knowledge* (New York: Columbia University Press, 2015), 177, for further analysis of "the experiental in an age of mass mediation."
19 See James Berger, "Which Prosthetic? Mass Media, Narrative, Empathy, and Progressive Politics," *Rethinking History* 11, no. 4 (2007): 605; Arnold-de Simine, *Mediating Memory*, 91–92.
20 Arnold-de Simine, *Mediating Memory*, 203.
21 Ibid.
22 See also Thiemeyer, *Fortsetzung des Krieges*, 322–325.
23 See Angelika Schoder, *Die Vermittlung des Unbegreiflichen: Darstellungen des Holocaust im Museum* (Frankfurt am Main: Campus, 2014) 73–74; Arnold-de Simine, *Mediating Memory*, 33.
24 See Stephen Watson in Gerald D. Swick, "The National WWII Museum—2015 and Beyond," interview with Stephen Watson. January 21, 2015, accessed November 20, 2015, www.historynet.com/the-national-wwii-museum-2015-and-beyond.htm, for the general goal of the museum to create immersive environments.
25 Crane, "Memory, History and Distortion," 63.
26 The executive vice president of the museum, Stephen Watson, highlights in a historynet interview how the name of Tom Hanks and the idea of a film that gives "a dramatic, broad overview of the war in a very personal and engaging way" has drawn an audience that may not have come to a mere military history museum (Swick, "The National WWII Museum," 2015).
27 See Apor, "An Epistemology"; Thiemeyer, *Fortsetzung des Krieges*, 224. However, collective memory also cannot simply be ignored. Susan Crane has precisely shown by example of the Enola Gay exhibition in the Smithsonian's National Air and Space Museum in Washington, DC, how ignoring the existing personal memories of powerful interest groups such as war veterans can risk the educational goals by historians:

> Historically conscious individuals may turn out to be quite interested in the study of historical consciousness, but it will take time and patience on the part of historians and a willingness to engage personal memories in the production of history.
> ("Memory, History and Distortion," 63)

28 Designer Roger Mann, "Shock: Bringing the First World War to Life at the Imperial War Museum," *Guardian*, July 17, 2014, accessed November 20, 2015, www.theguardian.com/culture-professionals-network/culture-professionals-blog/2014/jul/17/first-world-war-imperial-war-museum, highlights that the new media should make objects and stories from the past "at times visually arresting, at others challenging, but always appealing to the senses." The museum wants "to stimulate the imagination, provoke reflection and transform the experience of standing in front of an object into one that is felt, and shared."
29 See Jaeger, "Temporalizing History," 240.
30 See Mann, "Shock."
31 Several reviewers lament the loss of the old trench experience and its effective authenticity, while the new trench experience with its projected silhouettes of soldiers does not mediate the horrific experience of the war, e.g. Marion Löhndorff, "Die Helden werden zur Fußnote: Umgestaltung des Imperial War Museum in London," *Neue Zürcher Zeitung*, November 25, 2014, accessed November 20, 2015, www.nzz.ch/feuilleton/kunst_architektur/die-helden-werden-zur-fussnote-1.18431264. In other words, a naive reconstructive and mimetic staging of war experience is still the preferable representational option for at least some critics and visitors.
32 For the history of the museum and its predecessor exhibition (from 1998) that was more strongly based on *mise en scene*, see Thiemeyer, *Fortsetzung des Krieges*, 67–69.
33 See also Arnold-de Simine, *Mediating Memory*, 47–48.
34 See Jaeger, "Temporalizing History."
35 For its history, cf. Karen E. Till, *The New Berlin: Memory, Politics, Place* (Minneapolis: University of Minnesota Press, 2005), especially 63–152.

36 See Thomas Lutz, *Zwischen Vermittlungsanspruch und emotionaler Wahrnehmung: Die Gestaltung neuer Dauerausstellungen in Gedenkstätten für NS-Opfer in Deutschland und deren Bildungsanspruch*, Diss. Dr. phil. Technische Universität Berlin, 2009, urn:nbn: de:kobv:83-opus-25005, 205–222.
37 See Klaus Hesse, "Die Bilder lesen: Interpretationen fotografischer Quellen zur Deportation der deutschen Juden," in *Vor aller Augen: Fotodokumente des nationalsozialistischen Terrors in der Provinz*, ed. Klaus Hesse and Philipp Springer (Essen: Klartext, 2002) for the photographs' tension between authenticity and ideological construction.
38 See Philipp Springer, "Auf Straßen und Plätzen: Zur Fotogeschichte des nationalsozialistischen Deutschland," in *Vor aller Augen: Fotodokumente des nationalsozialistischen Terrors in der Provinz*, ed. Klaus Hesse and Philipp Springer (Essen: Klartext, 2002) for the complex relation between propaganda and private photography during National Socialism.
39 E.g. Williams, *Memorial Museums*, 73–75.
40 See Jaeger, "Historical Museum Meets Docu-Drama," 151.

Bibliography

Apor, Péter. "An Epistemology of the Spectacle? Arcane Knowledge, Memory and Evidence in the Budapest House of Terror." *Rethinking History* 18, no. 3 (2014): 328–344.

Arnold-de Simine, Silke. *Mediating Memory in the Museum: Trauma, Empathy, Nostalgia.* London: Palgrave Macmillan, 2013.

Berger, James. "Which Prosthetic? Mass Media, Narrative, Empathy, and Progressive Politics." *Rethinking History* 11, no. 4 (2007): 597–612.

Crane, Susan. "Memory, History and Distortion in the Museum." *History and Theory* 36, no. 4 (1997): 44–63.

Hesse, Klaus. "Die Bilder lesen: Interpretationen fotografischer Quellen zur Deportation der deutschen Juden." In *Vor aller Augen: Fotodokumente des nationalsozialistischen Terrors in der Provinz*, edited by Klaus Hesse and Philipp Springer, 185–211. Essen: Klartext, 2002.

Jaeger, Stephan: "Poietic Worlds and Experientiality in Historiographic Narrative." *Towards a Historiographic Narratology*, edited by Julia Nitz and Sandra Harbert Petrulionis. Special Issue *SPIEL* (Siegener Periodicum zur Internationalen Empirischen Literaturwissenschaft) 30, no. 1 (2011): 29–50.

——. "Historical Museum Meets Docu-Drama: The Recipient's Experiental Involvement in the Second World War." In *Exhibiting the German Past: Museums, Film, Musealization*, edited by Peter M. McIsaac and Gabriele Mueller, 138–157. Toronto: University of Toronto Press, 2015.

——. "Temporalizing History Toward the Future: Representing Violence and Human Rights Violations in the Military History Museum in Dresden." In *The Idea of a Human Rights Museum*, edited by Karen Busby, Adam Muller, and Andrew Woolford, 229–246. Winnipeg: University of Manitoba Press, 2015.

——. "Between the National and the Transnational: European Memory of the Second World War in the 21st Century Museum by Example of Germany and Poland." In *Usable Pasts and Futurities: The Changing Place of Europe in Global Memory Culture*, edited by Christina Kraenzle and Maria Mayr, 24–47. Basingstoke: Palgrave Macmillan, 2016.

Landsberg, Alison. *Prosthetic Memory: The Transformation of American Remembrance in the Age of Mass Culture.* New York: Columbia University Press, 2004.

——. *Engaging the Past: Mass Culture and the Production of Historical Knowledge.* New York: Columbia University Press, 2015.

Löhndorff, Marion. "Die Helden werden zur Fußnote: Umgestaltung des Imperial War Museum in London." *Neue Zürcher Zeitung*, November 25, 2014. www.nzz.ch/feuilleton/kunst_architektur/die-helden-werden-zur-fussnote-1.18431264 (accessed November 20, 2015).

Lutz, Tomas. *Zwischen Vermittlungsanspruch und emotionaler Wahrnehmung: Die Gestaltung neuer Dauerausstellungen in Gedenkstätten für NS-Opfer in Deutschland und deren Bildungsanspruch.* Diss. Dr. phil. Technische Universität Berlin, 2009. urn:nbn:de:kobv: 83-opus-25005.

McLuhan, Marshall. *Understanding Media: The Extensions of Man*. New York: McGraw-Hill Book Company, 1965 [1964].

Mann, Roger. "Shock: Bringing the First World War to Life at the Imperial War Museum." *Guardian*, July 17, 2014. www.theguardian.com/culture-professionals-network/culture-professionals-blog/2014/jul/17/first-world-war-imperial-war-museum (accessed November 20, 2015).

Mitchell, W.J.T. *What Do Pictures Want? The Lives and Loves of Images*. Chicago: The University of Chicago Press, 2005.

Pirker, Eva Ulrike and Mark Rüdiger. "Authentizitätsfiktionen in populären Geschichtskulturen: Annäherungen." In *Echte Geschichte: Authentizitätsfiktionen in populären Geschichtskulturen*, edited by Eva Ulrike Pirker, Mark Rüdiger, Christa Klein, Thorsten Leiendecker, Carolyn Oesterle, Miriam Sénécheau, and Michiko Uike-Bormann, 11–30. Bielefeld: transcript, 2010.

Schoder, Angelika. *Die Vermittlung des Unbegreiflichen: Darstellungen des Holocaust im Museum*. Frankfurt am Main: Campus, 2014.

Springer, Philipp. "Auf Straßen und Plätzen: Zur Fotogeschichte des nationalsozialistischen Deutschland." In *Vor aller Augen: Fotodokumente des nationalsozialistischen Terrors in der Provinz*, edited by Klaus Hesse and Philipp Springer, 11–33. Essen: Klartext, 2002.

Swick, Gerald D. "The National WWII Museum—2015 and Beyond." Interview with Stephen Watson. January 21, 2015. www.historynet.com/the-national-wwii-museum-2015-and-beyond.htm (accessed November 20, 2015).

Thiemeyer, Thomas. *Fortsetzung des Krieges mit anderen Mitteln: Die beiden Weltkriege im Museum*. Paderborn: Schöningh, 2010.

Till, Karen E. *The New Berlin: Memory, Politics, Place*. Minneapolis: University of Minnesota Press, 2005.

Williams, Paul. *Memorial Museums: The Global Rush to Commemorate Atrocities*. Oxford: Berg, 2007.

Winter, Jay. "Museum and the Representation of War." In *Does War Belong in Museums? The Representation of Violence in Exhibitions*, edited by Wolfgang Muchitsch, 21–37. Bielefeld: transcript, 2013.

11 War in the Age of Anti-Social Media

Jan Mieszkowski

In 2004, at the height of the Abu Ghraib prison scandal, US Secretary of Defense Donald Rumsfeld lamented that it would no longer be possible to conduct military operations if individual soldiers could casually make and share photos and videos documenting every facet of their operations.[1] The end of secrets in the digital information age would spell the end of warfare as we knew it. Today visual records of graphic violence permeate the public sphere in ways that would have been unthinkable a decade ago. Combatants' real-time mobile uploads to social networking sites and YouTube are available for immediate consumption 24-7, where they become part of the public record, as well as elements in complex propaganda campaigns. As we have seen with the so-called Arab Spring, recent Israeli-Palestinian clashes, and various attacks around the globe carried out by individuals who claim an allegiance to ISIS despite having had only fleeting online contact with the organization, a group or state's very capacity to organize, fight, or resist is increasingly thought to depend on its social media prowess. Moreover, the move to describe one's adversary as uniquely networked is an act of aggression in its own right, not least because it casts sociability itself, historically perceived as a bulwark against strife, as the condition of possibility of, if not an outright impetus for, violence. In a kind of Habermasian nightmare, the more we deliberate in a digital public sphere in which each of us is putatively an equal—and equally ephemeral—avatar, the bloodier our off-line interactions are fated to become.

At the same time, if there is considerable interest in the ways in which new forms of communication are shaping contemporary political events, the public is equally conscious of the limits of the online archive. Rumsfeld made his dire pronouncement just as the military's growing reliance on drones began to make headlines. These unmanned weapons raise the concern that governments will be able to wage war with impunity because it will be impossible to monitor the engagements, the very notion of a battlefield having been rendered abstract. The age of the ultimate public war threatens to be the age of the ultimate private war, as well.

Taking this tension as its starting point, this essay explores the conceptualization of warfare in the contemporary mediascape. I begin by arguing that the dynamics organizing military spectatorship today predate the Internet, film, or photography, emerging in Napoleonic Europe as battles first came to be regarded as objects of mass entertainment. From this point on, the aesthetic paradigms with which the battlefield would be evaluated would be articulated by the military as much as by civilian observers. In the second part of the essay, I look at the unique form that watching war has taken today, when it has become almost impossible not to be an onlooker in one capacity or another. I conclude with an analysis of some contemporary artists who have sought

to craft representations of warfare that can be distinguished from the military's own self-representational products. In unsettling the very premise that the battlefield is best understood as something that one can observe, these projects challenge the notion that social media have enhanced our ability to pierce the fog of war.

The Napoleonic Legacy

For the past two centuries, the predominant aesthetic models of violence have been advanced by the military which has billed itself—overtly and covertly—as the greatest show on earth, the site of unparalleled human tragedy and triumph, or the purveyor of shock and awe. This tradition of melodramatic self-promotion begins in earnest at the end of the eighteenth century as the term "theater of war" first appears in Western European languages, and Napoleon Bonaparte becomes the leading media theorist of his age. The cornerstone of his military ideology was the notion that a clash of armies is a theatrical production to be observed, interpreted, and even enjoyed. In the many accounts of his battles that he wrote for broad distribution, he described his colossal operations as if they followed the precise narrative arc and respected the formal constraints of an Aristotelian drama. To witness an enormous struggle between hundreds of thousands of soldiers was to view a metaphysical contest between good and evil, between the willful and the arbitrary, acted out in the flesh. Finally, it was imperative that these first forms of mass entertainment produce clear winners and losers, thereby providing a basis for allegories of justice and national legitimacy.

Even at its onset, this notion of an illuminating battlefield was ridden with tensions. The public embraced the idea of the theater of war at the very moment at which battles were becoming too large, too complex, and too smoke-filled to be comprehensible to onlookers, or even to the men who fought in them. The vast majority of people followed the Napoleonic campaigns from afar via newspapers and government bulletins; for them, speculations about how the waves of soldiers *should* or *must* appear came to be regarded as no less reliable than what could have been seen with one's own eyes if one had been there, which wouldn't have been very much, no matter where one had been standing. The ideal war spectator was thus conceived of not as an observant firsthand witness, but as a uniquely creative individual, be it a novelist who was never within hundreds of miles of the action, a poet who saw the fighting in person but didn't write about it until decades later, or even an innocent bystander who just happened to wander into the fray and was therefore able to evaluate the event with a disinterested aesthetic judgment rather than a teleological one.

If early nineteenth-century Europe saw the beginning of what in the twentieth century would be called "total war," this was not simply because of the scale of the battles or the immense casualties realized by new weapons. War became total only once it could no longer be viewed in its entirety and had to be grasped by the mind's eye, that is, war became total once it could only be witnessed with the help of the imagination. The legacy of the Napoleonic era is therefore fundamentally contradictory. On the one hand, this period saw the battlefield realize an unprecedented size and destructiveness and be accorded a unique status as the ultimate showcase of human history, the limit of human experience that revealed its essence. On the other hand, these spectacles could not be and were never viewed as discrete, comprehensible exhibitions. Waterloo, Borodino, Austerlitz—these fabled killing

grounds quickly acquired the phantom-like quality of something one heard or read about but never encountered firsthand, evidence of the power of what I call the Napoleonic imaginary.

The spectacle logic of the Napoleonic era was the culmination of a century and a half of reflections on the concept of warfare, which began with Thomas Hobbes' *Leviathan*, where a clear distinction is made between a war and the battles fought in its name. "War," insists Hobbes, "consists not in actual fighting, but in the known disposition thereto."[2] For Hobbes, the quintessential military facility is not the ability to use a weapon but the capacity to assume a posture that makes something metaphysical—your will to fight—manifest to your foe. Insofar as one's relationship to any alleged intention to fight—especially when it is one's own—is highly mediated, Hobbes's distinction between war and battle delineates a realm ripe for duplicity. If war is the ultimate example of a sequence of events with consequences, it is equally a field of simulation, since any war is permanently under suspicion of being a phony war, emerging only in virtue of a difference between an act and the announcement of an alleged plan to act. This is why military campaigns are necessarily discursive systems in their own right, defined by their self-representational dynamics and their strategies for controlling how their actions are interpreted; and this is why any writer, journalist, or combatant who tries to tell the story of a battle must implicitly choose to affirm or reject the accounts of the event that were already formulated by the warring parties as the battle took place. Perhaps most importantly, on the basis of Hobbes' doctrine, any given scene of combat will inevitably disappoint, since it can never show us the distinction between war and battle that is the essence of war. Images of corpses, fires, or destroyed buildings can reveal something about the effects of combat, but they cannot illustrate the simulation and posturing that separates warfare from mere violence.

The Contemporary Mediascape

If military operations are distinguished by their self-representational dynamics, this means that no interpretation of a battle can ever be disseminated quickly enough to outpace the auto-interpretive praxis at the heart of the military enterprise, irrespective of whether the reports travel with riders on horseback or on the digital superhighway. This also means that any representation of a battlefield engagement is necessarily under suspicion of being just one more facet of the military's own discursive systems rather than some external or objective documentation of them. Reporters, it would appear, have always already been embedded with the troops.

The Abu Ghraib scandal that occasioned Rumsfeld's remarks was a quintessential example of the power of images to impact public opinion.[3] The ensuing decade has only seen an intensification of the conviction that visual representations are a uniquely forceful means of imparting the true magnitude of human tragedies. In recent reporting on the Syrian refugee crisis, numerous European press reports followed the *Independent* in declaring: "If these extraordinarily powerful images of a dead Syrian child washed up on a beach don't change Europe's attitude to refugees, what will?"[4] The logic of this rhetorical question suggests that the capacity of images to facilitate insight and galvanize a response has not been blunted by the technological advances that have made it virtually impossible for even the most sophisticated observer to distinguish between "genuine" and "staged" pictures of suffering and death. In fact,

the opposite is the case. The more tenuous the claim of any still or moving image to unambiguously bear an irreducible trace of non-manipulated empirical reality, the louder the demand for more powerful, more improbable footage grows. This unshakable loyalty to the visual medium is not, however, reflected in a correspondingly rapt audience. Television viewers tend to tire quickly of any given war report, eagerly moving on to the next news story about a hurricane, a flu epidemic, or a politician's risqué tweets. If photos or videos can alter the public's perception of an issue overnight, this is not the same thing as saying that they will necessarily hold anyone's attention through the next night.

In September of 2014, the US journalist and war correspondent Peter Maass published an article entitled: "Why More Americans Should See the Beheading Videos."[5] His text began with reproductions of two sensationalist *New York Post* covers, one displaying a photo of the bodies of four contractors from the private security firm Blackwater hanging from an Iraqi bridge, another showing a still from a video of an ISIS soldier in the process of decapitating an American hostage. Maass opens his article:

> Beheading is barbaric. The men of the Islamic State who executed [American hostages] James Foley and Steve Sotloff are monsters. Yet their monstrosity does not fully explain our fury over their beheading videos, or the exhortations we have heard to not share or distribute the harrowing images.[6]

Maass suggests that in contrast to the rest of the world, citizens of the United States have been sheltered during their past quarter century of conflicts in the Middle East, because censorship has prevented photographers embedded with American troops from recording and disseminating images of dead or wounded US servicemen and women. In a kind of Vietnam hangover, the powers-that-be apparently still believe that if the American public saw graphic depictions of their own casualties, civilian support for the campaigns would wane. Correspondingly, it is assumed that sharing images of foreign dead and wounded will help the war effort.

Maass writes as if it were in the power of the US government, or any government, to regulate the imagesphere and legislate what people do or don't see. If this was once possible, it presumably isn't any longer. Perhaps implicitly acknowledging this problem, Maass, his catchy title notwithstanding, never actually sets out an argument for why more Americans should view the beheading videos. In fact, in his closing paragraph he allows that his accounts of various cause-and-effect relationships may be misleading. Confronting American civilians with images of US casualties could prompt reasoned discussions about a more progressive foreign policy, or it could lead to vituperative calls for revenge and thereby to further violence. Maass also entertains a third possibility, namely that more exposure to records of injury and death may produce indifference in the audience, an argument famously put forth by Susan Sontag, who argued that the "fuller" or "more precise" picture of reality facilitated by greater access to representations of human misery, far from resolving the mysteries of mortality, turns scenes of violence and destruction into something surreal or fantastic.

Maass references Sontag's two-edged suggestion that the sharing of images of tragedies from around the world "may spur people to feel they ought to 'care' more, [but] it also invites them to feel that the sufferings and misfortunes are too vast, too irrevocable, too epic to be much changed by any local, political intervention."[7] Sontag's casual

"it also" underscores the uncertainty that has surrounded photographic and filmic representations of violence since the inception of these media. If such visual documents can unquestionably cast light on what would otherwise remain outside one's ken, they also underscore just how thin the line between the real and the surreal can be. To this day, there is no consensus among humanists or social scientists as to whether pictures of violence and its effects traumatize their viewers or inure them to the traumatic effects of such representations, be that because people become acclimated to them or because they become convinced that what they are viewing is more fictive than factual. Given these uncertainties, it is perhaps unsurprising that an article like Maass' that begins by exhorting more people to watch gruesome videos quickly devolves into a series of acknowledgements that we don't really know what the consequences of being the audience to such a show are.

The fact that the relationships organizing these dynamics are poorly understood has by no means quelled enthusiasm for the engineering of violent spectacles. The beheading videos highlighted in Maass' discussion were one of first prominent media events orchestrated by the Islamic State. From the moment it became a news sensation in the West, ISIS was deemed significant as much for its self-promotional savvy as for its brutality, with particular stress laid on its skillful command of social media. As has been well documented, an entire ministry of this self-proclaimed caliphate is staffed with professional production crews who package and distribute an enormous range of still and moving images, all of them—be they of beheadings, drownings, or mass executions—staged for maximum sensationalism.[8] Indeed, in some cases the production quality has been so good that it has led to charges that these films must have been staged. One could even argue that some of the ISIS videos are designed to play with the razor-thin line between compelling empirical evidence and the implausibly hyper- or surreal, deliberately foregrounding the inherent ambiguity of the medium, which documents and confabulates "reality" in one and the same gesture.

Thanks to the marketing prowess of ISIS, stories about their exploits dominate the international press, despite the fact that their operations have arguably killed fewer people than have died in the civil war in Syria over the past six years.[9] Human rights groups and activists seeking to bring international scrutiny to the atrocities perpetrated by Bashar al-Assad's government have responded by creating arresting videos designed specifically to compete with ISIS on the global media stage. The results are macabre. The most widely publicized sequence shows small children in orange jump suits standing in a cage—some of them are clearly frightened and crying—while a man outside the cage waves a torch and asks why the ISIS video of a Jordanian pilot being burned alive has obscured discussion of the countless children killed in the Damascus suburbs.[10] The film is simultaneously an example of grassroots journalism, an instance of performance art, and an advertisement, similar to something that would be aired by Greenpeace or Doctors Without Borders.[11] Even more important than the video's resistance to simple classification is the logic of proliferation inherent to it. Confronted with the extremity of ISIS productions, it is assumed that only a more outlandish video can win back the public's attention, but to rely on such tactics is necessarily to invite others, most obviously ISIS itself, to up the ante yet again, with no obvious end to this cycle of shock filmmaking.

Insofar as ISIS designs executions to optimize their shock value for audiences around the globe, an interpretation of what these videos show is built in from the start, immensely complicating any distinction between what happens in front of the camera

and what happens for the camera. The question is whether something similar now takes place on battlefields everywhere. A video of a firefight or a bombing can appear on YouTube within seconds of the event, if it is not streamed live; and once such a document is there, it is immediately supplemented by Twitter, Instagram, and Tumblr posts in which military personnel and civilians offer their highly partisan accounts of what you're seeing and what you should conclude from it. Combat is analyzed and debated by virtual audiences as it takes place. One consequence is that the media's traditional relationship to its subject matter has been inverted. Rather than creating texts, photo essays, or documentary videos intended to impart information about battles, journalists now spend a great deal of their time commenting on the photos and videos made by others, and commenting on the online commentary that particularly arresting ones spawn. All too often, the story is that the story went viral.

Unfortunately, the fact that the press is now preoccupied with commenting on others' videos and the myriad online interpretations of them does not tend to enhance the scrutiny and analysis of any given document. With the monopoly of governments and the fourth estate on the dissemination of such records of violence and destruction broken, media outlets find that they are scooped at every turn, because anything they share will already have circulated widely on the Internet and have been seen and discussed by far more people than will ever view any report a particular journalist might file. It is therefore relatively immaterial to a newspaper or television station if a video turns out to have been fake, since the controversy surrounding the document will be as real as any "real" story, and the interest prompted by allegations of inauthenticity will only enhance the attention the report receives.[12] What was once known as "fact-checking" thus becomes at most a secondary concern, if not an outright obstacle to doing business.

Meet the New Spectacle, Same as the Old Spectacle

It is tempting to conclude that the contemporary media ecology is unprecedented, the product of a unique constellation of economic, socio-political, and technological factors, the development of the Internet the most obvious among them. Previous generations, however, were just as preoccupied as we are with the radical transformations in experience supposedly effected by changes in recording and communications media. More than a quarter century has passed since Jean Baudrillard advanced his concept of hyperreality and claimed, among other things, that the 1991 Gulf War did not take place; and it was over 45 years ago that Guy Debord famously described the society of the spectacle, declaring that "all that once was directly lived has become mere representation."[13] Viewed in an even broader time horizon, it would not be difficult to show that these arguments build on claims made by Siegfried Kracauer, Walter Benjamin, and Theodor W. Adorno, who were themselves drawing on nineteenth-century ideas about the emergence of mass culture and the new kinds of informational systems that were irrevocably altering society. It would appear that each generation of theorists feels a need to make radical claims about transformations in the authority of the virtual, while the precise origins of these virtual dynamics recede further into the past.

Of course, resituating the discussion of contemporary militarism within a broader historical framework does not necessarily tell us anything about the impact of spectacles of violence on their mass audience. Even if we embrace Sontag's claim that we have been inured to the horrors we view on a daily basis, it remains uncertain whether

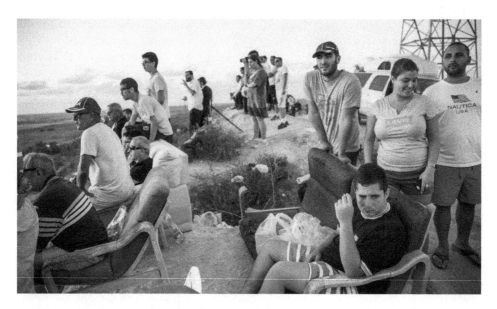

Figure 11.1 Israelis gathered on a hilltop outside the town of Sderot to watch the
 bombardment of Gaza.

Source: Courtesy of Andrew Burton/Getty Images.

this is a healthy form of adaptation, a confirmation of our ethical indifference to the
plight of others, or a symptom of having been profoundly disturbed by the show.

In July of 2014, some of the most widely circulated photos of the conflict in Gaza
showed not corpses or leveled buildings, but Israeli civilians gathering to watch the
aerial bombardment on a hilltop just outside of Sderot, a city in the western Negev (see
Figure 11.1). A Danish reporter described the scene as

> something that most closely resembles the front row of a reality war theatre.
> People have dragged camping chairs and sofas to the top of the hill. Several sit
> with crackling bags of popcorn, while others smoke hookahs and talk cheerfully.
> People come and go from the site in a steady stream; [when targets appear to be
> struck] cheers break out on the hill, followed by solid applause.[14]

As journalists were quick to point out, this was not the first time this very hilltop had
played host to such activities. Five years prior, an article in the *Times of London* had
described exactly the same scene as local residents and television crews flocked to the
vantage point outside Sderot for the "panoramic view of Israel's relentless bombard-
ment of the Gaza Strip."[15] With each clash between Israel and Hamas, the denizens of
this town and their hillside come into the limelight as a kind of prepackaged feature
story, as if the opportunity to report on this spectacle of the consumption of wartime
spectacles were simply too good to pass up.

Opinions about the activities of these hillside onlookers vary widely. Some press
reports intimate that this is a ghoulish form of voyeurism; others suggest that this kind
of dehumanization of the enemy is a normal feature of wartime life. Indeed, having

entertained the various options, one may well find oneself feeling judgmental about the desire to watch—and judge—the people watching from the hilltop, as if what were really disturbing about this scenario were the systematic need on the part of journalists to make these people's activities into an allegory of the relationship that twenty-first-century citizens have with warfare. To support this latter claim, it is observed that Sderot has been heavily targeted by missile attacks for almost 15 years, some reports putting the rate of PTSD among the city's children at 50 percent.[16] From this perspective, the citizenry of the town is to be applauded for turning the trials and tribulations of their geo-political predicament into a night at the movies, while it is the journalistic vulturism that should be condemned. At the same time, one could equally well ask whether the people who have lugged their sofas to this viewpoint and made popcorn are not themselves posturing for the international press, playing well-established roles, in full awareness that they are the spectacle, and not the bombardment itself. In this account, it is the war–audience relationship that has been inverted, war's observers proving more newsworthy than what they're watching.

The Art of the Mediascape

Whether we are focusing on the professional-quality films of ISIS, the grassroots video festival that is YouTube, or the experiences of the inhabitants of Sderot, contemporary spectacles of warfare are not easily assimilated to the paradigms of tragedy and sublimity with which military operations have historically been understood. Working in a variety of media, offline and online, a number of contemporary artists have explored new aesthetic paradigms that may be more apposite. One figure whose work stands out in this context is the French photographer Luc Delahaye. An accomplished photojournalist and war correspondent, in 2001 Delahaye started using a wide-angle, medium-format handheld camera to photograph the war-torn places he had previously covered, displaying the pictures in galleries as panorama-like prints in 4 × 8 foot color. Playing with the conventions of history painting, Delahaye attempts to rethink his predecessor Henri Cartier-Bresson's notion that a photo must capture the decisive moment—the "decisive moment" being of course a term that Cartier-Bresson took from Napoleon.[17]

Delahaye took *Baghdad IV* in the Iraqi capital in 2003, although he exhibits it without a date (see Figure 11.2). The photo is curiously ambiguous. It is difficult to decide whether one is viewing a noteworthy incident or an ordinary street scene, one of countless that day in the battle-ravaged city. There is neither an obvious focal point nor an implied narrative, as if the picture were simultaneously an action shot, a landscape portrait, and a poorly timed mistake showing some people who just happened to be wandering in and out of the frame. The smoke that hovers in the foreground is potentially ominous, threatening to obscure the view entirely, or it may be incidental and on the verge of dissipating. The human figures present are not all looking in the same direction or preoccupied with the same thing, and the elegant shapes of the buildings that line the street contrast starkly with the trash strewn on the right side of the photo, as if this were an architectural shot prior to being airbrushed.

One could argue that this photograph is ominous as much for what it doesn't show as for what it does, and it uneasily includes its viewer in this space of uncertain possibility, a ghostly arena in which something tragic may happen, may have happened, or may never happen. In this regard, Delahaye's picture is part of a line of battlefield

Figure 11.2 Luc Delahaye, Baghdad IV. C-print, 245 cm × 111 cm.
Source: Courtesy of the artist/Galerie Nathalie Obadia.

shots that would extend back to Roger Fenton's famous photo of an empty road from the Crimean war in the 1850s. Richard Pare has described Fenton's piece as the first iconic photo of war, which gains its significance from the fact that "it is devoid of any topographical detail that defines a particular place; [hence] . . . it suggests the potential for sudden and indiscriminate death," anywhere and everywhere, without actually illustrating anything dead.[18] In this respect, we might say that Delahaye's photo of Baghdad is a representation of warfare precisely because it is permanently open to the possibility that it is not representing warfare at all.

Ostensibly an exemplar of one of the most traditional topoi of war photography, a young man tragically slain in the flower of youth, this beautiful-death picture entitled

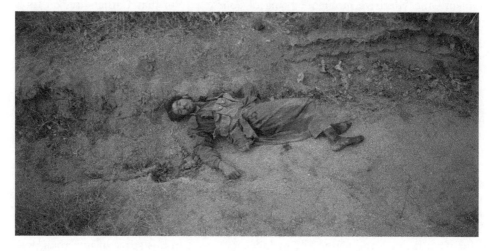

Figure 11.3 Luc Delahaye, Taliban. C-print, 237 cm × 111 cm.
Source: Courtesy of the artist/Galerie Nathalie Obadia.

Taliban shows an inert figure, untroubled by live comrades (see Figure 11.3). Although Delahaye has stated that he came upon this body in a great rush as he advanced with the troops who had just killed the individual, the scene is a little too tranquil, and what the viewer sees in the photograph is less evidence of the recentness of the soldier's demise than a rich catalog of what has transpired since. The man's boots and weapon have already been looted, and the corpse is surrounded by a network of traces of the comings and goings of others in the sand. Delahaye's photo depicts not the blitz of war but its spectral aftermath. What the image ultimately documents, then, is an open question. It may be a representation of a dead body, a record of the encounter of a passerby with a dead body, or a picture of a patch of landscape that just happens to include a dead body. Delahaye's own comments on *Taliban* consistently emphasize the sense of danger on the field of combat—the photographer has to work quickly and hurry on as the troops advance. Yet from the perspective of what the picture exhibits rather than how it was supposedly made, it is anything but an action shot.

When one first looks at *Taliban*, it may seem as if one is hovering above the corpse in the air, but this intuition is gradually complemented by the impression that one is looking down on the scene from a small ridge somewhere to the side, a levitation effect typical of devotional pictures of Christ descending from the cross, which often have a similar telephoto feel about them. This sense of participating in a quasi-disembodied gaze contributes to the intimacy of the encounter, as if the viewer were part of a private meeting between souls or engaging with an icon or devotional image intended to serve as a portal to the transcendent. Such details recall the long tradition of battlefield paintings in which fallen warriors are portrayed as Christ descending from the cross, but these are generally group scenes, whereas Delahaye's fighter is alone. This solitude renders the posture of his body curiously ambiguous: it may be erotic, suggestive of a state of grace, or arched like a posing dancer. Alternatively, the figure may be contorted in agony.

Delahaye's photograph appears to be part of a long tradition of humanist presentations of the fallen enemy as a noble "other" who is potentially a stand-in for anyone viewing the picture. When one looks at the Taliban soldier's face, however, one encounters neither the closed eyes of a sleeper nor a riveting return of one's gaze that might implicate one in a reflective relationship, but a quasi-disembodied stare. The sense of repose surrounding the corpse is further complicated by the piece of straw on the face, which may either confirm or refute the suspicion that the scene was arranged depending on whether one assesses the detail as genuinely or artificially random.[19] In either case, the straw highlights the reduction of the human form to lifeless matter while forcing the viewer to consider the extent to which the photo's rich colors and the coordination of the tones of the body and its clothing with the surrounding landscape recall the formal elegance of a history painting. Any identification between the picture and a painting, however, is temporary, for the viewer of *Taliban* experiences a constant shift in the work's themes and motifs. While the corpse modulates from a randomly found object to an icon, emblem, or even a synecdoche for the humanist ideal of the self, the scene oscillates between a close-up of a lovely natural setting, a contemplative portrait of a staged figure, and a realistic depiction of the horrific costs of war. The picture gives a shock to the traditional idea of the photograph as a preservation of a unique moment, but this never culminates in a confirmation of the image of the dead soldier as, in Cartier-Bresson's terms, decisive or non-decisive. An echo of the fleeting lingers, a hint that the picture has captured a trace of something that was never there.

The affective tone *Taliban* imparts to its viewer is security. There is no intimation that the bullet that felled this young man might have hit you. In pitting the conventions of art and art history against the documentarist ideologies of photojournalism, Delahaye confronts his audience with the most concrete, tangible evidence of the price of battle—a youth killed before his time—but he does so in an elaborate performance that seems to necessitate some discussion of the image's stagecraft or even its status as fake. This photo plays with its own potential contingency and with its inability to illustrate the difference between chance details and determined ones—in the final instance, one could imagine it to be part of a tasteless advertisement for socks.

Whatever one wants to say about the posture of Delahaye's corpse, it is not menacing, and in this respect, it is not strictly speaking military. In *War and Cinema*, Paul Virilio describes the central role that observation plays in military praxis. His analysis leads to the now familiar story in which the evolution of combat is shown to parallel the evolution of viewing and recording technologies, as we move from advances in viewfinders on rifles to aerial reconnaissance to satellite imagery. There is another side to Virilio's argument, however, that is often overlooked by those who adopt his claims in support of some form of technological determinism. Virilio maintains that a threatening posture that enables one to cow one's opponent prior to defeating him is an integral feature of warfare and that "to fell the enemy is not so much to capture as to 'captivate' him, to instill the fear of death before he *actually* dies."[20] In a thoroughly Hobbesian gesture, Virilio underscores the importance of petrifying—the Medusa subtext is clear—one's adversary. The ability to make one's willingness to fight visible is as or more important than one's skill with weapons. In this context, what is notable about the posture of the corpse in *Taliban* is that it lies outside of this threatening/not-threatening opposition, for it is neither a menace nor something that can be entirely disregarded. One is drawn into the dead soldier's gaze to such a degree that one's normal routine is interrupted, but not to the point that one is held riveted, much less turned to stone. This may be the sense in which *Taliban* is a war photograph that reveals itself to be something other than just a product of the military's own discourses—the picture offers a momentary engagement with a spectacle, but the moment this spectacularity recedes, one is no longer sure that it was ever present in the first place.

Delahaye made this picture before public attention had been directed to the US and British drone campaigns, but in a curious brush with prolepsis, one wonders if the photo or something similar could have been taken by some form of unmanned aerial device, had such a thing been present on the battlefield that day in Afghanistan. In Virilio's understanding of warfare, the notion of captivating one's foe is based on at least the possibility of parity between the optical capacities of the adversaries. Drone technology is thus ominous because it appears to realize the military fantasy of an all-seeing army that can monitor its foe for days or weeks on end before deciding exactly when and where to strike, yet do so invisibly. This is not to say that the drone gives no warning of its presence—the deleterious impact of the buzzing noises in the sky on the civilian populations below has been well documented—but nonetheless, this is warfare with only the faintest glimmer of the posturing that since Hobbes has constituted the essence of war. Moreover, once the status of the battlefield as spectacle has largely been factored out of the equation, the scopic volatility of drones proves to be destabilizing for much more than just our models of combat. This radical visual mobility appears to effortlessly traverse borders and international conventions, threatening to undo not just

Figure 11.4 Google Earth Image from the Ma'rib Governorate in Yemen.
Source: James Bridle, *Dronestagram* (June 1–10, 2015).

the war/battle opposition on which the modern understanding of war is based, but the very distinction between friend and foe, as well.

There have been a variety of artistic responses to the rise of military drones. One of the best-known projects is James Bridle's *Dronestagram*, a three-year-long attempt to examine whatever information was publicly available about each British and American drone strike taking place and pair the account with a Google Earth picture of the site of the attack (see Figure 11.4).[21] The satellite imagery replicates the drone's-eye-view to a degree, but Google's data is not updated daily, so one may well be seeing into the past and looking at an image of the locale before the strike, and from a distance that makes it unlikely that the casual viewer could discern any visual record of the event irrespective of when the picture was made. Further complicating the question of precisely how the images from Google Earth relate to the accounts of the drone strikes with which they are coupled, Bridle allows that with attacks in extremely remote areas, his satellite shot may be as much as two kilometers from the precise location in question. In effect, Bridle is showing us ghosts—of the past and the future—rather than visual documents of an incident as it occurs, or more precisely, he is showing us guesses as to where these ghosts could be haunting the landscape.

Had he wished, Bridle could have represented these events very differently, for there is a wealth of drone's-eye-view footage of missile strikes available on YouTube. These videos are shot from a much closer vantage point than what the Google Earth stills offer, so one can see vehicles and people in motion, and of course the actual explosions. Many of these films are released by the military to document its own achievements; in form and intent, they are still part of Napoleon's theater of war in which the generals script the story.[22] In contrast, the Dronestagram entries are the tweets or Snapchat messages of war. Each pairing of an image and a caption refers to something specific—a precise place on the surface of the planet, a precise event—but there is never any confirmation that the two line up, as if space, time, and language were imperfectly intermingled. The result is a battlefield that is simultaneously fact and fiction, everywhere and nowhere, in time and out of time.

As Bridle and Delahaye reveal, contemporary conflicts elude the theatrical model of spectacle and the spatio-temporal determinations that organize a traditional Napoleonic account of two armies colliding. In the face of these difficulties, a curiously self-reflexive public discourse has emerged in which the stories being told about warfare focus as much on the unique ways in which its audiences process—or fail to process—it as on the violent events themselves. Whereas previous generations worried about the dangers of aestheticizing warfare and treating mass destruction as a beautiful phenomenon, today we are more at risk of aestheticizing the technical prowess of our communicative media, as when the hype about the capacity of a particular video to go viral overshadows the tragic content depicted in it. The more dynamic our spectatorial experiences become, the less confident we are in our ability to determine what any given scene of death and devastation means. In this new Society of the Spectacle, the spectacle of the spectacle risks occluding the original show, and the results are less than provocative. If contemporary representations of warfare reveal the core truth of the Napoleonic imaginary—the fact that *watching* war may never be the key to understanding it—they offer little hope that fantasizing about war will hasten its obsolescence.

Notes

1 Associated Press, "Iraq Prisoner Abuse 'Un-American,' Says Rumsfeld," *Washington Times*, May 7, 2004, accessed August 1, 2006, www.washingtontimes.com/news/2004/may/7/20040507-115901-6736r/?page=all.
2 Thomas Hobbes, *Leviathan* (New York: Cambridge University Press, 1991), 88–89.
3 The appearance of these shocking pictures rekindled debates about the nature of the photographic image, including a prominent contribution by Susan Sontag. See her "Regarding the Torture of Others," *New York Times*, May 23, 2004, accessed June 1, 2004, www.nytimes.com/2004/05/23/magazine/regarding-the-torture-of-others.html?pagewanted=all.
 A year earlier, Sontag had published *Regarding the Pain of Others* (New York: Farrar, Straus & Giroux, 2003). For a critical response to Sontag, see Judith Butler's "Torture and the Ethics of Photography: Thinking with Sontag," in *Frames of War: When Is Life Grievable?* (London: Verso, 2008).
4 Adam Withnall, "If these Extraordinarily Powerful Images of a Dead Syrian Child Washed Up on a Beach Don't Change Europe's Attitude to Refugees, What Will?" *Independent*, September 3, 2015, accessed September 5, 2015, www.independent.co.uk/news/world/europe/if-these-extraordinarily-powerful-images-of-a-dead-syrian-child-washed-up-on-a-beach-don-t-change-10482757.html.
5 Peter Maass, "Why More Americans Should See the Beheading Videos," *Intercept*, September 10, 2014, accessed November 1, 2014, theintercept.com/2014/09/10/case-for-watching-beheading-videos/.

6 Maass, "Why More Americans."
7 Susan Sontag, "Looking At War: Photography's View of Devastation and Death," *New Yorker*, December 9, 2002, accessed May 1, 2003, www.newyorker.com/magazine/2002/12/09/ looking-at-war.
8 For a book-length study of this phenomenon, see Abdel-Bari Atwan, *Islamic State: The Digital Caliphate* (London: Saqi Books, 2015).
9 See Hugh Naylor, "Islamic State has Killed Many Syrians, But Assad's Forces have Killed More," *Washington Post*, September 5, 2015, accessed September 30, 2015, www. washingtonpost.com/world/islamic-state-has-killed-many-syrians-but-assads-forces-have-killed-even-more/2015/09/05/b8150d0c-4d85-11e5-80c2-106ea7fb80d4_story.html.
10 Anne Barnard, "Children, Caged for Effect, to Mimic Imagery of ISIS," *New York Times*, February 20, 2015, accessed July 30, 2015, www.nytimes.com/2015/02/21/world/middlee-ast/activists-trying-to-draw-attention-to-killings-in-syria-turn-to-isis-tactic-shock-value.html?hp&action=click&pgtype=Homepage&module=first-column-region®ion=top-news&WT.nav=top-news.
11 There is a history of commercial advertisers using graphic photos of the suffering effected by current events. In the early 1990s, the clothing manufacturer United Colors of Benetton had a controversial campaign that prominently featured pictures of AIDS patients on their deathbeds, refugees struggling to stay alive at sea, and soldiers in African civil wars holding human bones.
12 In one recent example, a video depicting a Syrian boy saving a girl from sniper fire was widely circulated before it was revealed to have been made by a Norwegian camera crew on a movie set. See Robert Mackey, "Norwegian Filmmakers Apologize for Fake Syria Video," *New York Times*, November 18, 2014, accessed January 15, 2015, www.nytimes.com/2014/11/19/world/europe/norwegian-filmmakers-apologize-for-fake-syria-video.html?_r=1.
13 See Jean Baudrillard, *Simulacra and Simulation*, trans. Sheila Faria Glaser (Michigan: University of Michigan Press, 1994), and *The Gulf War Did Not Take Place*, trans. Paul Patton (Bloomington: Indiana University Press, 1995); Guy Debord, *Society of the Spectacle*, trans. Ken Knabb (Detroit: Black & Red, 1983), 7.
14 Quoted in Robert Mackey, "Israelis Watch Bombs Drop on Gaza From Front-Row Seats," *New York Times*, July 14, 2014, accessed July 14, 2014, www.nytimes.com/2014/07/15/world/middleeast/israelis-watch-bombs-drop-on-gaza-from-front-row-seats.html?_r=0.
15 Martin Fletcher and Yonit Farago, "Hill of Shame Where Gaza Bombing Is Spectator Sport," *Times of London*, January 13, 2009, accessed July 1, 2014, www.thetimes.co.uk/tto/news/world/middleeast/article2604242.ece.
16 Dan Even, "Israeli Survey: Almost Half of Sderot Preteens Show Symptoms of PTSD," *Haaretz*, November 20, 2012, accessed July 1, 2014, www.haaretz.com/israel-news/israeli-survey-almost-half-of-sderot-preteens-show-symptoms-of-ptsd.premium-1.479113.
17 See *The Decisive Moment: Photography by Henri Cartier-Bresson* (New York: Simon & Schuster, 1952).
18 Richard Pare, cited in Errol Morris, *Seeing is Believing* (New York: Penguin, 2011), 17.
19 In this context, one should recall Carl von Clausewitz's canonical claim that war is the human activity in which chance receives its fullest expression.
20 Paul Virilio, *War and Cinema: The Logistics of Perception*, trans. Patrick Camiller (New York: Verso, 2000), 5.
21 For more information, see booktwo.org/notebook/dronestagram-drones-eye-view/. The project was available as Instagram, Twitter, and Tumblr feeds, which can still be viewed.
22 The US Department of Defense has a website that shares clips of "classified" drone attacks: www.dvidshub.net/.

Bibliography

Associated Press. "Iraq Prisoner Abuse 'Un-American,' Says Rumsfeld." *Washington Times*, May 7, 2004. www.washingtontimes.com/news/2004/may/7/20040507-115901-6736r/?page=all (accessed August 1, 2006).
Atwan, Abdel-Bari. *Islamic State: The Digital Caliphate*. London: Saqi Books, 2015.

Barnard, Anne. "Children, Caged for Effect, to Mimic Imagery of ISIS." *New York Times*, February 20, 2015. www.nytimes.com/2015/02/21/world/middleeast/activists-trying-to-draw-attention-to-killings-in-syria-turn-to-isis-tactic-shock-value.html?hp&action=click&pgtype=Homepage&module=first-column-region®ion=top-news&WT.nav=top-news (accessed July 30, 2015).

Baudrillard, Jean. *Simulacra and Simulation*. Translated by Sheila Faria Glaser. Michigan: University of Michigan Press, 1994.

——. *The Gulf War Did Not Take Place*. Translated by Paul Patton. Bloomington: Indiana University Press, 1995.

Bridle, James. *Dronestagram: The Drone's-Eye View*, 2012–2015. http://booktwo.org/notebook/dronestagram-drones-eye-view/ (accessed June 1–10, 2015).

Butler, Judith. "Torture and the Ethics of Photography: Thinking with Sontag." In *Frames of War: When Is Life Grievable?*, 63–100, London: Verso, 2008.

Cartier-Bresson, Henri. *The Decisive Moment: Photography by Henri Cartier-Bresson*. New York: Simon & Schuster, 1952.

Debord, Guy. *Society of the Spectacle*. Trans. Ken Knabb. Detroit: Black & Red, 1983.

Even, Dan. "Israeli Survey: Almost Half of Sderot Preteens Show Symptoms of PTSD." *Haaretz*, November 20, 2012. www.haaretz.com/israel-news/israeli-survey-almost-half-of-sderot-preteens-show-symptoms-of-ptsd.premium-1.479113 (accessed July 1, 2014).

Fletcher, Martin and Yonit Farago. "Hill of Shame where Gaza bombing is Spectator Sport." *The Times of London*, January 13, 2009. www.thetimes.co.uk/tto/news/world/middleeast/article2604242.ece (accessed July 1, 2014).

Hobbes, Thomas. *Leviathan*. New York: Cambridge University Press, 1991.

Mackey, Robert. "Israelis Watch Bombs Drop on Gaza From Front-Row Seats." *New York Times*, July 14, 2014. www.nytimes.com/2014/07/15/world/middleeast/israelis-watch-bombs-drop-on-gaza-from-front-row-seats.html?_r=0 (accessed July 14, 2014).

——. "Norwegian Filmmakers Apologize For Fake Syria Video." *New York Times*, November 18, 2014. www.nytimes.com/2014/11/19/world/europe/norwegian-filmmakers-apologize-for-fake-syria-video.html?_r=1 (accessed January 15, 2015).

Maass, Peter. "Why More Americans Should See the Beheading Videos." *The Intercept*, September 10, 2014. theintercept.com/2014/09/10/case-for-watching-beheading-videos/ (accessed November 1, 2014).

Morris, Errol. *Seeing is Believing*. New York: Penguin, 2011.

Naylor, Hugh. "Islamic State Has Killed Many Syrians, But Assad's Forces Have Killed More." *Washington Post*, September 5, 2015. www.washingtonpost.com/world/islamic-state-has-killed-many-syrians-but-assads-forces-have-killed-even-more/2015/09/05/b8150d0c-4d85-11e5-80c2-106ea7fb80d4_story.html (accessed September 30, 2015).

Sontag, Susan. "Looking at War: Photography's View of Devastation and Death." *New Yorker*, December 9, 2002. www.newyorker.com/magazine/2002/12/09/looking-at-war (accessed May 1, 2003).

——. *Regarding the Pain of Others*. New York: Farrar, Straus & Giroux, 2003.

——. "Regarding the Torture of Others." *New York Times*, May 23, 2004. www.nytimes.com/2004/05/23/magazine/regarding-the-torture-of-others.html?pagewanted=all (accessed June 1, 2004).

Virilio, Paul. *War and Cinema: The Logistics of Perception*. Translated by Patrick Camiller. New York: Verso, 2000.

Withnall, Adam. "If these Extraordinarily Powerful Images of a Dead Syrian Child Washed Up on a Beach Don't Change Europe's Attitude to Refugees, What Will?" *Independent*, September 3, 2015. www.independent.co.uk/news/world/europe/if-these-extraordinarily-powerful-images-of-a-dead-syrian-child-washed-up-on-a-beach-don-t-change-10482757.html (accessed September 5, 2015).

Contributors

Thomas Ærvold Bjerre is Associate Professor in American Studies at the University of Southern Denmark. He has published on war in literature and film in, for example, *Journal of War and Culture Studies* and *Orbis Litterarum*. In 2009 he co-authored (with Torben Huus Larsen) the first Danish book about the American Western, *Coywboynationen* (University Press of Southern Denmark), and more recently he co-edited (with Beata Zawadka) *The Scourges of the South? Essays on 'The Sickly South' in History, Literature, and Popular Culture* (Cambridge Scholars, 2014). His current research examines representations of 9/11 and the war on terror in literature, film, and photography—with a focus on depictions of masculinities.

Svea Braeunert is DAAD Visiting Associate Professor in German Studies at the University of Cincinnati. Her research interests include twentieth- and twenty-first-century art, literature, and film, media theory and visual culture, concepts of memory, trauma, and deferred action, and gender studies. She is the author of *Gespenstergeschichten: Der linke Terrorismus der RAF und die Künste* (Kadmos, 2015), and co-author and co-curator of *To See Without Being Seen: Contemporary Art and Drone Warfare* (University of Chicago Press, 2016) and *Method: Sasha Kurmaz* (Kehrer, 2016).

Anders Engberg-Pedersen is Associate Professor of Comparative Literature at the University of Southern Denmark. In 2012 he earned his PhD from Harvard University in Comparative Literature as well as from Humboldt Universität in German Literature. His research centers on warfare, cartography, the history of knowledge, and aesthetic theory. He is the author of *Empire of Chance: The Napoleonic Wars and the Disorder of Things* (Harvard University Press, 2015), and the editor of *Literature and Cartography: Histories, Theories, Genres* (MIT Press, 2017). His articles have appeared in journals such as *Representations*, *Imago Mundi*, *Boundary 2*, and *Russian Literature*, and he is currently working on a book entitled *Military Aesthetics: Technology, Experience, and Late Modern War*.

Stephan Jaeger is Professor of German Studies at the University of Manitoba and Head of the Department of German and Slavic Studies. He has written extensively on narratology, history and literature, documentary history in historiography, film, and the museum, representations of war, and romantic and modern poetry. He has published two monographs: *Theorie lyrischen Ausdrucks* (Fink, 2001) and *Performative Historiography in the Late Eighteenth Century* (Walter de Gruyter, 2011), and five co-edited books including *Fighting Words and Images: Representing War across*

the Disciplines (University of Toronto Press, 2012) and a special issue of *Seminar: Representations of German War Experiences from the Eighteenth Century to the Present* (February 2014). He is co-coordinator of the Interdisciplinary Network *War and Violence* of the German Studies Association. Currently he works on a comparative research project, funded by the Social Sciences and Humanities Research Council of Canada (SSHRC), on twenty-first-century museum representations of the Second World War in North America and Europe (Germany, Poland, UK, Belgium, Canada, US).

Christine Kanz is Professor of Modern German Literature at the University of Education Upper Austria in Linz. Her research interests are interdisciplinary. They include European literature from the eighteenth century to the present with an emphasis on the European avant-gardes, postwar and contemporary literature, culture and art, history of knowledge formations such as psychoanalysis or reproductive technologies, history and theory of emotions, gender and family studies, and critical theory. She is the author of two monographs: *Angst und Geschlechterdifferenzen: Ingeborg Bachmanns Todesarten-Projekt in Kontexten der Gegenwartsliteratur* (J.B. Metzler, 1999) as well as *Maternale Moderne: Männliche Gebärphantasien zwischen Kultur und Wissenschaft, 1890–1933* (Fink, 2009). Among her edited books are *Schriftstellerinnen und das Wissen um das Unbewusste* (Marburg Verlag, 2011), *Zerreissproben/Double Bind: Familie und Geschlecht in der deutschen Literatur des 18. und des 19. Jahrhunderts* (eFeF, 2007), *Zwischen Demontage und Sakralisierung: Revisionen des Familienmodells in der europäischen Moderne (1880–1945)* (Königshausen & Neumann, 2015).

Hermann Kappelhoff is Professor in the Department of Film Studies at the Freie Universität, Berlin. He is Director and Principal Investigator of the Exzellenzcluster "Languages of Emotion" also at the Freie Universität, Berlin. He represents Media Studies in the Council of the Deutsche Forschungsgemeinschaft (DFG) (German Research Foundation), and is a staff member of the Graduate School of North American Studies and of the Dahlem Humanities Center. His dissertation on the poetics of the Weimar auteur cinema was published in 1995 under the title, *Der möblierte Mensch. G.W. Pabst und die Utopie der Sachlichkeit. Ein poetologischer Versuch zum Weimarer Autorenkino.* Another monograph appeared with Vorwerk 8 in 2004 entitled *Matrix der Gefühle. Das Kino, das Melodrama und das Theater der Empfindsamkeit.* Recently he edited the volume *Mobilisierung der Sinne: Der Hollywood-Kriegsfilm zwischen Genrekino und Historie* (2013). Since 2007, he has been head of a research project on the politics of aesthetics in Western European cinema.

Elisabeth Krimmer is Professor of German at the University of California, Davis. She is the author of *In the Company of Men: Cross-Dressed Women around 1800* (Wayne State University Press, 2004), *The Representation of War in German Literature: From 1800 to the Present* (Cambridge University Press, 2010) and co-author (with Susanne Kord) of *Hollywood Divas, Indie Queens and TV Heroines: Contemporary Screen Images of Women* (Rowman & Littlefield, 2004) and *Contemporary Hollywood Masculinities: Gender, Genre and Politics* (Palgrave Macmillan, 2011). Her articles have appeared in journals such as *PMLA, The German Quarterly, Seminar, German Life and Letters,* and *Eighteenth-Century Fiction.* Her most recent projects include two co-edited collections (with Patricia Simpson) entitled *Enlightened War: Theories*

and Cultures of Warfare in Eighteenth-Century Germany (Camden House, 2011) and *Religion, Reason, and Culture in the Age of Goethe* (Camden House, 2013). She is currently working on a book-length study of women and war in twentieth-century Germany entitled *Complicity: German Women, the Second World War and the Holocaust.*

Kathrin Maurer is Associate Professor of German Studies at the University of Southern Denmark. She earned her PhD in German Literature from Columbia University and worked as an Assistant Professor at the University of Arizona. Her research interests are German literature of the nineteenth and twentieth century, visual culture, representations of history, war studies, and German realism. She is the author of *Visualizing History: The Power of the Image in German Historicism* (Walter de Gruyter, 2013) and *Discursive Interaction: Literary Realism and Academic Historiography* (Synchron, 2006). Her articles have appeared in journals such as *New German Critique, The Germanic Review, Colloquia Germanica.* She is currently conducting research on drones and culture.

Jan Mieszkowski is Professor of German and Comparative Literature at Reed College. He is the author of *Labors of Imagination: Aesthetics and Political Economy from Kant to Althusser* (Fordham University Press, 2006) and *Watching War* (Stanford University Press, 2012). His work has appeared in journals such as *PMLA, MLN, Modernism/Modernity,* and *Postmodern Culture.* Recent articles explore a variety of topics in Romanticism and critical theory, modern art and performance studies, and the philosophical and ideological foundations of contemporary literary criticism. He is currently writing a new book called *Crises of the Sentence.*

Katarzyna Ruchel-Stockmans is Lecturer in Contemporary Art, Photography and New Media at the Free University of Brussels, Belgium. She graduated from Philosophy and Art History in Cracow, Poland, and subsequently obtained a doctorate in Art History at the University of Leuven, Belgium, where she was Fellow of the Lieven Gevaert Research Centre for Photography. In 2015 she published *Images Performing History: Photography and Representations of the Past in European Art after 1989* with Leuven University Press. Her research interests include art and photography theory, media studies, East European cultures, history and representations.

Andrea Schütte is postgraduate scholar in the Department of German Studies, General and Comparative Literature at Bonn University. She worked at the research center "Media and Cultural Communication" in Cologne and received her Ph.D. in Literary Studies with a cultural science-based study on Jacob Burckhardt and the museum of the nineteenth century. Her research focus is on text theory and theory of the body. She has been working on a study on the phenomenon of intensity in aesthetic theory. She is the co-editor of *Medien der Präsenz. Museum, Bildung und Wissenschaft im 19. Jahrhundert* (DuMont, 2001) and of *Tribunale. Literarische Darstellung und juridische Aufarbeitung von Kriegsverbrechen im globalen Kontext* (Vittorio Klostermann, 2014). Several articles deal with the newest contemporary German literature and have appeared in journals such as *Zeitschrift für deutsche Philologie* and *Zeitschrift für Literaturwissenschaft und Linguistik.*

Index

Lightning Source UK Ltd.
Milton Keynes UK
UKHW030155150719
346148UK00011B/286/P